THE BIRTH OF THE MUSEUM

What is the cultural function of the museum? How did modern museums evolve? Tony Bennett's invigorating study enriches and challenges our understanding of the museum, placing it at the centre of modern relations of culture and government.

Bennett argues that the public museum should be understood not just as a place of instruction but as a reformatory of manners in which a wide range of regulated social routines and performances take place. Discussing the historical development of museums alongside that of the fair and the international exhibition, he sheds new light upon the relationship between modern forms of official and popular culture.

In a series of richly detailed case studies from Britain, Australia and North America, Bennett investigates how nineteenth- and twentieth-century museums, fairs and exhibitions have organised their collections, and their visitors. His use of Foucaultian perspectives and his consideration of museums in relation to other cultural institutions of display provides a distinctive perspective on contemporary museum policies and politics.

Tony Bennett is Professor of Cultural Studies and Foundation Director of the Institute for Cultural Policy Studies in the Faculty of Humanities at Griffith University, Australia. He is the author of *Formalism and Marxism, Outside Literature* and (with Janet Woollacott) *Bond and Beyond: The Political Career of a Popular Hero.*

CULTURE: POLICIES AND POLITICS
Series editors: Tony Bennett, Jennifer Craik, Ian Hunter, Colin Mercer and Dugald Williamson

What are the relations between cultural policies and cultural politics? Too often, none at all. In the history of cultural studies so far, there has been no shortage of discussion of cultural politics. Only rarely, however, have such discussions taken account of the policy instruments through which cultural activities and institutions are funded and regulated in the mundane politics of bureaucratic and corporate life. *Culture: Policies and Politics* addresses this imbalance. The books in this series interrogate the role of culture in the organization of social relations of power, including those of class, nation, ethnicity and gender. They also explore the ways in which political agendas in these areas are related to, and shaped by, policy processes and outcomes. In its commitment to the need for a fuller and clearer policy calculus in the cultural sphere, *Culture: Policies and Politics* aims to promote a significant transformation in the political ambit and orientation of cultural studies and related fields.

ROCK AND POPULAR MUSIC
politics, policies, institutions
Edited by: Tony Bennett, Simon Frith, Lawrence Grossberg, John Shepherd, Graeme Turner

GAMBLING CULTURES
Edited by: Jan McMillen

FILM POLICY
Edited by: Albert Moran

THE BIRTH OF
THE MUSEUM

History, theory, politics

Tony Bennett

London and New York

First published 1995
by Routledge
11 New Fetter Lane, London EC4P 4EE

Simultaneously published in the USA and Canada
by Routledge
29 West 35th Street, New York, NY 10001

Reprinted 1996, 1997, 1998, 1999, 2000

Routledge is an imprint of the Taylor & Francis Group

© 1995 Tony Bennett

Typeset in Times by
Ponting–Green Publishing Services, Chesham, Bucks
Printed and bound in Great Britain by
T.J. International Ltd, Padstow, Cornwall

British Library Cataloguing in Publication Data
A catalogue record for this book is available from the British
Library

Library of Congress Cataloging in Publication Data
A catalog record for this book is available from the Library of
Congress

ISBN 0–415–05387–0 (hbk)
ISBN 0–415–05388–9 (pbk)

6793 A (BEN)

CONTENTS

CONTENTS

FIGURES

ACKNOWLEDGEMENTS

I owe a good deal to many people for their help in making this book possible. First, I am grateful to Bronwyn Hammond for her skilled and enthusiastic research assistance over a number of years. Apart from helping to keep the book a live prospect in the midst of other commitments, Bronwyn's love for sleuthing in the archives proved invaluable in locating material which I doubt I should otherwise have found.

Jennifer Craik and Ian Hunter offered very helpful editorial suggestions at the final stage of assembling the book. I am grateful to both of them for the pains they went to in leaving no sentence unturned. While, no doubt, there is still room for improvement, my arguments are a good deal more economical and more clearly formulated as a consequence.

Both also helped with their comments on the substance of the argument in particular chapters. Many others have contributed to the book in this way. Those whose advice has proved especially helpful in this regard include Colin Mercer, whose unfailing friendship and collegiality I have enjoyed for many years now, and David Saunders who can always be counted on for pointed but constructive criticism – and for much more. I am also grateful to Pat Buckridge, David Carter and John Hutchinson for their comments on Chapter 8.

As is always the case, I have learned a good deal from the points made in criticism and debate in the discussions that have followed the various seminars at which I have presented the ideas and arguments brought together here. I especially valued the points made by Wayne Hudson in his comments on an early draft of the arguments of Chapter 1 when I presented these at a seminar in the School of Cultural and Historical Studies at Griffith University. I also learned a good deal from the discussion which followed a similar presentation to the Department of English at the University of Queensland.

Chapter 3 was first presented at the conference 'Cultural Studies and Communication Studies: Convergences and Divergences' organized by the Centre for Research on Culture and Society at Carleton University in 1989. I am grateful to the conference organizers, Ian Taylor, John Shepherd and Valda Blundell, for inviting me to take part in the conference and for their hospitality during the period I was in Ottawa.

However, perhaps my greatest debt of this kind is to the colleagues and students involved in two courses – 'Knowledge and Power' and 'Australian Cultural Policies' – in which many of the arguments presented here were first developed. So far as the first course is concerned, I learned much from working alongside Jeffrey Minson and Ian Hunter; with regard to the second, I especially valued the inputs of Mark Finnane and Stephen Garton.

I doubt that the book would ever have been completed but for a period of extended study-leave granted me by Griffith University. I am grateful to the University for its generosity and support in this matter. I am also grateful to the Department of English at the University of Queensland for offering me the facilities of a Visiting Scholar over this period. I especially valued the opportunity this gave me for extended discussions with John Frow and Graeme Turner: I benefited much from their friendship and advice over this period. I am similarly grateful to St Peter's College, Oxford University, for the hospitality it extended me when I visited Oxford to consult the resources of the Bodleian Library – whose assistance I should also like to gratefully acknowledge.

Some of this book was written during the period that I was Dean of the Faculty of Humanities at Griffith University. The assistance lent me over this period by Teresa Iwinska, the Faculty Manager, was a real help in allowing me to divert my energies to the joys of the study from time to time.

I am also grateful to the staff of the Institute for Cultural Policy Studies for their help and support over a number of years, and often with particular reference to work undertaken for this book. Barbara Johnstone provided much valued research assistance in relation to some of the earlier phases of the work; Sharon Clifford has provided expert administrative support; and Glenda Donovan and Bev Jeppeson have helped at various stages in preparing the text. Robyn Pratten and Karen Yarrow have also assisted in this. I am grateful to all of them.

Some of the chapters have been published previously in other contexts. Chapter 2 was first published in *New Formations* (no. 4, 1988) while Chapter 3 was first published in *Continuum* (vol. 3, no. 1, 1989). Chapter 4 initially appeared in Robert Lumley (ed.) *The Museum Time-Machine: Putting Cultures on Display* (Routledge, 1988), while Chapter 6 was included in Jody Berland and Will Straw (eds) *Theory Rules* (University of Toronto Press, 1993). Chapter 8 first appeared in *Cultural Studies* (vol. 5, no. 1, 1991) while Chapter 9 was first published in *Formations of Pleasure* (Routledge, 1982). All of these are reprinted here without any substantial variation. Chapter 5 is a shortened version of an occasional paper published by the Institute for Cultural Policy Studies. Some aspects of Chapter 1 were rehearsed in an article published under the title 'Museums, government, culture' in *Sites* (no. 25, 1992). However, the formulations published here are substantially revised and extended.

I am grateful to Beamish Museum for its permission to use the illustrations

accompanying Chapter 4, and to Brisbane's South Bank Corporation, Selcom, and IBM Australia Ltd for their permission in relation to the illustrations accompanying Chapter 8. I am indebted to Steve Palmer and to Blackpool Pleasure Beach Ltd for their help in locating the illustrations for Chapter 9.

It's hard to say why, but, as a matter of convention, partners seem always to get the last mention in acknowledgements although they contribute most. Sue is no exception – so thanks, yet again, for helping me through this one in ways too numerous to mention.

INTRODUCTION

In his essay 'Of other spaces', Michel Foucault defines heterotopias as places
in which 'all the other real sites that can be found within the culture, are
simultaneously represented, contested, and inverted' (Foucault 1986: 24). As
such, he argues that the museum and the library – both 'heterotopias of
indefinitely accumulating time' – are peculiar to, and characteristic of,
nineteenth-century Western culture:

> the idea of accumulating everything, of establishing a sort of general
> archive, the will to enclose in one place all times, all epochs, all forms,
> all tastes, the idea of constituting a place of all times that is itself outside
> of time and inaccessible to its ravages, the project of organising in this
> a sort of perpetual and indefinite accumulation of time in an immobile
> place, this whole idea belongs to our modernity.
>
> (Foucault 1986: 26)

Ranged against the museum and the library, Foucault argues, are those
heterotopias which, far from being linked to the accumulation of time, are
linked to time 'in its most fleeting, transitory, precarious aspect, to time in
the mode of the festival' (ibid.: 26). As his paradigm example of such spaces,
Foucault cites 'the fairgrounds, these marvellous empty sites on the outskirts
of cities that teem once or twice a year with stands, displays, heteroclite
objects, wrestlers, snake-women, fortune-tellers, and so forth' (ibid.: 26).

The terms of the opposition are familiar. Indeed, they formed a part of the
discursive co-ordinates through which the museum, in its nineteenth-century
form, was thought into being via a process of double differentiation. For the
process of fashioning a new space of representation for the modern public
museum was, at the same time, one of constructing and defending that space
of representation as a rational and scientific one, fully capable of bearing the
didactic burden placed upon it, by differentiating it from the disorder that
was imputed to competing exhibitionary institutions. This was, in part, a
matter of distinguishing the museum from its predecessors. It was thus quite
common, toward the end of the nineteenth century, for the museum's early
historians – or, perhaps more accurately, its rhapsodists – to contrast its

1

achieved order and rationality with the jumbled incongruity which now seemed to characterize the cabinets of curiosity which, in its own lights, the museum had supplanted and surpassed. Those who would visit the local museums in Britain's smaller towns, Thomas Greenwood warned in 1888, should be prepared to find 'dust and disorder reigning supreme'. And worse:

> The orderly soul of the Museum student will quake at the sight of a Chinese lady's boot encircled by a necklace made of sharks's teeth, or a helmet of one of Cromwell's soldiers grouped with some Roman remains. Another corner may reveal an Egyptian mummy placed in a mediaeval chest, and in more than one instance the curious visitor might be startled to find the cups won by a crack cricketer of the county in the collection, or even the stuffed relics of a pet pug dog.
>
> (Greenwood 1888: 4)

By contrast, where new museums had been established under the Museums or Public Library Acts, Greenwood asserts that 'order and system is coming out of chaos' owing to the constraints placed on 'fossilism or foolish proceedings' by the democratic composition of the bodies responsible for governing those museums.

This attribution of a rationalizing effect to the democratic influence of a citizenry was, in truth, somewhat rare, especially in the British context.[1] For it was more usually science that was held responsible for having subjected museum displays to the influence of reason. Indeed, the story, as it was customarily told, of the museum's development from chaos to order was, simultaneously, that of science's progress from error to truth. Thus, for David Murray, the distinguishing features of the modern museum were the principles of 'specialisation and classification' (Murray 1904: 231): that is, the development of a range of specialist museum types (of geology, natural history, art, etc.) within each of which objects were arranged in a manner calculated to make intelligible a scientific view of the world. In comparison with this educational intent, Murray argued, pre-modern museums were more concerned to create surprise or provoke wonder. This entailed a focus on the rare and exceptional, an interest in objects for their singular qualities rather than for their typicality, and encouraged principles of display aimed at a sensational rather than a rational and pedagogic effect. For Murray, the moralized skeletons found in early anatomical collections thus achieved such a sensational effect only at the price of an incongruity which nullified their educational potential.

> For example, the anatomical collection at Dresden was arranged like a pleasure garden. Skeletons were interwoven with branches of trees in the form of hedges so as to form vistas. Anatomical subjects were difficult to come by, and when they were got, the most was made of them. At Leyden they had the skeleton of an ass upon which sat a

2

woman that killed her daughter; the skeleton of a man, sitting upon an ox, executed for stealing cattle; a young thief hanged, being the Bridegroom whose Bride stood under the gallows. . .

(Murray 1904: 208)

Yet similar incongruities persisted into the present where, in commercial exhibitions of natural and artificial wonders, in travelling menageries and the circus and, above all, at the fair, they formed a part of the surrounding cultural environs from which the museum sought constantly to extricate itself. For the fair of which Foucault speaks did not merely relate to time in a different way from the museum. Nor did it simply occupy space differently, temporarily taking up residence on the city's outskirts rather than being permanently located in its centre. The fair also confronted – and affronted – the museum as a still extant embodiment of the 'irrational' and 'chaotic' disorder that had characterized the museum's precursors. It was, so to speak, the museum's own pre-history come to haunt it.

The anxiety exhibited by the National Museum of Victoria in the stress it placed, in its founding years (the 1850s), on its intention to display 'small and ugly creatures' as well as 'showy' ones – to display, that is, objects for their instructional rather than for their curiosity or ornamental value thus related as much to the need to differentiate it from contemporary popular exhibitions as to that of demonstrating its historical surpassing of the cabinet of curiosities. The opening of the National Museum of Victoria coincided with Melbourne's acquisition of its first permanent menagerie, an establishment housed in a commercial amusement park which – just as much as the menagerie it contained – was given over to the principles of the fabulous and the amazing. Whereas the menagerie stressed the exotic qualities of animals, so the accent in the surrounding entertainments comprising the amusement park was on the marvellous and fantastic: 'Juan Fernandez, who nightly put his head into a lion's mouth, a Fat Boy, a Bearded Woman, some Ethiopians, Wizards, as well as Billiards, Shooting Galleries, Punch and Judy Shows and Bowling Saloons' (Goodman 1990: 28). If, then, as Goodman puts it, the National Museum of Victoria represented itself to its public as a 'classifying house', emphasizing its scientific and instructional qualities, this was as much a way of declaring that it was not a circus or a fair as it was a means of stressing its differences from earlier collections of curiosities.

Yet, however much the museum and the fair were thought of and functioned as contraries to one another, the opposition Foucault posits between the two is, perhaps, too starkly stated. It is also insufficiently historical. Of course, Foucault is fully alert to the historical novelty of those relations which, in the early nineteenth century, saw the museum and the fair emerge as contraries. Yet he is not equally attentive to the historical processes which have subsequently worked to undermine the terms of that opposition. The emergence, in the late nineteenth century, of another 'other space' – the

3

fixed-site amusement park – was especially significant in this respect in view of the degree to which the amusement park occupied a point somewhere between the opposing values Foucault attributes to the museum and the travelling fair.

The formative developments here were American. From the mid-1890s a succession of amusement parks at Coney Island served as the prototypes for this new 'heterotopia'. While retaining some elements of the travelling fair, the parks mixed and merged these with elements derived, indirectly, from the programme of the public museum. In their carnival aspects, amusement parks thus retained a commitment to 'time in the mode of the festival' in providing for the relaxation or inversion of normal standards of behaviour. However, while initially tolerant of traditional fairground side-shows – Foucault's wrestlers, snake-women and fortune-tellers – this tolerance was always selective and, as the form developed, more stringent as amusement parks, modelling their aspirations on those of the public parks movement, sought to dissociate themselves from anything which might detract from an atmosphere of wholesome family entertainment.

Moreover, such side-shows increasingly clashed with the amusement park's ethos of modernity and its commitment, like the museum, to an accumulating time, to the unstoppable momentum of progress which, in its characteristic forms of 'hailing' (accenting 'the new' and 'the latest') and entertainments (mechanical rides), the amusement park claimed both to represent and to harness to the cause of popular pleasure. Their positions within the evolutionary time of progress were, of course, different, as were the ways in which they provided their visitors with opportunities to enact this time by building it into the performative regimes which regulated their itineraries. However, by the end of the century, both the museum and the amusement park participated in elaborating and diffusing related (although rarely identical) conceptions of time. This was not without consequence for travelling fairs which came to feature the new mechanical rides alongside wrestlers, snake-women and fortune-tellers, thereby encompassing a clash of times rather than a singular, fleeting time that could be simply opposed to the accumulating time of modernity.

If, then, unlike the traditional travelling fair, fixed-site amusement parks gave a specific embodiment to modernity, they were also unlike their itinerant predecessors in the regulated and ordered manner of their functioning. In the late eighteenth and early nineteenth centuries, the fair had served as the very emblem for the disorderly forms of conduct associated with all sites of popular assembly. By contrast, early sociological assessments of the cultural significance of the amusement park judged that it had succeeded in pacifying the conduct of the crowd to a much greater degree than had the public or benevolent provision of improving or rational recreations.[2]

By the end of the nineteenth century, then, the emergence of the amusement park had weakened that sense of a rigorous duality between two heterotopias

– the museum and the fair – viewed as embodying antithetical orderings of time and space. However, this situation had been prepared for in the earlier history of international exhibitions which, throughout the second half of the nineteenth century, provided for a zone of interaction between the museum and the fair which, while not undoing their separate identities, undermined their seemingly inherent contrariness in involving them, indirectly, in an incessant and multifaceted set of exchanges with one another. If the most immediate inspiration for Coney Island's amusement parks was thus the Midway (or popular fair zone) at Chicago's Columbian Exhibition in 1893, it is no less true that the Chicago Midway was profoundly influenced by museum practices.

The role accorded museum anthropology in harmonizing the representational horizons of the Midway with the ideological theme of progress was especially significant in this respect, albeit that, in the event, traditions of popular showmanship often eclipsed the scientific pretensions of anthropology's claims to rank civilizations in an evolutionary hierarchy. There were, however, many other ways in which (in spite of the efforts to keep them clearly separated) the activities of fairs, museums and exhibitions interacted with one another: the founding collections of many of today's major metropolitan museums were bequeathed by international exhibitions; techniques of crowd control developed in exhibitions influenced the design and layout of amusement parks; and nineteenth-century natural history museums throughout Europe and North America owed many of their specimens to the network of animal collecting agencies through which P.T. Barnum provided live species for his various circuses, menageries and dime museums.

The organizing focus for my concerns in this study is provided by the museum. Indeed, my purpose – or at least a good part of it – has been to provide a politically focused genealogy for the modern public museum. By 'genealogy', I mean an account of the museum's formation and early development that will help to illuminate the co-ordinates within which questions of museum policies and politics have been, and continue to be, posed. As such, this account is envisaged as contributing to a shared enterprise. For there are, now, a number of such histories which aspire to provide accounts of the museum's past that will prove more serviceable in relation to present-day museum debates and practices than those accounts – still dominant in the 1950s – cast in the whiggish mould of the museum's early chroniclers.[3] Where, however, the account offered here most obviously differs from other such endeavours is in its diacritical conception of the tasks a genealogy of the museum might usefully address. Eilean Hooper-Greenhill, for example, proposes a genealogy of the museum which concerns itself mainly with transformations in those practices of classification and display – and of the associated changes in subject positions these implied – that are internal to the museum (Hooper-Greenhill 1988). By contrast, I shall argue

that the museum's formation needs also to be viewed in relation to the development of a range of collateral cultural institutions, including apparently alien and disconnected ones.

The fair and the exhibition are not, of course, the only candidates for consideration in this respect. If the museum was conceived as distinct from and opposed to the fair, the same was true of the ways in which its relations to other places of popular assembly (and especially the public house) were envisaged. Equally, the museum has undoubtedly been influenced by its relations to cultural institutions which, like the museum itself and like the early international exhibitions, had a rational and improving orientation: libraries and public parks, for example. None the less, a number of characteristics set the museum, international exhibitions and modern fairs apart as a distinctive grouping. Each of these institutions is involved in the practice of 'showing and telling': that is, of exhibiting artefacts and/or persons in a manner calculated to embody and communicate specific cultural meanings and values. They are also institutions which, in being open to all-comers, have shown a similar concern to devise ways of regulating the conduct of their visitors, and to do so, ideally, in ways that are both unobtrusive and self-perpetuating. Finally, in their recognition of the fact that their visitors' experiences are realized via their physical movement through an exhibitionary space, all three institutions have shared a concern to regulate the performative aspects of their visitors' conduct. Overcoming mind/body dualities in treating their visitors as, essentially, 'minds on legs', each, in its different way, is a place for 'organized walking' in which an intended message is communicated in the form of a (more or less) directed itinerary.

None the less, for all their distinctiveness, the changes that can be traced within the practices of these exhibitionary institutions need also to be viewed in their relations to broader developments affecting related cultural institutions. In this regard, my account of the 'birth of the museum' is one in which the focus on the relations between museums, fairs and exhibitions is meant to serve as a device for a broader historical argument whose concern is a transformation in the arrangement of the cultural field over the course of the nineteenth century.

These are the issues engaged with in the chapters comprising Part I. Three questions stand to the fore here. The first concerns the respects in which the public museum exemplified the development of a new 'governmental' relation to culture in which works of high culture were treated as instruments that could be enlisted in new ways for new tasks of social management. This will involve a consideration of the manner in which the museum, in providing a new setting for works of culture, also functioned as a technological environment which allowed cultural artefacts to be refashioned in ways that would facilitate their deployment for new purposes as parts of governmental programmes aimed at reshaping general norms of social behaviour.

In being thus conceived as instruments capable of 'lifting' the cultural level

of the population, nineteenth-century museums were faced with a new problem: how to regulate the conduct of their visitors. Similar difficulties were faced by other nineteenth-century institutions whose function required that they freely admit an undifferentiated mass public: railways, exhibitions, and department stores, for example. The problems of behaviour management this posed drew forth a variety of architectural and technological solutions which, while having their origins in specific institutions, often then migrated to others. The second strand of analysis in Part I thus considers how techniques of behaviour management, developed in museums, exhibitions, and department stores, were later incorporated in amusement parks whose design aimed to transform the fair into a sphere of regulation.

The third set of questions focuses on the space of representation associated with the public museum and on the politics it generates. In *The Order of Things*, Foucault refers to the ambiguous role played by the 'empirico-transcendental doublet of man' in the human sciences: man functions as an *object* made visible by those sciences while also doubling as the *subject* of the knowledges they make available. Man, as Foucault puts it, 'appears in his ambiguous position as an object of knowledge and as a subject that knows; enslaved sovereign, observed spectator' (Foucault 1970: 312). The museum, it will be argued, also constructs man (and the gendered form is, as we shall see, historically appropriate) in a relation of both subject and object to the knowledge it organizes. Its space of representation, constituted in the relations between the disciplines which organize the display frameworks of different types of museum (geology, archaeology, anthropology, etc), posits man – the outcome of evolution – as the object of knowledge. At the same time, this mode of representation constructs for the visitor a position of achieved humanity, situated at the end of evolutionary development, from which man's development, and the subsidiary evolutionary series it sub-sumes, can be rendered intelligible. There is, however, a tension within this space of representation between the apparent universality of the subject and object of knowledge (man) which it constructs, and the always socially partial and particular ways in which this universality is realized and embodied in museum displays. This tension, it will be suggested, has supplied – and continues to supply – the discursive co-ordinates for the emergence of contemporary museum policies and politics oriented to securing parity of representation for different groups and cultures within the exhibitionary practices of the museum.

If this demand constitutes one of the distinctive aspects of modern political debates relating to the museum, a second consists in the now more or less normative requirement (although one more honoured in theory than in practice) that public museums should be equally accessible to all sections of the population. While this demand is partly inscribed in the conception of the modern museum as a *public* museum, its status has been, and remains, somewhat ambivalent. For it can be asserted in the form of an expectation

7

that the museum's benevolent and improving influence ought, in the interests of the state or society as a whole, to reach all sections of the population. Or it can be asserted as an inviolable cultural right which all citizens in a democracy are entitled to claim. Something of the tension between these two conceptions is visible in the history of museum visitor statistics. Crude visitor statistics were available from as early as the 1830s, but only in a form which allowed gross visitor numbers to be correlated with days of the week or times of the year. The earliest political use of these figures was to demonstrate the increased numbers visiting in the evenings, bank holidays and – when Sunday opening was permitted – Sundays. Reformers like Francis Place and, later, Thomas Greenwood seized on such figures as evidence of the museum's capacity to carry the improving force of culture to the working classes. This concern with measuring the civilizing influence of the museum is both related to and yet also distinct from a concern with improving access to museums on the grounds of cultural rights – an issue which did not emerge until much later when studies of the demographic profiles of museum visitors demonstrated socially differentiated patterns of use. More to the point, perhaps, if developments in adjacent fields are anything to go by, is that powerful ideological factors militated against the acquisition of information of this type. Edward Edwards, one of the major figures in the public library movement in Britain, thus sternly chastized local public libraries for obtaining information regarding the occupations of their users as being both unauthorized and irrelevant to their purpose.[4]

An adequate account of the history of museum visitor studies has yet to be written. It seems clear, however, that the development of clearly articulated demands for making museums accessible to all sections of the population has been closely related to the development of statistical surveys which have made visible the social composition of the visiting public. The provenance of such studies is, at the earliest, in the 1920s and, for the most part, belongs to the post-war period.[5] Be this as it may, cultural rights principles are now strongly enshrined in relation to public museums and, although dependent on external monitoring devices for their implementation, they have clearly also been fuelled by the internal dynamics of the museum form in its establishment of a public space in which rights are supposed to be universal and undifferentiated.

These, then, are the main issues reviewed in the first part of this study. While each of the three chapters grouped together here has something to say about each of these questions, they differ in their stress and emphasis as well as in their angle of theoretical approach. In the first chapter, 'The Formation of the Museum', the primary theoretical co-ordinates are supplied by Foucault's concept of liberal government. This is drawn on to outline the ways in which museums formed a part of new strategies of governing aimed at producing a citizenry which, rather than needing to be externally and coercively directed, would increasingly monitor and regulate its own conduct.

In the second chapter, 'The Exhibitionary Complex', the stress falls rather on Foucault's understanding of disciplinary power in its application to museums and on the ways in which the insights this generates might usefully be moderated by the perspectives on the rhetorical strategies of power suggested by Gramsci's theory of hegemony. The final chapter in Part I, 'The Political Rationality of the Museum', looks primarily to Foucault again, although to another aspect of his work. Here, Foucault's writings on the prison are treated as a model for an account of the respects in which many aspects of contemporary museum policies and politics have been generated out of the discursive co-ordinates which have governed the museum's formation.

There are, I have suggested, two distinctive political demands that have been generated in relation to the modern museum: the demand that there should be parity of representation for all groups and cultures within the collecting, exhibition and conservation activities of museums, and the demand that the members of all social groups should have equal practical as well theoretical rights of access to museums. More detailed and specific examples of the kinds of issues generated by these political demands form the subject matter of the second part of this study. If, in Part I, my concern is to trace the conditions which have allowed modern museum policies and politics to emerge and take the shape that they have, the focus in the second part moves to specific engagements with particular contemporary political and policy issues from within the perspectives of what I have called the museum's 'political rationality'.

There is, however, a broadening of focus in this part of the book in that my attention is no longer limited exclusively to public museums. In Chapter 4, 'Museums and "the People"', I consider the competing and contradictory ways in which 'the people' might be represented in the display practices of a broad variety of different types of museum. For the purpose of demonstrating some effective contrasts, my discussion here ranges across the romantic populism that is often associated with the open-air museum form to the social-democratic conceptions of 'the people' which govern many contemporary Australian museum installations. I also evaluate the more radical socialist and feminist conceptions of the forms in which 'the people' might most appropriately be represented by considering the example of Glasgow's peerless People's Palace.

The next chapter, 'Out of Which Past?', broadens the scope of the discussion. It considers the respects in which the demand for forms of representing the past that are appropriate to the interests and values of different groups in the community can be extended beyond the public museum. This demand can encompass heritage sites just as it can be applied to the picture of the past that emerges from the entire array of museums and heritage sites in a particular society. In the final chapter in Part II, however, the focus returns to the public museum, especially the public art gallery.

Drawing on the arguments of Pierre Bourdieu, 'Art and Theory: The Politics of the Invisible' explores the relationship between the display practices of art galleries and the patterns of their social usage. Art galleries, it is suggested, remain the least publicly accessible of all public collecting institutions. This is largely because of their continuing commitment to display principles which entail that the order subtending the art on display remains invisible and unintelligible to those not already equipped with the appropriate cultural skills. Such an entrenched position now seems increasingly wilful as notions of access and equity come to permeate all domains of culture and to legitimate public expenditure in such domains.

In the final part of the book, my attention returns to museums, fairs and exhibitions, and to the relations between them. These, however, are now broached from a different perspective. Here, I consider the different ways in which, in their late nineteenth- and early twentieth-century formation, museums, fairs and exhibitions functioned as technologies of progress. The notion is not a new one. Indeed, it was quite common at the time for museums and the like to be referred to as 'machines for progress'. Such metaphors, I shall argue, were by no means misplaced. Viewed as cultural technologies which achieve their effectiveness through the articulated combination of the representations, routines and regulations of which they are comprised, museums, fairs and exhibitions do indeed have a machine-like aspect to their conception and functioning. The elaboration of this argument, however, involves a shift of perspective. It requires that we consider not merely how progress is represented in each of these institutions – for this is fairly familiar ground – but also the different ways in which those representations were organized as performative resources which programmed visitors' behaviour as well as their cognitive horizons. This will involve viewing such representations of progress as props which the visitor might utilize for particular forms of self-development – evolutionary exercises of the self – rather than solely as parts of textual regimes whose influence is of a rhetorical or ideological nature.

Chapter 7, 'Museums and Progress: Narrative, Ideology, Performance' opens the argument in reviewing a variety of the different ways in which the layout of late nineteenth-century natural history, ethnology and anatomy collections was calculated so as to allow the visitor to retread the paths of evolutionary development which led from simple to more complex forms of life. This argument is exemplified by considering how the Pitt-Rivers typological system for the display of 'savage' peoples and their artefacts constituted a 'progressive machinery' which, in seeking to promote progress, sought also to limit and direct it. There then follows a consideration of the respects in which the evolutionary narratives and itineraries of nineteenth-century museums were gendered in their structure as well as in the performative possibilities to which they gave rise.

The next chapter, 'The Shaping of Things to Come: Expo '88', considers

how the form of the international exhibition has developed to provide an environment in which the visitor is invited to undertake an incessant updating or modernizing of the self. In applying this perspective to Brisbane's Expo '88, this chapter also considers the ways in which rhetorics of progress combined with those of the nation and of the city to provide a complexly organized environment that was open to – indeed, designed for – many different kinds of social performance. Finally, in Chapter 9, 'A Thousand and One Troubles: Blackpool Pleasure Beach', my attention turns to the ways in which rhetorics of progress can saturate the environment of a whole town, but paying special regard to Blackpool's fair – the Pleasure Beach – where progress is encoded into the pleasurable performances that the fairgoer is expected to undertake. However, this detailed case-study of a modern amusement park serves a further purpose in graphically illustrating the respects in which the modernization and streamlining of pleasure associated with the contemporary fair draw on the modernizing rhetorics and technologies of museums and exhibitions.

This final chapter also introduces a qualification which it might be useful to mention at the outset. My concern in this book is largely with museums, fairs and exhibitions as envisaged in the plans and projections of their advocates, designers, directors and managers. The degree to which such plans and projections were and are successful in organizing and framing the experience of the visitor or, to the contrary, the degree to which such planned effects are evaded, side-stepped or simply not noticed raises different questions which, important though they are, I have not addressed here.

I have already mentioned some of the theoretical sources I have drawn on in preparing this study. The work of Foucault, in its various forms and interpretations, has been important to me as has been that of Gramsci, although I have been aware – and have not sought to disguise – the often awkward and uneasy tension that exists between these. It is perhaps worth adding that, as it has developed, the tendency of my work in this area has inclined more towards the Foucaultian than the Gramscian paradigm.

Pierre Bourdieu's work has also been invaluable for the light it throws on the contradictory dynamics of the museum, and especially the art gallery. While the gallery is theoretically a public institution open to all, it has typically been appropriated by ruling elites as a key symbolic site for those performances of 'distinction' through which the *cognoscenti* differentiate themselves from 'the masses'. Jurgen Habermas's historical arguments regarding the formation of the bourgeois public sphere have been helpful, too, although I have been careful to extricate these from Habermas's dialectical expectation that such a public sphere anticipates a more ideal speech situation into which history has yet to deliver us. Equally important, if not more so, have been the significant feminist re-thinkings of the notion of the public sphere, and of the public–private divide more generally, offered by Joan Landes, Carole Pateman and Mary Ryan. Finally, Krzysztof Pomian's

work has been helpful in suggesting how collections might usefully be distinguished from one another in terms of the different kinds of contract they establish between the spheres of the visible and invisible.

My use of this fairly diverse set of theoretical resources has been largely pragmatic in orientation. While I have not sought to deny or repress important theoretical differences where these have been relevant to my concerns, resolving such questions has not been my purpose in this book. For the most part, I have simply drawn selectively on different aspects of these theoretical traditions as has seemed most appropriate in relation to the specific issues under discussion.

For all that this is an academic book motivated by a particular set of intellectual interests, I doubt that I should have finished it had I not had a fairly strong personal interest in its subject matter. While biographical factors are usually best left unsaid, there may be some point, in this case, in dwelling briefly on the personal interests and investments which have helped to sustain my interests in the issues this book explores. In *The Sacred Grove*, Dillon Ripley informs the reader that his philosophy of museums was established when, at the age of ten, he spent a winter in Paris:

> One of the advantages of playing in the Tuileries Gardens as a child was that at any one moment one could be riding the carousel, hoping against hope to catch the ring. The next instant one might be off wandering the paths among the chestnuts and the plane trees, looking for the old woman who sold *gaufres*, those wonderful hot wafer-thin, wafflelike creations dusted over with powdered sugar. A third instant in time, and there was the Punch and Judy show, mirror of life, now comic, now sad. Another moment and one could wander into one of the galleries at the Louvre. . . . Then out to the garden again where there was a patch of sand in a corner to build sand castles. Then back to the Louvre to wander through the Grand Gallery.
>
> (Ripley 1978: 140)

The philosophy Ripley derived from this experience was that there was, and should be, no essential differences between the learning environment of the museum and the world of fun and games; one should be able to move naturally between the two. For a bourgeois boy, such an effortless transition between the museum and a gentrified selection of fairground pleasures would, no doubt, have proved possible. My own experience – and I expect it is rather more typical – was different. For me, the fair came before the museum, and by a good many years. And the fair in all its forms: the travelling fairs that set up camp in Lancashire's towns during their wakes-weeks holidays; Manchester's permanent amusement park, Belle Vue, where my father taught me the white-knuckle art of riding the bone-shaking Bobs; and Blackpool's Pleasure Beach which I visited many times as a child and as a teenager before returning to it later in life as an object of study. When, in my early adulthood,

I began to explore the world of museums and art galleries, it was not with a sense of an effortless transition such as Ripley describes; it was, to the contrary, part of a cultural itinerary, travelled with some reluctance, which required a familiarity with a new *habitus* in order to feel in any way at home in such institutions. Equally, however, for the reasons I have already alluded to, going to fairs and visiting museums or exhibitions have always struck me as in some way related activities.

Writing this book, then, has served as a means of trying to account for the experience of 'different but similar' which I still have when visiting either fairs or museums. Its ambition, however, is to explain these similarities and differences in terms of historical processes of cultural formation rather than as than personal idiosyncracies.

Part I
HISTORY AND THEORY

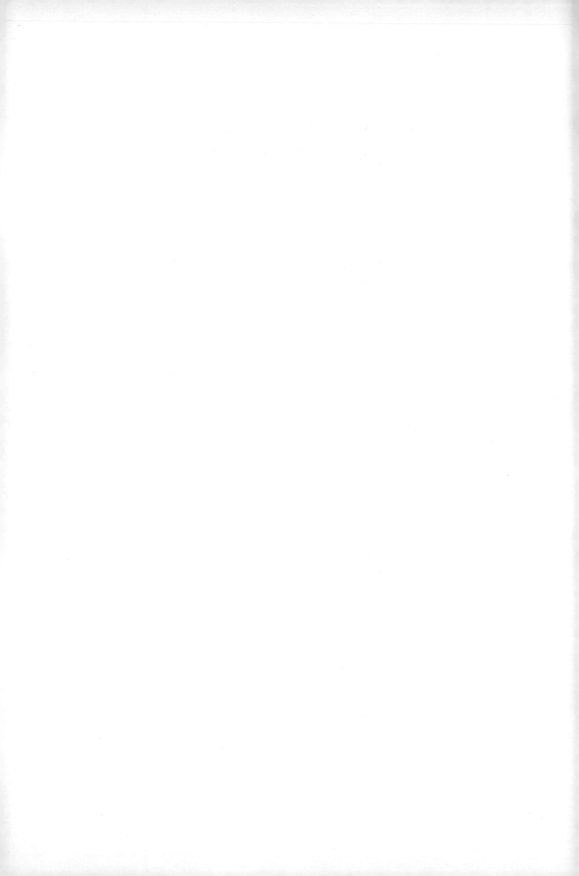

1

THE FORMATION OF
THE MUSEUM

In 1849, James Silk Buckingham, a prominent English social reformer, published a plan for a model town. In extolling the virtues of his proposals he drew attention to their capacity to prepare all members of the community for 'a higher state of existence, instead of merely vegetating like millions in the present state of society, who are far less cared for, and far less happy, than the brutes that perish' (Buckingham 1849: 224). Buckingham was insistent, however, that such a transformation could be wrought solely by the application of, as he called them, 'practical remedies'. It is worth quoting in full the passage in which he argues with himself on this question:

It is constantly contended that mankind are not to be improved by mere mechanical arrangements, and that their reformation must first begin within. But there is surely no reason why both should not be called into operation. A person who is well fed, well clad, cheerfully because agreeably occupied, living in a clean house, in an open and well ventilated Town, free from the intemperate, dissolute, and vicious associations of our existing cities and villages – with ready access to Libraries, Lectures, Galleries of Art, Public Worship, with many objects of architectural beauty, fountains, statues, and colonnades, around him, instead of rags, filth, drunkenness, and prostitution, with blasphemous oaths or dissolute conversation defiling his ears, would at least be more likely to be accessible to moral sentiments, generous feelings, and religious and devout convictions and conduct, than in the teeming hives of iniquity, with which most of our large cities and towns abound. Inward regeneration will sometimes occur in spite of all these obstacles, and burst through every barrier, but these are the exceptions, and not the rules; and the conduct pursued by all good parents towards their children, in keeping them away as much as possible from evil associations, and surrounding them by the best examples and incentives to virtue, is sufficient proof of the almost universal conviction, that the circumstances in which individuals are placed, and the kind of training and education they receive, have a great influence in the formation of

17

their character, and materially assist at least the development of the noblest faculties of the mind and heart.

(Buckingham 1849: 224–5)

The passage echoes a characteristic trait of late eighteenth- and early nineteenth-century conceptions of the tasks of government. In the formulations of the science of police that were produced over this period, Foucault has argued, it was the family that typically served as the model for a form of government which, in concerning itself with 'the wealth and behaviour of each and all', aspired to subject the population of the state to 'a form of surveillance and control as attentive as that of the head of a family over his household and his goods' (Foucault 1978: 92). 'The People', as Patrick Colquhoun put it, 'are to the Legislature what a child is to a parent' (Colquhoun 1796: 242–3). Just as remarkable, however, is Buckingham's persistence in maintaining that the exercise of such surveillance and control need not be thought of as any different in principle, when applied to the moral or cultural well being of the population, from its application to the field of physical health. Both are a matter of making the appropriate 'mechanical arrangements'. Libraries, public lectures and art galleries thus present themselves as instruments capable of improving 'man's' inner life just as well laid out spaces can improve the physical health of the population. If, in this way, culture is brought within the province of government, its conception is on a par with other regions of government. The reform of the self – of the inner life – is just as much dependent on the provision of appropriate technologies for this purpose as is the achievement of desired ends in any other area of social administration.

There is no shortage of schemes, plans and proposals cast in a similar vein. In 1876, Benjamin Ward Richardson, in his plan for Hygeia, a city of health, set himself the task of outlining sanitary arrangements that would result in 'the co-existence of the lowest possible general mortality with the highest possible individual longevity' (Richardson 1876: 11). However, he felt obliged to break off from detailing these to advise the reader that his model town would, of course, be 'well furnished with baths, swimming baths, Turkish baths, playgrounds, gymnasia, libraries, board schools, fine art schools, lecture halls, and places of instructive amusement' (ibid.: 39). The museum's early historians had a similar conception of the museum's place in the new schemes of urban life. Thus, as Thomas Greenwood saw it, 'a Museum and Free Library are as necessary for the mental and moral health of the citizens as good sanitary arrangements, water supply and street lighting are for their physical health and comfort' (Greenwood 1888: 389). Indeed, for Greenwood, these provisions tended to go hand-in-hand and could serve as an index of the development of a sense of civic duty and self-reliance in different towns and cities. For it is, he says, no accident that the municipalities in which 'the most has been done for the education of the people,

either in the way of Board Schools, Museums, or Free Libraries' should also be the ones with 'the best street lighting and street cleansing arrangements' (ibid.: 18).

The public museum, as is well known, acquired its modern form during the late eighteenth and early nineteenth centuries. The process of its formation was as complex as it was protracted, involving, most obviously and immediately, a transformation of the practices of earlier collecting institutions and the creative adaptation of aspects of other new institutions – the international exhibition and the department store, for example – which developed alongside the museum. However, the museum's formation – whether understood as a developmental process or as an achieved form – cannot be adequately understood unless viewed in the light of a more general set of developments through which culture, in coming to be thought of as useful for governing, was fashioned as a vehicle for the exercise of new forms of power.

In what did this enlistment of culture for the purposes of governing consist? And how was the topography of the sphere of government to which it gave rise organized?[1] On the one hand, culture – in so far as it referred to the habits, morals, manners and beliefs of the subordinate classes – was targeted as an object of government, as something in need of both transformation and regulation. This had clearly been viewed as a part of the proper concern of the state in earlier formulations of the functions of police. In his *Treatise on the Police of the Metropolis*, first published in 1795, Patrick Colquhoun had thus argued:

> And it is no inconsiderable feature in the science of Police to encourage, protect, and control such as tend to innocent recreation, to preserve the good humour of the Public, and to give the minds of the people a right bias. . . . Since recreation is necessary to Civilised Society, all Public Exhibitions should be rendered subservient to improvement of morals, and to the means of infusing into the mind a love of the Constitution, and a reverence and respect for the Laws. . . . How superior this to the odious practice of besotting themselves in Ale houses, hatching seditious and treasonable designs, or engaging in pursuits of vilest profligacy, destructive to health and morals.
>
> (Colquhoun 1806: 347–8)

It is, however, only later – in the mid to late nineteenth century – that the relations between culture and government come to be thought of and organized in a distinctively modern way via the conception that the works, forms and institutions of high culture might be enlisted for this governmental task in being assigned the purpose of civilizing the population as a whole. It was, appropriately enough, James Silk Buckingham who first introduced such a conception of culture's role into the practical agendas of reforming politics in early Victorian England. In the wake of the report of the 1834 Select

19

Committee on Drunkenness, whose establishment he had prompted and which he had chaired, Buckingham brought three bills before parliament proposing that local committees be empowered to levy rates to establish walks, paths, playgrounds, halls, theatres, libraries, museums and art galleries so as 'to draw off by innocent pleasurable recreation and instruction, all who can be weaned from habits of drinking' (Buckingham, cited in Turner 1934: 305). The bills were not successful, although the principles they enunciated were eventually adapted in the legislation through which, some two decades later, local authorities were enabled to establish municipal museums and libraries.

What matters rather more, however, is the capacity that is attributed to high culture to so transform the inner lives of the population as to alter their forms of life and behaviour. It is this that marks the distinction between earlier conceptions of government and the emerging notions of liberal government which Buckingham helped articulate. There is scarcely a glimmer of this in Colquhoun's understanding of the means by which the morals and manners of the population might be improved. These, for Colquhoun, focus on the need to increase the regulatory capacities of the state in relation to those sites and institutions in which refractory bodies might be expected to assemble: public houses, friendly societies, and the sex-segregated asylums and places of industry provided for men and women released from gaol with no employment.

For Buckingham and other advocates of 'rational recreations', by contrast, the capacity to effect an inner transformation that is attributed to culture reflects a different problematic of government, one which, rather than increasing the formal regulatory powers of the state, aims to 'work at a distance', achieving its objectives by inscribing these within the self-activating and self-regulating capacities of individuals. For Colquhoun, the ale-house was a space to be regulated as closely as possible; for Buckingham, new forms of government proceeding by cultural means, while not obviating the need for such regulation, would go further in producing individuals who did not *want* to besot themselves in ale-houses.

It is, then, in the view of high culture as a resource that might be used to regulate the field of social behaviour in endowing individuals with new capacities for self-monitoring and self-regulation that the field of culture and modern forms of liberal government most characteristically interrelate. This was what George Brown Goode, in elaborating his view of museums as 'passionless reformers', was to refer to as 'the modern Museum idea' in his influential *Principles of Museum Administration* (1895: 71). While this 'idea' had an international currency by the end of the century, Goode attributed its conception to the role initially envisaged for museums by such mid-nineteenth century British cultural reformers as Sir Henry Cole and Ruskin.[2] For Cole, for example, the museum would help the working man *choose* a life characterized by moral restraint as preferable to the temptations of both bed and the ale-house:

20

If you wish to vanquish Drunkenness and the Devil, make God's day of rest elevating and refining to the working man; don't leave him to find his recreation in bed first, and in the public house afterwards; attract him to church or chapel by the earnest and persuasive eloquence of the preacher, restrained with reasonable limits; . . . give him music in which he may take his part; show him pictures of beauty on the walls of churches and chapels; but, as we cannot live in church or chapel all Sunday, give him his park to walk in, with music in the air; give him that cricket ground which the martyr, Latimer, advocated; open all museums of Science and Art after the hours of Divine service; let the working man get his refreshment there in company with his wife and children, rather than leave him to booze away from them in the Public house and Gin Palace. The Museum will certainly lead him to wisdom and gentleness, and to Heaven, whilst the latter will lead him to brutality and perdition.

(Cole 1884, vol. 2: 368)

Of course, and as this passage clearly indicates, museums were not alone in being summoned to the task of the cultural governance of the populace. To the contrary, they were envisaged as functioning alongside a veritable battery of new cultural technologies designed for this purpose. For Goode, libraries, parks and reading-rooms were just as much 'passionless reformers' as museums. And if the forms and institutions of high culture now found themselves embroiled in the processes of governing – in the sense of being called on to help form and shape the moral, mental and behaviourial characteristics of the population – this was, depending on the writer, with a plurality of aims in view. Museums might help lift the level of popular taste and design; they might diminish the appeal of the tavern, thus increasing the sobriety and industriousness of the populace; they might help prevent riot and sedition.[3] Whichever the case, the embroilment of the institutions and practices of high culture in such tasks entailed a profound transformation in their conception and in their relation to the exercise of social and political power.

This is not to say that, prior to their enlistment for governmental programmes directed at civilizing the population, such institutions had not already been closely entangled in the organisation of power and its exercise. By 1600, as Roy Strong puts it, 'the art of festival was harnessed to the emergent modern state as an instrument of rule' (Strong 1984: 19). And what was true of the festival was, or subsequently came to be, true of court masques, the ballet, theatre, and musical performances. By the late seventeenth century all of these formed parts of an elaborate performance of power which, as Norbert Elias (1983) has shown, was concerned first and foremost with exhibiting and magnifying royal power before *tout le monde* – that is, the world of courtly society – and then, although only indirectly and secondarily, before the populace. If culture was thus caught up in the

symbolization of power, the principal role available to the popular classes – and especially so far as secular forms of power were concerned – was as spectators of a display of power to which they remained external. This was also true of the position accorded them before the scaffold within the theatre of punishment. The people, so far as their relations to high cultural forms were concerned, were merely the witnesses of a power that was paraded before them.

In these respects, then, high cultural practices formed part of an apparatus of power whose conception and functioning were juridico-discursive: that is, as Foucault defines it, of a form of power which, emanating from a central source (the sovereign), deployed a range of legal and symbolic resources in order to exact obedience from the population.[4] Over the late eighteenth and early nineteenth centuries, by contrast, these practices came to be inscribed in new modalities for the exercise of power which, at different times, Foucault has variously described as disciplinary or governmental power.[5] Two aspects of these modalities of power are especially worthy of note from the point of view of my concerns here.

First, unlike power in the juridico-discursive mode, disciplinary or governmental power is not given over to a single function. In his discussion of Machiavellian conceptions of the art of governing, Foucault thus argues that the prince constitutes a transcendental principle which gives to the state and governing a singular and circular function such that all acts are dedicated to the exercise of sovereignty – to the maintenance and extension of the prince's power – as an end itself: 'the end of sovereignty is the exercise of sovereignty' (Foucault 1978: 95). Governmental power, by contrast, is characterized by the multiplicity of objectives which it pursues, objectives which have their own authorization and rationality rather than being derived from the interests of some unifying central principle of power such as the sovereign or, in later formulations, the state. Whereas in these formulations the state or sovereign is its own finality, governmental power, in taking as its object the conditions of life of individuals and populations, can be harnessed to the pursuit of differentiated objectives whose authorization derives from outside the self-serving political calculus of juridico-discursive power. As Foucault puts it, 'the finality of government resides in the things it manages and in the pursuit of the perfection and intensification of the processes which it directs' (ibid.: 95). Nineteenth-century reformers thus typically sought to enlist high cultural practices for a diversity of ends: as an antidote to drunkenness; an alternative to riot, or an instrument for civilizing the morals and manners of the population. While these uses were often closely co-ordinated with bourgeois class projects, their varied range stood in marked contrast to the earlier commitment of high culture to the singular function of making manifest or broadcasting the power of the sovereign.

Second, however, and perhaps more important, governmental power aims at a different kind of effectivity from power conceived in the juridico-

22

discursive mode. The latter is exercised by means of laws, edicts and promulgations supported by whatever means of enforcement the prince has at his disposal. Governmental power, however, typically works through detailed calculations and strategies which, embodied in the programmes of specific technologies of government, aim at manipulating behaviour in specific desired directions. The 'instruments of government,' as Foucault puts it, 'instead of being laws, now come to be a range of multiform tactics' (Foucault 1978: 95) – and especially of tactics which, in aiming at changed conduct as their outcome, depend on a close relationship between the government of the state and the government of the self. The critical developments affecting the sphere of culture in these regards concerned the shift – which, of course, was a relative rather than a total one – from a conception in which culture served power by embodying, staging or representing it, making it spectacularly visible. In place of this, culture was increasingly thought of as a resource to be used in programmes which aimed at bringing about changes in acceptable norms and forms of behaviour and consolidating those norms as self-acting imperatives by inscribing them within broadly disseminated regimes of self-management.

There are, in this sense, many similarities between what was expected of the cultural technologies most closely associated with this new modality of power – the museum and the library, say – and the parallel reshaping of the ends and means of the power to punish. In *Discipline and Punish* (1977), Foucault argues that late eighteenth- and early nineteenth-century penal reformers condemned the scaffold less on humanitarian grounds than because they perceived it as part of a poor economy of power: poor because it was intermittent in its effects, aiming to terrorize the population into obedience by means of periodic representations of the sovereign's power to punish; poor because it lacked an effective apparatus for apprehending law-breakers; and poor because it wasted bodies which might otherwise be rendered useful. Advocacy of the penitentiary as the primary form of punishment was thus based on what seemed to be its promise of a more efficient exercise of power: more efficient because it was calculated to transform the conduct of inmates through the studied manipulation of their behaviour in an environment built specifically for that purpose. More efficient also, to recall James Silk Buckingham, because – albeit via 'mere technical arrangements' – it aimed at an inner transformation, at the production of penitents with a built-in and ongoing capacity to monitor and hence curb their own tendency to wrong-doing.

The enlistment of the institutions and practices of high culture for governmental purposes was similarly aimed at producing a better economy of cultural power. As has been noted, festivals, royal entries, tournaments, theatrical performances and the like had all served as means (among other things) for the periodic – and hence intermittent and irregular – display of power before the populace. The presence of the people – where it was required at all – was called for only in so far as the representation of power

23

required that there be an audience before whom such representations might be displayed. Transformations in the character, manners, morals, or aptitudes of the population were rarely the point at issue within such strategies of culture and power. The governmentalization of culture, by contrast, aimed precisely at more enduring and lasting effects by using culture as a resource through which those exposed to its influence would be led to ongoingly and progressively modify their thoughts, feelings and behaviour.

The inscription of cultural forms and practices within new technologies, rather than involving the population only intermittently, aimed at permanent and developmental and regular and repeatable effects and thus involved a significantly new economy of cultural power. This also offered the populace a more active and differentiated set of roles than merely as witnesses of a symbolic display of power (although this remained important – and more so than Foucault's formulations often allow). To the contrary, culture, in this new logic, comprised a set of exercises through which those exposed to its influence were to be transformed into the active bearers and practitioners of the capacity for self-improvement that culture was held to embody. Enlisting the existing forms, practices and institutions of high culture for such purposes, however, required that they be instrumentally refashioned, retooled for new purposes. Nineteenth-century cultural reformers were resolutely clear-eyed about this. Culture, in its existing forms, could not simply be made available and be expected to discharge its reforming obligations of its own and unaided. It needed to be fashioned for the tasks to which it was thus summoned and be put to work in new contexts specially designed for those purposes.

In the case of museums, three issues stood to the fore. The first concerned the nature of the museum as a social space and the need to detach that space from its earlier private, restricted and socially exclusive forms of sociality. The museum had to be refashioned so that it might function as a space of emulation in which civilized forms of behaviour might be learnt and thus diffused more widely through the social body. The second concerned the nature of the museum as a space of representation. Rather than merely evoking wonder and surprise for the idly curious, the museum's representations would so arrange and display natural and cultural artefacts as to secure 'the utilisation of these for the increase of knowledge and for the culture and enlightenment of the people' (Goode 1895: 3). 'The museum of the past,' as Goode put it in an 1889 lecture to the Brooklyn Institute, 'must be set aside, reconstructed, transformed into a nursery of living thought' (cited in Key 1973: 86). The third issue, by contrast, related more to the museum's visitor than to its exhibits. It concerned the need to develop the museum as a space of observation and regulation in order that the visitor's body might be taken hold of and be moulded in accordance with the requirements of new norms of public conduct.

In what follows, I shall consider each of these issues in turn. Although, of

course, the ways in which these matters were addressed differed from one national context to another, as they did also between different types of museum, I shall, by and large, overlook such considerations in order to identify those most obviously shared characteristics which distinguished public museums from their predecessors.

MUSEUMS AND THE PUBLIC SPHERE

The reorganization of the social space of the museum occurred alongside the emerging role of museums in the formation of the bourgeois public sphere. The institutions comprising this sphere had already partially detached high cultural forms and practices from their functions of courtly display and connected them to new social and political purposes. If, under feudal and monarchical systems of government, art and culture formed a part, as Habermas puts it, of the 'representative publicness' of the lord or sovereign, the formation of the bourgeois public sphere was closely bound up with the development of new institutions and practices which detached art and culture from that function and enlisted it for the cause of social and political critique (Habermas 1989). This helped prepare the ground for the subsequent view that the sphere of culture might be reorganized in accordance with a governmental logic.

The picture Habermas paints of the relations between different spheres of social and political life and influence in late eighteenth-century European societies is, roughly, one characterized by a division between the state and the court on the one hand and, on the other, civil society and the sphere of private intimacy formed by the newly constituted conjugal family. Mediating the relations between these was an array of new literary, artistic and cultural institutions in which new forms of assembly, debate, critique and commentary were developed. In the process, works of art and literature were fashioned so as to serve as the vehicles for a reasoned critique of the edicts of the state. These institutions comprised, on the one hand, literary journals, philosophical and debating societies (sometimes with museums attached), and coffee houses where the accent fell on the formation of opinions via a process of rational exchange and debate. On the other, they also included the new cultural markets (academies, art galleries, salons) which, in their separation from both court and the state, allowed the formative bourgeois public to meet and, in rendering itself visually present to itself, acquire a degree of corporate self-consciousness.[6]

The crucial discursive events accompanying these institutional changes consisted in the early formation of art and literary criticism, a development which Habermas in turn attributes to the commodification of culture. For if the latter allowed cultural products to be made generally available, it did so only by simultaneously detaching those products from their anchorage in a tradition which had previously vouchsafed their meaning. As works of culture

no longer derived their meaning from their place within an authoritative tradition emanating from the monarch (or church), the process of arriving at a meaning and a value for cultural products was a task which bourgeois consumers had now to undertake for themselves, both individually and, via debate, in collaboration with one another. They were assisted in' this, however, by the newly flourishing genres of cultural criticism and comment-ary through which questions of aesthetic meaning and judgement came to form parts of a proto-political process whereby acts of state were subjected to reasoned debate and criticism.[7]

For Habermas, of course, this critical deployment of art and culture served as an ideal – albeit an imperfectly realized one – in whose name the subsequent development of the debased public sphere of mass culture could be castigated for the loss of the critical function for culture which it entailed. There are, however, other ways of construing the matter. In his reflections on the role of technology in cultural production, Benjamin argued that the development of mass reproduction played a crucial role in politicizing art to the degree that, in depriving the work of art of its aura and thus detaching it from the singular function and identity associated with it embeddedness in tradition, its meaning could become an object of political contestation (Benjamin 1936). The argument is a familiar one within the Frankfurt tradition up to and including Habermas, albeit that the responsibility for freeing art from the restraints of tradition may be variously attributed to technology, the market, criticism, or all three. By the same token, the same conditions, in freeing high cultural forms from their earlier juridico-discursive forms of deployment, also made it possible for them to be thought of as useful for governing.

However, this required that the conditions regulating culture's social deployment within the bourgeois public sphere should themselves be trans-formed. So far as the museum was concerned, two matters stand to the fore here. The first concerns the reversal of the tendency towards separation and social exclusiveness which had characterized the earlier formation of the bourgeois public sphere. It will be helpful to consider this issue in the light of a longer historical perspective.

It is true, of course, that the secular collecting practices of European princes and monarchs in the post-Renaissance period had not usually played a major role in symbolizing the monarch's power before and to the popular classes. 'It is,' as Gerard Turner puts it, 'part of the exercise and maintenance of any leader's power to ensure that his image is constantly before the people who count.' As he continues, however, in the past 'this has not, of course, been the mass of the population, but rather the ruler's immediate supporters, the courtiers and nobility, and his rivals in other states' (Turner 1985: 214). Obviously, there were exceptions and, in the course of the eighteenth century, these tended to multiply as a number of royal collections were made publicly accessible, usually as parts of statist conceptions of popular instruction. Even so, we should not mistake these for examples of the public museum

avant la lettre in that the form of power they instanced and exercised was still clearly juridico-discursive rather than governmental. Thus when, in 1584, the collection of Francesco I de Medici was transferred into the new and more public context of the Uffizi Gallery, this was in response to the need for public legitimation of the Medici dynasty, a need which, as Guiseppe Olmi puts it, 'meant that the glorification of the prince, the celebration of his deeds and the power of his family had constantly to be exposed to the eyes of all and to be impressed on the mind of every subject' (Olmi 1985: 10).

In the main, however, collections of valued objects formed a part of the cultural accessories of power in contexts in which it was the organization and transmission of power within and between ruling strata rather than the display of power before the populace that was the point at issue. Consequently, few collections were accessible to the popular classes; and, in some cases, those who might be admitted to view princely collections were so few that they symbolized not so much the power to amass artefacts which might be impressively displayed to others as the power to reserve valued objects for private and exclusive inspection (see Seelig 1985).

Museums continued to be characterized by similar kinds of exclusiveness during the period of their articulation to the institutions comprising the bourgeois public sphere. For, whether they were older museums annexed to the public sphere or new ones built in association with literary, debating, scientific or philosophical societies, access to them continued to be socially restricted.[8] Habermas touches on these matters in his comments concerning the class and gender characteristics of the institutions comprising the bourgeois public sphere. His concern in doing so, however, is largely to point to the conflict between the theoretical commitment to the universalist and equitably dialogic principles of discourse which characterized these institutions and their practical limitation to middle-class men as a means of retaining the view that such discursive norms might yet be realized in a more ideal speech situation.

As Stallybrass and White have suggested, however, the social logic of the bourgeois public sphere is not adequately understood if attention focuses solely on its discursive properties. The institutions comprising this sphere were characterized not merely by their subscription to certain rules of discourse (freedom of speech, the rule of reason, etc.). They were also characterized by their proscription of codes of behaviour associated with places of popular assembly-fairs, taverns, inns and so forth. No swearing, no spitting, no brawling, no eating or drinking, no dirty footwear, no gambling: these rules which, with variations, characterized literary and debating societies, museums, and coffee-houses also, as Stallybrass and White put it, formed 'part of an overall strategy of expulsion which clears a space for polite, cosmopolitan discourse by constructing popular culture as the "low-Other", the dirty and crude outside to the emergent public sphere' (Stallybrass and White 1986: 87).

The construction of the public sphere as one of polite and rational discourse, in other words, required the construction of a negatively coded other sphere – that comprised of places of popular assembly – from which it might be differentiated. If the institutions of the public sphere comprised places in which its members could assemble and, indeed, recognize themselves as belonging to the same public, this was only because of the rules which excluded participation by those who – in their bodily appearances and manners – were visibly different.[9]

The mid-nineteenth-century reconceptualization of museums as cultural resources that might be deployed as governmental instruments involving the whole population thus entailed a significant revaluation of earlier cultural strategies. In the earlier phase, the rules and proscriptions governing attendance at museums had served to distinguish the bourgeois public from the rough and raucous manners of the general populace by excluding the latter. By contrast, the museum's new conception as an instrument of public instruction envisaged it as, in its new openness, an exemplary space in which the rough and raucous might learn to civilize themselves by modelling their conduct on the middle-class codes of behaviour to which museum attendance would expose them. The museum, in its Enlightenment conception, had, of course, always been an exemplary space, and constitutively so. As Anthony Vidler argues, the didactic function attributed to it meant that the objects it housed were invested with an exemplary status (Vidler 1987: 165–7). To be rendered serviceable as a governmental instrument, then, the public museum attached to this exemplary didacticism of objects an exemplary didacticism of personages in arranging for a regulated commingling of classes such that the subordinate classes might learn, by imitation, the appropriate forms of dress and comportment exhibited by their social superiors.

This, at least, was the theory. In practice, museums, and especially art galleries, have often been effectively appropriated by social elites so that, rather than functioning as institutions of homogenization, as reforming thought had envisaged, they have continued to play a significant role in differentiating elite from popular social classes. Or perhaps it would be better to say that the museum is neither simply a homogenizing nor simply a differentiating institution: its social functioning, rather, is defined by the contradictory pulls between these two tendencies. Yet, however imperfectly it may have been realized in practice, the conception of the museum as an institution in which the working classes – provided they dressed nicely and curbed any tendency towards unseemly conduct – might be exposed to the improving influence of the middle classes was crucial to its construction as a new kind of social space.

There was also a gendered aspect to this refashioning of the social space of the museum. Joan Landes (1988) and Denise Riley (1988) have demonstrated the respects in which, in France and Britain respectively, the late eighteenth and early nineteenth centuries witnessed a deep and far-reaching

reduction of women's involvement in public and political life and a parallel naturalization of femininity in which women were made to embody a Rousseauesque conception of the natural.[10] In Riley's argument, this natural-ization of women prepared the ground for the subsequent emergence of the social as a zone of population management in which the naturalized virtues of the feminine were accorded a key role in redressing social problems identified as having their provenance in the conditions (housing, hygiene, morality, etc.) affecting family life. 'This new production of "the social"', as Riley puts it, 'offered a magnificent occasion for the rehabilitation of "women". In its very founding conceptions, it was feminised; in its detail, it provided the chances for some women to enter upon the work of restoring other, more damaged, women to a newly conceived sphere of grace' (Riley 1988: 48).

The consequences of women's naturalization for the cultural sphere were somewhat similar. In an important reappraisal of Habermas's conception of the public sphere, Joan Landes, with the French context primarily in mind, views women's exclusion from this sphere as part of a cultural-political tactic that 'promised to reverse the spoiled civilisation of *le monde* where stylish women held sway and to return to men the sovereign rights usurped by an absolutist monarch' (Landes 1992: 56). The redefinition of femininity that accompanied this process in associating women with the spheres of the natural and the domestic, and with the functions of nurturing and growth, prepared the way for a redefinition of women's role in the cultural sphere. Women no longer appeared as the domineering mistresses of the world of salons but, rather, in the guise of culture's gentle handmaidens.

It was, then, just as important that, in their new conception as public institutions, museums were equally accessible to men and women. This had not always been so, and even where women had been admitted, their presence was not always welcomed. An eighteenth-century German visitor to the Ashmolean Museum thus complained that 'even the women are allowed up here for sixpence: they run here and there, grabbing at everything and taking no rebuff from the *Sub-Custos*' (cited in MacGregor 1983: 62.) By the early nineteenth century, however, women were permitted – and sometimes encouraged – to attend museums in a way that distinguished this component of the bourgeois public sphere from the coffee-houses, academies, and literary and debating societies which were still largely reserved for men. In this regard, museums belonged, as Linda Mahood has shown, to a select range of public contexts (parks, shopping arcades) which, in being differentiated from the unregulated sexual commingling associated with fairs and other sites of popular assembly, respectable women were able to attend – but only if accompanied by their menfolk or if chaperoned (Mahood 1990).

It was, however, within the commercially provided space of the department store that women found their first custom-built, single-sex, urban public space (see Leach 1984). Designed mainly by men but with women in mind, department stores allowed women to enjoy the amenities of urban sociability

without being threatened by the disturbing sights of the street scene which had formed a part of the scopic pleasures of the male *flâneur* and without courting the associations that were attached to women who frequented the public world of male pleasure. The department store, as Judith Walkowitz puts it, offered a space in which 'women safely reimagined themselves as *flâneurs*, observing without being observed' (Walkowitz 1992: 48). But it was more than that. In putting aside spaces reserved exclusively for women, the department store provided an enclave within which women could 'mimic the arts of urban mingling without incurring the risks of the world outside' (Ryan 1990: 76). It also created a precedent which public authorities were not slow to follow in providing special places for women in public places and institutions: special reading-rooms in public libraries; special compartments for women on ferries; women's rooms in city halls and post offices. The consequence was the organization of an urban space which had been 'sanitized' through the provision of locales in which respectable women could recreate themselves in public free from fear that their sensibilities might be assaulted or their conduct be misinterpreted. This, in turn, paved the way for the civilizing strategy of attracting men away from places of raucous male assembly and ushering them 'into public spaces that had been sanitised by the presence of women' (ibid.: 79).

It is in the light of these broader changes that we need to consider the role played by gender in the constitution of the space of the public museum. For, in so far as it was envisaged as a reformatory of manners, the complex relations between the cross-class and cross-gender forms of commingling the museum allowed for are crucial to an understanding of the types of behaviourial reformations it was to effect and of the means by which it was to do so. The most interesting development here consisted in the organization of a role for the working-class woman as a mediating agent helping to pass on the improving influence of middle-class culture to the recalcitrant working-class man.

Consideration of the parallel and complementary strategies of class regulation associated with department stores will help both to make the point and to underline the specificity of the museum's aims and practices in this regard. The similarities between the museum and the department store have often been noted.[11] Both were formally open spaces allowing entry to the general public, and both were intended to function as spaces of emulation, places for mimetic practices whereby improving tastes, values and norms of conduct were to be more broadly diffused through society. The *Bon Marché* in Paris thus offered, as Michael Miller puts it, 'a vision of a bourgeois life-style that became a model for others to follow' (Miller 1981: 183). This was, in part, a function of the goods on sale. In offering a version of the lifestyle of the Parisian *haute-bourgeoisie* that was within the reach of the middle classes and that the upper echelons of the working classes could aspire to, the *Bon Marché* served as an important instrument of social homogenization at the

levels of dress and domestic decor. However, the influence of the department store went further than this. In the person of the sales assistant it supplied a living model of transformed appearances and conduct on which the socially aspirant might model themselves.

Yet, if this was a delicate matter, it was also very much a gendered matter too. For if the sales assistant was typically female, so, too, was the customer. Susan Porter Benson's examination of the relations between gender and power in department stores tellingly describes the complex dialectic between class and gender that was played out in the relations between sales assistants and customers (see Benson 1979, 1988). Much as was true of the museum, the department store was subject to contradictory imperatives. On the one hand, it needed to mark itself off from the rough and the vulgar as a zone of exclusivity and privilege if it were to retain the custom of bourgeois women. On the other hand, it needed to reach a broader buying public – partly in order to realize appropriate economies of scale in its operations but also as a necessary means of influencing popular tastes, values and behaviour. While there were many different ways in which these tensions were managed,[12] the point at which they were most acutely manifest was in the grooming of the sales assistant who, in being typically recruited from the store's local working-class environs, needed her rough edges smoothing in order to be rendered 'fit to serve' the bourgeois clientele.[13] Yet it was equally important that this grooming should not be carried too far. Should her dress and demeanour become too refined, the sales assistant would threaten that distinction between herself and her customer on which the latter's sense of her own superiority depended. Equally, though, the sales assistant did have to be distanced from her class of origin sufficiently for her to embody higher standards on which the aspirant working-class customer might model herself.

As a consequence of the need to balance these competing requirements, the body and person of the sales assistant were targeted for quite intense and detailed regulation. In part, it was envisaged that, just as she would come to constitute a model for the working-class customer, so the sales girl would herself simply learn new ways from observing the behaviour of both her supervisors and those of her customers who were of higher social position. These 'natural' civilizing effects of the department store environment, however, were typically augmented by active civilizing programmes – lessons in hygiene, etiquette and grammar; visits to museums and art galleries to acquire the principles of taste; the provision of well-stocked reading rooms – through which the sales assistant was groomed both to serve and to function as a living testimony of cultural improvement.

If, then, the civilizing programmes associated with the department store were directed mainly at women, there is little doubt that, in the mid-nineteenth-century British context, the primary target of the museum's reforming intent was the working-class man. As the museum's advocates saw it, it was the working-class man who needed to be attracted away from the

31

corrupting pleasures of fair or tavern in a reforming strategy which sought constantly to recruit, or at least to envisage, the working-class wife as an ally of culture's advocates. Lloyds' response to the opening of the Sheepshank Gallery in the Victoria and Albert Museum in 1858 was, no doubt, a piece of fond imagining, but it was typical of the period:

> The anxious wife will no longer have to visit the different taprooms to drag her poor besotted husband home. She will seek for him at the nearest museum, where she will have to exercise all the persuasion of her affection to tear him away from the rapt contemplation of a Raphael.
>
> (Cited in Physik 1982: 35)

If, however, the working-class woman was envisaged as a beneficiary of culture's reformatory powers, she was also enlisted as an accomplice of those powers, as a cog in culture's mechanisms. This was, in part, a matter of the museum functioning, like the department store, as a learning environment in which bourgeois conceptions of femininity and domesticity might be transmitted to working-class women. Equally important, however, such norms then served as models through which the tastes of the working man might be improved. In the museum projects of Ruskin and Morris, reconstructions of the ideal home – fashioned on the bourgeois interior, but supposedly within the economic reach of the artisan – were thus the primary means through which the working man was to be led to 'better things'.

More generally, however, women were held to exert a civilizing influence through their mere presence in both embodying and enjoining a gentleness of manners. This conception, moreover, was not limited to women's participation in museums. Peter Bailey has shown how – as a recurring trope through the literature of the rational recreations movement in Britain – women are envisaged as a civilizing influence on men. Robert Slane, extolling the virtues of public parks, thus opined:

> A man walking out with his family among his neighbours of different ranks, will naturally be desirous to be properly clothed, and that his wife should be also; but this desire duly directed and controlled, is found by experience to be of the most powerful effect in promoting Civilisation and exciting industry.
>
> (Cited in Bailey 1987: 53)

Similarly, in her discussion of the early public library movement in America, Dee Garrison has shown how women were often thought of as more suited to library work than men owing to their ability to 'soften the atmosphere' in which culture was called on to perform its reformatory labours (see Garrison 1976). The same was true of teaching, and especially of the role accorded women in the teaching of English (see Doyle 1989). The specific position accorded women in these different cultural apparatuses, of course, varied. Museums, for example, did not develop into spheres of employment for women along the

same lines as, in America, libraries did; the authoritative voice of the museum remained monologically male. None the less, there was a common pattern in which women, in being welcomed out of the 'separate sphere' of domesticity to which their naturalization had earlier confined them, were accorded a role in which the attributes associated with that sphere were enlisted for reformatory purposes – as culture's instruments rather than its targets.

THE REORDERING OF THINGS

While thus recruited for a civilizing task, the position accorded women within the museum's conception of civilization as a process was more ambivalent. This is to touch on the second transformation of available cultural resources and practices associated with the public museum's formation: the fashioning of a new space of representation which, in providing a new context for display of the valued objects inherited from previous collections, allowed those objects to be harnessed to new social purposes. In the period of absolutism, Habermas argues, all major forms of display, including those associated with collections, served to fashion a representative publicness for the prince: that is, to enhance the prince's power by symbolically magnifying it in the public domain. In the course of the nineteenth century, the museum's space of representation comes to be reorganized through the use of historicized principles of display which, in the figure of 'man' which they fashioned, yielded a democratic form of public representativeness, albeit one which organized its own hierarchies and exclusions.

What kind of a change was this? The emergence of historicized principles of display associated with the formation of the modern public museum was part of the more general transition Foucault has traced from the classical to the modern episteme. Yet the museum's semiotic recoding of the artefactual field was also shaped by, and contributed to, the task of using cultural resources in new ways and for new purposes that was associated with the development of liberal forms of government. Viewed in this light, I shall suggest, the museum's reordering of things needs to be seen as an event that was simultaneously epistemic and governmental. To develop this argument adequately, however, will require that we pay attention to the ways in which the museum's new field of representations, as well as functioning semiotically, provided a performative environment in which new forms of conduct and behaviour could be shaped and practised.

As before, it will be convenient to take our initial cue here from Habermas. In his discussion of the relations between the fields of the public and the private in the late medieval and early modern periods, Habermas notes that, in contrast to present-day usage, the field of the public was distinguished from that of the common and ordinary in referring to that which, through its association with persons of high status, was deemed worthy of being accorded a representative publicness. As Habermas, quoting Carl Schmitt, puts it:

33

For representation pretended to make something invisible visible through the public presence of the person of the lord: '. . . something that has no life, that is inferior, worthless, or mean, is not representable. It lacks the exalted sort of being suitable to be elevated into public status, that is, into existence. Words like excellence, highness, majesty, fame, dignity, and honour seek to characterise this peculiarity of a being that is capable of representation.

(Habermas 1989: 5)

Under the absolutism of Louis XIV, this principle had, as its correlate, the requirement that everything associated with the monarch should be deemed representable, as of public significance. Louis Marin, in his vivid dissection of a proposal for a history of the king, thus shows how, since the life and acts of the king were taken to be co-extensive with those of the state, this history had to be a total one – a history that 'admits of no remainder . . . [and] is also a space of total visibility and of absolute representability' (Marin 1988: 71). To suppose otherwise, Marin continues, would be to 'admit a "corner" of the royal universe where a kingly act, word, or thought would not be representable, would not be praisable, would not be sayable in the form of narrative-praise' (ibid.: 71). Since this would be to think the unthinkable of an absolutism that was no longer absolute, a history of the king could only be imagined as one in which the king was both 'the archactor of History and the metanarrator of his narrative' (ibid.: 72). A history that would be the accomplice of absolutism must see the king everywhere and in everything, the moving force of all that happens, and it must tell the story of history as the unfolding of the monarch's self-originating activity from the monarch's point of view. Since this is the source of all illumination, it offers the only vantage point from which history's unfolding can possibly be understood. The royal historiographer must write constantly both in His Majesty's service and from his side:

To see the historical event at the place of the king, to be placed in this supreme – or almost – position, is to see the coming of History itself, since the king is its unique agent. And since the gaze of the absolute master sends the light that gives sight and produces what is to be seen, to be present at his side is to participate in his gaze and to share, in a fashion, his power: to double and substitute for him in the narrative-to-come that this past presence not only authenticates but permits and authorises.

(Marin 1988: 73)

Similar principles were evident in the royal collections which, at varying points in the eighteenth century, were made more accessible to broader sections of the population: the Viennese Royal Collection, moved into the Belvedere Palace in 1776, and the Dresden Gallery are among the more famous examples. These were not public museums in the modern sense. Their

theoretical openness proved, more often than not, to be qualified by all kinds of practical restrictions just as the collections they housed remained royal property rather than being owned by the state on behalf of the people. Even so, the placement of royal collections in new public or quasi-public contexts involved a significant transformation in the spheres of visibility they formed a part of as well as in the relations of visibility to which they gave rise.

Krzysztof Pomian's analysis of the phenomenological structure of collections usefully illuminates these matters. All collections, Pomian argues, are involved in organizing an exchange between the fields of the visible and the invisible which they establish (Pomian 1990). What can be seen on display is viewed as valuable and meaningful because of the access it offers to a realm of significance which cannot itself be seen. The visible is significant not for its own sake but because it affords a glimpse of something beyond itself: the order of nature, say, in the case of eighteenth-century natural history collections.[14] Looked at in this light, Pomian suggests, collections can be distinguished from one another in terms of the ways in which their classification and arrangement of artefacts, the settings in which these are placed, etc., serve both to refer to a realm of significance that is invisible and absent (the past, say) and to mediate the visitor's or spectator's access to that realm by making it metonymically visible and present.

It has to be added, however, that collections only function in this manner for those who possess the appropriate socially-coded ways of seeing – and, in some cases, power to see – which allow the objects on display to be not just *seen* but *seen through* to establish some communion with the invisible to which they beckon. Collections can therefore also be differentiated from one another in terms of who has access to the possibility of, and capacity for, the kinds of double-levelled vision that are called for if the contract they establish between the visible and the invisible is to be entered into.

Pierre Bourdieu's critique of the modern art gallery is a case in point. The art gallery's capacity to function as an instrument of social distinction depends on the fact that only those with the appropriate kinds of cultural capital can both *see* the paintings on display and *see through* them to perceive the hidden order of art which subtends their arrangement. However, similar processes are discernible in relation to other collections. In a recent study of late nineteenth-century colonial museums in India, Prakash shows how, in the process of negotiating a privileged relation to the imperial power, Indian elites used these museums to claim a 'second sight' which served to distinguish them from the illiterate peasantry who failed to see through the objects on display to understand the organizing principles of Western science on which they rested (Prakash 1992).

An account of the museum's formation must therefore include an account of the changing forms and social relations of visibility associated with the different stages of its development. The *studioli* of Renaissance princes, which were among the more important precursors of the royal collections of

35

absolutist regimes, reserved this power for double-levelled vision exclusively to the prince. Indeed, the significance of this power was underscored by the production of a division within the field of the visible such that one level of this was not open to inspection. Typically comprising a small, windowless room whose location in the palace was often secret, the walls of a *studiolo* housed cupboards whose contents symbolized the order of the cosmos. These cupboards and the objects they contained were arranged around a central point of inspection whose occupancy was reserved for the prince. The *studiolo*, as Giuseppe Olmi has put it, formed 'an attempt to reappropriate and reassemble all reality in miniature, to constitute a place from the centre of which the prince could symbolically reclaim dominion over the entire natural and artificial world' (Olmi 1985: 5). The real distinctiveness of the *studiolo*, however, consisted in the fact that the doors of the cupboards containing the objects were closed. 'Their presence, and their meaning', as Eilean Hooper-Greenhill puts it, 'was indicated through the symbolic images painted on the cupboard doors' (Hooper-Greenhill 1992: 106). The sphere of the actually visible (the paintings on the doors) mediated the prince's exclusive access to the, in principle, visible but, in practice, invisible contents of those cupboards – and thence to the order of the cosmos which those contents represented. To the degree that this doubly mediated access to the order of the cosmos was available only to the prince, the *studiolo* embodied a power–knowledge relation of a very particular kind in that it 'reserved to the prince not only the knowledge of the world constituting his supremacy, but the possibility of knowing itself' (ibid.: 106).

When, in the eighteenth century, royal collections were translated into more public domains, this involved a transformation in their functioning for the objects they contained then assumed the function of embodying a representative publicness of and for the power of the king. This was what royal art galleries made visible: addressing their visitors as subjects of the king, they comprised part of a semio-technique of power through which the sovereign's power was to be augmented by making it publicly visible. However, as Carol Duncan and Alan Wallach have observed, the royal art gallery also served as a context for organizing a new set of relations between the fields of the visible and the invisible. The development of display principles in which paintings were grouped by national schools and art-historical periods conferred a new codified visibility on the history of the nation and the history of art. This aspect of the royal art gallery allowed the form to be subsequently adapted, with relatively little refashioning, in the service of a democratic citizenry. Thus the administration of the Louvre during the French Revolution required no fundamental change in its icono-graphic programme for it to be adjusted to this end. Strategic replacements of images of royalty with allegorical and depersonalized representations of the state permitted a recodification of the works of art exhibited such that the nation they now made manifest was not 'the nation as the king's realm' but

'the nation as the state – an abstract entity in theory belonging to the people' (Duncan and Wallach 1980: 454).

Most authorities are in agreement on this point. For Eilean Hooper-Greenhill, for example, the Louvre remained tied to statist principles derived from its earlier monarchical organization. Its centring of the citizen or, later, the emperor thus 'could not help but recall those older renditions of the prince who represented the world, which centred himself, through the organisation of meaningful objects' (Hooper-Greenhill 1992: 168). Perhaps more to the point, there is little or no evidence to suggest that, during the course of the revolution, the programme envisaged for the Louvre departed appreciably from that which had already been proposed during the pre-revolutionary period.

The articulation of a clear political demand that the royal collections, once housed in the Louvre but subsequently moved to Versailles, should be returned to the Louvre and be opened to the public was first made by La Font de Saint Yenne in 1747 in his *Réflexions sur quelques causes de l'état présent de la peinture en France*. The demand was repeated fairly regularly thereafter, receiving the support of the Encyclopedists in 1765. Partly in response to these demands, and partly in response to other circumstances (the establishment of public collections in many areas of provincial France; the examples of the Dusseldorf and Belvedere Galleries), 1778 saw the establishment of a commission to advise on opening the grand gallery of the Louvre as a public museum. In his discussion of the concerns of this commission, Edouard Pommier suggests that the plans it developed for the Louvre envisaged it as a museum which, in its dedication to civic virtues, was to promote attachment to the state and nation as entities that were conceived as partly separate from and superior to the king. He further contends – and the documents concur that there was very little evidence of any new conception of the museum's purpose and function evident in the proceedings of the *Commission du Museum* and, subsequently, the *Conservatoire* – the organizations established, once the museum had been seized for the people, to superintend its develop ment. Indeed, if anything, the contrary was true. These revolutionary organizations, Pommier argues, simply inherited the earlier conception of the museum, worked out by the commission established in 1778, as 'the sanctuary of the example' through which civic virtues were to be instilled in the public while failing to give any attention to the detailed museological matters (the arrangement of space, the classification of the paintings) through which this programme might be carried out and put into effect. Instead, the revolution was content simply 'to fill the grand gallery with paintings and open it to the public' (Pommier 1989: 27).[15]

The adjustments made to the programme of the Louvre during the revolution, then, were a development of earlier tendencies rather than in any sense announcing a radical break with the past. Even so, this should not incline us to underrate the cumulative significance of these changes. Their

effect, to recall Marin's discussion, was the organization of a narrative ('the history of the state') in which it was not the king but the citizen who functioned, simultaneously, as both archactor and metanarrator. The consequence, as Dominique Poulot puts it, was a form in which a national citizenry was meant to commune with itself through a celebration of art in which the nation served as both subject and object (see Poulot, 1983: 20). In this respect, the transformation of the Louvre into a public art museum and the iconographic adjustments which accompanied this provided the basis for a new form. Duncan and Wallach call this the 'universal survey museum'. Its objective was to make a new conception of the state visible to the inspection of the citizen by redeploying expropriated royal treasures in a democratic public setting and thereby investing them with new meanings in embodying a democratic public representativeness:

> The public art collection also implies a new set of social relations. A visitor to a princely collection might have admired the beauty of individual works, but his relationship to the collection was essentially an extension of his social relationship to the palace and its lord. The princely gallery spoke for and about the prince. The visitor was meant to be impressed by the prince's virtue, taste and wealth. The gallery's iconographic programme and the splendour of the collection worked to validate the prince and his rule. In the museum, the wealth of the collection is still a display of national wealth and is still meant to impress. But now the state, as an abstract entity, replaces the king as host. This change redefines the visitor. He is no longer the subordinate of a prince or lord. Now he is addressed as a citizen and therefore a shareholder in the state.
>
> (Duncan and Wallach 1980: 456)

The royal art gallery is merely one of the precursors of the modern public art museum. Moreover, we shall not fully understand the latter and the significance of the semiotic recoding to which it subjected works of art unless we consider it in relation to the other museum types (of geology, natural history, anthropology, science and technology, etc.) which developed alongside it and which, in doing so, subjected their own precursors to equally significant transformations, re-arranging their objects in new configurations so as to allow new concepts and realities to be figured forth into the sphere of visibility. Viewed in this light, the displacement, in the art gallery, of the king by the citizen as the archactor and metanarrator of a self-referring narrative formed part of a new and broader narrative, one with a wider epistemic reach in which it is 'Man' who functions as the archactor and metanarrator of the story of his (for it was a gendered narrative) own development.

This narrative was made possible as a consequence of a complex set of transformations governing the objects and procedures of a wide range of

knowledges. The most crucial developments concerned the extensions of time produced by discoveries in the fields of geology and palaeontology, especially in the 1830s and 1840s, and the reorientations of anthropology which this production of a deep historical time prompted in allowing for the historicization of other peoples as 'primitive'.[16] While important differences remained between competing schools of evolutionary thought throughout the nineteenth century, the predominating tendency was one in which the different times of geology, biology, anthropology and history were connected to one another so as to form a universal time. Such a temporality links together the stories of the earth's formation, of the development of life on earth, of the evolution of human life out of animal life and its development from 'primitive' to 'civilized' forms, into a single narrative which posits modern Man (white, male, and middle class, as Catherine Hall (1992) would put it) as the outcome and, in some cases, *telos* of these processes.

These changes are often accounted for, by those who draw on Foucault's work, as parts of a more general shift from the classical to the modern episteme and as a reaction to its splintering effects. For Stephen Bann (1984) and Eilean Hooper-Greenhill (1989) the museum functions as a site in which the figure of 'Man' is reassembled from his fragments. If the dispersal of that figure across what now emerges as a series of separated histories means that Man's unity can no longer be regarded as pre-given, the museum allowed that unity to be reconstituted in the construction of 'Man' as a project to be completed through time. Like all the king's horses and all the king's men, the museum is engaged in a constant historical band-aid exercise in seeking to put back together the badly shattered human subject.

While true so far as it goes, this account is too abstract to engage adequately with the representational regime of the public museum or the manner of its functioning. It is also necessary to consider the consequences of a related transformation whereby collections were rearranged in accordance with the principle of *representativeness* rather than that of *rarity*. At the same time as being a representational shift, however, this change is tied up with and enables a functional transformation as collections, no longer thought of as means for stimulating the curiosity of the few, are reconceptualized as means for instructing the many.

These changes, together with those which reorganized museum displays in accordance with the requirements of an evolutionary historicism, were developed and implemented in a gradual and piecemeal fashion over an extended period: they were not completed until the final quarter of the nineteenth century. They are also ones which saw the centre of initiative move away from France and towards Britain and, later, the United States as societies in which the deployment of cultural resources in accordance with the principles of liberal government proceeded more rapidly and more evenly. In France this process was interrupted by a succession of royal and imperial restorations through which art and culture were periodically re-enlisted in the

service of power by being called on to symbolize it. By contrast, the programme the South Kensington Museum developed in the 1850s – and it was a programme that proved influential throughout the English-speaking world – detached art and culture from the function of bedazzling the population and harnessed them, instead, to that of managing the population by providing it with the resources and contexts in which it might become self-educating and self-regulating.

These transformations are perhaps most readily discernible in the formation of the natural history museum. Krzysztof Pomian's discussions of the principles of curiosity and of their gradual erosion, in the eighteenth century, by the new orientations embodied in natural history collections, provides a convenient point of departure. In Pomian's view, the principles of curiosity, as exemplified in the *cabinets de curieux* of sixteenth- and seventeenth-century collectors, comprised a distinctive epistemic universe, an inter-regnum between the restrictions that had been placed on inquiry by religion and those that were to be placed on it by the requirements of scientific rationality. As Pomian puts it, the *Kunstkammer* and *Wunderkammer* of the Renaissance constructed:

> a universe peopled with strange beings and objects, where anything could happen, and where, consequently, every question could legitim-ately be posed. In other words, it was a universe to which corresponded a type of curiosity no longer controlled by theology and not yet controlled by science, both these domains tending to reject certain questions as either blasphemous or impertinent, thus subjecting curi-osity to a discipline and imposing certain limits on it. Given free reign during its brief interregnum, curiosity spontaneously fixed on all that was most rare and most inaccessible, most astonishing and most enigmatic.
>
> (Pomian 1990: 77–8)

In his discussion of the collection of Pierre Borel, Pomian notes how the stress that was placed on the singular, the unique and the exceptional reflected a pre-scientific rationality in its commitment to a view of nature's infinite variability and diversity.[17] The reason for this, he argues, is clear: 'if nature is said to be governed always and everywhere by the same laws, then logically it should be reflected in the common, the repetitive and the reproducible, but if, on the other hand, no laws can be seen at work in nature, rare things alone are seen to be capable of representing nature properly' (Pomian 1990: 47). For Pomian, the regime of representation to which the governing principles of curiosity gave rise was, at the same time, the manifestation of a specific form of epistemic desire – the desire for a knowledge of totality acquired by means that were, ultimately, secretive and cultic. For the *curieux*, the singular and exceptional objects assembled in the cabinet are valued because they stand in a special relationship to the totality and, hence, offer a means of

40

acquiring a knowledge of, and privileged relation to, that totality. But this form of knowledge is, like the objects through which it is accessible, a rare one only available to those special few who actively seek it. And the cabinet of curiosities, in its design and in its social relations, reflects its role as a storehouse of a knowledge that is, at once, rare and exclusive, intelligible only to those with the time, inclination and cultural training to be able to decipher the relationship in which each object stands to the whole.

The initial challenge to the principles of curiosity, Pomian argues, came from the changing focus of natural history displays which, through the eighteenth century, came increasingly to accord priority of attention to the normal, the commonplace and the close-at-hand at the expense of the exceptional and the exotic. This shift of emphasis was, as Pomian puts it, simultaneously epistemic and utilitarian. It was the product of new principles of scientific rationality in which a search for laws as revealed by recurrences at the level of the average or commonplace came to prevail over the fascination with nature's singular wonders. Yet it also entailed a new concern with the general communicability of this knowledge in order, through its effective dissemination, to allow it to be put to useful effect in the productive exploitation of nature. What changed, then, was not merely the classificatory principles governing the arrangement of exhibits. There was also a changed orientation to the visitor – one which was increasingly pedagogic, aiming to render the principles of intelligibility governing the collections readily intelligible to all and sundry, as contrasted with the secretive and cultic knowledge offered by the cabinet of curiosity.

The issues at stake here are posed most clearly by the debates regarding whether or not collections might be separated into two parts: one for research purposes and the other for public display. Richard Owen had proved recalcitrantly opposed to this during his period as Director of the Natural History collections at the British Museum as well as, later, founding-Director of the Museum of Natural History when it moved to its own premises. Owen insisted, throughout, on the need for a national collection to be as wholly and exhaustively representative of nature's diversity as space would allow (see Owen 1862).[18] None the less, it was Edward Gray, the Keeper of Zoology at the British Museum and Owen's subordinate, who was the first to suggest, in 1858, 'that it would be desirable to form a *study-series* as distinct from the *exhibition-series*'. Gray argued that what 'the largest class of visitors, the general public, want, is a collection of the more interesting objects so arranged as to afford the greatest possible amount of information in a moderate space, and to be obtained, as it were, at a glance' (cited in Winson 1991: 121). Louis Agassiz, who had argued, in 1862, that 'collections of natural history are less useful for study in proportion as they are more extensive' (Agassiz 1862: 415) was to prove the first influential advocate of this principle of separate displays. Although at first seeking to reconcile the two functions of research and popular pedagogy, in 1878 he divided the

collection of Harvard's Museum of Comparative Zoology along the lines Gray had suggested. Sir William Henry Flower, Owen's successor at London's Museum of Natural History, was to do the same in 1884.

In the principles Flower enunciated for public natural history displays, the singularity of the object – its unique properties – is no longer of any interest. Citing G. Brown Goode's famous definition of a well-arranged museum as 'a collection of instructive labels illustrated by well-selected specimens', Flower goes on to describe the process through which, ideally, the arrangement of that part of a museum intended for public instruction should be arrived at:

> First, as I said before, you must have your curator. He must carefully consider the object of the museum, the class and capacities of the persons for whose instruction it is founded, and the space available to carry out this object. He will then divide the subject to be illustrated into groups, and consider their relative proportions, according to which he will plan out the space. Large labels will next be prepared for the principal headings, as the chapters of a book, and smaller ones for the various subdivisions. Certain propositions to be illustrated, either in the structure, classification, geographical distribution, geological position, habits, or evolution of the subjects dealt with, will be laid down and reduced to definite and concise language. Lastly will come the illustrative specimens, each of which as procured and prepared will fall into its appropriate place.
>
> (Flower 1898: 18)

The main point to note here is less that the object comes last but that, in doing so, its function and place is drastically altered to the extent that its status is now that of an illustration of certain general laws or tendencies. The implications of this new status are clearly identified as Flower proceeds to argue both the need for, and the possibility of, sparsity in the display of specimens so that the visitors' attention should not be distracted by the proliferation of objects on display. This new representational principle of sparsity, however, is possible only on the condition that the object displayed is viewed as representative of other objects falling within the same class. This contrasts markedly with the principles of curiosity which, since objects are valued for their uniqueness, and since, therefore, no object can stand in for another, can assign no limits to the potentially endless proliferation of objects which they might contain.

But the principle of sparsity is, at the same time, a principle of legibility – and of public legibility. If the museum object is an illustration, there is, in Flower's scheme, no room for ambiguity regarding its meaning. This is already vouchsafed for it by the evolutionary narratives which assign it its place – narratives which, ideally, govern the performative as well as the representational aspects of the museum's environment. Thus, in outlining his

perfect plan for a natural history museum, Flower visualizes a representational arrangement that is, at the same time, a performative one or, better, a representation that is realized in and through its performance. His plan, an adaptation of one that James Bogardus had earlier proposed for a world's fair (see Giedion 1967: 199), consisted of a series of galleries arranged in the form of circles, one within the other, and communicating at frequent intervals:

> Each circle would represent an epoch in the world's history, commencing in the centre and finishing at the outermost, which would be that in which we are now living. The history of each natural group would be traced in radiating lines, and so by passing from the centre to the circumference, its condition of development in each period of the world's history could be studied.
>
> (Flower 1898: 49)

The visitor at such a museum is not placed statically before an order of things whose rationality will be revealed to the visitor's immobile contemplation. Rather, locomotion – and sequential locomotion – is required as the visitor is faced with an itinerary in the form of an order of things which reveals itself only to those who, step by step, retrace its evolutionary development.

How far similar principles of representation characterized the full range of specialist museums that developed in the nineteenth century is a moot point. Its influence on anthropological collections is clear. Pitt Rivers (or, as he was then, Colonel Fox) clearly articulated the relationship between the principles of representativeness, sparsity and public instruction governing the typological method he used in displaying his collections. In outlining the principles of classification governing the first public display of his collections at Bethnal Green in 1874, he thus stated:

> The collection does not contain any considerable number of unique specimens, and has been collected during upwards of twenty years, not for the purpose of surprising any one, either by the beauty or value of the objects exhibited, but solely with a view to instruction. For this purpose ordinary and typical specimens, rather than rare objects, have been selected and arranged in sequence, so as to trace, as far as practicable, the succession of ideas by which the minds of men in a primitive condition of culture have progressed from the simple to the complex, and from the homogeneous to the heterogeneous.
>
> (Lane-Fox 1875: 293–4)

The museum type most usually cited as an exception to this general tendency is the art museum. For Stephen Greenblatt (1991), the modern art museum is still governed by the principle of wonder to the degree that it seeks to stop the visitor in her or his tracks by conveying a sense of the uniqueness of the work of art. In contrast with the principle of resonance which characterizes

other modern collections where the viewer's attention is diverted away from the object itself and towards the implied system of relationships of which it forms a part, the modern art museum, Greenblatt contends, is dedicated to displaying the singularity of the masterpiece. This requires such an intensity of regard from the visitor that everything else is blocked out from her or his vision. Barbara Kirshenblatt-Gimblett's position is similar. While agreeing that, in the sciences, nineteenth-century museum classifications had shifted 'the grounds of singularity from the object to a category within a particular taxonomy' (Kirshenblatt-Gimblett 1991: 392), the exhibition of works of art continued to be predicated on the singularity of each object and its power to dazzle.

There is, then, a fairly widespread school of thought according to which the art museum stands to one side of the representational regime that has developed in association with the formation of other types of public museums. However, this view has been compellingly challenged by Philip Fisher who sees the modern art museum as being just as much dominated by what he calls the 'technology of the series' as other museum types and for much the same sorts of reasons. As art came to be envisaged as a cultural resource which might be utilized in governmental programmes aimed at enriching the whole population, then so the principles of its display were fundamentally modified. Where once sensory values had governed displays of art with paintings, mirrors, tapestries, etc., being placed in relation to one another in such a way as to produce a pleasing harmony, the public art museum developed new forms of exhibition that 'involved an instruction in history and cultures, periods and schools, that in both order and combination was fundamentally pedagogic' (Fisher 1991: 7). The resulting technology of the series, Fisher argues, was inherently inimical to the logic of the masterpiece. Whereas the masterpiece is 'the quintessential complete and finished object' (ibid.: 174), a self-subsistent singularity existing outside the orders of time, the script of the art museum necessarily deprives the work of art of any such status in subordinating it to the effects of the technology of the series – that is, of works of art placed one after the other in a sequential toil that is historicized. This technology forms merely a part of the modern 'machinery of a history of art which sequences each object and provides it with sources (ancestors) and consequences (descendants) beyond itself', hanging paintings in a row so that 'the individual work is implied to be following this and leading to that' (ibid.: 97).

The pedagogy comprised by this technology is not just a representational one that works via its influence on the visitor's consciousness. It is a technology which also saturates the routines of the visitor as the lesson of art's progress takes the form of an itinerary that the visitor is obliged to perform. The museum converts rooms into paths, into spaces leading from and to somewhere. Fisher outlines what he means by this in contending that it is the museum that teaches us to 'follow' art:

That we walk through a museum, walk past the art, recapitulates in our act the motion of art history itself, its restlessness, its forward motion, its power to link. Far from being a fact that shows the public's ignorance of what art is about, the rapid stroll through a museum is an act in deep harmony with the nature of art, that is, art history and the museum itself (*not* with the individual object, which the museum itself has profoundly hidden in history).

(Fisher 1991: 9)

The performative consequences of this technology of the series are most clearly discernible where it is absent. The Museum of Modern Art at the Pompidou Centre is perhaps the best-documented example. Here there is no history of art to be performed. Instead, the museum substitutes a directed form of directionlessness for the narrativized route of the historical collection in the aimless wandering it obliges its visitors to undertake. For more traditional visitors used to the performative requirements of the technology of the series, the new demands posed by such a de-historicized context for art's display have been experienced as deeply disorientating (see Heinich 1988).

To summarize, then, while the formation of the public museum forms part and parcel of the fashioning of a new discursive space in which 'Man' functions as the archactor and metanarrator of the story of his own development, we shall not adequately understand the functioning and organization of this space if we view it solely as fabricating a compensatory totality in the face of the ruins of the human subject. Nor shall we do so if we focus solely on its representational aspects. This is the central weakness of post-structuralist criticisms of the museum in their focus on the museum's claims to representational adequacy and then, inevitably, finding those claims wanting.

For Eugenio Donato, for example, the aspiration of the nineteenth-century museum 'to give by the ordered display of selected artefacts a total representation of human reality and history' depended on the fiction that 'a repeated metonymic displacement of fragment for totality, object to label, series of objects to series of labels, can still produce a representation which is somehow adequate to a nonlinguistic universe' (Donato 1979: 221–3). Once these assumptions are questioned, Donato argues, the museum collapses into a meaningless bric-a-brac. This criticism, whilst perfectly correct, is also beside the point in that the specific efficacy of the museum does not depend on the adequacy or otherwise of its relationship to a referential *ding-an-sich*. Indeed, its efficacy, its specific *modus operandi*, does not derive from the structure of the representations it happens to contain. To suppose that it does is to view the museum itself, as an apparatus, as of an entirely incidental significance compared with the representations it contains.

It is, of course, true that the museum's construction of 'Man' as the (still incomplete) outcome of a set of intertwined evolutionary series (geological, biological, anthropological, archaeological) was articulated to existing social

45

hierarchies in the most obvious and palpable of ways. Christina Crosby has noted the respects in which the view of history as the 'truth of man' necessarily entails the production of a number of positions outside that history – the position of women and 'primitives', for example – in relation to which its specificity can be defined. 'In these ways,' she argues, '"man," that generic, universal category typifying everything human, is in fact constituted through violently hierarchical differences. "Women" must be radically other to history and to men; "primitive" men must be barely human, potentially but not actually historical' (Crosby 1991: 2). Moreover, the conflict between the theoretical universalism of the museum's discursive space and its actual articulation to existing social hierarchies has been, and continues to be, responsible for fuelling a politicization of the museum as it has been called on to reverse these exclusionary and hierarchical effects.

Yet an important characteristic of the public museum as compared with its various forebears consists in the fact that it deploys its machinery of representation within an apparatus whose orientation is primarily governmental. As such, it is concerned not only to impress the visitor with a message of power but also to induct her or him into new forms of programming the self aimed at producing new types of conduct and self-shaping. From this perspective, the significance of the new discursive space of Man's progressive development also consisted in its role in providing a discursive accompaniment to, and context for, the new kinds of performance the museum was associated with, either directly or indirectly. Let me suggest two possibilities.

In the first, the museum might be seen as providing a reinforcement mechanism in relation to the new institutions of social training governed by what Foucault calls evolutive time. The marking out of time into a series of stages comprising a linear path of evolution; the organization of these stages into an itinerary that the visitor's route retraces; the projection of the future as a course of limitless development: in all these ways the museum echoes and resonates with those new institutions of discipline and training through which, via the construction of a series of stages that were to be passed through by means of the successful acquisition of the appropriate skills, individuals were encouraged to relate to themselves as beings in incessant need of progressive development. The comments of Joseph Lancaster in summarizing the logic of the monitorial schools will help convey the point I'm after here:

> Some classes in a school will occasionally be *extinct* in consequence of the improvement of the scholars. If all the children who are in the alphabet class, improve so as to be removed to the second, the alphabet class must be extinct, unless fresh scholars are admitted.
>
> (Lancaster 1838: 12)

The nineteenth-century museum was a space in which the prospect of extinction was posed in many ways: through the depiction of the history of life on earth in natural history displays and, of course, in the futures of non-

46

existence that ethnographic displays projected for colonized peoples. The part that such representations played in authorizing the practices of colonialism has been amply documented. However, the evolutionary space of the museum had another, more local set of articulations. It provided a context in which the visitor might rehearse and recapitulate the ordering of social life promoted by those institutions of discipline and regulation which provided a new grid for daily life. The relationship worked the other way, too, with the hierarchical rankings associated with the museum often providing a model for other social institutions. In outlining the series of stages that education should follow, Herbert Spencer reproduced the hierarchical logic governing the arrangement of classes at international exhibitions. A rational programme of education, Spencer proposed, should commence with those activities which directly and indirectly 'minister to self-preservation' and proceed, thence, to those activities which 'have for their end the rearing and discipline of offspring'. The higher stages of education would comprise instruction in 'those activities which are involved in the maintenance of proper social and political relations' to be crowned, finally, by instruction in 'those miscellaneous activities which fill up the leisure part of life, devoted to the gratification of the tastes and feelings' (Spencer, cited in Humes 1983: 31).

Viewed in this light, the museum might be regarded as a machinery for producing 'progressive subjects'. Its routines served to induct the visitor into an improving relationship to the self. This yielded – ideally – a citizenry which, in drilling itself, would come to be auto-tuned to the requirements of the new forms of social training whose operations provided the museum with a salient point of external reference and connection. In a second argument, however, the performative context of the museum might be seen as having a more directly 'progressive effect' in its own right. For the space of the museum was also an emulative one; it was envisaged as a place in which the working classes would acquire more civilized habits by imitating their betters. It was, moreover, seen as crucial to the future progress of civilization that this should occur: the dissemination of middle-class forms of prudential restraint into the working classes via the male head of household was seen, throughout most of the century, as a necessity if civilization was not to be forfeited to nature and progress collapse beneath the weight of overpopulation. Viewed in this light, the museum might be seen as issuing its visitors with both a prompt and an opportunity to civilize themselves and in so doing, by treating the exhibits as props for a social performance aimed at ascending through the ranks, to help to keep progress on path.

In these respects, the museum provided its visitors with a set of resources through which they might actively insert themselves within a particular vision of history by fashioning themselves to contribute to its development. In other respects, however, the museum was heir to earlier utopian conceptions of a society perfectly transparent to itself and, as a consequence, self-regulating.

TRANSPARENCY AND SOCIAL REGULATION

As well as being provided with museums, libraries and art galleries, the inhabitants of James Silk Buckingham's model town, which he proposed to call Victoria, were to enjoy the benefits of what Anthony Vidler refers to as its 'colonnades of morality' (Vidler 1978: 63). Comprising, essentially, a series of raised promenades which traversed all the main thoroughfares and public spaces of the town, these colonnades were intended to confer a visibility on all aspects of urban life and to transform the *flâneur* into a citizen policeman – or, more accurately, a citizen who was interchangeably the object and the subject of policing in circulating between being subjected to the controlling gaze of others to, in turn, exercising such a gaze. For the intended effect of these promenades, combined with that of the central tower whose gallery was to provide for a panoptic inspection of the whole urban scene, was to banish any and all spaces of darkness and secrecy in which vice might flourish (see Figure 1.1). As Buckingham summarized his intent:

> From the entire absence of all wynds, courts and blind alleys, or culs-de-sac, there would be no secret and obscure haunts for the retirement of the filthy and the immoral from the public eye, and for the indulgence of that morose defiance of public decency which such secret haunts generate in their inhabitants.
>
> (Buckingham 1849: 193)

Similar schemes abounded during this period. Indeed, as Vidler shows, Buckingham's plan drew on Robert Owen's earlier plan for a harmonious community – the Parallelogram – for much of its detail. Similarly, the role it envisaged for the colonnades echoed that which, in the design for Fourier's Phalanstery, had been assigned to a network of galleries in providing for the supervision of communal spaces. In her discussion of nineteenth-century utopian and religious communities, Dolores Hayden has also shown how important the architectural manipulation of relations of space and vision was to the ways in which such communities aspired to be morally self-regulating in subjecting each individual to the controlling gaze of their fellows (Hayden 1976).

This utopian fascination with architecture as a moral science was nothing new. In his study of Claude-Nicolas Ledoux – for whom architecture provided an opportunity 'to join the interests of art with those of government' (cited in Vidler 1990: 75) – Vidler shows the degree to which the architectural production of relations of transparency was central to the reforming projects of the Enlightenment. In his designs for salt-works, masonic lodges, theatres, and for Houses of Education and Houses of Games, the organization of relations of either hierarchical or mutual visibility played a crucial role in Ledoux's conception of the ways in which architecture might help to shape and fashion human conduct.

Yet the wish to make a society transparent to itself as a means of rendering

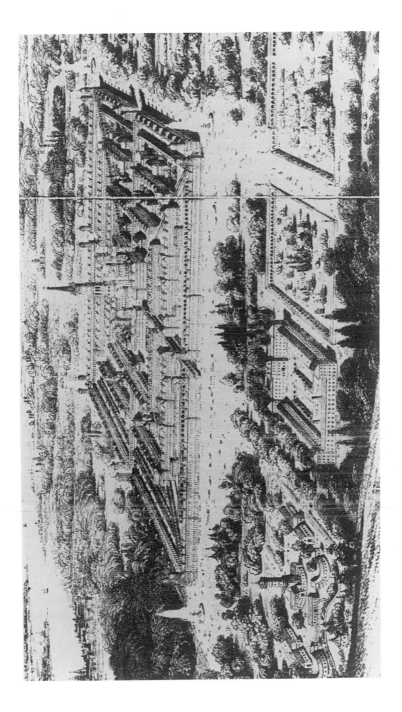

Figure 1.1 Perspective view of Victoria
Source: Buckingham (1849).

it self-regulating is not limited, in either its origins or its provenance, to the architectural sphere. Indeed, the aspiration was perhaps first most thoroughly worked through, both philosophically and practically, in the various attempts that were made, in the course of the French Revolution, to refashion the practices of the festival so that they might serve as an instrument of civic self-consciousness for a citizen democracy. In the political imaginary of the Revolution, the festival, as Mona Ozouf puts it, was regarded as providing for 'the mingling of citizens delighting in the spectacle of one another and the perfect accord of their hearts' (Ozouf 1988: 54). The festival, as Ozouf elaborates the argument, was thought of as an occasion in which the individual was 'rebaptised as a citizen'(ibid.: 9). It was a form through which 'the new social bond was to be made manifest, eternal, and untouchable' (ibid.: 9) in allowing the members of society to be rendered visually co-present to and with one another.

It was chiefly for this reason that the amphitheatre was the preferred architectural setting for the festival in allowing spectators and participants to see one another in, theoretically, relations of perfect reciprocity. 'The ideal place in which to install the Revolutionary festival', as Ozouf puts it, 'was therefore one that provided an uninterrupted view, in which every movement was immediately visible, in which everyone could encompass at a glance the intentions of its organisers' (Ozouf 1988: 129). Yet if 'unimpeded vision and the festive spirit' seemed to go hand-in-hand, it was also true that the 'spontaneity' of the festival became increasingly organized and, indeed, coercive to the extent that the official ideal of the festival form could only be

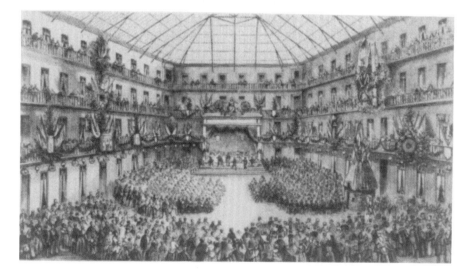

Figure 1.2 Festival of Labour, the Familistère, 1872
Source: Hayden (1981).

realized by the rigorous exclusion of all those elements of misrule, riotous assembly and carnivalesque inversion associated with traditional popular festivals. An occasion for the exercise of social virtues, the revolutionary festival constituted an overdetermined context in which 'mere contact between people was an education in civics' and in this, its civic function, the festival was regarded as 'very different from the riotous assembly or even the crowd' (ibid.: 200). The ideal of scopic reciprocity, in other words, was as much an instrument of social discipline as it was a means of celebrating the citizenry's co-presence to and with itself.

The architectural legacy of such conceptions is evident in the design of the courtyard for the Familistère, or Social Palace, built in Guise from 1859 and modelled on Fourier's communitarian principles (see Figure 1.2). Here, in the Festival of Labour, the community is gathered together in a collective celebratory mode which, at the same time that it is self-affirming, is also self-policing. The most striking aspects of this scene are its resemblances to the new forms of exhibitionary architecture developed in the nineteenth century. In arcades (see Figure 1.3), department stores (see Figure 1.4) and the new

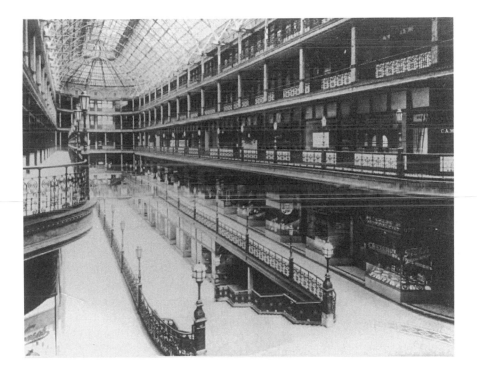

Figure 1.3 Cleveland Arcade, Cleveland, 1888–90
Source: Pevsner (1976).

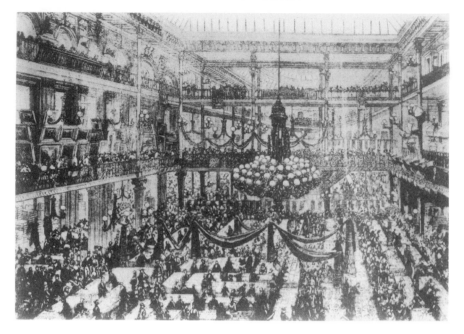

Figure 1.4 The *Bon Marché*
Source: Miller (1981).

museums that were custom built for their new public function (see Figures 1.5 and 1.6), the same architectural principle recurs again and again. Relations of space and vision are organized not merely to allow a clear inspection of the objects exhibited but also to allow for the visitors to be the objects of each other's inspection – scenes in which, if not a citizenry, then certainly a public displayed itself to itself in an affirmative celebration of its own orderliness in architectural contexts which simultaneously guaranteed and produced that orderliness.[19]

That this was a wholly conscious technology of regulation is clear from the way in which these new exhibitionary architectures were developed out from, and by means of, a critique of earlier architectural forms. Significantly enough, however, it was not the museum's most immediate precursors that were most typically looked to in this regard. Where collections were reserved for royal inspection or were assembled in cabinets of curiosities to which only the privileged were admitted, and then usually on the basis of per-sonalized tours for a handful of visitors at a time, the need for an architectural regulation of the visitor did not arise. The warren-like layout of Sir John Soane's museum thus provided no mechanism for inhibiting the visitor's conduct (see Figure 1.7). When, in 1841, a House of Commons Select Committee on National Monuments and Works of Art considered the

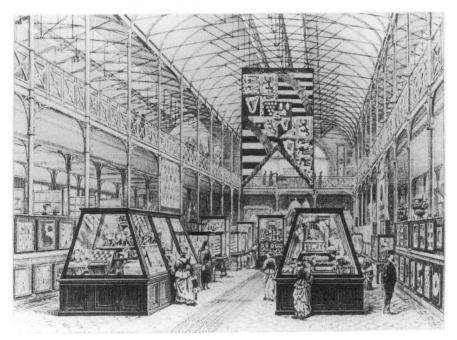

Figure 1.5 Bethnal Green Museum, 1876
Source: Physik (1982).

architectural layout of public buildings, buildings of this kind and – where they existed – the labour-intensive practices of visitor supervision which accompanied them were assessed as inefficient so far as their regulatory capacities were concerned. The Tower of London emerged as antiquated in its continued use of wardens as the primary means of guiding visitors while keeping a watchful eye on them. For William Buss, an artist, the guided tours of the armouries diminished their potential value:

> at that time it appeared to me to be very defective; the people were hurried through in gangs of from 20 to 30, and there was no time allowed for the investigation of any thing whatever; in fact, they were obliged to attend to the warder, and if the people had catalogues they might as well have kept them in their pockets; when they wanted to read them in conjunction with the object they saw, of course they lagged behind, and then the warder would say, 'You must not do that; the catalogues are to be read at home; you must follow me, or you will lose a great deal;' and I was peculiarly struck by that, for I thought it a very odd mode of exhibiting national property.
>
> (Report, 1841, minute 2805)

The primary objection to this form of visitor regulation, as it emerges in the

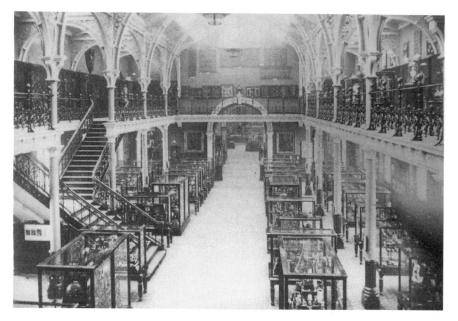

Figure 1.6 The Industrial Gallery, Birmingham
Source: S. Tait, *Palaces of Discovery*, London, Quiller Press, 1989.

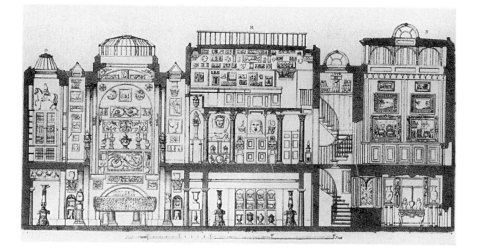

Figure 1.7 Section drawing of Sir John Soane's Museum, 1827
Source: S. Tait, *Palaces of Discovery*, London, Quiller Press, 1989.

Report, consists in its inability to regulate public spaces into which indi-
viduals are admitted in large numbers but on a one-by-one basis and in which
– as in the art museum – the individual must be allowed to contemplate the
work displayed in order to be receptive to its beauty and uplifting influence.
The guided tour, in herding the visitor round to a fixed time-schedule in an
obligatory close association with strangers, and in requiring attention to the
set patter of the warden, was regarded as inconsistent with this objective. The
preference was for more streamlined ways of managing the visitor via
organized routes (one-way systems which do not allow visitors to retrace their
steps) and impersonalized forms of surveillance (two guards per room, as at
the National Gallery). However, perhaps the most distinctive aspect of the
Report was the interest evinced in making use of the visitors themselves as
a regulatory resource. For Sir Henry Ellis, the chief librarian of the British
Museum, it was thus clear that 'if a small number of persons are distributed
through the whole house there is a great chance that you may some day or
other be robbed; our servants cannot watch them so well when a few persons
are distributed over a large space; when there are many, one visitor, to a
certain extent, may be said to watch another' (Report, 1841, Minute 2944).

The most interesting comparisons, from this point of view, were those drawn
between the new public exhibitionary institutions of the time and cathedrals.
Just as conservatives objected that opening museums to the public would result
in the destruction and desecration of art by the mob, so it was argued that
cathedrals, in allowing unrestricted entry during service time, ran the risk of
undermining their own spirituality. 'Even now, with the restricted right of
entrance,' the Reverend Smith of St Paul's thus argued in his written submis-
sion, 'we see beggars, men with burthens, women knitting, parties eating
luncheon, dogs, children playing, loud laughing and talking, and every kind
of scene incompatible with the solemnity of worship' (Report, 1841, Minute
23). Yet, at the same time, if they were a means of stating the problem,
cathedrals also promised a solution. In the evidence that was submitted, it was
suggested that, where unrestricted entry was granted to large numbers, the
resultant capacity for self-watching might provide for a more effective
regulation of conduct than the supervision of groups of visitors by wardens.
When Charles Smith, a contemporary expert on cathedrals, was asked whether
'the number of persons admitted form a number of witnesses who observe the
wrong-doer and deter him?', he agreed that 'the number is not so great as to
form a crowd to hide each other' (Report, 1841, Minute 1582). This, of course,
was precisely what Buckingham's 'colonnades of morality' were designed to
prevent. The elevated vantage point they offer stops an assembly of people
becoming a crowd; it breaks it up and individualizes it through the capacity
for self-monitoring it provides. The transparency of the crowd to itself
prevents it from being a crowd except in purely numerical terms.

If this was an achievement of the museum, it also had parallels in the
architectural evolution of the fair. The elevated promenade of Luna Park

echoed Buckingham's colonnades of morality (see Figure 1.8) just as the observation tower in the pool area of the park provided for a panoptic surveillance similar to that of Buckingham's central tower (see Figure 1.9). While closely interconnected in many ways, the architectural developments leading to this scopic regulation of the fair were distinct from those associated with the development of exhibitionary institutions. Indeed, they are most obviously indebted to the discourses of town planning which, modelled on Haussmann's surgical dissection of Paris, aimed at the moral regulation of the population by opening up the streets to the cleansing light of public inspection – albeit, in the case of Luna Park, Haussmann's influence was routed via that ideal city of light, Chicago's White City (see Boyer 1986). The result, however, was essentially the same in installing a scopic regime which led to the breakdown and individuation of the crowd. The contrasting scene of Southwark Fair in 1733 makes the point (see Figure 1.10). It was in this form – the grotesque body of the people appearing in all its tumultuous disorder – that conservatives had feared the crowd would inflict all its excesses on the museum. The early nineteenth-century depiction of the behaviour of the popular classes in William Bullock's commercial museum shows the transference of meanings from the one scene to the other (see Figure 1.11).

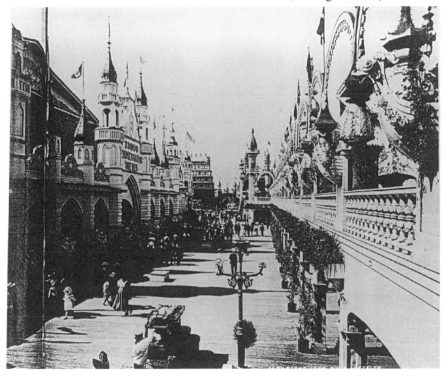

Figure 1.8 Elevated promenade at Luna Park
Source: Kasson (1978)

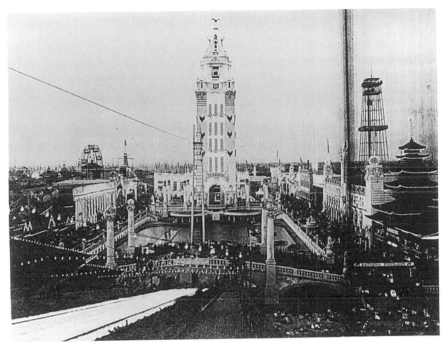

Figure 1.9 Observation tower at Luna Park
Source: Kasson (1978)

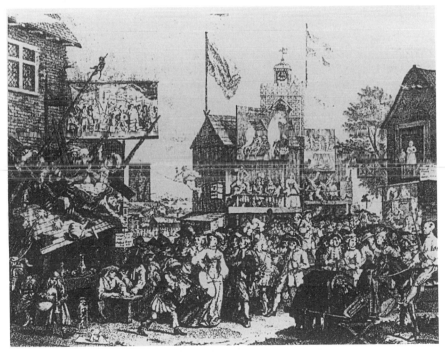

Figure 1.10 Southwark Fair, 1733
Source: S. Rosenfeld, *The Theatre of London Fairs in the 18th Century*, Oxford, Oxford University Press, 1960.

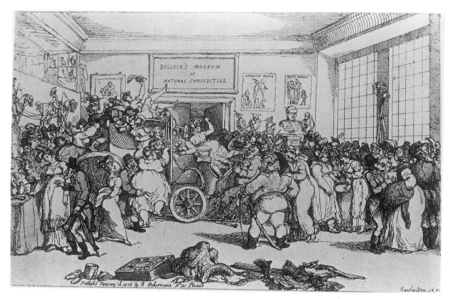

Figure 1.11 Bullock's Museum of Natural Curiosities
Source: Altick (1978).

In the event these apprehensions proved unfounded – partly because of the new technologies of regulation that were developed by public museums and related institutions, and partly because of the parallel developments which reorganized the social and architectural relations of popular recreations. By the end of the century, museums had, as George Brown Goode put it, become 'passionless reformers', capable of breaking up, segregating and regulating the conduct of those who entered through their doors. It was also true that the cultural environment surrounding the museum no longer delivered a rowdy crowd to those doors. This is not to say the museum visitor and the fair-goer were indistinguishable: to the contrary, they were significantly different from one another even when they were the same people. The two activities were perceived as different cultural occasions even by those who took part in both. But the gap between them had lessened to the degree that both had developed similar techniques for regulating the conduct of their participants.

2

THE EXHIBITIONARY COMPLEX

In reviewing Foucault on the asylum, the clinic, and the prison as institutional articulations of power and knowledge relations, Douglas Crimp suggests that there 'is another such institution of confinement ripe for analysis in Foucault's terms – the museum – and another discipline – art history' (Crimp 1985: 45). Crimp is no doubt right, although the terms of his proposal are misleadingly restrictive. For the emergence of the art museum was closely related to that of a wider range of institutions – history and natural science museums, dioramas and panoramas, national and, later, international exhibitions, arcades and department stores – which served as linked sites for the development and circulation of new disciplines (history, biology, art history, anthropology) and their discursive formations (the past, evolution, aesthetics, man) as well as for the development of new technologies of vision. Furthermore, while these comprised an intersecting set of institutional and disciplinary relations which might be productively analysed as particular articulations of power and knowledge, the suggestion that they should be construed as institutions of confinement is curious. It seems to imply that works of art had previously wandered through the streets of Europe like the Ships of Fools in Foucault's *Madness and Civilisation*; or that geological and natural history specimens had been displayed before the world, like the condemned on the scaffold, rather than being withheld from public gaze, secreted in the *studiolo* of princes, or made accessible only to the limited gaze of high society in the *cabinets des curieux* of the aristocracy (Figure 2.1). Museums may have enclosed objects within walls, but the nineteenth century saw their doors opened to the general public – witnesses whose presence was just as essential to a display of power as had been that of the people before the spectacle of punishment in the eighteenth century.

Institutions, then, not of confinement but of exhibition, forming a complex of disciplinary and power relations whose development might more fruitfully be juxtaposed to, rather than aligned with, the formation of Foucault's 'carceral archipelago'. For the movement Foucault traces in *Discipline and Punish* is one in which objects and bodies – the scaffold and the body of the condemned – which had previously formed a part of the public display of

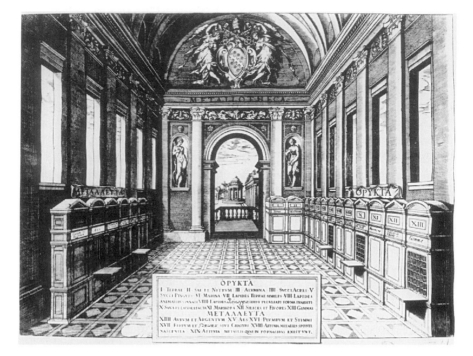

Figure 2.1 The cabinet of curiosities: the *Metallotheca* of
Michele Mercati in the Vatican, 1719
Source: Impey and MacGregor (1985).

power were withdrawn from the public gaze as punishment increasingly took
the form of incarceration. No longer inscribed within a public dramaturgy of
power, the body of the condemned comes to be caught up within an inward-
looking web of power relations. Subjected to omnipresent forms of surveil-
lance through which the message of power was carried directly to it so as to
render it docile, the body no longer served as the surface on which, through
the system of retaliatory marks inflicted on it in the name of the sovereign,
the lessons of power were written for others to read:

> The scaffold, where the body of the tortured criminal had been exposed
> to the ritually manifest force of the sovereign, the punitive theatre in
> which the representation of punishment was permanently available to
> the social body, was replaced by a great enclosed, complex and
> hierarchised structure that was integrated into the very body of the state
> apparatus.
>
> (Foucault 1977: 115–16)

The institutions comprising 'the exhibitionary complex', by contrast, were
involved in the transfer of objects and bodies from the enclosed and private

60

domains in which they had previously been displayed (but to a restricted public) into progressively more open and public arenas where, through the representations to which they were subjected, they formed vehicles for inscribing and broadcasting the messages of power (but of a different type) throughout society.

Two different sets of institutions and their accompanying knowledge/ power relations, then, whose histories, in these respects, run in opposing directions. Yet they are also parallel histories. The exhibitionary complex and the carceral archipelago develop over roughly the same period – the late eighteenth to the mid-nineteenth century – and achieve developed articulations of the new principles they embodied within a decade or so of one another. Foucault regards the opening of the new prison at Mettray in 1840 as a key moment in the development of the carceral system. Why Mettray? Because, Foucault argues, 'it is the disciplinary form at its most extreme, the model in which are concentrated all the coercive technologies of behaviour previously found in the cloister, prison, school or regiment and which, in being brought together in one place, served as a guide for the future development of carceral institutions' (Foucault 1977: 293). In Britain, the opening of Pentonville Model Prison in 1842 is often viewed in a similar light. Less than a decade later the Great Exhibition of 1851 (see Figure 2.2) brought together an ensemble of disciplines and techniques of display that had been developed within the previous histories of museums, panoramas, Mechanics' Institute exhibitions, art galleries, and arcades. In doing so, it translated these into exhibitionary forms which, in simultaneously ordering objects for public inspection and ordering the public that inspected, were to have a profound and lasting influence on the subsequent development of museums, art galleries, expositions, and department stores.

Nor are these entirely separate histories. At certain points they overlap, often with a transfer of meanings and effects between them. To understand their interrelations, however, it will be necessary, in borrowing from Foucault, to qualify the terms he proposes for investigating the development of power/knowledge relations during the formation of the modern period. For the set of such relations associated with the development of the exhibitionary complex serves as a check to the generalizing conclusions Foucault derives from his examination of the carceral system. In particular, it calls into question his suggestion that the penitentiary merely perfected the individualizing and normalizing technologies associated with a veritable swarming of forms of surveillance and disciplinary mechanisms which came to suffuse society with a new – and all pervasive – political economy of power. This is not to suggest that technologies of surveillance had no place in the exhibitionary complex but rather that their intrication with new forms of spectacle produced a more complex and nuanced set of relations through which power was exercised and relayed to – and, in part, through and by – the populace than the Foucaultian account allows.

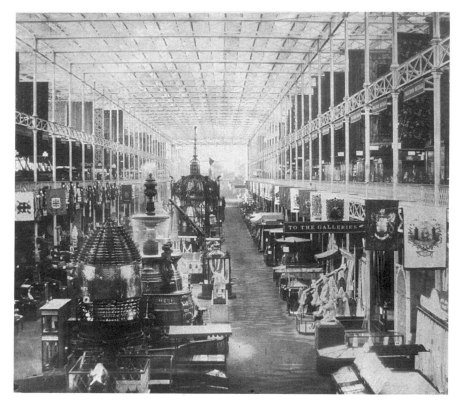

Figure 2.2 The Great Exhibition, 1851: the Western, or British, Nave, looking East
Source: Plate by H. Owen and M. Ferrier.

Foucault's primary concern, of course, is with the problem of order. He conceives the development of new forms of discipline and surveillance, as Jeffrey Minson puts it, as an 'attempt to reduce an ungovernable *populace* to a multiply differentiated *population*', parts of 'an historical movement aimed at transforming highly disruptive economic conflicts and political forms of disorder into quasi-technical or moral problems for social administration'. These mechanisms assumed, Minson continues, 'that the key to the populace's social and political unruliness and also the means of combating it lies in the "opacity" of the populace to the forces of order' (Minson 1985: 24). The exhibitionary complex was also a response to the problem of order, but one which worked differently in seeking to transform that problem into one of culture – a question of winning hearts and minds as well as the disciplining and training of bodies. As such, its constituent institutions reversed the orientations of the disciplinary apparatuses in seeking to render the forces and principles of order visible to the populace – transformed, here,

into a people, a citizenry – rather than vice versa. They sought not to map the social body in order to know the populace by rendering it visible to power. Instead, through the provision of object lessons in power – the power to command and arrange things and bodies for public display – they sought to allow the people, and *en masse* rather than individually, to know rather than be known, to become the subjects rather than the objects of knowledge. Yet, ideally, they sought also to allow the people to know and thence to regulate themselves; to become, in seeing themselves from the side of power, both the subjects and the objects of knowledge, knowing power and what power knows, and knowing themselves as (ideally) known by power, interiorizing its gaze as a principle of self-surveillance and, hence, self-regulation.

It is, then, as a set of cultural technologies concerned to organize a voluntarily self-regulating citizenry that I propose to examine the formation of the exhibitionary complex. In doing so, I shall draw on the Gramscian perspective of the ethical and educative function of the modern state to account for the relations of this complex to the development of the bourgeois democratic polity. Yet, while wishing to resist a tendency in Foucault towards misplaced generalizations, it is to Foucault's work that I shall look to unravel the relations between knowledge and power effected by the technologies of vision embodied in the architectural forms of the exhibitionary complex.

DISCIPLINE, SURVEILLANCE, SPECTACLE

In discussing the proposals of late eighteenth-century penal reformers, Foucault remarks that punishment, while remaining a 'legible lesson' organized in relation to the body of the offended, was envisioned as 'a school rather than a festival; an ever-open book rather than a ceremony' (Foucault 1977: 111). Hence, in schemes to use convict labour in public contexts, it was envisaged that the convict would repay society twice: once by the labour he provided, and a second time by the signs he produced, a focus of both profit and signification in serving as an ever-present reminder of the connection between crime and punishment:

> Children should be allowed to come to the places where the penalty is being carried out; there they will attend their classes in civics. And grown men will periodically relearn the laws. Let us conceive of places of punishment as a Garden of the Laws that families would visit on Sundays.
>
> (Foucault 1977: 111)

In the event, punishment took a different path with the development of the carceral system. Under both the *ancien régime* and the projects of the late eighteenth-century reformers, punishment had formed part of a public system of representation. Both regimes obeyed a logic according to which 'secret

punishment is a punishment half-wasted' (Foucault 1977: 111). With the development of the carceral system, by contrast, punishment was removed from the public gaze in being enacted behind the closed walls of the penitentiary, and had in view not the production of signs for society but the correction of the offender. No longer an art of public effects, punishment aimed at a calculated transformation in the behaviour of the convicted. The body of the offender, no longer a medium for the relay of signs of power, was zoned as the target for disciplinary technologies which sought to modify the behaviour through repetition.

> The body and the soul, as principles of behaviour, form the element that is now proposed for punitive intervention. Rather than on an art of representation, this punitive intervention must rest on a studied manipulation of the individual. . . . As for the instruments used, these are no longer complexes of representation, reinforced and circulated, but forms of coercion, schemata of restraint, applied and repeated. Exercises, not signs . . .
>
> (Foucault 1977: 128)

It is not this account itself that is in question here but some of the more general claims Foucault elaborates on its basis. In his discussion of 'the swarming of disciplinary mechanisms', Foucault argues that the disciplinary technologies and forms of observation developed in the carceral system – and especially the principle of panopticism, rendering everything visible to the eye of power – display a tendency 'to become "de-institutionalised", to emerge from the closed fortresses in which they once functioned and to circulate in a "free" state' (Foucault 1977: 211). These new systems of surveillance, mapping the social body so as to render it knowable and amenable to social regulation, mean, Foucault argues, that 'one can speak of the formation of a disciplinary society . . . that stretches from the enclosed disciplines, a sort of social "quarrantine", to an indefinitely generalisable mechanism of "panopticism"' (ibid.: 216). A society, according to Foucault in his approving quotation of Julius, that 'is one not of spectacle, but of surveillance':

> Antiquity had been a civilisation of spectacle. 'To render accessible to a multitude of men the inspection of a small number of objects': this was the problem to which the architecture of temples, theatres and circuses responded In a society in which the principal elements are no longer the community and public life, but, on the one hand, private individuals and, on the other, the state, relations can be regulated only in a form that is the exact reverse of the spectacle. It was to the modern age, to the ever-growing influence of the state, to its ever more profound intervention in all the details and all the relations of social life, that was reserved the task of increasing and perfecting its

guarantees, by using and directing towards that great aim the building and distribution of buildings intended to observe a great multitude of men at the same time.

(Foucault 1977: 216–17)

A disciplinary society: this general characterization of the modality of power in modern societies has proved one of the more influential aspects of Foucault's work. Yet it is an incautious generalization and one produced by a peculiar kind of misattention. For it by no means follows from the fact that punishment had ceased to be a spectacle that the function of displaying power – of making it visible for all to see – had itself fallen into abeyance.[1] Indeed, as Graeme Davison suggests, the Crystal Palace might serve as the emblem of an architectural series which could be ranged against that of the asylum, school, and prison in its continuing concern with the display of objects to a great multitude:

The Crystal Palace reversed the panoptical principle by fixing the eyes of the multitude upon an assemblage of glamorous commodities. The Panopticon was designed so that everyone could be seen; the Crystal Palace was designed so that everyone could see.

(Davison 1982/83: 7)

This opposition is a little overstated in that one of the architectural innovations of the Crystal Palace consisted in the arrangement of relations between the public and exhibits so that, while everyone could see, there were also vantage points from which everyone could be seen, thus combining the functions of spectacle and surveillance. None the less, the shift of emphasis is worth preserving for the moment, particularly as its force is by no means limited to the Great Exhibition. Even a cursory glance through Richard Altick's *The Shows of London* convinces that the nineteenth century was quite unprecedented in the social effort it devoted to the organization of spectacles arranged for increasingly large and undifferentiated publics (Altick 1978). Several aspects of these developments merit a preliminary consideration.

First, the tendency for society itself – in its constituent parts and as a whole – to be rendered as a spectacle. This was especially clear in attempts to render the city visible, and hence knowable, as a totality. While the depths of city life were penetrated by developing networks of surveillance, cities increasingly opened up their processes to public inspection, laying their secrets open not merely to the gaze of power but, in principle, to that of everyone; indeed, making the specular dominance of the eye of power available to all. By the turn of the century, Dean MacCannell notes, sightseers in Paris 'were given tours of the sewers, the morgue, a slaughterhouse, a tobacco factory, the government printing office, a tapestry works, the mint, the stock exchange and the supreme court in session' (MacCannell 1976: 57). No doubt such tours conferred only an imaginary dominance over the city, an illusory rather

than substantive controlling vision, as Dana Brand suggests was the case with earlier panoramas (Brand 1986). Yet the principle they embodied was real enough and, in seeking to render cities knowable in exhibiting the workings of their organizing institutions, they are without parallel in the spectacles of earlier regimes where the view of power was always 'from below'. This ambition towards a specular dominance over a totality was even more evident in the conception of international exhibitions which, in their heyday, sought to make the whole world, past and present, metonymically available in the assemblages of objects and peoples they brought together and, from their towers, to lay it before a controlling vision.

Second, the increasing involvement of the state in the provision of such spectacles. In the British case, and even more so the American, such involvement was typically indirect.[2] Nicholas Pearson notes that while the sphere of culture fell increasingly under governmental regulation in the second half of the nineteenth century, the preferred form of administration for museums, art galleries, and exhibitions was (and remains) via boards of trustees. Through these, the state could retain effective direction over policy by virtue of its control over appointments but without involving itself in the day-to-day conduct of affairs and so, seemingly, violating the Kantian imperative in subordinating culture to practical requirements (Pearson 1982: 8–13, 46–7). Although the state was initially prodded only reluctantly into this sphere of activity, there should be no doubt of the importance it eventually assumed. Museums, galleries, and, more intermittently, exhibitions played a pivotal role in the formation of the modern state and are fundamental to its conception as, among other things, a set of educative and civilizing agencies. Since the late nineteenth century, they have been ranked highly in the funding priorities of all developed nation-states and have proved remarkably influential cultural technologies in the degree to which they have recruited the interest and participation of their citizenries.

Finally, the exhibitionary complex provided a context for the *permanent* display of power/knowledge. In his discussion of the display of power in the *ancien régime*, Foucault stresses its episodic quality. The spectacle of the scaffold formed part of a system of power which 'in the absence of continual supervision, sought a renewal of its effect in the spectacle of its individual manifestations; of a power that was recharged in the ritual display of its reality as "super-power"' (Foucault 1977: 57). It is not that the nineteenth century dispensed entirely with the need for the periodic magnification of power through its excessive display, for the expositions played this role. They did so, however, in relation to a network of institutions which provided mechanisms for the permanent display of power. And for a power which was not reduced to periodic effects but which, to the contrary, manifested itself precisely in continually displaying its ability to command, order, and control objects and bodies, living or dead.

There is, then, another series from the one Foucault examines in tracing

the shift from the ceremony of the scaffold to the disciplinary rigours of the penitentiary. Yet it is a series which has its echo and, in some respects, model in another section of the socio-juridical apparatus: the trial. The scene of the trial and that of punishment traversed one another as they moved in opposite directions during the early modern period. As punishment was withdrawn from the public gaze and transferred to the enclosed space of the penitentiary, so the procedures of trial and sentencing – which, except for England, had hitherto been mostly conducted in secret, 'opaque not only to the public but also to the accused himself' (Foucault 1977: 35) – were made public as part of a new system of judicial truth which, in order to function as truth, needed to be made known to all. If the asymmetry of these movements is compelling, it is no more so than the symmetry of the movement traced by the trial and the museum in the transition they make from closed and restricted to open and public contexts. And, as a part of a profound transformation in their social functioning, it was ultimately to these institutions – and not by witnessing punishment enacted in the streets nor, as Bentham had envisaged, by making the penitentiaries open to public inspection – that children, and their parents, were invited to attend their lessons in civics.

Moreover, such lessons consisted not in a display of power which, in seeking to terrorize, positioned the people on the other side of power as its potential recipients but sought rather to place the people – conceived as a nationalized citizenry – on this side of power, both its subject and its beneficiary. To identify with power, to see it as, if not directly theirs, then indirectly so, a force regulated and channelled by society's ruling groups but for the good of all: this was the rhetoric of power embodied in the exhibitionary complex – a power made manifest not in its ability to inflict pain but by its ability to organize and co-ordinate an order of things and to produce a place for the people in relation to that order. Detailed studies of nineteenth-century expositions thus consistently highlight the ideological economy of their organizing principles, transforming displays of machinery and industrial processes, of finished products and *objets d'art*, into material signifiers of progress – but of progress as a collective national achievement with capital as the great co-ordinator (Silverman 1977, Rydell 1984). This power thus subjugated by flattery, placing itself on the side of the people by affording them a place within its workings; a power which placed the people behind it, inveigled into complicity with it rather than cowed into submission before it. And this power marked out the distinction between the subjects and the objects of power not within the national body but, as organized by the many rhetorics of imperialism, between that body and other, 'non-civilized' peoples upon whose bodies the effects of power were unleashed with as much force and theatricality as had been manifest on the scaffold. This was, in other words, a power which aimed at a rhetorical effect through its representation of otherness rather than at any disciplinary effects.

Yet it is not merely in terms of its ideological economy that the exhib-

itionary complex must be assessed. While museums and expositions may have set out to win the hearts and minds of their visitors, these also brought their bodies with them creating architectural problems as vexed as any posed by the development of the carceral archipelago. The birth of the latter, Foucault argues, required a new architectural problematic:

> that of an architecture that is no longer built simply to be seen (as with the ostentation of palaces), or to observe the external space (cf. the geometry of fortresses), but to permit an internal, articulated and detailed control – to render visible those who are inside it; in more general terms, an architecture that would operate to transform individuals: to act on those it shelters, to provide a hold on their conduct, to carry the effects of power right to them, to make it possible to know them, to alter them.

<div align="right">(Foucault 1977: 172)</div>

As Davison notes, the development of the exhibitionary complex also posed a new demand: that everyone should see, and not just the ostentation of imposing façades but their contents too. This, too, created a series of architectural problems which were ultimately resolved only through a 'political economy of detail' similar to that applied to the regulation of the relations between bodies, space, and time within the penitentiary. In Britain, France, and Germany, the late eighteenth and early nineteenth centuries witnessed a spate of state-sponsored architectural competitions for the design of museums in which the emphasis shifted progressively away from organizing spaces of display for the private pleasure of the prince or aristocrat and towards an organization of space and vision that would enable museums to function as organs of public instruction (Seling 1967). Yet, as I have already suggested, it is misleading to view the architectural problematics of the exhibitionary complex as simply reversing the principles of panopticism. The effect of these principles, Foucault argues, was to abolish the crowd conceived as 'a compact mass, a locus of multiple exchanges, individualities merging together, a collective effect' and to replace it with 'a collection of separated individualities' (Foucault 1977: 201). However, as John MacArthur notes, the Panopticon is simply a technique, not itself a disciplinary regime or essentially a part of one, and, like all techniques, its potential effects are not exhausted by its deployment within any of the regimes in which it happens to be used (MacArthur 1983: 192–3). The peculiarity of the exhibitionary complex is not to be found in its reversal of the principles of the Panopticon. Rather, it consists in its incorporation of aspects of those principles together with those of the panorama, forming a technology of vision which served not to atomize and disperse the crowd but to regulate it, and to do so by rendering it visible to itself, by making the crowd itself the ultimate spectacle.

An instruction from a 'Short Sermon to Sightseers' at the 1901 Pan-American Exposition enjoined: 'Please remember when you get inside the

gates you are part of the show' (cited in Harris 1978: 144). This was also true of museums and department stores which, like many of the main exhibition halls of expositions, frequently contained galleries affording a superior vantage point from which the layout of the whole and the activities of other visitors could also be observed.[3] It was, however, the expositions which developed this characteristic furthest in constructing viewing positions from which they could be surveyed as totalities: the function of the Eiffel Tower at the 1889 Paris exposition, for example. To see and be seen, to survey yet always be under surveillance, the object of an unknown but controlling look: in these ways, as micro-worlds rendered constantly visible to themselves, expositions realized some of the ideals of panopticism in transforming the crowd into a constantly surveyed, self-watching, self-regulating, and, as the historical record suggests, consistently orderly public – a society watching over itself.

Within the hierarchically organized system of looks of the penitentiary in which each level of looking is monitored by a higher one, the inmate constitutes the point at which all these looks culminate but he is unable to return a look of his own or move to a higher level of vision. The exhibitionary complex, by contrast, perfected a self-monitoring system of looks in which the subject and object positions can be exchanged, in which the crowd comes to commune with and regulate itself through interiorizing the ideal and ordered view of itself as seen from the controlling vision of power – a site of sight accessible to all. It was in thus democratizing the eye of power that the expositions realized Bentham's aspiration for a system of looks within which the central position would be available to the public at all times, a model lesson in civics in which a society regulated itself through self-observation. But, of course, self-observation from a certain perspective. As Manfredo Tafuri puts it:

> The arcades and the department stores of Paris, like the great expositions, were certainly the places in which the crowd, itself become a spectacle, found the spatial and visual means for a self-education from the point of view of capital.
>
> (Tafuri 1976: 83)

However, this was not an achievement of architecture alone. Account must also be taken of the forces which, in shaping the exhibitionary complex, formed both its publics and its rhetorics.

SEEING THINGS

It seems unlikely, come the revolution, that it will occur to anyone to storm the British Museum. Perhaps it always was. Yet, in the early days of its history, the fear that it might incite the vengeance of the mob was real enough. In 1780, in the midst of the Gordon Riots, troops were housed in the gardens

and building and, in 1848, when the Chartists marched to present the People's Charter to Parliament, the authorities prepared to defend the museum as vigilantly as if it had been a penitentiary. The museum staff were sworn in as special constables; fortifications were constructed around the perimeter; a garrison of museum staff, regular troops, and Chelsea pensioners, armed with muskets, pikes, and cutlasses, and with provisions for a three-day siege, occupied the buildings; stones were carried to the roof to be hurled down on the Chartists should they succeed in breaching the outer defences.[4]

This fear of the crowd haunted debates on the museum's policy for over a century. Acknowledged as one of the first public museums, its conception of the public was a limited one. Visitors were admitted only in groups of fifteen and were obliged to submit their credentials for inspection prior to admission which was granted only if they were found to be 'not exceptionable' (Wittlin 1949: 113). When changes to this policy were proposed, they were resisted by both the museum's trustees and its curators, apprehensive that the unruliness of the mob would mar the ordered display of culture and knowledge. When, shortly after the museum's establishment, it was proposed that there be public days on which unrestricted access would be allowed, the proposal was scuttled on the grounds, as one trustee put it, that some of the visitors from the streets would inevitably be 'in liquor' and 'will never be kept in order'. And if public days should be allowed, Dr Ward continued:

> then it will be necessary for the Trustees to have a presence of a Committee of themselves attending, with at least two Justices of the Peace and the constables of the division of Bloomsbury . . . supported by a guard such as one as usually attends at the Play-House, and even after all this, Accidents must and will happen.
>
> (Cited in Miller 1974: 62)

Similar objections were raised when, in 1835, a select committee was appointed to inquire into the management of the museum and suggested that it might be opened over Easter to facilitate attendance by the labouring classes. A few decades later, however, the issue had been finally resolved in favour of the reformers. The most significant shift in the state's attitude towards museums was marked by the opening of the South Kensington Museum in 1857 (Figure 2.3). Administered, eventually, under the auspices of the Board of Education, the museum was officially dedicated to the service of an extended and undifferentiated public with opening hours and an admissions policy designed to maximize its accessibility to the working classes. It proved remarkably successful, too, attracting over 15 million visits between 1857 and 1883, over 6.5 million of which were recorded in the evenings, the most popular time for working-class visitors who, it seems, remained largely sober. Henry Cole, the first director of the museum and an ardent advocate of the role museums should play in the formation of a rational public culture, pointedly rebutted the conceptions of the unruly mob which

70

had informed earlier objections to open admissions policies. Informing a House of Commons committee in 1860 that only one person had had to be excluded for not being able to walk steadily, he went on to note that the sale of alcohol in the refreshment rooms had averaged out, as Altick summarizes it, at 'two and a half drops of wine, fourteen-fifteenths of a drop of brandy, and ten and a half drops of bottled ale per capita' (Altick 1978: 500). As the evidence of the orderliness of the newly extended museum public mounted, even the British Museum relented and, in 1883, embarked on a programme of electrification to permit evening opening.

The South Kensington Museum thus marked a significant turning-point in the development of British museum policy in clearly enunciating the principles of the modern museum conceived as an instrument of public education. It provided the axis around which London's museum complex was to develop throughout the rest of the century and exerted a strong influence on the

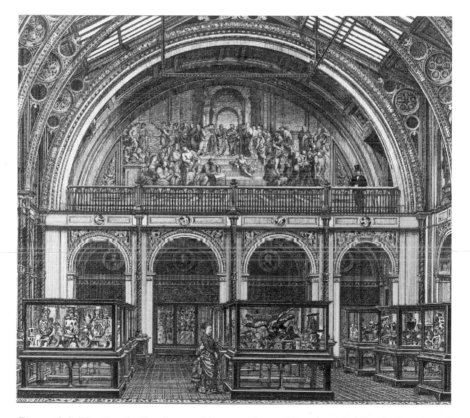

Figure 2.3 The South Kensington Museum (later Victoria and Albert): interior of the South Court, eastern portion, from the south, 1876 (drawing by John Watkins)
Source: Physik (1982).

71

development of museums in the provincial cities and towns. These now rapidly took advantage of the Museum Bill of 1845 (hitherto used relatively sparingly) which empowered local authorities to establish museums and art galleries: the number of public museums in Britain increased from 50 in 1860 to 200 in 1900 (White 1983). In its turn, however, the South Kensington Museum had derived its primary impetus from the Great Exhibition which, in developing a new pedagogic relation between state and people, had also subdued the spectre of the crowd. This spectre had been raised again in the debates set in motion by the proposal that admission to the exhibition should be free. It could only be expected, one correspondent to *The Times* argued, that both the rules of decorum and the rights of property would be violated if entry were made free to 'his majesty the mob'. These fears were exacerbated by the revolutionary upheavals of 1848, occasioning several European monarchs to petition that the public be banned from the opening ceremony (planned for May Day) for fear that this might spark off an insurrection which, in turn, might give rise to a general European conflagration (Shorter 1966). And then there was the fear of social contagion should the labouring classes be allowed to rub shoulders with the upper classes.

In the event, the Great Exhibition proved a transitional form. While open to all, it also stratified its public in providing different days for different classes of visitors regulated by varying prices of admission. In spite of this limitation, the exhibition proved a major spur to the development of open-door policies. Attracting over 6 million visitors itself, it also vastly stimulated the attendance at London's main historic sites and museums: visits to the British Museum, for example, increased from 720,643 in 1850 to 2,230,242 in 1851 (Altick 1978: 467). Perhaps more important, though, was the orderliness of the public which, in spite of the 1,000 extra constables and 10,000 troops kept on stand-by, proved duly appreciative, decorous in its bearing and entirely apolitical. More than that, the exhibition transformed the many-headed mob into an ordered crowd, a part of the spectacle and a sight of pleasure in itself. Victoria, in recording her impressions of the opening ceremony, dwelt particularly on her pleasure in seeing so large, so orderly, and so peaceable a crowd assembled in one place:

> The Green Park and Hyde Park were one mass of densely crowded human beings, in the highest good humour and most enthusiastic. I never saw Hyde Park look as it did, being filled with crowds as far as the eye could see.
>
> (Cited in Gibbs-Smith 1981: 18)

Nor was this entirely unprepared for. The working-class public the exhibition attracted was one whose conduct had been regulated into appropriate forms in the earlier history of the Mechanics Institute exhibitions. Devoted largely to the display of industrial objects and processes, these exhibitions pioneered policies of low admission prices and late opening hours

to encourage working-class attendance long before these were adopted within the official museum complex. In doing so, moreover, they sought to tutor their visitors on the modes of deportment required if they were to be admitted. Instruction booklets advised working-class visitors how to present themselves, placing particular stress on the need to change out of their working clothes – partly so as not to soil the exhibits, but also so as not to detract from the pleasures of the overall spectacle; indeed, to become parts of it:

> Here is a visitor of another sort; the mechanic has resolved to treat himself with a few hours' holiday and recreation; he leaves the 'grimy shop', the dirty bench, and donning his Saturday night suit he appears before us – an honourable and worthy object.
>
> (Kusamitsu 1980: 77)

In brief, the Great Exhibition and subsequently the public museums developed in its wake found themselves heirs to a public which had already been formed by a set of pedagogic relations which, developed initially by voluntary organizations – in what Gramsci would call the realm of civil society – were henceforward to be more thoroughgoingly promoted within the social body in being subjected to the direction of the state.

Not, then, a history of confinement but one of the opening up of objects to more public contexts of inspection and visibility: this is the direction of movement embodied in the formation of the exhibitionary complex. A movement which simultaneously helped to form a new public and inscribe it in new relations of sight and vision. Of course, the precise trajectory of these developments in Britain was not followed elsewhere in Europe. None the less, the general direction of development was the same. While earlier collections (whether of scientific objects, curiosities, or works of art) had gone under a variety of names (museums, *studioli*, *cabinets des curieux*, *Wunderkammern*, *Kunstkammern*) and fulfilled a variety of functions (the storing and dissemination of knowledge, the display of princely and aristocratic power, the advancement of reputations and careers), they had mostly shared two principles: that of private ownership and that of restricted access.[5] The formation of the exhibitionary complex involved a break with both in effecting the transfer of significant quantities of cultural and scientific property from private into public ownership where they were housed within institutions administered by the state for the benefit of an extended general public.

The significance of the formation of the exhibitionary complex, viewed in this perspective, was that of providing new instruments for the moral and cultural regulation of the working classes. Museums and expositions, in drawing on the techniques and rhetorics of display and pedagogic relations developed in earlier nineteenth-century exhibitionary forms, provided a context in which the working- and middle-class publics could be brought together and the former – having been tutored into forms of behaviour to suit them for the occasion – could be exposed to the improving influence of the

73

latter. A history, then, of the formation of a new public and its inscription in new relations of power and knowledge. But a history accompanied by a parallel one aimed at the destruction of earlier traditions of popular exhibition and the publics they implied and produced. In Britain, this took the form, *inter alia*, of a concerted attack on popular fairs owing to their association with riot, carnival, and, in their side-shows, the display of monstrosities and curiosities which, no longer enjoying elite patronage, were now perceived as impediments to the rationalizing influence of the restructured exhibitionary complex.

Yet, by the end of the century, fairs were to be actively promoted as an aid rather than a threat to public order. This was partly because the mechanization of fairs meant that their entertainments were increasingly brought into line with the values of industrial civilization, a testimony to the virtues of progress.[6] But it was also a consequence of changes in the conduct of fairgoers. By the end of the century, Hugh Cunningham argues, 'fairgoing had become a relatively routine ingredient in the accepted world of leisure' as 'fairs became tolerated, safe, and in due course a subject of nostalgia and revival' (Cunningham 1982: 163). The primary site for this transformation of fairs and the conduct of their publics – although never quite so complete as Cunningham suggests – was supplied by the fair zones of the late-nineteenth-century expositions. It was here that two cultures abutted on to one another, the fair zones forming a kind of buffer region between the official and the popular culture with the former seeking to reach into the latter and moderate it. Initially, these fair zones established themselves independently of the official expositions and their organizing committees. The product of the initiative of popular showmen and private traders eager to exploit the market the expositions supplied, they consisted largely of an *ad hoc* melange of both new (mechanical rides) and traditional popular entertainments (freak shows, etc.) which frequently mocked the pretensions of the expositions they adjoined. Burton Benedict summarizes the relations between expositions and their amusement zones in late nineteenth-century America as follows:

> Many of the display techniques used in the amusement zone seemed to parody those of the main fair. Gigantism became enormous toys or grotesque monsters. Impressive high structures became collapsing or whirling amusement 'rides'. The solemn female allegorical figures that symbolised nations (Miss Liberty, Britannia) were replaced by comic male figures (Uncle Sam, John Bull). At the Chicago fair of 1893 the gilded female statue of the Republic on the Court of Honour contrasted with a large mechanical Uncle Sam on the Midway that delivered forty thousand speeches on the virtues of Hub Gore shoe elastics. Serious propagandists for manufacturers and governments in the main fair gave way to barkers and pitch men. The public no longer had to play the role of impressed spectators. They were invited to become frivolous participants. Order was replaced by jumble, and instruction by entertainment.
>
> (Benedict 1983: 53–4)

As Benedict goes on to note, the resulting tension between unofficial fair and official exposition led to 'exposition organisers frequently attempting to turn the amusement zone into an educational enterprise or at least to regulate the type of exhibit shown'. In this, they were never entirely successful. Into the twentieth-century, the amusement zones remained sites of illicit pleasures – of burlesque shows and prostitution – and of ones which the expositions themselves aimed to render archaic. Altick's 'monster-mongers and retailers of other strange sights' seem to have been as much in evidence at the Panama Pacific Exhibition of 1915 as they had been, a century earlier, at St Bartholomew's Fair, Wordsworth's Parliament of Monsters (McCullough 1966: 76). None the less, what was evident was a significant restructuring in the ideological economy of such amusement zones as a consequence of the degree to which, in subjecting them to more stringent forms of control and direction, exposition authorities were able to align their thematics to those of the official expositions themselves and, thence, to those of the rest of the exhibitionary complex. Museums, the evidence suggests, appealed largely to the middle classes and the skilled and respectable working classes and it seems likely that the same was true of expositions. The link between expositions and their adjoining fair zones, however, provided a route through which the exhibitionary complex and the disciplines and knowledges which shaped its rhetorics acquired a far wider and more extensive social influence.

THE EXHIBITIONARY DISCIPLINES

The space of representation constituted by the exhibitionary complex was shaped by the relations between an array of new disciplines: history, art history, archaeology, geology, biology, and anthropology. Whereas the disciplines associated with the carceral archipelago were concerned to reduce aggregates to individualities, rendering the latter visible to power and so amenable to control, the orientation of these disciplines – as deployed in the exhibitionary complex might best be summarized as that of 'show and tell'. They tended also to be generalizing in their focus. Each discipline, in its museological deployment, aimed at the representation of a type and its insertion in a developmental sequence for display to a public.

Such principles of classification and display were alien to the eighteenth century. Thus, in Sir John Soane's Museum, architectural styles are displayed in order to demonstrate their essential permanence rather than their change and development (Davies 1984: 54). The emergence of a historicized framework for the display of human artefacts in early-ninetenth-century museums was thus a significant innovation. But not an isolated one. As Stephen Bann shows, the emergence of a 'historical frame' for the display of museum exhibits was concurrent with the development of an array of disciplinary and other practices which aimed at the life-like reproduction of an authenticated past and its representation as a series of stages leading to

the present – the new practices of history writing associated with the historical novel and the development of history as an empirical discipline, for example (Bann 1984). Between them, these constituted a new space of representation concerned to depict the development of peoples, states, and civilizations through time conceived as a progressive series of developmental stages.

The French Revolution, Germaine Bazin suggests, played a key role in opening up this space of representation by breaking the chain of dynastic succession that had previously vouchsafed a unity to the flow and organization of time (Bazin 1967: 218). Certainly, it was in France that historicized principles of museum display were first developed. Bazin stresses the formative influence of the Musée des monuments français (1795) in exhibiting works of art in galleries devoted to different periods, the visitor's route leading from earlier to later periods, with a view to demonstrating both the painterly conventions peculiar to each epoch and their historical development. He accords a similar significance to Alexandre du Sommerard's collection at the Hôtel de Cluny which, as Bann shows, aimed at 'an integrative construction of historical totalities', creating the impression of a historically authentic milieu by suggesting an essential and organic connection between artefacts displayed in rooms classified by period (Bann 1984: 85).

Bann argues that these two principles – the *galleria progressiva* and the period room, sometimes employed singly, at others in combination – constitute the distinctive poetics of the modern historical museum. It is important to add, though, that this poetics displayed a marked tendency to be nationalized. If, as Bazin suggests, the museum became 'one of the fundamental institutions of the modern state' (Bazin 1967: 169), that state was also increasingly a nation-state. The significance of this was manifested in the relations between two new historical times – national and universal – which resulted from an increase in the vertical depth of historical time as it was both pushed further and further back into the past and brought increasingly up to date. Under the impetus of the rivalry between France and Britain for dominion in the Middle East, museums, in close association with archaeological excavations of progressively deeper pasts, extended their time horizons beyond the medieval period and the classical antiquities of Greece and Rome to encompass the remnants of the Egyptian and Mesopotamian civilizations. At the same time, the recent past was historicized as the newly emerging nation-states sought to preserve and immemorialize their own formation as a part of that process of 'nationing' their populations that was essential to their further development. It was as a consequence of the first of these developments that the prospect of a universal history of civilization was opened up to thought and materialized in the archaeological collections of the great nineteenth-century museums. The second development, however, led to these universal histories being annexed to national histories as, within

the rhetorics of each national museum complex, collections of national materials were represented as the outcome and culmination of the universal story of civilization's development.

Nor had displays of natural or geological specimens been organized historically in the various precursors of nineteenth-century public museums. Throughout the greater part of the eighteenth century, principles of scientific classification testified to a mixture of theocratic, rationalist, and proto-evolutionist systems of thought. Translated into principles of museological display, the result was the table, not the series, with species being arranged in terms of culturally codified similarities/dissimilarities in their external appearances rather than being ordered into temporally organized relations of precession/succession. The crucial challenges to such conceptions came from developments within geology and biology, particularly where their researches overlapped in the stratigraphical study of fossil remains.[7] However, the details of these developments need not concern us here. So far as their implications for museums were concerned, their main significance was that of allowing for organic life to be conceived and represented as a temporally ordered succession of different forms of life where the transitions between them were accounted for not as a result of external shocks (as had been the case in the eighteenth century) but as the consequence of an inner momentum inscribed within the concept of life itself.[8]

If developments within history and archaeology thus allowed for the emergence of new forms of classification and display through which the stories of nations could be told and related to the longer story of Western civilization's development, the discursive formations of nineteenth-century geology and biology allowed these cultural series to be inserted within the longer developmental series of geological and natural time. Museums of science and technology, heirs to the rhetorics of progress developed in national and international exhibitions, completed the evolutionary picture in representing the history of industry and manufacture as a series of progressive innovations leading up to the contemporary triumphs of industrial capitalism.

Yet, in the context of late-nineteenth-century imperialism, it was arguably the employment of anthropology within the exhibitionary complex which proved most central to its ideological functioning. For it played the crucial role of connecting the histories of Western nations and civilizations to those of other peoples, but only by separating the two in providing for an interrupted continuity in the order of peoples and races – one in which 'primitive peoples' dropped out of history altogether in order to occupy a twilight zone between nature and culture. This function had been fulfilled earlier in the century by the museological display of anatomical peculiarities which seemed to confirm polygenetic conceptions of mankind's origins. The most celebrated instance was that of Saartjie Baartman, the 'Hottentot Venus', whose protruding buttocks – interpreted as a sign of separate development – occasioned a flurry of scientific speculation when she was

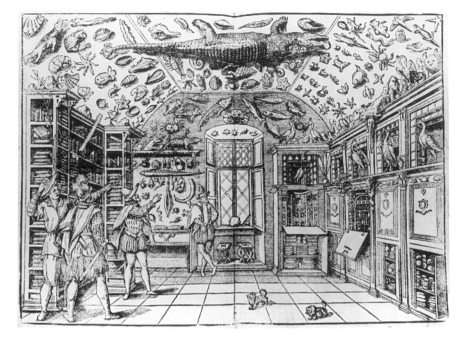

Figure 2.4 The cabinet of curiosities: Ferrante Imperato's museum in Naples, 1599
Source: Impey and MacGregor (1985).

displayed in Paris and London. On her death in 1815, an autopsy revealed alleged peculiarities in her genitalia which, likened to those of the orang-utan, were cited as proof positive of the claim that black peoples were the product of a separate – and, of course, inferior, more primitive, and bestial – line of descent. No less an authority than Cuvier lent his support to this conception in circulating a report of Baartman's autopsy and presenting her genital organs – 'prepared in a way so as to allow one to see the nature of the labia' (Cuvier, cited in Gilman 1985a: 214–15) – to the French Academy which arranged for their display in the Musée d'Ethnographie de Paris (now the Musée de l'homme).

Darwin's rebuttal of theories of polygenesis entailed that different means be found for establishing and representing the fractured unity of the human species. By and large, this was achieved by the representation of 'primitive peoples' as instances of arrested development, as examples of an earlier stage of species development which Western civilizations had long ago surpassed. Indeed, such peoples were typically represented as the still-living examples of *the* earliest stage in human development, the point of transition between nature and culture, between ape and man, the missing link necessary to account for the transition between animal and human history. Denied any history of their own, it was the fate of 'primitive peoples' to be dropped out

of the bottom of human history in order that they might serve, representationally, as its support – underlining the rhetoric of progress by serving as its counterpoints, representing the point at which human history emerges from nature but has not yet properly begun its course.

So far as the museological display of artefacts from such cultures was concerned, this resulted in their arrangement and display – as at the Pitt-Rivers Museum – in accordance with the genetic or typological system which grouped together all objects of a similar nature, irrespective of their ethnographic groupings, in an evolutionary series leading from the simple to the complex (van Keuren 1989). However, it was with regard to the display of human remains that the consequences of these principles of classification were most dramatically manifested. In eighteenth-century museums, such displays had placed the accent on anatomical peculiarities, viewed primarily as a testimony to the rich diversity of the chain of universal being. By the late nineteenth century, however, human remains were most typically displayed as parts of evolutionary series with the remains of still extant peoples being allocated the earliest position within them. This was particularly true for the remains of Australian Aborigines. In the early years of Australian settlement, the colony's museums had displayed little or no interest in Aboriginal remains (Kohlstedt 1983). The triumph of evolutionary theory transformed this situation, leading to a systematic rape of Aboriginal sacred sites – by the representatives of British, European, and American as well as Australian museums – for materials to provide a representational foundation for the story of evolution within, tellingly enough, natural history displays.[9]

The space of representation constituted in the relations between the disciplinary knowledges deployed within the exhibitionary complex thus permitted the construction of a temporally organized order of things and peoples. Moreover, that order was a totalizing one, metonymically encompassing all things and all peoples in their interactions through time. And an order which organized the implied public – the white citizenries of the imperialist powers – into a unity, representationally effacing divisions within the body politic in constructing a 'we' conceived as the realization, and therefore just beneficiaries, of the processes of evolution and identified as a unity in opposition to the primitive otherness of conquered peoples. This was not entirely new. As Peter Stallybrass and Allon White note, the popular fairs of the late eighteenth and early nineteenth centuries had exoticized the grotesque imagery of the carnival tradition by projecting it on to the representatives of alien cultures. In thus providing a normalizing function via the construction of a radically different Other, the exhibition of other peoples served as a vehicle for 'the edification of a national public and the confirmation of its imperial superiority' (Stallybrass and White 1986: 42). If, in its subsequent development, the exhibitionary complex latched on to this pre-existing representational space, what it added to it was a historical dimension.

Figure 2.5 The Crystal Palace: stuffed animals and ethnographic figures
Source: Plate by Delamotte.

THE EXHIBITIONARY APPARATUSES

The space of representation constituted by the exhibitionary disciplines, while conferring a degree of unity on the exhibitionary complex, was also somewhat differently occupied – and to different effect – by the institutions comprising that complex. If museums gave this space a solidity and permanence, this was achieved at the price of a lack of ideological flexibility. Public museums instituted an order of things that was meant to last. In doing so, they provided the modern state with a deep and continuous ideological backdrop but one which, if it was to play this role, could not be adjusted to respond to shorter-term ideological requirements. Exhibitions met this need, injecting new life into the exhibitionary complex and rendering its ideological configurations more pliable in bending them to serve the conjuncturally specific hegemonic strategies of different national bourgeoisies. They made

the order of things dynamic, mobilizing it strategically in relation to the more immediate ideological and political exigencies of the particular moment.

This was partly an effect of the secondary discourses which accompanied exhibitions. Ranging from the state pageantry of their opening and closing ceremonies through newspaper reports to the veritable swarming of pedagogic initiatives organized by religious, philanthropic and scientific associations to take advantage of the publics which exhibitions produced, these often forged very direct and specific connections between the exhibitionary rhetoric of progress and the claims to leadership of particular social and political forces. The distinctive influence of the exhibitions themselves, however, consisted in their articulation of the rhetoric of progress to the rhetorics of nationalism and imperialism and in producing, via their control over their adjoining popular fairs, an expanded cultural sphere for the deployment of the exhibitionary disciplines.

The basic signifying currency of the exhibitions, of course, consisted in their arrangement of displays of manufacturing processes and products. Prior to the Great Exhibition, the message of progress had been carried by the arrangement of exhibits in, as Davison puts it, 'a series of classes and subclasses ascending from raw products of nature, through various manufactured goods and mechanical devices, to the "highest" forms of applied and fine art' (Davison 1982/83: 8). As such, the class articulations of this rhetoric were subject to some variation. Mechanics Institutes' exhibitions placed considerable stress on the centrality of labour's contributions to the processes of production which, at times, allowed a radical appropriation of their message. 'The machinery of wealth, here displayed,' the *Leeds Times* noted in reporting an 1839 exhibition, 'has been created by the men of hammers and papercaps; more honourable than all the sceptres and coronets in the world' (cited in Kusamitsu 1980: 79). The Great Exhibition introduced two changes which decisively influenced the future development of the form.

First, the stress was shifted from the *processes* to the *products* of production, divested of the marks of their making and ushered forth as signs of the productive and co-ordinating power of capital and the state. After 1851, world fairs were to function less as vehicles for the technical education of the working classes than as instruments for their stupefaction before the reified products of their own labour, 'places of pilgrimage', as Benjamin put it, 'to the fetish Commodity' (Benjamin 1973: 165).

Second, while not entirely abandoned, the earlier progressivist taxonomy based on stages of production was subordinated to the dominating influence of principles of classification based on nations and the supra-national constructs of empires and races. Embodied, at the Crystal Palace, in the form of national courts or display areas, this principle was subsequently developed into that of separate pavilions for each participating country. Moreover, following an innovation of the Centennial Exhibition held at Philadelphia in 1876, these pavilions were typically zoned into racial groups: the Latin,

Teutonic, Anglo-Saxon, American, and Oriental being the most favoured classifications, with black peoples and the aboriginal populations of conquered territories, denied any space of their own, being represented as subordinate adjuncts to the imperial displays of the major powers. The effect of these developments was to transfer the rhetoric of progress from the relations between stages of production to the relations between races and nations by superimposing the associations of the former on to the latter. In the context of imperial displays, subject peoples were thus represented as occupying the lowest levels of manufacturing civilization. Reduced to displays of 'primitive' handicrafts and the like, they were represented as cultures without momentum except for that benignly bestowed on them from without through the improving mission of the imperialist powers. Oriental civilizations were allotted an intermediate position in being represented either as having at one time been subject to development but subsequently degenerating into stasis or as embodying achievements of civilization which, while developed by their own lights, were judged inferior to the standards set by Europe (Harris 1975). In brief, a progressivist taxonomy for the classification of goods and manufacturing processes was laminated on to a crudely racist teleological conception of the relations between peoples and races which culminated in the achievements of the metropolitan powers, invariably most impressively displayed in the pavilions of the host country.

Exhibitions thus located their preferred audiences at the very pinnacle of the exhibitionary order of things they constructed. They also installed them at the threshold of greater things to come. Here, too, the Great Exhibition led the way in sponsoring a display of architectural projects for the amelioration of working-class housing conditions. This principle was to be developed, in subsequent exhibitions, into displays of elaborate projects for the improvement of social conditions in the areas of health, sanitation, education, and welfare – promissory notes that the engines of progress would be harnessed for the general good. Indeed, exhibitions came to function as promissory notes in their totalities, embodying, if just for a season, utopian principles of social organization which, when the time came for the notes to be redeemed, would eventually be realized in perpetuity. As world fairs fell increasingly under the influence of modernism, the rhetoric of progress tended, as Rydell puts it, to be 'translated into a utopian statement about the future', promising the imminent dissipation of social tensions once progress had reached the point where its benefits might be generalized (Rydell 1984: 4).

Iain Chambers has argued that working- and middle-class cultures became sharply distinct in late nineteenth-century Britain as an urban commercial popular culture developed beyond the reach of the moral economy of religion and respectability. As a consequence, he argues, 'official culture was publicly limited to the rhetoric of monuments in the centre of town: the university, the museum, the theatre, the concert hall; otherwise it was reserved for the "private" space of the Victorian residence' (Chambers 1985: 9). While not

disputing the general terms of this argument, it does omit any consideration of the role of exhibitions in providing official culture with powerful bridge-heads into the newly developing popular culture. Most obviously, the official zones of exhibitions offered a context for the deployment of the exhibitionary disciplines which reached a more extended public than that ordinarily reached by the public museum system. The exchange of both staff and exhibits between museums and exhibitions was a regular and recurrent aspect of their relations, furnishing an institutional axis for the extended social deployment of a distinctively new ensemble of disciplines. Even within the official zones of exhibitions, the exhibitionary disciplines thus achieved an exposure to publics as large as any to which even the most commercialized forms of popular culture could lay claim: 32 million people attended the Paris Exposition of 1889; 27.5 million went to Chicago's Columbian Exposition in 1893 and nearly 49 million to Chicago's 1933/4 Century of Progress Exposition; the Glasgow Empire Exhibition of 1938 attracted 12 million visitors, and over 27 million attended the Empire Exhibition at Wembley in 1924/5 (MacKenzie 1984: 101). However, the ideological reach of exhibitions often extended significantly further as they established their influence over the popular entertainment zones which, while initially deplored by exhibition authorities, were subsequently to be managed as planned adjuncts to the official exhibition zones and, sometimes, incorporated into the latter. It was through this network of relations that the official public culture of museums reached into the developing urban popular culture, shaping and directing its development in subjecting the ideological thematics of popular entertainments to the rhetoric of progress.

The most critical development in this respect consisted in the extension of anthropology's disciplinary ambit into the entertainment zones, for it was here that the crucial work of transforming non-white peoples themselves – and not just their remains or artefacts – into object lessons of evolutionary theory was accomplished. Paris led the way here in the colonial city it constructed as part of its 1889 Exposition. Populated by Asian and African peoples in simulated 'native' villages, the colonial city functioned as the showpiece of French anthropology and, through its influence on delegates to the tenth Congrès Internationale d'Anthropologie et d'Archéologie Pré-historique held in association with the exposition, had a decisive bearing on the future modes of the discipline's social deployment. While this was true internationally, Rydell's study of American world fairs provides the most detailed demonstration of the active role played by museum anthropologists in transforming the Midways into living demonstrations of evolutionary theory by arranging non-white peoples into a 'sliding-scale of humanity', from the barbaric to the nearly civilized, thus underlining the exhibitionary rhetoric of progress by serving as visible counterpoints to its triumphal achievements. It was here that relations of knowledge and power continued to be invested in the public display of bodies, colonizing the space of earlier

freak and monstrosity shows in order to personify the truths of a new regime of representation.

In their interrelations, then, the expositions and their fair zones constituted an order of things and of peoples which, reaching back into the depths of prehistoric time as well as encompassing all corners of the globe, rendered the whole world metonymically present, subordinated to the dominating gaze of the white, bourgeois, and (although this is another story) male eye of the metropolitan powers. But an eye of power which, through the development of the technology of vision associated with exposition towers and the positions for seeing these produced in relation to the miniature ideal cities of the expositions themselves, was democratized in being made available to all. Earlier attempts to establish a specular dominance over the city had, of course, been legion – the camera obscura, the panorama – and often fantastic in their technological imaginings. Moreover, the ambition to render the whole world, as represented in assemblages of commodities, subordinate to the controlling vision of the spectator was present in world exhibitions from the outset. This was represented synecdochically at the Great Exhibition by Wylde's Great Globe, a brick rotunda which the visitor entered to see plaster casts of the world's continents and oceans. The principles embodied in the Eiffel Tower, built for the 1889 Paris Exposition and repeated in countless subsequent expositions, brought these two series together, rendering the project of specular dominance feasible in affording an elevated vantage point over a micro-world which claimed to be representative of a larger totality.

Barthes has aptly summarized the effects of the technology of vision embodied in the Eiffel Tower. Remarking that the tower overcomes 'the habitual divorce between *seeing* and *being seen*', Barthes argues that it acquires a distinctive power from its ability to circulate between these two functions of sight:

> An object when we look at it, it becomes a lookout in its turn when we visit it, and now constitutes as an object, simultaneously extended and collected beneath it, that Paris which just now was looking at it.
>
> (Barthes 1979: 4)

A sight itself, it becomes the site for a sight; a place both to see and be seen from, which allows the individual to circulate between the object and subject positions of the dominating vision it affords over the city and its inhabitants (see Figure 2.6). In this, its distancing effect, Barthes argues, 'the Tower makes the city into a kind of nature; it constitutes the swarming of men into a landscape, it adds to the frequently grim urban myth a romantic dimension, a harmony, a mitigation', offering 'an immediate consumption of a humanity made natural by that glance which transforms it into space' (Barthes 1979: 8). It is because of the dominating vision it affords, Barthes continues, that, for the visitor, 'the Tower is the first obligatory monument; it is a Gateway, it marks the transition to a knowledge' (ibid.: 14). And to the power associated

Figure 2.6 The Chicago Columbian Exposition, 1893: view from the roof of the Manufactures and Liberal Arts Building

Source: Reid (1979).

with that knowledge: the power to order objects and persons into a world to be known and to lay it out before a vision capable of encompassing it as a totality.

In *The Prelude*, Wordsworth, seeking a vantage point from which to quell the tumultuousness of the city, invites his reader to ascend with him 'Above the press and danger of the crowd/Upon some showman's platform' at St Bartholomew's Fair, likened to mobs, riotings, and executions as occasions when the passions of the city's populace break forth into unbridled expression. The vantage point, however, affords no control:

> All moveables of wonder, from all parts,
> All here – Albinos, painted Indians, Dwarfs,
> The Horse of knowledge, and the learned Pig,
> The Stone-eater, the man that swallows fire,
> Giants, Ventriloquists, the Invisible Girl,
> The Bust that speaks and moves its goggling eyes,
> The Wax-work, Clock-work, all the marvellous craft
> Of modern Merlins, Wild Beasts, Puppet-shows,
> All out-o'-the-way, far-fetched, perverted things,
> All freaks of nature, all Promethean thoughts
> of man, his dullness, madness, and their feats
> All jumbled up together, to compose
> A Parliament of Monsters.
>
> (VII, 684–5; 706–18)

Stallybrass and White argue that this Wordsworthian perspective was typical of the early nineteenth-century tendency for the educated public, in withdrawing from participation in popular fairs, also to distance itself from, and seek some ideological control over, the fair by the literary production of elevated vantage points from which it might be observed. By the end of the century, the imaginary dominance over the city afforded by the showman's platform had been transformed into a cast-iron reality while the fair, no longer a symbol of chaos, had become the ultimate spectacle of an ordered totality. And the substitution of observation for participation was a possibility open to all. The principle of spectacle – that, as Foucault summarizes it, of rendering a small number of objects accessible to the inspection of a multitude of men – did not fall into abeyance in the nineteenth century: it was surpassed through the development of technologies of vision which rendered the multitude accessible to its own inspection.

CONCLUSION

I have sought, in this chapter, to tread a delicate line between Foucault's and Gramsci's perspectives on the state, but without attempting to efface their differences so as to forge a synthesis between them. Nor is there a compelling

need for such a synthesis. The concept of the state is merely a convenient shorthand for an array of governmental agencies which – as Gramsci was among the first to argue in distinguishing between the coercive apparatuses of the state and those engaged in the organization of consent – need not be conceived as unitary with regard to either their functioning or the modalities of power they embody.

That said, however, my argument has been mainly with (but not against) Foucault. In the study already referred to, Pearson distinguishes between the 'hard' and the 'soft' approaches to the nineteenth-century state's role in the promotion of art and culture. The former consisted of 'a systematic body of knowledge and skills promulgated in a systematic way to specified audiences'. Its field was comprised by those institutions of schooling which exercised a forcible hold or some measure of constraint over their members and to which the technologies of self-monitoring developed in the carceral system undoubtedly migrated. The 'soft' approach, by contrast, worked 'by example rather than by pedagogy; by entertainment rather than by disciplined schooling; and by subtlety and encouragement' (Pearson 1982: 35). Its field of application consisted of those institutions whose hold over their publics depended on their voluntary participation.

There seems no reason to deny the different sets of knowledge/power relations embodied in these contrasting approaches, or to seek their reconciliation in some common principle. For the needs to which they responded were different. The problem to which the 'swarming of disciplinary mechanisms' responded was that of making extended populations governable. However, the development of bourgeois democratic polities required not merely that the populace be governable but that it assent to its governance, thereby creating a need to enlist active popular support for the values and objectives enshrined in the state. Foucault knows well enough the symbolic power of the penitentiary:

> The high wall, no longer the wall that surrounds and protects, no longer the wall that stands for power and wealth, but the meticulously sealed wall, uncrossable in either direction, closed in upon the now mysterious work of punishment, will become, near at hand, sometimes even at the very centre of the cities of the nineteenth century, the monotonous figure, at once material and symbolic, of the power to punish.
>
> (Foucault 1977: 116)

Museums were also typically located at the centre of cities where they stood as embodiments, both material and symbolic, of a power to 'show and tell' which, in being deployed in a newly constituted open and public space, sought rhetorically to incorporate the people within the processes of the state. If the museum and the penitentiary thus represented the Janus face of power, there was none the less – at least symbolically – an economy of effort between them. For those who failed to adopt the tutelary relation to the self promoted

by popular schooling or whose hearts and minds failed to be won in the new pedagogic relations between state and people symbolized by the open doors of the museum, the closed walls of the penitentiary threatened a sterner instruction in the lessons of power. Where instruction and rhetoric failed, punishment began.

3

THE POLITICAL RATIONALITY OF THE MUSEUM

In her essay 'The Museum in the Disciplinary Society', Eilean Hooper-Greenhill argues that the ruptures of the French Revolution 'created the conditions of emergence for a new "truth", a new rationality, out of which came a new functionality for a new institution, the public museum' (Hooper-Greenhill 1989: 63). Established as a means of sharing what had previously been private, of exposing what had been concealed, the public museum 'exposed both the decadence and tyranny of the old forms of control, the *ancien régime*, and the democracy and utility of the new, the Republic.' (ibid · 68). Appropriating royal, aristocratic and church collections in the name of the people, destroying those items whose royal or feudal associations threatened the Republic with contagion and arranging for the display of the remainder in accordance with rationalist principles of classification, the Revolution transformed the museum from a symbol of arbitrary power into an instrument which, through the education of its citizens, was to serve the collective good of the state.

Yet, and from the very beginning, Hooper-Greenhill argues, (Hooper-Greenhill 1989) the public museum was shaped into being as an apparatus with two deeply contradictory functions: 'that of the elite temple of the arts, and that of a utilitarian instrument for democratic education' (Hooper-Greenhill 1989: 63). To which, she contends, there was later added a third function as the museum was shaped into an instrument of the disciplinary society. Through the institution of a division between the producers and consumers of knowledge – a division which assumed an architectural form in the relations between the hidden spaces of the museum, where knowledge was produced and organized in camera, and its public spaces, where knowledge was offered for passive consumption – the museum became a site where bodies, constantly under surveillance, were to be rendered docile.

In taking my bearings from these remarks, my purpose in what follows is to offer an account of the birth of the museum which can serve to illuminate its political rationality, a term I borrow from Foucault. The development of modern forms of government, Foucault argues, is traced in the emergence of new technologies which aim at regulating the conduct of individuals and

89

populations – the prison, the hospital and the asylum, for example. As such, Foucault contends, these technologies are characterized by their own specific rationalities: they constitute distinct and specific modalities for the exercise of power, generating their own specific fields of political problems and relations, rather than comprising instances for the exercise of a general form of power. There is, Foucault further suggests, frequently a mismatch between the rhetorics which seemingly govern the aims of such technologies and the political rationalities embodied in the actual modes of their functioning. Where this is so, the space produced by this mismatch supplies the conditions for a discourse of reform which proves unending because it mistakes the nature of its object. The prison, Foucault thus argues, has been endlessly subject to calls for reform to allow it to live up to its rehabilitative rhetoric. Yet, however ineffective such reforms prove, the viability of the prison is rarely put into question. Why? Because, Foucault argues, the political rationality of the prison lies elsewhere – less in its ability to genuinely reform behaviour than in its capacity to separate a manageable criminal sub-class from the rest of the population.

The museum too, of course, has been constantly subject to demands for reform. Moreover, although its specific inflections have varied with time and place as have the specific political constituencies which have been caught up in its advocacy, the discourse of reform which motivate these demands has remained identifiably the same over the last century. It is, in the main, characterized by two principles: first the principle of public rights sustaining the demand that museums should be equally open and accessible to all; and second, the principle of representational adequacy sustaining the demand that museums should adequately represent the cultures and values of different sections of the public. While it might be tempting to see these as alien demands imposed on museums by their external political environments, I shall suggest that they are ones which flow out of, are generated by and only make sense in relation to the internal dynamics of the museum form. Or, more exactly, I shall argue that they are fuelled by the mismatch between, on the one hand, the rhetorics which govern the stated aims of museums and, on the other, the political rationality embodied in the actual modes of their functioning – a mismatch which guarantees that the demands it generates are insatiable.

Thus, to briefly anticipate my argument, the public rights demand is produced and sustained by the dissonance between, on the one hand, the democratic rhetoric governing the conception of public museums as vehicles for popular education and, on the other, their actual functioning as instruments for the reform of public manners. While the former requires that they should address an undifferentiated public made up of free and formal equals, the latter, in giving rise to the development of various technologies for regulating or screening out the forms of behaviour associated with popular assemblies, has meant that they have functioned as a powerful means for

differentiating populations. Similarly, demands based on the principle of representational adequacy are produced and sustained by the fact that, in purporting to tell the story of Man, the space of representation shaped into being in association with the formation of the public museum embodies a principle of general human universality in relation to which, whether on the basis of the gendered, racial, class or other social patterns of its exclusions and biases, any particular museum display can be held to be inadequate and therefore in need of supplementation.

To argue that this discourse of reform is insatiable, however, is not to argue against the political demands that have been, still are and, for the foreseeable future, will continue to be brought to bear on museums. To the contrary, in arguing the respects in which these demands grow out of the museum's contradictory political rationality, my purpose is to suggest ways in which questions of museum politics might be more productively pursued if posed in the light of those cultural dynamics and relations peculiar to the museum which they must take account of and negotiate. In this respect, apart from looking to his work for methodological guidance, I shall draw on Foucault politically in suggesting that a consideration of the 'politics of truth' peculiar to the museum allows the development of more focused forms of politics than might flow from other perspectives.

Let me mention one such alternative here. For the birth of the museum could certainly be approached, from a Gramscian perspective, as forming a part of a new set of relations between state and people that is best understood as pedagogic in the sense defined by Gramsci when he argued the state 'must be conceived of as an "educator", in as much as it tends precisely to create a new type or level of civilisation' (Gramsci 1971: 247). Nor would such an account be implausible. Indeed, a Gramscian perspective is essential to an adequate theorization of the museum's relations to bourgeois-democratic politics. In allowing an appreciation of the respects in which the museum involved a rhetorical incorporation of the people within the processes of power, it serves – in ways I shall outline – as a useful antidote to the one-eyed focus which results if museums are viewed, solely through a Foucaultian lens, as instruments of discipline. However, I want, here, to bend the stick in the other direction. For once, as in the Gramscian paradigm they generally are, museums are represented as instruments of ruling-class hegemony, then so museums tend to be thought of as amenable to a general form of cultural politics – one which, in criticizing those hegemonic ideological articulations governing the thematics of museum displays, seeks to forge new articulations capable of organizing a counter-hegemony. The difficulty with such formulations is that they take scant account of the distinctive field of political relations constituted by the museum's specific institutional properties. Gramscian politics, in other words, are institutionally indifferent in ways which a Foucaultian perspective can usefully temper and qualify.

THE BIRTH OF THE MUSEUM

Let me now turn, in the light of these considerations, to the origins and early history of the public museum, an institution whose distinguishing characteristics crystallized during the first half of the nineteenth century. In doing so I shall foreground three principles which highlight the distinctiveness of the public museum with respect to, first, its relations to the publics it helped to organize and constitute, second, its internal organization, and, third, its placement in relation both to kindred institutions as well as to those – both ancient and modern – to which it might most usefully be juxtaposed.

Douglas Crimp's account of the birth of the modern art museum offers an instructive route into the first set of questions (Crimp 1987). Crimp regards the Altes Museum in Berlin as the paradigmatic instance of the early art museum, seeing in it the first institutional expression of the modern idea of art whose initial formulation he attributes to Hegel. Constructed by Karl August Schinkel, a close friend of Hegel's, over the period 1823 to 1829 when Hegel delivered his lectures on aesthetics at the University of Berlin, the conception of the Altes Museum's function, Crimp argues, was governed by Hegel's philosophy of art in which art, having ceded its place to philosophy as the supreme mode of our knowledge of the Absolute, becomes a mere object of philosophical contemplation. The space of the museum, as this analysis unfolds, thus becomes one in which art, in being abstracted from real life contexts, is depoliticized. The museum, in sum, constitutes a specific form of art's enclosure which, in Crimp's postmodernist perspective, art must break with in order to become once more socially and politically relevant.

The argument is hardly new. The stress Crimp places on the Hegelian lineage of the art museum is reminiscent of Adorno's conception of museums as 'like family sepulchres of works of art' (Adorno 1967: 175), while his postmodernist credo echoes to the tune of Malraux's 'museum without walls' (Malraux 1967). Yet while it may make good sense, as part of a political polemic, to view art museums as institutions of enclosure from the point of view of the possible alternative contexts in which works of art might be exhibited, Crimp is led astray when he proposes 'an archaeology of the museum on the model of Foucault's analysis of the asylum, the clinic and the prison' on the grounds that, like these, it is 'equally a space of exclusion and confinement' (Crimp 1987: 62). Quite apart from the fact that it's difficult to see in what sense works of art, once placed in an art museum, might be likened to the inmate of the penitentiary whose confinement results in subjection to a normalizing scrutiny directed at the modification of behaviour, Crimp's thesis would require that the context for art's display provided by the art museum be regarded as more enclosed than the contexts provided by the variety of institutions within which works of art, together with other valued objects, had been housed from the Renaissance through to the Enlightenment.

This is patently not so. While such collections (whether of works of art,

curiosities or objects of scientific interest) had gone under a variety of names (museums, *studioli*, *cabinets des curieux*, *Wunderkammern*, *Kunst-kammern*) and fulfilled a variety of functions (demonstrations of royal power, symbols of aristocratic or mercantile status, instruments of learning), they all constituted socially enclosed spaces to which access was remarkably re-stricted. So much so that, in the most extreme cases, access was available to only one person: the prince. As we trace, over the course of the late eighteenth and early nineteenth centuries, the dispersal of these collections and their reconstitution in public museums, we trace a process in which not just works of art but collections of all kinds come to be placed in contexts which were considerably less enclosed than their antecedents. The closed walls of museums, in other words, should not blind us to the fact that they pro-gressively opened their doors to permit free access to the population at large. The timing of these developments varied: what was accomplished in France, violently and dramatically, in the course of the Revolution was, elsewhere, more typically the product of a history of gradual and piecemeal reforms. Nevertheless, by roughly the mid-nineteenth century, the principles of the new form were everywhere apparent: everyone, at least in theory, was welcome. David Blackbourn and Geoff Eley, in tracing these developments in the German context, thus stress the respects in which the advocacy of museums – along with that of adjacent institutions embodying similar principles, such as public parks and zoos – was premised on a bourgeois critique of earlier absolutist forms of display, such as the royal menagerie. In doing so, they counterpose its formative principle – that of addressing 'a general public made up of formal equals' – to the formally differentiated forms of sociability and edification that had characterized the *ancien régime* (Blackbourn and Eley 1984: 198).

In these respects, then, and contrary to Crimp's suggestion, the trajectory embodied in the museum's development is the reverse of that embodied in the roughly contemporary emergence of the prison, the asylum and the clinic. Whereas these effected the sequestration and institutional enclosure of indigent and other populations, which had previously mixed and intermingled in establishments whose boundaries proved relatively permeable or, as in the scene of punishment or the ships of fools, had formed parts of elaborate public dramaturgies, the museum placed objects which had previously been con-cealed from public view into new open and public contexts. Moreover, unlike the carceral institutions whose birth coincided with its own, the museum – in its conception if not in all aspects of its practice – aimed not at the sequestration of populations but, precisely, at the mixing and intermingling of publics – elite and popular – which had hitherto tended towards separate forms of assembly.

I make these points not merely to score off Crimp but rather to stress the respects in which the public museum occupied a cultural space that was radically distinct from those occupied by its various predecessors just as it

was distinct in its function. This, in turn, serves to underscore a methodological limitation of those accounts which tell the story of the museum's development in the form of a linear history of its emergence from earlier collecting institutions. For it is by no means clear that these provide the most appropriate historical co-ordinates for theorizing the museum's distinctiveness as a vehicle for the display of power. Depending on the period and the country, many candidates might be suggested for this role – the royal entry, the court masque, the tournament, the *ballet de cour* and, of course, the various precursors of the public museum itself. However, while, in the early Renaissance period, many of these had formed vehicles for the display of royal power to the populace, they ceased to have this function from the sixteenth century as, with the emergence of absolutism and the associated refeudalization of courtly society, they came to function mainly as court festivals or institutions designed to display monarchical power within the limited circles of the aristocracy.

So far as the public display of power to the general population was concerned, this increasingly took the form, especially in the eighteenth century, of the public enactment of the scene of punishment. Yet if the museum took over this function, it also transformed it in embodying a new rhetoric of power which enlisted the general public it addressed as its subject rather than its object. The logic of this transformation is best seen in the respects in which the development of the museum and the prison criss-cross one another in the early nineteenth century – but as histories running in opposing rather than, as Crimp suggests, parallel directions. Thus, if in the eighteenth century the prison is a relatively permeable institution effecting an incomplete enclosure of its inhabitants, its nineteenth-century development takes the form of its increasing separation from society as punishment – now severed from the function of making power publicly manifest – is secreted within the closed walls of the penitentiary. The course of the museum's development, by contrast, is one of its increasing permeability as the variety of restrictions placed on access (when granted at all) – people with clean shoes, those who came by carriage, persons able to present their credentials for inspection – are removed to produce, by the mid-nineteenth century, an institution which had migrated from a variety of private and exclusive spheres into the public domain.

The place of the two institutions in the history of architecture underlines this inverse symmetry of their respective trajectories. Robin Evans has shown how, while there was no distinctive prison architecture before 1750, the next century witnessed a flurry of architectural initiatives oriented to the production of the prison as an enclosed space within which behaviour could be constantly monitored; an architecture that was causal in its focus on the organization of power relations within the interior space of the prison rather than emblematic in the sense of being concerned with the external display of power (Evans 1982). Museum architecture was comparably innovative over

the same period, witnessing a spate of architectural competitions for the design of museums in which the emphasis moved progressively away from organizing enclosed spaces of display for the private pleasure of the prince, aristocrat or scholar and towards an organization of space and vision that would allow museums to function as instruments of public instruction (Seling 1967).

Nor, in thus passing one another like ships in the night, are the museum and the penitentiary oblivious of the fact. When Millbank Penitentiary opened in 1817, a room festooned with chains, whips and instruments of torture was set aside as a museum. The same period witnessed an addition to London's array of exhibitionary institutions when, in 1835, Madame Tussaud set up permanent shop featuring, as a major attraction, the Chamber of Horrors where the barbarous excesses of past practices of punishment were displayed in all their gory detail. As the century developed, the dungeons of old castles were opened to public inspection, often as the centrepieces of museums. In brief, although often little remarked, the exhibition of past regimes of punishment became, and remains, a major museological trope.[1] While the functioning of such exhibitions in relation to Whiggish accounts of the history of penality is clear, this trope has also served as a means whereby the museum, in instituting a public critique of the forms for the display of power associated with the *ancien régime*, has simultaneously declared its own democratic status. Thus, if the museum supplanted the scene of punishment in taking on the function of displaying power to the populace, the rhetorical economy of the power that was displayed was significantly altered. Rather than embodying an alien and coercive principle of power which aimed to cow the people into submission, the museum – addressing the people as a public, as citizens – aimed to inveigle the general populace into complicity with power by placing them on this side of a power which it represented to it as its own.

AN ORDER OF THINGS AND PEOPLES

This was not, however, merely a matter of the state claiming ownership of cultural property on behalf of the public or of the museum opening its doors. It was an effect of the new organizational principles governing the arrange-ment of objects within museum displays and of the subject position these produced for that new public of free and formal equals which museums constituted and addressed. In Hooper-Greenhill's account, the function of princely collections during the Renaissance was 'to recreate the world in miniature around the central figure of the prince who thus claimed dominion over the world symbolically as he did in reality' (Hooper-Greenhill 1989: 64). Based on the interpretative logic of what Foucault has characterized as the Renaissance *episteme*, which read beneath the surface of things to discover hidden connections of meaning and significance, such collections were

'organised to demonstrate the ancient hierarchies of the world and the resemblances that drew the things of the world together' (ibid.: 64). As, in the course of the eighteenth century, the force of the Renaissance *episteme* weakened under the weight of, again in Foucault's terms, the principles of classification governing the classical *episteme*, museum displays came to be governed in accordance with a new programme. Governed by the new principles of scientific taxonomy, the stress was placed on the observable differences between things rather than their hidden resemblances; the common or ordinary object, accorded a representative function, was accorded priority over the exotic or unusual; and things were arranged as parts of series rather than as unique items.

It is odd, however, that Hooper-Greenhill should leave off her account at this point. For the epistemic shift that most matters so far as the public museum is concerned is not that from the Renaissance to the classical *episteme* but that from the latter to the modern *episteme*. As a consequence of this shift, as Foucault describes it in tracing the emergence of the modern sciences of Man, things ceased to be arranged as parts of taxonomic tables and came, instead, in being inserted within the flow of time, to be differentiated in terms of the positions accorded them within evolutionary series. It is this shift, I suggest, which can best account for the discursive space of the public museum. The birth of the museum is coincident with, and supplied a primary institutional condition for, the emergence of a new set of knowledges – geology, biology, archaeology, anthropology, history and art history – each of which, in its museological deployment, arranged objects as parts of evolutionary sequences (the history of the earth, of life, of man, and of civilization) which, in their interrelations, formed a totalizing order of things and peoples that was historicized through and through.

The conceptual shifts which made this possible did not, of course, occur evenly or at the same time across all these knowledges. In the case of history and art history, Stephen Bann (1984) attributes the development of the two principles governing the poetics of the modern history museum – the *galleria progressiva* and the period room – to the Musée des monuments français (1795) and Alexandre du Sommerard's collection at the Hôtel de Cluny (1832), although Pevsner (1976) traces elements of the former to Christian von Michel's display at the Dusseldorf gallery in 1755. In the case of anthropology, while Jomard, curator at the Bibliothèque Royale, had argued, as early as the 1820s, for an ethnographic museum that would illustrate 'the degree of civilisation of peoples/who are/but slightly advanced' (cited in Williams 1985: 140), it was not until Pitt Rivers developed his typological system that display principles appropriate to this objective were devised. Nor was it until towards the end of the century that these principles were widely diffused, largely due to the influence of Otis Mason of the Smithsonian. Similarly, the theoretical triumph of Darwinism had little effect on museum practices in Britain until Richard Owen, a defender of Cuvier's principle of

the fixity of species, was succeeded, towards the end of the century, by William Henry Flower.[2]

When all these caveats are entered, however, the artefacts – such as geological specimens, works of art, curiosities and anatomical remains – which had been displayed cheek by jowl in the museum's early precursors in testimony to the rich diversity of the chain of universal being, or which had later been laid out on a table in accordance with the principles of classi-fication, had, by roughly the mid-nineteenth century, been wrenched from both these spaces of representation and were in the process of being ushered into the new one constituted by the relations between the evolutionary series organized by each of these knowledges. In these respects, and like their predecessors, museums produced a position of power and knowledge in relation to a microcosmic reconstruction of a totalized order of things and peoples. Yet, and as a genuinely new principle, these power–knowledge relations were democratic in their structure to the degree that they constituted the public they addressed – the newly formed, undifferentiated public brought into being by the museum's openness – as both the culmination of the evolutionary series laid out before it and as the apex of development from which the direction of those series, leading to modern man as their accom-plishment, was discernible. Just as, in the festivals of the absolutist court, an ideal and ordered world unfolds before and emanates from the privileged and controlling perspective of the prince, so, in the museum, an ideal and ordered world unfolds before and emanates from a controlling position of knowledge and vision; one, however, which has been democratized in that, at least in principle, occupancy of that position – the position of Man – is openly and freely available to all.

It is, however, around that phrase 'at least in principle' that the key issues lie. For in practice, of course, the space of representation shaped into being by the public museum was hijacked by all sorts of particular social ideologies: it was sexist in the gendered patterns of its exclusions, racist in its assignation of the aboriginal populations of conquered territories to the lowest rungs of human evolution, and bourgeois in the respect that it was clearly articulated to bourgeois rhetorics of progress. For all that, it was an order of things and peoples that could be opened up to criticism from within inasmuch as, in purporting to tell the story of Man, it incorporated a principle of generality in relation to which any particular museum display could be held to be partial, incomplete, inadequate. When contrasted with earlier absolutist or theocratic spaces of representation – spaces constructed in relation to a singular controlling point of reference, human or divine, which does not claim a representative generality – the space of representation associated with the museum rests on a principle of general human universality which renders it inherently volatile, opening it up to a constant discourse of reform as hitherto excluded constituencies seek inclusion – and inclusion on equal terms – within that space.

I shall return to these considerations later. Meanwhile, let me return to the question of the relations between the prison and the museum in order to clarify their respective positions within the power–knowledge relations of nineteenth-century societies. In examining the formation of the new social disciplines associated with the development of the carceral archipelago and, more generally, the development of modern forms of governmentality, Foucault stresses the respects in which these knowledges, in mapping the body with their individualizing and particularizing gaze, render the populace visible to power and, hence, to regulation. While the various exhibitionary knowledges associated with the rise of the museum similarly form part of a set of power–knowledge relations, these differ in both their organization and functioning from those Foucault is concerned with. If the orientation of the prison is to discipline and punish with a view to effecting a modification of behaviour, that of the museum is to show and tell so that the people might look and learn. The purpose, here, is not to know the populace but to allow the people, addressed as subjects of knowledge rather than as objects of administration, to know; not to render the populace visible to power but to render power visible to the people and, at the same time, to represent to them that power as their own.

In thus rhetorically incorporating an undifferentiated citizenry into a set of power–knowledge relations which are represented to it as emanating from itself, the museum emerged as an important instrument for the self-display of bourgeois-democratic societies. Indeed, if, in Foucault's account, the prison emblematizes a new set of relations through which the populace is constituted as the object of governmental regulation, so the museum might serve as the emblem for the emergence of an equally important new set of relations – best summarized in Gramsci's conception of the ethical state – through which a democratic citizenry was rhetorically incorporated into the processes of the state. If so, it is important to recall that Gramsci viewed this as a distinguishing feature of the modern bourgeois state rather than a defining attribute of the state as such. Whereas, he argues, previous ruling classes 'did not tend to construct an organic passage from the other classes into their own, i.e. to enlarge their class sphere "technically" and ideo-logically,' the bourgeoisie 'poses itself as an organism in continuous movement, capable of absorbing the entire society, assimilating it to its own cultural and moral level' (Gramsci 1971: 260). It is in this respect, he contends, that the entire function of the state is transformed as it becomes an educator. The migration of the display of power from, on the one hand, the public scene of punishment and, on the other, from the enclosed sphere of court festivals to the public museum played a crucial role in this transforma-tion precisely to the degree that it fashioned a space in which these two differentiated functions – the display of power to the populace and its display within the ruling classes – coalesced.

THE MUSEUM AND PUBLIC MANNERS

Yet this is only half the story. For however much it may have aimed at promoting a mixing and intermingling of those publics – elite and popular – which had hitherto tended towards separate forms of assembly, the museum also served as an instrument for differentiating populations. In doing so, moreover, it too formed a part of the emergence of those techniques of regulation and self-regulation Foucault is concerned with whereby the behaviour of large populations is subject to new forms of social management. To appreciate the respects in which this is so account must be taken of the emergence of new technologies of behaviour management which allowed museums to offer a technical solution to the problem that had always plagued earlier forms for the display of power with their attendant risks of disorder. An examination of these issues will also serve to show how, in spite of its formally addressing an undifferentiated public, the practices of the museum served to drive a wedge between the publics it attracted and that recalcitrant portion of the population whose manners remained those of the tavern and the fair.

Foucault describes well enough the risks of disorder associated with the scene of punishment: 'on execution days,' he writes, 'work stopped, the taverns were full, the authorities were abused, insults or stones were thrown at the executioner, the guards and the soldiers; attempts were made to seize the condemned man, either to save him or to kill him more surely; fights broke out, and there was no better prey for thieves than the curious throng around the scaffold' (Foucault 1977: 63). David Cooper, noting the fairlike atmosphere of public executions, paints a similar picture for late-eighteenth century England by when, of course, the fair itself had become the very symbol of popular disorder: in 1817, for example, Bartholomew Fair, suspected of being a breeding ground for sedition, was attacked by four regiments of horse.[5] If the birth of the prison, in detaching punishment from the public scene, was one response to the problem, the birth of the museum provided its complement. Detaching the display of power – the power to command and arrange objects for display – from the risk of disorder, it also provided a mechanism for the transformation of the crowd into an ordered and, ideally, self-regulating public.

This is not to say that it immediately presented itself in this light. To the contrary, in the British context, the advocates of public museums had to fight hard against a tide of influential opinion which feared that, should museums be opened to the public, they would fall victim to the disorderliness of the crowd. In conservative opinion, images of the political mob, the disorderly crowd of the fair, or of the drunk and debauched rabble of the pub or tavern were frequently conjured up as interchangeable spectres to suggest that opening the doors of museums could only result in either the destruction of their exhibits or the desecration of their aura of culture and knowledge by

unseemly forms of behaviour. We know well enough from the literature on rational recreations that, in reforming opinion, museums were envisaged as a means of exposing the working classes to the improving mental influence of middle-class culture. However, the point I want to stress here concerns the respect in which, conceived as antidotes to the forms of behaviour associated with places of popular assembly, museums were also regarded as instruments capable of inducing a reform of public manners – that is, of modifying external and visible forms of behaviour quite independently of any inner mental or cultural transformation.[4]

The museum, that is to say, explicitly targeted the popular body as an object for reform, doing so through a variety of routines and technologies requiring a shift in the norms of bodily comportment. This was accomplished, most obviously, by the direct proscription of those forms of behaviour associated with places of popular assembly by, for example, rules forbidding eating and drinking, outlawing the touching of exhibits and, quite frequently, stating – or at least advising – what should be worn and what should not. In this way, while formally free and open, the museum effected its own pattern of informal discriminations and exclusions. Perhaps more distinctive, however, was the constitution of the museum – alongside public parks and the like – as a space of emulation in which the working classes, in being allowed to commingle with the middle classes in a formally and undifferentiated sphere, could learn to adopt new forms of behaviour by imitation. Supporters of the exhibitions held in the Leeds Mechanics Institute thus likened their pedagogic benefits to those of public walking areas whose virtue, according to one contemporary, was to promote 'a gentle and refined restraint' which 'keeps boisterous pleasure within bounds; and teaches the graceful art of being gay without coarseness and observing the limits which separate sport from riot' (cited in Arscott 1988: 154). In this way, through offering a space of 'supervised conformity', the museum offered a context in which new forms of behaviour might, in being internalized, become self-acting imperatives.[5]

In these respects, the museum constituted not merely a culturally differentiated space but the site for a set of culturally differentiating practices aimed at screening out the forms of public behaviour associated with places of popular assembly. The same end was achieved by the development of new architectural means of regulating the function of spectacle. In his essay 'The Eye of Power', Foucault argues that, as architecture ceases to be concerned with making power manifest, it comes, instead, to serve the purpose of regulating behaviour by means of new organizations of the relations between space and vision – the one-way, hierarchically organized system of looks of the penitentiary, for example, or the focusing of the pupil's gaze on the person of the teacher in popular schooling (Foucault 1980b). While, in their imposing exteriors, nineteenth-century museums retained an emblematic architectural function, changes in their internal architecture instituted a new set of relations between space and vision in which the public could not only

see the exhibits arranged for its inspection but could, at the same time, see and be seen by itself, thus placing an architectural restraint on any incipient tendency to rowdiness.

To foreground the point: the 1830s witnessed an inquiry into the administration of ancient monuments in Britain. A major finding of this inquiry concerned the impossibility of arranging for the effective surveillance of the public in buildings like Westminster Abbey which contained so many nooks and crannies that it was commonly used as a public urinal.[6] The museum's precursors, designed to admit only carefully selected publics, suffered from the same problem. Consisting, often, of myriad small rooms cluttered with objects they did not lend themselves to the task of regulating the conduct of a large and unscreened public. The architectural sources which fuelled the development of nineteenth-century exhibitionary institutions are many and various: shopping arcades, railway stations, conservatories, market halls and department stores to name but a few.[7] However, three general principles can be observed, all of which came together for the first time in the Crystal Palace in ways which exerted a decisive influence on the subsequent development of exhibitionary architecture: first, the use of new materials (cast-iron and sheet glass) to permit the enclosure and illumination of large spaces; second, the clearing of exhibits to the sides and centres of display areas, thus allowing clear passageways for the transit of the public, and breaking that public up from a disaggregated mass into an orderly flow; and, third, the provision of elevated vantage points in the form of galleries which, in allowing the public to watch over itself, incorporated a principle of self-surveillance and hence self-regulation into museum architecture. In thus allowing the public to double as both the subject and object of a controlling look, the museum embodied what had been, for Bentham, a major aim of panopticism – the democratic aspiration of a society rendered transparent to its own controlling gaze.[8]

Of course, this is not to gainsay Hooper-Greenhill's contention that the museum has functioned as an instrument of discipline, nor the fact that the museum was and remains a space of surveillance in the more obvious sense that the behaviour of the public is monitored by security staff or television. These, however, form only one aspect of the museum's organization of the relations between space and vision which, in affording the public a position of self-inspection, has allowed it to function – in its own right and directly – as an agent for both establishing and policing norms of public conduct. It is, moreover, in this respect, rather than in view of its ideological influence, that the specific form of hegemony promoted by the museum can best be deciphered. Barry Smart, in preferring a Foucaultian conception of hegemony to a Gramscian one, argues that, for Foucault, hegemony is to be understood as a form of social cohesion achieved by various ways of programming behaviour rather than through the mechanisms of consent which Gramsci posits (Smart 1986). The museum, viewed as a technology of behaviour management, served to organize new types of social cohesion precisely

through the new forms of both differentiating and aligning populations it brought into being. Its functioning in this respect, however, needs to be viewed in a comparative light in order to appreciate the distinctive economy of its effort. If, as has been suggested earlier, the prison served the purpose of depoliticizing crime by detaching a manageable criminal sub-class from the rest of the population, the museum provided its complement in instilling new codes of public behaviour which drove a wedge between the respectable and the rowdy.

In his discussion of the schemes of late eighteenth-century penal reformers, Foucault notes the respects in which punishment, conceived as 'a Garden of the Laws that families would visit on Sundays', was intended to provide a programme of instruction in civic ethics (Foucault 1977: 111). In the event, however, as punishment was withdrawn from the public scene, it was increasingly the museum that was conceived as the primary instrument of civic education. As such its function was a normalizing one. This was partly a matter of what it had to show and tell in constructing a norm of humanity – white, bourgeois and male – whose normative status was reinforced by the display of all manner of deviations: of the 'underdeveloped' crania of Aborigines at the Pitt Rivers Museum, for example, or elsewhere, of the allegedly peculiar crania of criminals. But it was also a matter of normalizing the visitor directly through the influence of a machinery for the regulation of behaviour. Thus when Henry Cole praises the museum for its educative potential, it is worth noting what he regards as its chief lesson. 'It would teach the young child', he writes, 'to respect property and behave gently' (Cole 1884: 356). Going to a museum, then as now, is not merely a matter of looking and learning; it is also – and precisely because museums are as much places for being seen as for seeing – an exercise in civics.

THE POLITICAL-DISCURSIVE SPACE OF THE MUSEUM

The discursive space of the museum, in its nineteenth-century formation, was thus a highly complex one shaped, in the main, by two contradictions which have served to generate and fuel a field of political relations and demands peculiar to the museum form. In considering these contradictions more closely I want, in concluding, to advance a conception of museum politics which, in relating itself to these contradictions self-consciously rather than simply occupying their grooves, would aim to dismantle the space of the museum by establishing a new set of relations between the museum, its exhibits and its publics which would allow it to function more adequately as an instrument for the self-display of democratic and pluralist societies.

The first contradiction, then, that which has fuelled political demands based on the principle of representational adequacy, has consisted in the disparity between, on the one hand, the museum's universalist aspirations embodied in the claim that the order of things and peoples it shaped into being was

generally representative of humanity and, on the other hand, the fact that any particular museum display can always be held to be partial, selective and inadequate in relation to this objective. Paul Greenhalgh puts his finger on the point I'm after here when he notes, in explaining why world's fairs became such important points of focus for late nineteenth-century feminists, that 'because of their claims to encyclopaedic coverage of world culture, exhibitions could not easily exclude women in the way other institutions continually did' (Greenhalgh 1988: 174). It was, that is to say, only the museum's embodiment of a principle of general human universality that lent potential significance to the exclusion or marginalization of women and women's culture, thereby opening this up as a politicizable question. The same, of course, is true of the range of demands placed on museums on behalf of other political constituencies as the space of the museum has been subject to a constant process of politicization in being called on both to expand the range of its representational concerns (to include artefacts relating to the ways of life of marginalized social groups, for example) and/or to exhibit familiar materials in new contexts to allow them to represent the values of the groups to which they relate rather than those of the dominant culture (I have in mind, for example, Aboriginal criticisms of the evolutionary assumptions governing the display of Aboriginal remains and artefacts in natural history museums). These demands arise out of, and are fuelled by, the internal dynamics of the museum which lends them a pertinence they did not, and could not, have had in eighteenth-century cabinets of curiosities, for example, and still do not have in relation to their contemporary bowlderized versions, such as the Ripley Believe It Or Not Museums.

Yet, important though they are, there are clear limits to what can be achieved by attempts to hoist the museum on the petard of its own universalist rhetorics. Indeed, it is partly as a consequence of the host of competing political demands placed on it that the pretensions of the museum to offer a microcosmic reconstruction of the order of things in the world outside the museum's walls has been exploded from within. Given this, rather than calling the museum to task in accordance with the principle of representational adequacy – thereby generating a politics which, since its goal is unachievable, is insatiable – political effort would be better devoted to transforming the relations between museum exhibits, their organizers and the museum visitor. This is to suggest that, in addition to what gets shown in museums, attention needs also to be paid to the processes of showing, who takes part in those processes and their consequences for the relations they establish between the museum and the visitor.

Presently, to recall Hooper-Greenhill's argument, the division between the hidden space of the museum in which knowledge is produced and organized and the public spaces in which it is offered for passive consumption produces a monologic discourse dominated by the authoritative cultural voice of the museum. To break this discourse down, it is imperative that the role of the

curator be shifted away from that of the source of an expertise whose function is to organize a representation claiming the status of knowledge and towards that of the possessor of a technical competence whose function is to assist groups outside the museum to use its resources to make authored statements within it. Aspects of this reconception of the museum's function can currently be found in a handful of Australian museums which have ceded to Aboriginal peoples the right to refashion the display of Aboriginal materials in order to make their own statements on their own terms. If the space of the museum is to become more fully dialogic, and if such statements are not to be framed within – and so, potentially, recuperated by – the official voice of the museum, the principle embodied in such experiments needs to be generalized, thereby, in allowing the museum to function as a site for the enunciation of plural and differentiated statements, enabling it to function as an instrument for public debate.

The second contradiction affecting the museum, I have argued, consists in the fact that while it organized and addressed a public made up of formal equals it also served to differentiate populations via a combination of cultural markers which established it in a cultural zone clearly distinct from that of popular assemblies and regulatory technologies aimed at modifying the behaviour of the visitor. Of course, many of the initial arguments made in favour of the museum's openness were based on an assessment of the benefits that would accrue to the state via the exposure of the population to its improving influence rather than on the basis of public rights principles. None the less, it is easy to see how, by virtue of their own democratic rhetoric, museums should have become the objects of politics based on such principles. Again, however, while the requirement that they should be equally accessible to all is one that flows out of the internal dynamic of the museum, that same dynamic, in so far as the museum embodies a means for differentiating populations in accordance with the norms for conduct which it establishes, places impediments in the way of realizing this objective. Studies of museum visitors thus make it abundantly clear not only that museum attendance varies directly with such variables as class, income, occupation and, most noticeable, education, but also that the barriers to participation, as perceived by non-attenders, are largely cultural.[9] Those sections of the population which make little use of museums clearly feel that the museum constitutes a cultural space that is not meant for them – and, as we have seen, not without reason.

The political issues posed by this second contradiction, however, are complex and contradictory. For, as museums are placed under increasingly strong fiscal pressure, there is enough evidence to suggest that the mechanisms of differentiation which characterized the nineteenth-century museum are being slammed into reverse. In order to attract sufficient visitors to justify continuing public funding, they thus now often seek to imitate rather than distinguish themselves from places of popular assembly: interactive computer displays competing with video parlours, for example, 'touch and feel'

exhibits, the reconstruction of places of popular assembly as museum exhibits (pubs and cinemas, for example), modelling museum shops on the sales outlets of tourist sites. While these attempts to democratize the ethos of the museum are to be welcomed, their capacity to substantially alter the visitor profiles of museums is difficult to assess. Indeed, so long as the education system delivers a culturally differentiated population to the museum's doors, socially skewed patterns of participation can be expected to persist.

The more interesting political questions, to my mind, concern the grounds – beyond those concerning the equitable apportionment of public resources – for arguing the political desirability of more equitable patterns of access to, and use of, museums. The options, as currently posed within the museum profession, are largely polarized between populist and statist positions – the former, envisioning the museum's future as part of the leisure industry, urging that the people should be given what they want, while the latter, retaining the view of museums as instruments of instruction, argues they should remain means for lifting the cultural and intellectual level of the population. Neither position offers sufficient grounds for viewing more demotic levels of participation in museums as necessarily of any positive political value if the forms of participation remain passive. As with the political demands based on the principle of representational adequacy, those demands brought to bear on the museum on the basis of public rights principles need to be re-thought as pertaining to the right to make active use of museum resources rather than an entitlement to be either entertained or instructed.

Part II

POLICIES AND POLITICS

4

MUSEUMS AND 'THE PEOPLE'

> One can say that until now folklore has been studied primarily as a 'picturesque' element. . . . Folklore should instead be studied as a 'conception of the world and life' implicit to a large degree in determinate (in time and space) strata of society and in opposition (also for the most part implicit, mechanical and objective) to 'official' conceptions of the world.
>
> (Gramsci 1985: 189)

The issue to which Gramsci points here – that of the political seriousness attaching to the ways in which the cultures of subordinate classes are studied and represented – has assumed a particularly telling significance in connection with recent developments in museum policy in Britain. Although somewhat belatedly compared with Scandinavian countries and North America, the post-war period has witnessed a flurry of new museum initiatives – folk museums, open-air museums, living history farms – orientated towards the collection, preservation, and display of artefacts relating to the daily lives, customs, rituals, and traditons of non-élite social strata.

This development is, in its way, as significant as the legislative and administrative reforms which, in the nineteenth century, transformed museums from semi-private institutions restricted largely to the ruling and professional classes into major organs of the state dedicated to the instruction and edification of the general public.[1] As a consequence of these changes, museums were regarded by the end of the century as major vehicles for the fulfilment of the state's new educative and moral role in relation to the population as a whole. While late nineteenth-century museums were thus intended *for* the people, they were certainly not *of* the people in the sense of displaying any interest in the lives, habits, and customs of either the contemporary working classes or the labouring classes of pre-industrial societies. If museums were regarded as providing object lessons in things, their central message was to materialize the power of the ruling classes (through the collections of imperialist plunder which found their way to the Victoria and Albert Museum, for example) in the interest of promoting a general acceptance of ruling-class cultural authority.

109

The extension of the social range of museum concerns in the post-war period, then, is a new departure. Yet while, in a relative sense, it is one to be welcomed, the consequence is often as Gramsci suggests: namely to represent the cultures of subordinate social classes not in their real complexity but 'as a "picturesque" element'. As a consequence, the terms in which the ways of life of such classes are represented are often so mortgaged to the dominant culture that 'the people' are encountered usually only in those massively idealized and deeply regressive forms which stalk the middle-class imagination. There are, of course, exceptions and I shall discuss some of these shortly. First, though, an example of the processes through which museums, in portraying 'the people', also sentimentalize them.

A COUNTRYSIDE OF THE MIND: BEAMISH

Visitors to the North of England Open Air Museum at Beamish, set in the heart of County Durham, are encouraged to make the Visitor Centre their first port of call. For there, the guidebook informs, they will find 'an introduction to the North East and its people, and an explanation of what Beamish is all about' (*Beamish: The Great Northern Experience* n.d.). This explanation takes the form of a tape-slide show which offers two interacting accounts of the region's origins. One strand of the narrative, organized in terms of geological time, traces the basis of the region's fortunes to the mineral deposits laid down in the volcanic period. A second strand, concerned with the human time of the region's inhabitants, tells the story of a tough and resilient people – retrospectively regionalized through cartoon sketches of, for example, cloth-capped Iron Age settlers who, in assimilating successive waves of invasion (Roman, Viking, Yorkshire), none the less remain the same throughout all ages, the embodiments of an undiluted and unchanging regional spirit. It is the convergence of these two strands of the narrative in the nineteenth century that purports to account for the North East's unique history conceived as the product of a region blessed with plentiful mineral resources and with a people sufficiently tenacious, inventive, and, above all, canny enough to exploit its natural advantages.

A mythic story, then, and, on the face of it, a fairly innocuous one for it doesn't take itself, nor asks to be taken, too seriously. Yet its significance consists as much in how it is told as in what is said. In the early and concluding parts of the show, those which set the scene and define the terms in which the region's history is told, the commentary is carried by an impersonal narrator whose 'neutral' accent and carefully modulated tone clearly identify his voice as that of the home counties or the BBC. However, at a key point in the narrative, the point at which the region's people and its mineral resources come together in the nineteenth-century development of the North East's mining industry, this narrative voice gives way to another voice – that of the region's working classes – as the story is picked up and

110

developed in the thick Geordie accent of a fictional miner ('we call him Jonti') who tells the story of the region's industrial development as the result of 'me and me marrers' pulling together. The device is a familiar one from many television documentaries where the voice of the dominant culture is usually accorded the authoritative role while regional voices, often reduced to signs of some local quirkiness or eccentricity, occupy clearly subordinated positions. And so it is here. It is the voice of the south that is dominant in the narrative, deriving its authority not merely from its familiar BBC associations but also from its anonymity and the fact that the role accorded it is that of narrating the hard truths of geological time. It is, in short, simultaneously the voice of the dominant culture and that of impersonal truth. Jonti's voice, by contrast, is the voice of local experience. It embodies the people – but the people as envisaged within the dominant culture; as a regional folk which is as endlessly cheerful and good natured as it is enterprising and industrious. The voice of Jonti – that of a cheeky and cheerful (jaunty) Geordie chappie – is that of the regional people as 'spoken' by the dominant culture in much the same way as the voice of the 'common man' is spoken by the popular press.

In this respect, the tape-slide show does indeed prepare the visitor for the museum proper where 'the people' of the North East can be seen, and see themselves, only through the cracked looking-glass of the dominant culture. In the guidebook, Beamish states its aim as being to exhibit the factors which 'influenced the life and work of the people of the region a century ago, when the North East was in the forefront of British industrial development' (*Beamish: The Great Northern Experience* n.d.). As such, it consists of a series of linked sites (see Figure 4.1) spanning the period from (roughly) the 1790s through to the 1930s, but with the greatest emphasis falling on the late Victorian and Edwardian periods. There is a model farm dating from the late eighteenth century but restored to an approximation of its mid-nineteenth-century layout and operating conditions; a colliery meant to represent the technology and working conditions in the mining industry on the eve of the First World War; a row of pit cottages, their interiors designed and furnished to exhibit changes in the tastes and ways of life of mining families over the period from the 1890s through to 1938. The centre of a market town has also been reconstructed, complete with cobbled streets, a Co-op, pub, and bandstand – a slice of urban history from the 1830s through to the 1920s which abuts on to a country railway station restored to its 1910 condition. Archaic forms of transport (coach and horses, a tramway) connect these sites while, within them, costumed museum workers act out their parts in this constructed past by displaying traditional industrial and domestic techniques.

Undoubtedly the significance of 'the Beamish experience' consists as much in what it excludes as in what it includes. No museum can include everything, of course, but, at Beamish, there is a pattern to the exclusions which suggests that the museum embodies, indeed is committed to, an institutionalized mode

111

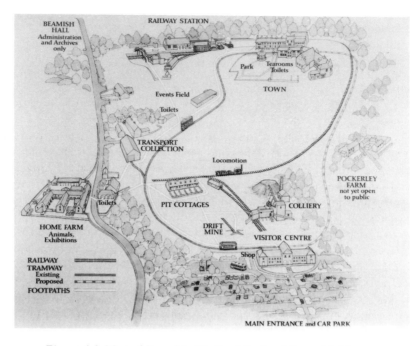

Figure 4.1 Map of Beamish, North of England Open Air Museum
Source: Beamish, North of England Open Air Museum

of amnesia. One would be hard put, for example, to find any materials relating to the history of the region's labour and trade union movements, and the activities of the women of the North East in suffrage and feminist campaigns go entirely unremarked. In short, the conception of the regional people installed at Beamish is very much that of a people without politics. Nor is this entirely a matter of the museum's absences. Many of the artefacts displayed might well have been exhibited in such a way as to suggest their associations with popular political movements. However, the tendency is for them to be severed of such associations and to serve, instead, as vehicles for the nostalgic remembrance of sentimentalized pasts. The premises of the Anfield Plain Industrial Co-operative Society, one of the major showpieces of the town centre, have thus been arranged so as to remind visitors of old pricing systems (pre-decimal), serving technologies (bacon slicers), and advertisements (the Fry's boys). No mention is made of the history of the co-operative movement, its aims and principles, or its relations to other socialist organizations. Similarly, the row of pit cottages, while showing shifts in interior decor and domestic technologies, represents these as solely concerning changes in taste rather than relating them to changing social relations within the home – changes in the sexual division of labour brought about by new domestic technologies or by shifts in the structure of the mining industry, for example.

112

None the less, important though such absences and omissions are, 'the Beamish experience' must ultimately be assessed in terms of what it *does* say rather than of what it leaves unsaid. Of crucial significance from this point of view are the respects in which the very conception of the museum as an embodiment of the region's history has been realized by bringing together buildings and artefacts from different areas of the North East. The railway station, for example, has been reassembled from the components of a number of different disused stations dating from the period of the North-Eastern Railway Company, while the town centre includes, in addition to the Co-op from Anfield Plain, a bandstand and a row of Georgian style middle class houses from Gateshead. Similarly, while the colliery buildings and much of the pit-head machinery are from the museum's immediate environs, the row of pit cottages has been brought to the site from Hetton le-Hole, near Sunderland. It is only by severing these buildings from their particular and local histories and bringing them together on the same site that Beamish is able to organize that conception of the North East as a distinctive region with a distinctive people whose interacting histories the museum then claims to realize.

Rather more significant, perhaps, is the fact that these diverse buildings and the artefacts they contain are also imagined as belonging to the same essential and unified time. And this in spite of the fact that the museum spans the period from the 1790s to the 1930s, with all the major exhibits being clearly dated. For the differentiation of times within this period impresses itself on the visitor with less force than the overwhelming sense of an undifferentiated time suggested by the museum's setting. At Beamish, everything – no matter how old it is – is frozen at the same point in time: the moment of transition from a rural to an industrial society. It matters little whether some parts of the town date from the 1830s and others from the 1920s, or whether the intereiors of the pit cottages are meant to span the period from the 1890s to the 1930s; the very fact of reconstructing these earlier industrial technologies and associated forms of social organization in the heart of the countryside has the effect of installing the visitor in a twilight zone between the rural past and the fully industrialized present. At Beamish the processes of industrialization are represented on a human and manageable scale, taking the form of little islands of industrialism and urbanism which emerge from, and yet also harmonize with, the surrounding countryside.

Not just any countryside either. The museum is set in the grounds of Beamish Hall, family home of the Shafto family until 1952 and, before that, of such notable families as the Eden family in a line of ownership traceable to the period of the Norman Conquest. Beamish Hall still stands, serving as the administrative centre of the museum and housing a further exhibition of local history artefacts. But it is also the museum's controlling ideological centre, a bourgeois country house under whose controlling gaze there is

organized a harmonious set of relationships – between town and country, agriculture and industry, for example, as well as between classes which, in occupying separate zones (the middle classes dominate the town while the working classes live by the colliery), seem to live side by side and in harmony with one another, each accepting its allotted space. The consequence is that the story of industrial development in the North East, rather than being told as one of ruptures, conflicts, and transformations, emerges as a process that is essentially continuous with the deeper and longer history of a countryside in which the power of the bourgeoisie has become naturalized. It is, in this respect, similar to the Ironbridge Gorge Museum which, as Bob West puts it, 'ironically reconstitutes a sense of the industrial through an arcane idealisation of an organic ruralism' (West 1985: 30).

Speaking of the ascendancy, in the late Victorian period, of ruralized conceptions of the 'English way of life', Martin Wiener writes:

> This countryside of the mind was everything industrial society was not – ancient, slow-moving, stable, cosy, and 'spiritual'. The English genius, it declared, was (despite appearances) not economic or technical, but social and spiritual; it did not lie in inventing, producing, or selling, but in preserving, harmonising, and moralising. The English character was not naturally progressive, but conservative; its greatest task – and achievement – lay in taming and 'civilising' the dangerous engines of progress it had unwittingly unleashed.
>
> (Wiener 1985: 6)

Beamish may boast of the North East's inventors, such as the Stephensons, and sing the virtues of its canny and industrious people. And it may claim that the North East spearheaded the processes of industrialization, leading in areas where the rest of the country would only follow later. At the same time though, and outweighing this regionalist rhetoric, Beamish succeeds in taming 'the dangerous engines of progress' in seeming to materialize the countryside of the mind of which Wiener writes and, thereby, to make actual a purely imaginary history. And yet an imaginary history whose cultural power is very considerable. Why else might it be thought that the history of a century and more of large-scale industrialization and urbanization might be adequately represented by dismantling industrial structures from their original locations and reassembling them in such a country-house setting? How else might we account for Beamish's ability to attract visitors from Gateshead and Newcastle, where the ravages of industrialization are only too readily apparent, to this constructed idyll unless, to borrow from Michel Foucault's designation of history, we recognize it as 'a place of rest, certainty, reconciliation, a place of tranquillised sleep' (Foucault 1972: 14).

114

PEOPLING THE PAST: SCANDINAVIAN AND AMERICAN FORERUNNERS

Much of this is not too surprising. As was noted earlier, Beamish forms a part of a more broadly based extension and democratization of the interests and concerns of British museums in the post-war period. Opened in the 1970s, it was the first open-air museum in England – but not in Britain: that title goes to the Welsh Folk Museum at St Fagan's which opened in 1946 – and, like most other such museums, has been deeply shaped and influenced by the earlier history of this museum form. The first such museum was opened by Artur Hazelius at Skansen, near Stockholm, in 1891. Consisting of re-assembled farm buildings, a manor house, craft industries, a log church, stocks, whipping posts, and the like, the museum was staffed with guides dressed in folk costumes, with strolling musicians and folk dancers re-enacting traditonal customs. The popularity of the museum led to similar ones being established in other European countries in the late nineteenth and early twentieth centuries. The interest in folk culture, which developed earlier in Scandinavian societies than anywhere else, had originally been a progressive phenomenon, a part, as Peter Burke puts it, of 'a movement of revolt against the centre by the cultural periphery of Europe; part of a movement, among intellectuals, towards self-definition and liberation in regional or national terms' (Burke 1977: 145). By the end of the century, however, Michael Wallace suggests that this interest in folk culture had degenerated into a form of a backward-looking romanticism:

> The Skansen movement blended romantic nostalgia with dismay at the emergence of capitalist social relations. As the new order had intro-duced mechanised mass production, a burgeoning working class, and class conflict, these museums, often organised by aristocrats and professionals, set out to preserve and celebrate fast disappearing craft and rural traditions. What they commemorated, and in some degree fabricated, was the life of 'the folk', visualised as a harmonious population of peasants and craft workers.
>
> (Wallace 1981: 72)

And worse was to come when, in the 1920s and 1930s, the open-air museum form was transplanted to American soil. Throughout the greater part of the nineteenth century, the USA's élites had displayed comparatively little interest in the development of museums or the preservation of historic sites. Moreover, such interest as there was came largely from representatives of the older American families whose wealth derived from inherited land, mercant-ile activities, or the early phases of industrial development. Indeed, many of the leading organizations in the preservationist lobby – the Daughters of the American Revolution (DAR), for example – explicitly required that their members be able to trace their descent to one of the early colonists.[2] If the

115

representatives of corporate capital, the real driving force in the American economy in the late nineteenth century, displayed relatively little interest in questions of museum and heritage policy, this was partly because such matters had been colonized by the USA's patrician élites in ways which were clearly intended to exclude the vulgarity of the *nouveau riche*. But it was also because a disinterest in, even disdain for, the past could find strong support in those elements of the American republican tradition which contended that, just as the USA had been founded through a series of breaks with the past, so it could continue to be true to itself, to its own dynamic essence, only if it continually regarded the past as fit only for the rubbish dump of history rather than as something to be fetishized and memorialized. Nathaniel Hawthorne summarized this view nicely when, in 1862, he recorded his reflections prompted by a visit to the Warwickshire village of Witnash:

> Rather than the monotony of sluggish ages, loitering on a village green, toiling in hereditary fields, listening to the parson's drone lengthened through centuries in the grey Norman church, let us welcome whatever change may come – change of place, social customs, political institutions, modes of worship – trusting that . . . they will but make room for better systems, and for a higher type of man to clothe his life in them, and to fling them off in turn.
>
> (Cited in Lowenthal 1985: 116)

Michael Wallace argues that the influence of this tradition declined appreciably in the aftermath of the First World War. So did the balance of influence within the preservationist lobby as, in the context of serious labour difficulties on the domestic front and the spectre of revolution in Europe, 'corporate capital moved to the forefront of the return to the past' (Wallace 1981: 68). It is one of the ironies of history that Henry Ford, who had earlier denounced history as bunk, was a prime mover in these developments and, in Greenfield Village, opened in 1929, was responsible for one of the first open-air museums in the USA – yet one which significantly transformed this hitherto exclusively European genre, just as it also embodied a break with the priorities of earlier American preservationist organizations. Wallace conveys something of this dual transformation of earlier museum forms effected by Greenfield Village in his discussion of the kind of 'peopling of the past' embodied in this imaginary township of yesteryear:

> Ford's Greenfield Village can best be understood as an Americanised Skansen. Ford celebrated not 'the folk' but the Common Man. He rejected the DAR's approach of exalting famous patriots and patrician élites. Indeed, he banished rich men's homes, lawyers' offices, and banks, from his village. This museum-hamlet paid homage to blacksmiths, machinists, the frontier farmers, celebrated craft skills and domestic labour, recalled old social customs like square dancing and

folk fiddling, and praised the 'timeless and dateless' pioneer virtues of hard work, discipline, frugality, and self-reliance. It was a pre-capitalist Eden immune to modern ills, peopled with men and women of character.

(Wallace 1981: 72)

But it was an Eden destined to develop beyond itself, and for the better, inasmuch as the village also contained an Industrial Museum which, in celebrating the inventions of men of genius, supplied the mechanism of development through which the idyllic past embodied in the rest of the village had since been improved on. In this way, Wallace suggests, Greenfield Village had it both ways in offering a vision of 'the good old days' since when, due to capitalist progress, things have only got better. 'The two messages together', as Wallace puts it, '– life had been better in the old days and it had been getting better ever since – added up to a corporate employer's vision of history' (ibid.: 73).

The message of Beamish is much the same, except that the engines of progress are attributed to the qualities of the region's people rather than being portrayed as the fruits of individual genius and, rather than being housed in a separate museum, are dispersed throughout the site, seeming to grow naturally out of the countryside. And this, as we have seen, is not just any countryside but that distinctively bourgeois countryside of the mind in which the present emerges uninterruptedly from a past in which the presence and leading role of the bourgeoisie is eternally naturalized. This ability to transform industrialism from a set of ruptural events into a mere moment in the unfolding of a set of harmonious relations between rulers and people may well turn out to be a distinctively English contribution to the development of the open-air museum form.

In brief, then, there are grounds for caution regarding the effects of the more demotic and socially expansive orientation towards the past that has been evident in post-war museum policy. And this in spite of the arguments often advanced in its favour – that it has at least acknowledged the importance of the everyday lives of ordinary working people. For while *what* is shown in museums is important, the question of *how* museum artefacts get displayed and represented – and thus of what they are made to mean – is at least as significant. From this perspective, if Beamish is anything to go by, the development of museums concerned primarily with artefacts relating to the daily lives and customs of 'ordinary people' has resulted in a 'peopling of the past' in which the cultures and values of non-élite strata are subordinated to bourgeois culture and values just as effectively as they are in the great public museums which developed in the nineteenth century. However, this subordination is wrought rather differently, the result of a different ideological economy and one which, perhaps, has a greater capacity for organizing the visitor's experience precisely to the degree that it is more likely to pass unnoticed.

In the nineteenth-century museum the cultures of subordinate classes were – and largely still are – a simple absence, excluded not only as a matter of definition (the working classes were not regarded as having a culture worthy of preservation) but also as a matter of deliberate policy (of 'improving' the people by exposing them to the beneficial influence of middle-class culture). To visit institutions like the Victoria and Albert is, accordingly, to experience and witness the power of the ruling culture, a power which manifests itself precisely through its ability to exclude everything which, through its exclusion, is defined as other and subordinate. There is, as a consequence – at least for most of us – nothing familiar which might help us to relax and feel at home there. However, if we know that we are out of our place, we also know that this effect is not accidental, that we are in the midst of an object lesson in things which, in some measure, instructs through its capacity to intimidate.

Beamish by contrast, works on the ground of popular memory, and restyles it. In evoking past ways of life of which the visitor is likely to have had either direct or, through parents and grandparents, indirect knowledge and experience, the overwhelming effect is one of an easy-going at-homeness and familiarity. At the same time, though, what one is at home with has, so to speak, been shifted elsewhere through the specific political and ideological associations which are lent to those remembered pasts by means of the rhetoric – the countryside of the mind – which governs the ways in which a past is selectively recalled and reconstructed. Of course, there is no reason to suppose that each and every visitor will consent to this restyling of popular memory, or experience it without some feeling of unease or contradiction. For the ground of popular memory – that is, of the institutions which organize the terms in which the past is most commonly perceived and 'remembered' – is not an even one. If Beamish works along with certain dominant modes of styling a sentimentalized past (a visit to the museum is a bit like spending a day as an extra in an episode of *When the Boat Comes In*), the traditions of labour, trade union, and feminist history provide resources which, if the visitor is so minded, might be called on to resist the lure of that past. Nor is the text of the museum entirely without contradictions of its own. It has its cracks, some of them occurring at the level of those practices which are least susceptible to planned control: the conduct of museum workers. For example, when I last visited Beamish the carefully contrived illusion of an authentic historical milieu (see Figure 4.2) was nicely undercut by a costumed museum worker who, in the midst of demonstrating traditional techniques of bread-making in a carefully reproduced pit-cottage kitchen, chatted with a colleague on Dennis Norden's performance in the previous evening's episode of *It'll Be Alright on the Night*.

However, these are general points that might be made in relation to any museum or, indeed (for this is how I am suggesting we should regard museums), any text. And, however valid they might be, their implications are

118

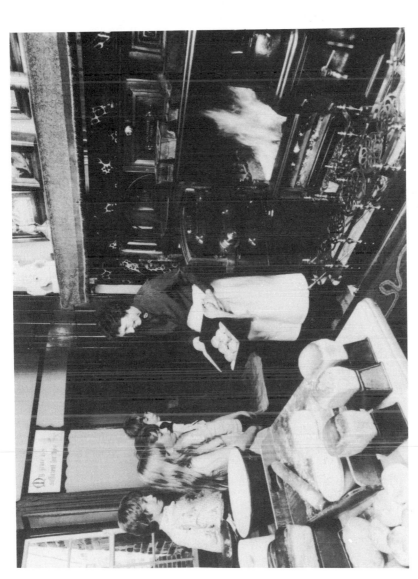

Figure 4.2 Demonstrators at the pit cottages, Beamish Museum, do routine cleaning and demonstrate breadmaking and rugmaking
Source: Beamish, North of England Open Air Museum

limited. No matter how true it might be that the ideal text of Beamish may be disrupted by its performers or that visitors may read against the grain of that text, it remains the case that the museum exemplifies a deeply conservative 'peopling of the past' in which the legacy of earlier moments in the development of the open-air museum form is readily apparent. Equally, though, this is not to suggest that the same result necessarily follows whenever and wherever museums concern themselves with the preservation and display of materials relating to the daily lives and customs of 'ordinary people'. While a conservative romanticism may be strongly associated with such practices historically, this connection is not an intrinsic or necessary one. It can be and, in view of the increasing popularity of 'museuming' as a leisure activity, needs to be broken.[3] The realization of such an objective on any significant scale would, of course, be dependent on changes in the structures of control over museums and a radical reorganization of their relations to different groups in the community. To pursue these questions properly would require another article. However, something of their significance can be gleaned from a brief consideration of two museums – Hyde Park Barracks in Sydney and People's Palace in Glasgow – which have been clearly committed to the project of producing other peoples and other pasts free from those socially dominant forms of the sentimentalization of the people which have plagued the development of open-air museums, folk museums, and the like.

OTHER PEOPLES, OTHER PASTS

According to the official guide

> The Hyde Park Barracks presents a social history of New South Wales. Rather than a history of great individuals, it is a history of people's everyday lives and experiences. The exhibitions cover two centuries of Australian social life: people celebrating, immigrating, coming to town for the show, building homes, living in the Barracks.
>
> (*The Mint and the Hyde Park Barracks* 1985: 16)

Like Beamish, then, a museum concerned with the everyday lives of ordinary people. Unlike Beamish, however, those people are not reduced, to recall Gramsci's terms, to being 'a picturesque element'. Located in the centre of Sydney, Hyde Park Barracks is concerned mainly to recall and commemorate moments in the popular history of that city. 'The people' represented in the museum is thus primarily an *urban people* and one that is in good measure defined in opposition to 'official conceptions of the world'.

This aspect of the museum is most conspicuous in the display 'Sydney Celebrates' which, in exhibiting materials relating to the public celebrations through which the city's history is conventionally punctuated, systematically undercuts and disavows the consensualist rhetoric which formed a part of

those celebrations and has governed the terms in which they have since been represented within official discourse. This is achieved partly by drawing attention to those groups which were excluded, or excluded themselves, from those celebrations. The text accompanying the materials relating to the celebrations in 1938 of the 150th anniversary of Australia's European settlement thus notes that floats depicting convict life or the activities of trade unions were banned from public parades in the city in the interests of representing Australian history as a process free from bitterness and conflict. More tellingly, the text also informs us that 26 January 1938 the anniversary of the founding of the first European settlement at Port Jackson – was also chosen as the date for a Day of Mourning Conference organized by Aboriginal leaders. Similarly the section of the display relating to the opening of Sydney Harbour Bridge in 1932 – a public celebration in which there was an unusually heightened degree of popular participation owing to the vital role the bridge's construction had played in the city's working-class economy – stresses the deep social divisions of the depression years. In further noting that the Labor government of New South Wales had declined to invite a representative of the royal family to open the bridge on the grounds that there were more pressing claims on the public purse, an anti-colonialist edge is lent to the pro-working-class sentiments which animate the display.

In these respects, then, the exhibition of artefacts relating to popular involvement in the city's public culture is informed by a conscious political didactic. The same is true of some of the other main displays. In the room devoted to the theme 'Bound for Botany Bay', for example, the story of successive waves of immigration to Australia is told by means of a series of individual narratives selected for their typicality and organized to promote critical reflection on the relations between past and present social conditions. Thus the story of the period of transportation is told so as to stress the similar relationships between unemployment and rising crime rates in nineteenth-century Britain and contemporary Australia.

In sum, Hyde Park Barracks not only differs from Beamish at the obvious level of its content, but also manifests and embodies a different way of conceiving and representing a people and their history. In part, no doubt, these differences reflect the different gestation periods for the two museums and, related to this, the different kinds of curatorial inputs which conditioned their development. The initial planning phase for Beamish occupied the period from 1958 to 1971 with the responsibility for collecting and arranging materials relating to the cultural lives of the popular classes being allocated to folk-life assistants at a time when, in Britain, the tradition of folk-life studies was (and remains) deeply influenced by romantic conceptions of the people as parts of a picturesque landscape (*Beamish One* 1978). Hyde Park Barracks, by contrast, was transformed into a museum over the period 1979–84, a period of renewed vigour in Australian historical scholarship owing to the challenges of important new work in labour, feminist, and

Aboriginal history – intellectual currents which fed into the conception of and planning for the museum via the emphasis that was placed on social history as its main curatorial focus.

A fuller appreciation of the distinctiveness of Hyde Park Barracks and an assessment of its significance within the Australian context, however, requires that it be viewed in the light of both adjacent and earlier developments in Australian museum policy. For the fact that the museum is concerned with *Australian* social life is at least as significant as its orientation towards the everyday habits and customs of the ordinary citizen. Or rather, its significance consists in its combination of these two points of focus. For in being concerned with the everyday lives of ordinary people who, in being identified as Australian, are thereby also distinguished from and opposed to colonial conceptions of Australia as an outpost of the British empire, Hyde Park Barracks materializes and makes present what had been conspicuously absent from earlier Australian museums: the sense of a national people with an autonomous history.

This was commented on when, in the 1930s, the Carnegie Corporation commissioned a survey of Australian museums. The resulting report, published in 1933, drew particular attention to the relative lack of interest evinced by Australian museums in the collection and display of materials relating to the history of the continent's European settlement. Only three museums, it was observed, were given over entirely to aspects of post-settlement history – and one of these, the Australian War Memorial, was not officially opened until 1941. Nor was post-settlement history particularly well represented in other museums, and least of all those aspects of Australian history relating to the lives of ordinary Australians. The authors of the report thus remarked particularly on the fact that 'in no museum are there reproductions of the buildings occupied by the earlier settlers', regarding this as 'one of the most notable gaps in the whole of the existing museum collections' (Markham and Richards 1933: 44). Yet museums had been established in Australia from as early as the 1820s and, by the 1930s, many of them had built up impressive geological and natural history collections as well as extensive collections of Aboriginal relics and cultural artefacts (Kohlstedt 1983).

Why, then, should the period since 1788 have seemed so devoid of interest to museums? A part of the answer consists in the disciplinary specialisms (usually geology or biology) of their curators. However, this in itself was merely a symptom of a deeper cultural problem: the perception, owing to the predominance of Eurocentric conceptions, that Australia, a fledgling among the nations of the world, had no history that was worthy of preservation, display, or commemoration. This was less true of the 1930s than it had been of the late nineteenth century when, at least to the members of the colonial bourgeoisie, it had seemed that the post-settlement period did not furnish the kind of raw materials out of which a past could be forged which could claim sufficient dignity and solemnity to vie with the European pasts which

supplied their point of cultural reference in such matters.[4] Compared with the British national past – a past, as materialized in public ceremonials and museums, organized primarily around the deeds of monarchs, military heroes, and great statesmen – the activities of the early colonists (the convicts, the marines who policed them, later settlers, gold diggers, bush-rangers) seemed lacking in substance of a similar kind.

It's not surprising, given this background, that the first museum to be conceived as a national institution and to devote itself entirely to the history of the post-settlement period should have been the Australian War Memorial. In its remembrance of the heroism of Australian troops in Europe and the Middle East (the theatres of 'real history'), this institution – intended as both a museum of the nation's military history and a shrine to its war dead – enabled there to be figured forth and materialized an Australian past which could claim the same status, weight, and dignity as the European pasts it so clearly sought to emulate and surpass.[5]

What is perhaps rather more surprising is the fact that the War Memorial is still the only fully national museum in Australia and will remain so until the Museum of Australia opens in 2001. This will constitute a significant moment in the development of Australian museum policy, particularly as one of its three main galleries will be devoted to the post-settlement period. It is important, however, to view the development of this museum in a broader perspective. For its opening will constitute merely the culmination and most visible manifestation of a protracted phase in the development of Australian museum and, more generally, heritage policy, in which the earlier lack of interest in the preservation and display of materials relating to the post-settlement period has been significantly reversed. Apart from the marked increase in the degree of importance accorded these overlapping areas of cultural policy, both have manifested a similar commitment to the production and organization of a more clearly autonomized Australian past, one which, by severing the ties of dependency through which (although always with some degree of ambivalence and tension) the Australian past had earlier been associated with the longer past of the British state, stands more clearly on its own.

The legislative peaks of these developments are soon summarized: the establishment of the Australian Council of National Trusts in 1967; the establishment of a Committee of Inquiry into the National Estate in 1973 leading, in 1976, to the enactment of the Australian Heritage Bill and the subsequent compilation of a register of protected properties; and, finally, the establishment, in 1974, of a Committee of Inquiry on Museums and National Collections with, as its most significant legislative outcome, the Museum of Australia Act, 1980. This is, by any standards, a quite exceptionally concentrated rush of legislative activity aimed at increasing the scope of those spaces, buildings, and artefacts which are officially zoned as belonging to the past while, at the same time, nationalizing that past.

Moreover, and as distinct from the situation in Britain where the politics of conservation and those of conservatism too often go hand in hand, anathematizing both past and present alike, the greater part of the impetus for these developments has been supplied by Labor administrations. And by Labor administrations backed by a fairly strong groundswell of popular support for their heritage policies which, in general terms, evinced a clear commitment to increasing the presence of the past within the public domain while simultaneously nationalizing and democratizing its associations. The inquiries referred to above were thus all inaugurated in the Whitlam years and fuelled by the 'new nationalism' of that period. Indeed the willingness of Labor administrations, state and federal, to preserve historic sites from threatened destruction by developers served as a key emblem of this 'new nationalism' and its commitment to representing the interests of 'all Australians' against what were seen as the socially and environmentally destructive activities of both international corporations and domestic elites. Nor was it merely at the level of governmental policies that this rhetoric was enunciated and put into practice. The campaigns, in the early 1970s, of residents' action groups to save historic sites and buildings threatened by inner-city development projects and the support offered those campaigns by the Builders Laborers Federation in banning work on the sites in dispute are the best indices of the degree to which the issue of conservation had acquired popular and democratic associations (Nittim 1980).

It was against the immediate political context of these campaigns that the decision to transform Hyde Park Barracks into a museum of the city's social history was taken. Initially a convict dormitory from its opening in 1819 to 1848, when the era of transportation drew to a close, the building subsequently served a variety of functions (a reception centre for female immigrants and a lunatic asylum, for example) as well as housing a range of government offices (the Vaccine Institute and Inspector of Distilleries, for instance) until the 1960s when, together with the adjacent Royal Mint, it too was threatened with demolition as part of inner-city development schemes. The decision to preserve the building and open it to the public as a museum was clearly a response to both the campaigns of local resident action groups and the strong support these had received at the federal level.[6]

It would, however, be a mistake to posit too direct or immediate a connection between this originating political context and the orientation to the past that has since been materialized in the museum itself. There are too many intervening variables for this to be credible. Moreover, the text of the museum itself is an uneven and contradictory one. The influence of different curatorial visions is readily discernible as one moves from one room to another. While those I have briefly outlined manifest an intention to disrupt and call into question socially dominant conceptions of the past, there are others of which this is not true. The room devoted to changing styles in domestic architecture, for example, fails just as signally as do the pit cottages

124

at Beamish to suggest any critical perspectives on changing social relations within the home.

Perhaps the most disappointing aspect of the museum, however, consists in the degree to which it conceives and represents the social and cultural history of the city as something distinct from, and having no organic connections with, its political history. While thus evoking popular cultures and ways of life, these are not connected to any political traditions or constituencies. At least, not except as a movable feast. When the Barracks first opened as a museum, one of the temporary exhibition rooms was given over to a display of trade-union banners and other mementoes of the city's labour movement. The subsequent removal of this display, and, to date, the failure to replace it with displays of an equivalent kind, has profoundly altered the whole ideological economy of the Barracks in depriving it of a point of political reference to which the representations of popular customs, traditions, and ways of life might be connected and thus be lifted above what often remains a level of purely anecdotal significance.

This point can be underlined by means of a brief contrast with the People's Palce in Glasgow, an institution which altogether justifies the claim of its present curator that there 'is no museum, gallery, arts or community centre quite like it anywhere else in the world' (King 1985). It was exceptional in its conception as housing under one roof a museum, picture gallery, winter garden, and musical hall, a place of both popular instruction and popular entertainment. It has been exceptional, as a museum, in having had the good fortune to be administered since its opening in 1898 by a city corporation with one of the longest and strongest traditions of municipal socialism in Europe. It is also exceptional in its location as the focal point of Glasgow Green, an important centre of Glasgow's popular culture – the place where the Glasgow Fair was held and where, now, the annual People's Marathon both starts and ends – as well as of its socialist and feminist political cultures (the place where Glasgow's trade union movement began, where suffrage marches started from, where anti-conscription campaigns were launched). But it is perhaps most exceptional in the degree to which, as a museum of the city's history, it represents that history primarily in the form of a set of deeply interacting relations between, on the one hand, the ways of life and popular entertainments of ordinary Glaswegians and, on the other hand, their political traditions. Nor, moreover, is this done didactically by means, for instance, of separate rooms or displays devoted to the political history of the city. Rather, and more often than not in an understated way, political traditions and concerns are injected into the very tissue of everyday life, in the spheres of work and leisure, by exhibiting artefacts relating to political campaigns side by side with those illustrating facets of the history of sport in the city or the development of different forms of domestic space.

There is, in other words, a clear attempt to connect a way of life to a way of politics, and in ways which suggest continuities between past and present

125

political struggles. Displays of old fashioned tobacconists and cinema foyers; the history of the local press; displays of tenement interiors depicting the history of housing conditions in the city; photographic displays of local strikes from the 1920s to the 1980s; an exhibition of local artists' depictions of the events, characters, and leaders of the 1984 miners' strike; pro-suffragette playing cards; accounts of the 1930s unemployment rallies side by side with salutes to local soccer heroes; exhibiting John MacLean's desk in the same room as Billy Connolly's banana boots – the juxtaposition of these different histories in such a way that their associations are carried over into one another conveys the suggestion of a radical political culture which grows out of and, in turn, suffuses the daily lives of ordinary Glaswegians. And of a political culture, moreover, which is – within the ideological economy of the museum – the dominant one. At the People's Palace, it is not 'the people' who are reduced to the level of the picturesque. Rather, it is ordinary Glaswegians – their culture and their politics – who supply the norm of humanity to which implicitly the museum addresses itself.

QUESTIONS OF FRAMEWORK

The development of museums in the nineteenth century was governed by the view that it would be possible to achieve 'by the ordered display of selected artefacts a total representation of human reality and history' (Donato 1979: 221). Museums, that is to say, were to arrange their displays so as to simulate the organization of the world – human and natural – outside the museum walls. This dream that the rational ordering of things might mirror the real order of things was soon revealed to be just that. Yet, both in the practices of museums and, as visitors, in our relations to them the illusion that they deal in the 'real stuff of history' persists. Few museums draw attention to the assumptions which have informed their choice of what to preserve or the principles which govern the organization of their exhibits. Few visitors have the time or inclination to look beyond what museums show them to ponder the significance of *how* they show what they show. Yet, as it has been my purpose to argue, this question of *how* is a critical one, sometimes bearing more consequentially on the visitor's experience than the actual objects displayed.

Indeed, to emphasize this point: there is relatively little difference between the types of objects displayed in the three museums I have considered, but there is a world of difference between the rhetorics governing the processes through which those objects have been assembled into particular display configurations with, as I have sought to show, significant consequences for the kinds of ideological meanings and associations likely to suggest themselves. If this calls attention to the political significance of the representational frameworks museums employ, this is not to suggest that there are not other aspects of museums equally in need of critical interrogation or that such

126

representational issues should be considered in isolation. It's clear, for example, that the question of how things get displayed in museums cannot be divorced from questions concerning the training of curators or the structures of museum control and management – very material constraints which considerably limit the room for manoeuvre of radical museum workers.

However, these are not matters which can be readily influenced on a short-term basis. Nor are they ones which it lies within the visitor's power to do much about. But, if read in the right way – as a lesson in ruling-class rhetoric rather than as an object lesson in things – even the most conservatively organized museum can be put to good use. An afternoon at Beamish can be most instructive provided that it is looked to less as providing a lesson in industrial or regional history and more as a crash course in the bourgeois myths of history.

5

OUT OF WHICH PAST?

PERSPECTIVES ON THE PAST

The past as text

In *Labyrinths*, Jorge Luis Borges imagines a modern writer, Pierre Menard, who sets out to write a few pages which would coincide – word for word and line for line – with some passages from Cervantes' *Don Quixote*. Assessing the results of this imaginary endeavour, Borges insists that while the two texts – Menard's and Cervantes' – may be verbally identical, their meanings are not the same. Although the same words are assembled in the same order, they could not help but convey different meanings by virtue of the different circumstances in which they were written and thus the different cultural horizons – those of twentieth-century France and seventeenth-century Spain – through which their significance would be inflected. Above all, Borges argues, Menard's text would be richer than Cervantes' – richer because more ambiguous, and more ambiguous because of its status as a facsimile (Borges 1970: 69).

A fanciful case, no doubt, and one whose bearing on questions of museum and heritage policy may not immediately be apparent. Yet what else do practices of historical restoration aspire to but the production of a site – a building, say, or a township – which will coincide as closely as possible, brick for brick and paling for paling, with an earlier model? And how can the outcomes of such projects avoid meaning differently from the originals to which they aspire by virtue of both the different histories which organize them and the ambiguity of their status as facsimiles? Take the post-war reconstruction of the medieval centre of Warsaw. No matter how close its resemblance to the original, the restored city centre inevitably connotes new meanings in serving as a symbol of a political and national will to efface the signs of the city's Nazi occupation (Lowenthal 1985: 291). Or, to take a case closer to home, consider the criticisms levelled against the restoration of Port Arthur. Jim Allen has argued that the reconstruction of the buildings and layout of the convict period tends towards 'the creation of moods of "relaxation and

128

tranquility"' (Allen 1976: 104–5). Not only does this travesty the original significance of the penal colony, it further serves, Allen suggests, to occlude the lessons which might otherwise have been drawn from the site had its deterioration been allowed to continue so that, precisely in its ruination, it would have provided an eloquent testimony to the failure of the convict system.

It might be thought that such examples echo too closely the nineteenth-century debates of 'scrape versus anti-scrape'.[1] Yet the situation is the same even where heritage policy aims at preserving historic sites in their current form, retaining the marks which attest to their age and usage rather than removing these to restore a site to its presumed original conditions. For the simple act of extracting a site from a continuing history of use and development means that a frame is put around it, separating that site from what it was prior to the moment of its preservation. Dedicated to a new use as, precisely, a historic site, it becomes a facsimile of what it once was by virtue of the frame – which may be as simple as a notice or as elaborate as a piece of legislation – which encloses it and separates it off from the present. Not a thing may have been removed or rearranged. None the less, the meaning is decisively altered. Much the same is true of objects placed in history museums. Although, materially, these remain as they were, they become, on the plane of meaning, facsimiles of themselves. They announce a distance between what they are and what they were through their very function, once placed in a museum, of representing their own pastness and, thereby, a set of past social relations.[2]

All of this is to say no more than that the past, as it is materially embodied in museums and heritage sites, is inescapably a product of the present which organizes it. A truism, perhaps, but one whose implications are significant. Consideration of an analogous case may help identify these. In a recent essay, Stephen Greenblatt notes that the entrance to Yosemite National Park in California is marked by a sign which establishes its status as a wilderness zone. Moreover, there are a number of provisions within the Park itself – climbing ladders, viewing points, even photographs of points of interest designed to make the Park more accessible to the visitor, as well as notices specifying prohibited forms of conduct. Greenblatt's purpose in these observations is to draw attention to the paradoxical nature of the Park's status as a wilderness. For if the Park, as wilderness, seems to be an instance of Nature, pure and undefiled, this is only because it is *publicly demarcated* as such. It exists as Nature (and thus in a relationship of implied opposition to culture and civilization) only because it is *represented* as such. The paradox here is that such representation is inevitably a product of culture. As Greenblatt puts it:

> The wilderness is at once secured and obliterated by the official gestures that establish its boundaries: the natural is set over against the artificial through means that render such an opposition meaningless.
>
> (Greenblatt 1987: 11)

The wilderness, in being represented and marked off as the site of an unspoilt Nature, is irretrievably marked by the signs of culture through the very processes by means of which its existence as wilderness is secured. No matter how strong the illusion to the contrary, therefore, what is encountered in such publicly demarcated wilderness zones is not Nature in its pristine purity or as the radical, untouched opposite of culture, but the wilderness as a *text*. Nor do such zones bear the marks of culture merely in the signs and facilities that are installed *in situ*. They are affected by culture in a host of more indirect ways ranging from the legislative frameworks and administrative procedures necessary to establish and maintain their boundaries to the literature – such as tourist brochures and heritage publications – which organizes the frames of reference and expectations of their visitors.

Similarly, the past, as embodied in historic sites and museums, while existing in a frame which separates it from the present, is entirely the product of the present practices which organize and maintain that frame. Its existence as 'the past' is, accordingly, similarly paradoxical. For that existence is secured only through the forms in which 'the past' is *publicly demarcated* and *represented* as such, with the obvious consequence that it inevitably bears the cultural marks of the present from which it is purportedly distinguished. Just as the visitor to a National Park encounters the wilderness as a culturally organized text, so the visitor to a museum or historic site is confronted with a set of textually organized meanings whose determinations must be sought in the present.

My concern in this chapter is to examine some of the textual properties informing the organization of the Australian past as it is embodied, in ways at once material and symbolic, in museums and historic sites. In doing so, I want also to argue the relevance of such considerations to the terms in which policy options are posed, resolved and implemented. Indeed, I shall argue that many of the central objectives of current museum and heritage policy – particularly those concerning questions of access and participation – cannot be cogently formulated or pursued unless such considerations are taken into account. Nor can the forms in which such policies are implemented be appropriately assessed without considering the textual properties of museum and heritage sites in relation to the varying historical cultures of different social groups.

Before coming to such specific policy concerns, however, it will be necessary to flesh out the terms of the foregoing argument more fully and outline its relevance to policy considerations in a more general way. A brief review of the history of Australian museum and heritage policy formation will then be offered in order to place current policy concerns in an appropriate context.

Reading the past: questions of theory and policy

The textual properties of museums and historic sites are many and various, and complex in their interactions. Here, by way of offering a preliminary

OUT OF WHICH PAST?

indication of the scope of the discussion, just a few might be mentioned. In the case of museums, apart from the obvious significance attaching to the nature of the artefacts selected for display, there arises a further set of questions relating to the principles governing the ways in which such artefacts are related to one another within particular display contexts. Are such artefacts classified and arranged by type or by period? Are they arranged as part of a narrative, telling a story of the relations between past and present? If so, how are such narratives organized? Do they imply a continuity between past and present? Or are past and present represented as radically dissimilar? Similar questions arise, in the case of historic sites, with regard to the choice of the period to which a site is restored or, in the case of preservation projects, at which its continued development is arrested. Take the case of the homes of prominent early settler families – Vaucluse House in Sydney, say, or Newstead House in Brisbane. Are buildings and furnishings restored to the founding years of those families' fortunes, or to the period of their most significant political and cultural influence? Then there is the question as to how the artefacts within such households should be arranged. What implications do different arrangements have for the ways in which the stories of the upstairs and downstairs members of such households are represented? And how are these different micro-narratives related to different ways of conceiving the broader political and cultural concerns of the period?

If such considerations relate to the textual properties evident in the artefactual structure of museums and historic sites, further questions are prompted by the more obviously textual forms which accompany such exhibits or which, in a more general sense, organize and demarcate the cultural frame in which they are located. This refers us not merely to the captions, videos and tape-slide shows through which artefacts are explained and contextualized; it also concerns the functions of guidebooks and souvenirs. How do these organize the visitor's expectations and/or memory of his or her tour? What conceptions of the public and of its values are suggested by the language and imagery of such publications?[3] Similar questions might be asked of the 'buffer zones' of historic sites – that is, those zones which regulate the visitor's entry to and exit from the demarcated space of the past. Finally, account has also to be taken of the broader range of cultural texts which, while not impinging directly on any particular museum or historic site, none the less significantly influence the framework of expectations and presuppositions governing the ways in which different sections of the public relate to such institutions. These range from the official publications of the Australian Heritage Commission through the activities of historical and genealogical societies to the kinds of historical representations put into general social circulation by the media in such forms as television mini-series.

In 'reading the past' as it is currently shaped and organized in the relations between these different practices, my purpose is to illustrate their consequences for the ways in which the socially demarcated zone of 'the past'

is experienced and interpreted. This does not mean, in the case of particular museum displays or historic sites, calling them to task for their failure to accurately portray the past 'as it really was'. This is not to minimize the importance of the curatorial concern to regulate historical displays by ensuring the authenticity of the materials exhibited. Rather, it is merely to note that, when such work is done, there unavoidably remains a host of detailed and separate questions regarding the *representational effects* of the considerations outlined above.

In an examination of similar issues in the British context, Michael Bommes and Patrick Wright have proposed the useful term 'public historical sphere' to refer to those institutions – from museums through national heritage sites to television historical dramas and documentaries – involved in producing and circulating meanings about the past. The practices of such institutions, they argue, need to be considered in their role in enacting 'a publicly instituted structuring of consciousness' (Bommes and Wright 1982: 266). Elaborating this argument in a subsequent study, Wright, considering the effects of different ways of representing the past, contends that 'the historiographic question of their truth or falsity is often peripheral to their practical appropriation in everyday life' (Wright 1985: 188). Similarly, the position adopted here is not that the effects of such practices of representation might be adjudicated by referring them to 'the truth of the past'. Rather, understanding *what* and *how* museums and historic sites *mean* depends on assessing their relations to, and placement within, a whole repertoire of textual conventions through which the socially demarcated zone of the past is made to connect with contemporary social, cultural and political preoccupations.

There can be few moments more timely than the present in which to raise such issues. Compared with earlier and prolonged periods of relative neglect, the period since the early 1970s has witnessed a flood of inquiries and policy initiatives in the museum and heritage areas. As a consequence, the Australian past, or public historical sphere, has expanded dramatically in quantitative terms while, at the same time, its signifying contours, or textual properties, have been significantly reshaped. Yet, except for the consideration given to questions concerning the appropriate representational contexts for the display of Aboriginal materials, most of the major governmental documents bearing on the recent development of museum and heritage policies have paid scant attention to the question of representational contexts and principles appropriate to the realization of specified policy objectives. Unsurprisingly, governmental attention has rather focused on the development of administrative arrangements appropriate to the development and management of an extended public historical sphere. Where questions concerning the nature of the past to be constructed within museums and historic sites have arisen, these have largely taken the form of a concern with content – that is, with what should be preserved and exhibited. The same is true of most submissions to the policy-making process and, with notable

exceptions (Allen 1976; Bickford 1982, 1985), of critical commentaries on new museum and heritage sites – which have been relatively few and far between anyway. While such considerations are obviously important – indeed, the *sine qua non* of policy formation – it is not the case, once such matters have been decided, that questions of representation can be left to fend for themselves. Since museum and heritage policies have as their eventual aim and outcome a regulated set of encounters between visitors (with different cultural backgrounds and orientations) and textually organized museum displays or historic sites, it is appropriate that policy should be guided by an awareness of the factors which influence and regulate the nature of the meanings transacted in those encounters.

Thoughts out of season

In addition to arguing the policy relevance of such considerations, however, I want also to offer a critical perspective on some of the predominant tendencies discernible in the recent formation of an expanded Australian public historical sphere. Apart from enlarging the past in the sense of significantly increasing the number of sites which are publicly demarcated as historical, this process has exhibited, in the main, three closely related textual characteristics. First, the Australian past has become more autonomous and self-referring; in brief, more Australianized as events in Australian history tend increasingly to be referred to one another rather than, as had previously been the case, finding their points of reference in earlier or contemporary moments in European, and especially British, history. In this respect, the Australian past has, so to speak, been cut off from its prehistory and set off on its own, self-supporting course. Second, this newly autonomized past has been considerably elongated, pushed further and further back into deeper indigenous times (as distinct from times derived from European history) so as to suggest a sense of long continuity for the history of the nation. Finally, this past has tended to become ever more inclusive in its orientation, enfolding into its own history the histories of groups and communities which had previously received little recognition in officially sanctioned versions of Australian history. Thus, the histories of Australian women, of Greek, Italian and Asian communities, and of course of Aborigines: all of these are now represented in the materialized pasts embodied in historic sites and museum displays.

So far as one can tell, these tendencies have been broadly supported by most groups within the community. There have, it is true, been signs of an old-guard resistance at the Australian War Memorial, and proposals for the preservation of specific historical sites have often incurred the opposition of property developers. Questions concerning the administration of Aboriginal sites and artefacts also remain intractably contentious. When all that is said, though, the claim made by Lord Chartis of Amisfield in the British

context – that the preservation of national heritage is a relatively non-contentious issue because all parties and publics support it – is largely true in Australia too (Chartis 1984: 326).

Certainly, I have no wish to introduce a note of contention into this relatively acquiescent climate just for the sake of it. Viewed abstractly, many of the tendencies I have identified are to be welcomed. The development of a more broad-ranging and inclusive scope for the Australian past – as realized in the focus on the everyday working lives and cultures of different classes, genders and ethnic communities at Hyde Park Barracks, for example – is unquestionably a change for the better. The positive consequences of such developments for the members of hitherto marginalized groups – the positive sense of self-recognition, of *being there*, accorded a place within the national past – should not be underestimated. Yet it's the contradictory aspects of these tendencies I want to dwell on here, for what sounds fine in principle often turns out to be more problematic when translated into a concrete representational context.

Roughly a hundred years ago, Friedrich Nietzsche, perhaps one of the most acerbic critics of nineteenth-century historical consciousness, and particularly of the tendency to monumentalize national histories in public statuary, recognized that his resistance to history was 'out of season'. 'These thoughts', he wrote in his essay *The Use and Abuse of History*, 'are "out of season," because I am trying to represent something of which the age is rightly proud – its historical culture – as a fault and a defect in our time, believing as I do that we are all suffering from a malignant historical fever and should at least recognise the fact' (Nietzsche 1974: 4). While not going so far as Nietzsche in his intransigent opposition to virtually any kind of historicization of social life, these reflections on Australian museum and heritage policy are similarly 'out of season' in querying the effects of the ways in which the publicly demarcated space of the Australian past is currently being reshaped. They are offered, however, in the conviction that that past is still malleable enough to be responsive to debates concerning its present contours and future trajectory.

This possibility is not given to the same degree where such pasts have a longer history and, thus, more accumulated weight behind them. In Britain, where protective legislation now covers some half a million historic structures, accounting for 4 per cent of the nation's housing stock, the past is often felt as a petrified, frozen and immobile zone which functions as a counterweight to the possibility of imagining new paths of national development except those – like Mrs Thatcher's fondness for the virtues of the Victorian period – which embody a return to the cherished values of the past. 'In its stately connection,' Patrick Wright writes of the past embodied in England's stately homes, 'history becomes "timeless" when it has been frozen solid, closed down and limited to what can be exhibited as a fully accomplished "historical past" which demands only appreciation and protection' (Wright 1985: 78). While in Australia the past is not – nor does

it yet pretend to be – stately, it is accumulating at an unprecedented rate. Unless many of the tendencies which define this past are checked, there are enough signs that it, too, will come to close in on itself, and on us, in inviting only passive contemplation rather than – as it is my purpose to suggest would be more appropriate – serving as a critical resource to prompt active participation in public debate concerning future paths of national development. First, though, a little history is in order.

THE FORMATION OF AN AUSTRALIAN PAST: CONTOURS OF A HISTORY

The national past as a vacuum

In 1933, the Museums Association of London published *A Report on the Museums and Art Galleries of Australia*. Commissioned by the Carnegie Corporation of New York and prepared by two British museologists, S.F. Markham and H.C. Richards, the report painted a fairly damning picture of the state of Australian museums. Poorly funded in comparison with their European, American and even New Zealand counterparts, their growth, it was argued, had been mostly haphazard, driven more by inter-state rivalries than by any consideration of providing a national museum service. So far as the contents of museum collections were concerned, Markham and Richards expressed surprise at the almost total lack of interest in either collecting or exhibiting historical materials. Apart from the Australian War Memorial (then merely a collection of artefacts which had yet to find a permanent home), only two museums were devoted to historical exhibits: Vaucluse House in Sydney and the historical collections housed in the Parliament Buildings at Canberra. Outside of these, the only period room in the whole of Australia was the exhibition of nineteenth-century furniture at the Melbourne Art Gallery. If this general neglect was cause for surprise, Markham and Richards found even more remarkable the lack of any developed concern with materials relating to the post-settlement period. They thus noted that 'in no museum are there reproductions of the buildings occupied by the earlier settlers', regarding this as 'one of the most notable gaps in the whole of the existing museum collections' (Markham and Richards 1933: 441).

Why should this have been so? In part, no doubt, because museum curators had been recruited mainly from the disciplines of geology and biology (and, in the twentieth century, occasionally from anthropology) and did not include a single historian. Yet this is merely to re-state the problem: for why should Australian museums have displayed this particular bias? After all, as Sally Kohlstedt has shown, by the late nineteenth century Australia had developed a range of museums which, in their disciplinary ambit, paralleled their European and American counterparts in all but this one respect (Kohlstedt 1983). If geology, biology, anthropology, science and technology and, in the

Macleay Museum at the University of Sydney, archaeology had all contributed significantly to the collecting interests of Australian museums, why not history? The models were there, for the use of museums as a means of representing and embodying national histories had been known in Europe from as early as the mid-eighteenth century and became increasingly prominent after the French Revolution.[4] Why were they not used?

The question has a more general reference, for the absence of a developed interest in the history of the post-settlement period was not limited to the museum world. It was thus not until after the First World War that Australia could lay claim to even a rudimentarily developed public historical sphere. One of the more important components in the public historical spheres of European societies consisted in the development of public statuary. Whereas, in the eighteenth century, sculptural memorials had tended to be limited to the private chapels or homes and gardens of the aristocracy, the early nineteenth century witnessed the transformation of such memorials into objects, as Mace puts it, of 'public display, often financed by the Government, with a direct didactic purpose' (Mace 1976: 49). The construction of the Napoleon column in the Place Vendôme and of Nelson's Column in Trafalgar Square – mirrored, throughout Europe's towns and cities, in the construction of memorials commemorating the deeds of military heroes and statesmen, of kings and queens – thus constituted a use of public space for a new representational purpose: that of materially embodying a sense of national history. Yet this tendency – which, in France, was to assume the proportions of what Hobsbawm has dubbed a tide of 'statuomania' – had relatively few echoes in Australia (Hobsbawm 1983). As K.S. Inglis has noted, campaigns to erect public monuments commemorating the achievements of prominent Australians were few and far between, often failing to recruit government support or sufficient private patronage to be viable or, where they were successful in this, enlisting little popular enthusiasm when built (Inglis 1974: Ch. 15).

And so one could go on. By the late nineteenth century, in most European societies and in the United States, influential preservationist lobbies had produced rudimentary forms of heritage legislation and provided the basis for heritage organizations capable of co-ordinating campaigns for the preservation of historic sites, and of administering those sites, at a national level.[5] In Australia, such developments belong to the period after the Second World War – and, even then, they came later rather than sooner. Whereas, in Britain, the National Trust was established in 1895, a similar national organization did not exist here until the establishment of the Australian Council of National Trusts in 1965.

How are these patterns of Australian exceptionalism to be accounted for? While there has been no shortage of explanations, few go to the roots of the matter. It was common, in the 1880s and 1890s, for social commentators to argue that there was little or no history in Australia worthy of preserving or commemorating. In this account, the failure to develop a set of institutions

136

in which conceptions of a national past might be materially embodied and represented is attributed to the shortcomings inherent within the real stuff of history. Australian history is, so to speak, indicted for its failure to supply an appropriate set of raw materials – events, characters and movements – out of which a national past might have been fashioned.

The inadequacy of such accounts is clear. For it is precisely those raw materials, overlooked at the time, which have since come to supply the mainstay of the forms in which the Australian past is stylized and represented. 'Why, for example,' Isabel McBryde asks, 'does Australia now have a well-publicised convict past, yet a century ago found this past too sensitive for popular appeal?' (McBryde 1985: 8–9). The considerations such questions point us to concern not the real nature of historical events but their relations to the forms that are available for their representation. In the case of late-nineteenth-century Australia, they refer us to what was clearly perceived as a lack of fit between the raw materials of post-settlement history and the rhetorics governing the forms in which national pasts could fittingly be represented. What was lacking, in other words, was not real historical events but a mould through which such events might be cast into representations that would be consistent with the largely Eurocentric lexicons of nationalism and history which governed public perceptions of such matters.

Had developments in Scandinavian or even American museum and heritage policy been more influential the story might have been different, for both Scandinavia (by the end of the nineteenth century) and America (by the 1920s) had developed preservationist philosophies in which folk culture materials were accorded a historical significance. It was, however, the British past which, for the greater part, supplied the model, stated or implied, in relation to which the representational possibilities of Australian history were judged and, usually, found wanting. Perhaps the most important factor in this respect consisted in the fact that the British past was largely shaped through the commemoration of the military exploits of Empire, a tendency that was equally strong in France. This was perhaps the greatest impediment to the formation of an Australian past. The fact, as it was often expressed at the time, that the Australian nation had not been forged in war – that it had not played any major role in the theatres of 'real history' – meant that it could not lay claim to a past which might be represented on the same footing as the pasts of other nations within the militarized modes of national commemoration which were dominant at the time. It was mainly for this reason that the post-settlement period, when viewed from the comparative perspective of European national pasts, was regarded as a vacuum – or, if not as a vacuum, as a period whose events and figures often proved difficult to use in the construction of an autonomized national past owing to their prior association with the longer history of the British state. Thus, as Inglis suggests, proposals to erect commemorative statues to the maritime explorers or to the colonies' early statesmen often came to nought because such figures

were too strongly associated with either Australia's prehistory or the continuing history of Britain. As a consequence of these two pressures, such tendencies as there were to organize a space of national-historical representations were caught in something of a double bind: the events and figures of the post-settlement period either lacked sufficient representational weight to support an Australian past which might take its place among other national pasts or, if weighty enough, were not able to be represented as sufficiently or uniquely Australian.

Viewed in this light, the significance of Gallipoli 'as a symbol of the nation's entrance into Real History' (Ross 1985: 15) consisted in its functioning as a marker of a set of historical events which could be fashioned into a national past in the terms of the then current lexicon of nationalism. While the primary site of this fashioning was the Australian War Memorial, it would be mistaken to view the Memorial's development as an isolated phenomenon. First mooted in 1917 and finally opened in 1941, the period of the Memorial's construction coincided with a more widespread renovation and restructuring of the Australian public historical sphere. As the first specifically cultural institution planned for the federal capital, the Memorial was both conceived and came to function as a central, co-ordinating point of reference for the countless memorials – statues, public baths, mausoleums – to the war-dead that were erected throughout the length and breadth of Australia over the same period.[6] These shrines, however local the impetus behind them may originally have been, were irretrievably nationalized once the Memorial was opened. They could not help but point to Canberra – rather than to the state capitals – as the apex of the nation's self-memorialization. In this respect, the War Memorial functioned as a crucial instrument of federation, embodying a national past conceived on a macro-scale which not merely superseded the micro-pasts of the different regions and states but provided a point of articulation to which those pasts could be connected. While the details of the Memorial's history testify to the delicacy with which the prior and frequently stronger state-based loyalties and identities were negotiated,[7] there is little doubt that the Memorial eventually succeeded in effecting a national overdetermination of the meaning of local and state memorials and war shrines.

In commemorating the deeds of the AIF and other services, the War Memorial thus fashioned a national past that could jostle for elbow room within the representational space produced by other national pasts, that could compete with them on the same terrain. Yet the discursive shaping of the past embodied in the Memorial was by no means merely derivative. On the contrary, the Memorial significantly transformed the lexicon of public modes of commemoration and remembrance in celebrating the heroism of the ordinary soldier rather than, as Bazin shows was the case in nineteenth-century Europe (except for revolutionary France), focusing exclusively on the exploits of military leaders (Bazin 1967). In truth, this innovation was

138

not so distinctively Australian as is often suggested. Similar tendencies were evident in Europe as the need to recruit the support of a democratic citizenry prompted the development of more demotic modes of public remembrance. Moreover, many of the themes Bean claimed as original had been publicly aired within the British museum profession in the course of the war.[8] None the less, the War Memorial genuinely did go further than its European counterparts in the respect that a demotic rhetoric provides the governing principle of its displays rather than being present merely interstitially. It is there in the dioramas; in the listing of names alphabetically, without distinction of rank, in the Roll of Honour; and, of course, in the celebration of the heroism of the digger and the display of the incidental aspects of daily life in the trenches – the improvised cricket bats and bookmakers' plates through which life was normalized and made bearable.

It is, moreover, the centrality accorded this demotic rhetoric that accounts for the War Memorial's ideological potency. For if, on the one hand, the focus on war enabled a fledgling Australian past to be both connected to and to vie with the deeper, more developed pasts of Europe, the fact that the Memorial's commemoration centred on the ordinary soldier allowed more popular and democratic conceptions of the Australian character to be grafted on to the inherited Eurocentric modes of stylizing and representing national pasts. The key development here, of course, consisted in the transformation of the signifying currency of the digger as the characteristics of self-reliance and anti-authoritarianism were shorn of their late-nineteenth-century radical nationalist associations and connected to a highly conservative set of values and ideologies under Bean's presiding genius.[9] This is especially clear in the Hall of Memory, where the qualities of the digger, shorn of any specific class associations, are represented as a set of trans-class, ahistorical and essentialist national virtues: comradeship, chivalry, loyalty, independence, coolness, and so on.

If, then, the War Memorial must be assessed as the first significant attempt to materialize an Australian past, this was at the price of a highly conservative – although, to its founders' credit, not militaristic – conception of the nation. Nor, viewed from more recent perspectives, are these the only limitations of the Memorial. Its conception of the past is excessively masculinist: women hardly figure at all (the stained glass windows in the Hall of Memory include one woman – a nurse – among fourteen men) and, when they do, it is usually in their capacity as auxiliaries to what is portrayed as the essentially male business of war.[10] Yet gender-bias is not the only point at issue here. There are, after all, many museums of war in which, where significance is accorded to struggles on the home front, representations of women figure significantly. Indeed, there is now a small corner of the Memorial devoted to the home front, but this is really quite gestural compared, for example, with the significance accorded this theme in the Imperial War Museum. In this respect, the relative absence of women points to another, and arguably more central

contradiction in the Memorial's discourse: the fact that, although rightly regarded as the first museum of Australian history, Australia itself is virtually entirely absent. For a founding national institution, the nation is curiously de-centred in the Memorial in the sense that its major references are constantly to Australia's participation in a history taking place elsewhere – in Europe and the Middle East. These are still, in the Memorial's conception, the places of 'real history' while – except in so far as they relate to Australia's participation in this wider history – references to contemporary events within Australia are almost entirely lacking. Thus, if the forms and terms in which women have been mobilized in support of Australia's war efforts are paid scant attention, the same is true of the role played by men outside the armed forces. This predominance of an externally oriented frame of reference, allied with the Memorial's gender bias, accounts for the most obvious limitation in its demotic rhetoric: the people and the soldiery are, in effect, equated.

The point I most want to stress, however, is the degree to which, in the Memorial, Australia remains evacuated of any historical significance of its own. The nation, so to speak, is historicized only by proxy, only to the degree that it takes a part in and joins the longer and deeper histories of Europe. In these respects, the discourse of the Memorial is still colonial or only proto-nationalist. The past which it embodies and figures forth lacks any decisive autonomy. Rather, it is a past which refers itself to, and seeks anchorage and support in, the deeper pasts of Europe. This colonial discourse is evident in the Memorial in many ways: in the references to European traditions in the Hall of Memory;[11] in the references to Europe in the Memorial's second centre of solemnity – the room housing William Longstaff's *Menin Gate at Midnight* (a memorial to soldiers of Britain and the Empire killed at Ypres) and *The Immortal Shrine* (the Cenotaph in London);[12] and the Empire-centred conception of the world governing the entry court which, naming all the places in the world where Australian troops have fought, just manages to squeeze in Australia between Java and the Coral Sea. And, above all perhaps, it is evident in the bitter struggle that was waged to obtain the Shellal Mosaic so that Australia might claim its own piece of imperialist plunder and root itself in deep time by boasting possession of a piece of antiquity.[13] In these respects, the visitor to the Memorial is caught up in a discourse which constantly refers him/her elsewhere, to experience a national history which is always hitched on to another, wider history on which it is dependent for its validation.

In these ways, the Memorial inscribes the visitor within a conception of the nation which remains subjected to the dominating look of the metropolitan powers. Bean was always quite clear that, apart from showing the nation to itself, the Memorial was intended to exhibit Australia to the world – that is, to Europe. 'We planned', as he put it, 'that, just as one had to go to Florence or Dresden to see the finest picture-galleries, so people would have to come to Australia to see the finest war memorial' (cited in Inglis 1985: 101). In thus soliciting the gaze of Europe, the Memorial remains partly within the colonial

conceptions which framed the first call, in 1828, for the establishment of an Australian museum to

> shew that Australia is not occupied by a handful of felons or a few poor needy adventurers, anxious only for the accumulation of wealth, but that the seeds of a great Nation are sown and are even now beginning to fructify – that a national feeling is springing up – that a fifth continent is gradually but rapidly advancing to the lists as a competitor in the race for honour and for fame . . .

> <div align="right">(Anon 1828: 62)</div>

Autonomizing the Australian past

The modern state, Nicos Poulantzas has argued, establishes a unique relationship between time and space, between history and territory, in organizing the unity of the nation in the form of a *'historicity of a territory and territorialisation of a history'* (Poulantzas 1980: 114). Benedict Anderson makes a similar point when he contrasts the spatio-temporal matrices of the modern nation-state with those of dynastic realms or religious communities (Anderson 1983: 31). For the unifying traditions which characterize the latter, Anderson argues, are neither bound to a particular territory nor especially historical to the degree that they evoke a world of eternal permanences. The unity of a nation, by contrast, is always conceived as more limited in scope, the unity of a people who share the same space and time, the occupants of a territory which has been historicized and the subjects of a history which has been territorialized. But of a history which is made rather than given, which is the result of an active process of organization through which other histories – other possible frameworks for organizing events into sequences and interpreting their significance – are either eliminated or annexed to and inscribed within the unfolding unity of the nation's development.

The state, Poulantzas suggests, plays a critical role in this process of nationing history while simultaneously historicizing the nation. It does so by concentrating within itself the unity of those moments which constitute the nation's history, specifying the direction of their sequence and prophesying their future trajectory.

> The State realises a movement of individualisation and unification; constitutes the people-nation in the further sense of representing its historical orientation; and assigns a goal to it, marking out what becomes a path. In this oriented historicity without a fixed limit, the State represents an eternity that it produces by self-generation. It organises the forward course of the nation and thus tends to monopolise the national tradition by making it the moment of a becoming designated by itself, and by storing up the memory of the people-nation.

> <div align="right">(Poulantzas 1980: 113)</div>

These perspectives throw a useful light on the development of post-war museum and heritage policies. For there are few areas of policy formation in which the state can play so direct and leading a role in organizing the time–space co-ordinates of the nation. And there are few institutions, correspondingly, which can rival the authority invested in those constructions of the nation's past and projections of its future destiny which are embodied in museums and national heritage sites. It is not surprising, therefore, that these should have been perceived as potentially powerful cultural technologies of nationing in the context of the broader post-war political and cultural initiatives to produce a post-colonial national culture and identity. Compared with the relatively *ad hoc* development of museums and related institutions over the preceding century, the last three decades have witnessed the emergence of museum and heritage questions as objects of major governmental attention, especially at the federal level. In consequence of a rush of governmental inquiries and a flurry of legislative initiatives, the size and scope of the national past have been vastly extended while its discursive properties have been significantly reorganized.

The single most important development, in this latter respect, has consisted in the production of a more clearly and more completely autonomized national past. This has entailed the organization of a new discursive space for the time–space co-ordinates of the nation, ones which sever its dependency on those of Europe and allow it to emerge as a free-standing entity rooted in its own past. Moreover, this has been accomplished by precisely the means both Poulantzas and Anderson suggest. The historicization of a territory and the territorialization of history; the subjection of other histories (of Aborigines, of immigrant communities, of Australia's European pre-history) into the story of the nation's unfolding unity; the back-projection of the nation's history into the deeper history of the land and of nature so that it seems to 'loom out of an immemorial past' (Anderson 1983: 19) – these are among the dominant tropes of the national past as it is currently being fashioned.

The political impetus for these developments derived from the Whitlam governments of 1972–4 and 1974–5.[14] Shortly after its election in December 1972 the first Whitlam government appointed the Hope Committee to inquire into the establishment of a National Estate. Although the Hope Committee submitted its report in the midst of the 1974 election, the government committed itself to its findings and, in its second term, appointed an Interim Committee on the National Estate (May, 1975) to prepare a National Heritage Policy to be administered by a permanent Heritage Commission. The Australian Heritage Bill was passed a year later, vesting the Department of Urban and Regional Development and the Department of the Environment with joint responsibility for administering the National Estate. It also established the Heritage Commission to serve in a permanent advisory capacity to these departments and charged it with the responsibility for

drawing up a Register of the National Estate. Although the Fraser government subsequently reduced the scope of the Heritage Bill and cut the funding available to the National Estate, this work continued and, in 1977, the first Register of the National Estate was published. In the interim, the Pigott Committee had been established in 1974 to inquire into museums and national collections. On reporting, in 1975, the Committee recommended the establishment of a Museum of Australia suggesting that a Gallery of Aboriginal Australia be incorporated within the Museum as one of its three main galleries.[15]

These two inquiries constituted a distinct turning point in the development of federal policy in signalling a clear commitment to the production of a more centrally co-ordinated national past.[16] Yet they should not be viewed in isolation from the more widespread initiatives to which, in part, they were a response and which, in turn, they prompted and encouraged. The Pigott Committee, while chastizing the major museums for their continuing lack of interest in Australian history ('only five institutions across the continent', it noted, 'have curators for whom the title "of history" is appropriate') (*Museums in Australia* 1975: para.4.27), sung the praises of the local museum movement:

> In the last fifteen years hundreds of small museums have been founded as a result of the quickening interest in Australian history. This has been primarily a grass-roots movement, one of the most unexpected and vigorous cultural movements in Australia in this century.
>
> (*Museums in Australia* 1975: para.5.8)

The 1960s also witnessed an increase in the membership of conservation societies and historical societies – a trend which continued in the 1970s – as well as the emergence of national organizations, most notably the Australian Council of National Trusts in 1965.[17] Rather more important, at least in terms of political symbolism, were the green bans and related campaigns of the early 1970s (Nittim 1980). In demonstrating the degree to which the preservation of both the natural and historic environment had recruited broadly based popular support, these allowed the issue of preservation to be connected to the 'new nationalism' of the Whitlam administrations which were thus able to present their environmental policies as representing the expressed wishes of the people against the self-interested actions of local business élites, multinational corporations and, where appropriate, state governments. This rhetoric of 'the people versus the developers' was most effectively voiced by Tom Uren, the Minister for Urban and Regional Development. When tabling the report of the Hope Committee before the House of Representatives, Uren noted with approval the Committee's diagnosis that 'uncontrolled development, economic growth and "progress", and the encouragement of private as against public interest' had been responsible for the degradation of the National Estate. He then went on to state:

A pleasing feature of the report is its rejection of the widely held notion that conservation and preservation of the environment are a middle-class issue. The Committee affirms this is just not true and that preserving the National Estate concerns us all. It shatters once and for all the illusion that the national estate is the preserve of the better-off members of the community. The forces which threaten our National Estate often bear most heavily on the less privileged. Poorer people suffer more intensely from the loss of parkland, familiar city and country scapes, and even dwellings. Deprived community groups have not the same access as the wealthy to other sources of personal enjoyment and fulfilment. That is why it is often the less affluent who are most active in working to protect the best features of our heritage. That is why the trade union movement has been active in trying to protect and enhance our National Estate.[18]

The results of this marked increase in governmental concern with museums – and specifically with historical museums – and the preservation of historic sites are, by now, readily apparent. The Australian public historical sphere has been significantly augmented owing to the enormous increase in the number and range of institutions which have been extracted from the flow of the present and grouped together within an officially demarcated zone of the past which, in its turn, has been more strongly nationalized. Most obviously, the development of the Register of the National Estate has served as the instrument *par excellence* for both extending and deepening the past while simultaneously organizing that past under the sign of the nation. By 1981, 6,707 sites had been listed in the Register and, of these, 5,417 were classified as historic places (*Australia's National Estate* 1985: 27, 31). Many of these sites are – or, more accurately, were – of a purely local significance and value. The official policy documents make much of this:

> The National Estate is only a convenient generalisation for a great wealth of individual, well-loved buildings, precincts, areas, gardens, parks and bushlands. The value of the National Estate lies in each individual item and especially in its local and immediate setting.
>
> (*Australia's National Estate* 1985: 19)

Yet this argument is, in some respects, disingenuous. For the mere fact of placing a site within the National Estate means the local values invested in it are, to some degree, overdetermined by national ones. It becomes, willy-nilly, linked to thousands of similar sites elsewhere and serves as a common point of reference for visitors from other states and regions with the consequence that parochial histories are irretrievably reorganized in being dovetailed to other parochial histories as parts of a wider, nationalized whole.

Similar tendencies have been evident in the development of museums. The interest in local and municipal museums noted by the Pigott Committee has

continued unabated, leading towards the innovation of many new museum types – as at Sovereign Hill and Timbertown. Equally, however, the development of major state and national institutions has subjected these often dispersed initiatives to a strongly unifying centripetal tendency. The respects in which locally and regionally dispersed developments are accompanied by unifying ones at both the state and national levels was especially clear as the logic of the Bicentennial celebrations unfolded. The innumerable local museum and heritage projects sponsored by the Australian Bicentennial Authority – from the Bicentennial Historical Museum at Landsborough through the Cooee Park Bicentennial Local History Museum at Gilgandra to the Historic Village at Rosny Park – were thus complemented by the opening of major state institutions (the new Power House museum in Sydney, the Stockman's Hall of Fame at Longreach) which, in turn, were co-ordinated and 'capped', at the national level, by the opening of the National Maritime Museum and the travelling Australian Bicentennial Exhibition.

In brief, when, in 2001, it eventually materializes, the projected Museum of Australia will clearly serve, as did the War Memorial in its day, as the culmination of an extended process in which the national past has been thoroughgoingly renovated while also providing the multiple local and state-based initiatives with a central and co-ordinating point of reference. Yet it is not merely in a quantitative sense that the past has been significantly transformed, although this itself has been important in altering the very texture of the past, increasing its density and, accordingly its presence within the present. The past has also been discursively reshaped in being subjected to the organizing influence of new rhetorics. More to the point, perhaps, these rhetorics have taken, as their primary raw materials, precisely those aspects of post-settlement history which, in earlier periods, were overlooked as a detritus devoid of historical significance. The lives of convicts and pioneers, of settlers and mining communities, of different immigrant groups and, in some contexts, of Aborigines: these are the materials out of which, in its most distinctively contemporary forms, the past is being remade.

However, only a knee-jerk populism would accord these demotic and multicultural impulses unqualified approval. For, ultimately, the raw materials out of which a national past is made count for less than the rhetorics which shape their discursive fashioning. Viewed from this perspective, the properties of the newly emerging national past are more ambiguous and contradictory than a one-eyed focus on the extended range of its raw materials would suggest. On the one hand, particularly where new museum initiatives have resulted in a curatorial input from social historians – in itself an important new development[19] – the result has often been critically interrogative museum displays which allow the visitor to reflect on the relations between the past and the present. This is true, to a degree, of Hyde Park Barracks, and even more so of The Story of Victoria Exhibition at the Museum of Victoria and the Migration and Settlement Museum in Adelaide.

Yet these are minority instances. Viewed in its broader aspects, the past has been shaped by different pressures, in response to different constituencies, and moulded by different discourses from those which seemed most actively influential in the Whitlam years. The active involvement of working-class communities has not been maintained, partly because questions of museum and heritage policy have since become centrally linked to the promotion of tourism. So much so that, whereas it had initially been envisaged that the past was to be preserved *from* development, it is now typically preserved *for* it, often with the result that long-term cultural considerations are forced to take second place to short-term, and often exceedingly hazardous, economic calculations.[20]

To place such issues in their context, however, a consideration of the discursive pressures active in reshaping the Australian past is called for. It will be helpful, in so doing, to relate my opening theoretical remarks to these concerns.

THE SHAPE OF THE PAST

The past in the present

In elaborating the educational advantages of museums, the Pigott Committee stressed their ability to 'dispense with those layers of interpretation which, in most media, separate an object or evidence from the audience', suggesting that 'a gold nugget found at Ballarat in 1860 or a "Tasmanian Tiger" trapped in 1900 will be lacquered less with layers of interpretation in a museum hall than in a film, history book, television documentary, photographs or song' (*Museums in Australia* 1975: para.74.17). Kimberley Webber strikes a similar note when, in criticizing the aura of sanctity attached to the exhibits in the Australian War Memorial, she suggests that the cultivation of a serious sense of Australia's past 'must rest upon a clear distinction between the rhetoric of the relic and the reality of the artefact' (Webber 1987: 170).

While occasionally challenged, the 'culture of the artefact' which underlies both positions continues to provide the primary terms of reference governing debate within the museum world. Yet the distinction on which it rests is a false one. For the artefact, once placed in a museum, itself becomes, inherently and irretrievably, a rhetorical object. As such, it is just as thickly lacquered with layers of interpretation as any book or film. More to the point, it is often lacquered with *the same* layers of interpretation. For it is often precisely the presuppositions derived from other media that determine both which artefacts are selected for display in museums and how their arrangement is conceived and organized. No matter how strong the illusion to the contrary, the museum visitor is never in a relation of direct, unmediated contact with the 'reality of the artefact' and, hence, with the 'real stuff' of the past. Indeed, this illusion, this fetishism of the past, is itself an effect of

146

discourse. For the seeming concreteness of the museum artefact derives from its *verisimilitude*; that is, from the familiarity which results from its being placed in an interpretative context in which it is conformed to a tradition and thus made to resonate with representations of the past which enjoy a broader social circulation.[21] As educative institutions, museums function largely as repositories of the *already known*. They are places for telling, and telling again, the stories of our time, ones which have become a *doxa* through their endless repetition. If the meaning of the museum artefact seems to go without saying, this is only because it has already been said so many times. A truly double-dealing rascal, the museum artefact seems capable of lending such self-evident truths its own material testimony only because it is already imprinted with the sedimented weight of those truths from the outset.

The authenticity of the artefact, then, does not vouchsafe its meaning. Rather, this derives from its nature and functioning, once placed in a museum, as a sign – or, more accurately, a sign vehicle or signifier. The consequences of this are far reaching. All of the developed theories of language available to us are in agreement that, apart from a few special classes, individual signifiers have no intrinsic or inherent meaning. Rather, they derive their meaning from their relations to the other signifiers with which they are combined, in particular circumstances, to form an utterance. This has the obvious consequence that the same signifiers may give rise to different meanings depending on the modes of their combination and the contexts of their use.

That this is true of museum artefacts is amply confirmed by those instances in which changes in the systems of classification governing museum displays have led to a radical transformation in the signifying function of identical artefacts. One of the best known examples concerns Franz Boas's breach with the typological system for the display of ethnographic materials. In this system, developed by Pitt Rivers, tools and weapons were extracted from their specific ethnographic origins and arranged into evolutionary series, leading from the simple to the complex, in order to demonstrate the universal laws of progress. Boas, by contrast, insisted that ethnographic objects should be viewed in the context of the specific cultures of which they formed a part and promoted tribally-based displays with a view to demonstrating 'the fact that civilisation is not something absolute, but that it is relative, and that our ideas and conceptions are true only so far as our civilisation goes' (cited in Jacknis 1985: 83).

Given this, it is clear that the significance of particular history museum displays or heritage sites is not a function of their fidelity or otherwise to the past 'as it really was'. Rather, it depends on their position within and relations to the presently existing field of historical discourses and their associated social and ideological affiliations – on what Patrick Wright has called their past–present alignments (Wright 1984: 512). To consider the shape of the Australian past from this perspective requires that the past–present alignments

147

embodied in its new and extended forms be considered in their relations to the political ideologies to which, in the main, they have been articulated. While a detailed study of this type cannot be attempted here, a brief consideration of some of the more distinctive past–present alignments currently characterizing the national past will suffice to highlight the ambivalent yield of its recent formation.

The never-ending story

We have noted that, for Anderson, nations seem always to loom out of an immemorial past. He goes on to add, however, that they seem also to 'glide into a limitless future' (Anderson 1983: 19). In so far as they are 'imagined communities' – ways of conceiving the occupants of a particular territory as essentially unified by an underlying commonality of tradition and purpose – nations exist through, and represent themselves in the form of, long continuous narratives. As ways of imagining, and so organizing, bonds of solidarity and community, nations take the form of never-ending stories which mark out the trajectory of the people-nation whose origins, rarely precisely specified, are anchored in deep time just as its path seems destined endlessly to unfold itself into a boundless future. Eric Hobsbawm makes a similar point when he notes, apropos the development of national traditions in late nineteenth-century Europe, that the continuity such traditions evoked was 'largely fictitious', stretching the imaginary continuity of nations back beyond the period of their establishment as identifiably distinct cultural and political entities (Hobsbawm 1983).

This process of stretching the national past so as to stitch it into a history rooted in deep time is particularly evident in the case of new nations where, however, it also gives rise to peculiar difficulties. In the case of settler societies which have achieved a newly autonomized post-colonial status, this process has to find some way of negotiating – of leaping over – their only too clearly identifiable and often multiple beginnings: 1788 and 1901, for example. The formation of the National Estate has been of especial significance in this respect. Its role in ironing out the ruptures of Australia's multiple beginnings to produce a national past which flows uninterruptedly from the present back to 1788 is especially clear. This is accomplished, in the main, by two means. First, the classification of cultural artefacts from the period prior to 1901 as parts of the National Estate serves to wrench those artefacts from the histories to which they were earlier connected – those of Empire, for example – and thus to back-project the national past beyond the point of its effective continuity. Equally important, the very concept of the National Estate entails that all particular histories are deprived of their autonomy as their relics – private homes, disused factories, explorers' tracks, marked trees – are dovetailed into the putative unity of the national past. It would, in this respect, be mistaken to conclude from the demotic structure of the National

Estate – that is, its all-embracing inclusiveness, encompassing the histories of subordinate as well as of élite groups – that it is democratic also. The very concept of a national heritage is, of necessity, demotic; its *raison d'être* is to enfold diverse histories into one, often with the consequence that the histories of specific social groups are depoliticized as their relics come to serve as symbols of the essential unity of the nation, or to highlight its recently achieved unity, by standing for a divisiveness which is past.[22] Whether or not the results of these processes can be described as democratic depends less on what is included within a national heritage than on the discourses which organize the relations between those artefacts.

Yet the Australian National Estate consists not merely of artefacts relating to the period of European settlement. Its other main classifications are the natural environment and Aboriginal sites. David Lowenthal, writing shortly after the publication of the first Register of the National Estate, notes the consequences of this precisely:

> The Australian heritage incorporates not only the few decades since the European discovery but the long reaches of unrecorded time comprised in Aboriginal life and, before that, in the history of nature itself, the animals and plants and the very rocks of the Australian continent. Thus the felt past expands, enabling Australia to equal the antiquity of any nation.
>
> (Lowenthal 1978: 86)

He might also have noted the similar function of the increased significance accorded maritime history in recent museum and heritage policy. This has emerged as a major area of interest within each of the states whose various maritime collections received a point of national co-ordination when the National Maritime Museum opened towards the end of 1988 – a year that saw the nation's maritime past conspicuously foregrounded through the First Fleet re-enactment, the Tall Ships events and the national tour of the Bicentennial Shipwreck exhibition. More generally, the Commonwealth Historic Shipwrecks Act of 1976 has officially annexed pre-settlement maritime history to the national past in declaring all wrecks found in Australia's coastal waters a part of the National Estate. The temporary return to Australia of Hartog's plate – currently the property of the Rijksmuseum in Amsterdam – for the period of Shipwreck exhibition's tour is symptomatic of the role maritime history plays in pushing the national past as far back beyond 1788 as possible to include the voyages of the explorers. Yet this particular way of extending the past also meets a broader purpose. To the degree that they are fashioned to represent both the outgoing history of Europe and the incoming history of Australia, the inclusion of the voyages of the explorers within the national past allows at least some of the various European constituencies in a multicultural Australia to anchor the 'shallow' histories of their recent immigration in the structures of a deeper time. At the same time, this rooting

149

of the nation in a broader history of contact also serves to liberate the national past from the British dependency which results from an exclusive focus on the moment of settlement.

Much of this is not surprising. Nor, in itself, is it in any way deplorable. That said, this process of elongating the national past does have some questionable aspects of which, here, I want to focus on two: the use of Aboriginal culture as an instrument of nationing, and the forward trajectories of the nation to which these newly created deep pasts – of the land and of the sea – are connected.

The following extracts from the 1982 *Plan for the Development of the Museum of Australia* offer a convenient illustration of the first of these concerns:

> The Museum of Australia will be a museum about Australia; a museum with which every Australian can identify. It will tell of the past, present and future of our nation – the only nation which spans a continent. It will tell the history of nature as well as the history of the Australian people . . .

> Much of the history of Australia – the driest continent – has been shaped by its climate, its geological antiquity, its vast distances and its island isolation. Because of this, its flora and fauna are unique, and the same timeworn landscape conceals ancient life forms and enormous mineral resources.

> Australia's human history is ancient and distinctive. Aboriginal people populated Australia early in the colonising surge of modern peoples across the world. Over a period of at least 40,000 years, the Aboriginal people developed a spiritually complex society with an exceptional emphasis upon ritual life and attachment to place. Through time, Aboriginal societies modified the environment and, in their turn, adapted to it with considerable regional variation.

> As the nation approaches the bicentenary of European settlement it has become a complex multicultural society. The continuing story of the transformation of Australia from a country of hunter-gatherers to an industrial nation is one of tragedy, triumph, persistence and innovation. It should be told with vigour and objectivity, using our collective heritage to promote the consciousness and self-knowledge which foster a mature national identity.

> (Museum of Australia 1982a: 2)

In 1975, the Pigott Committee was sharply critical of the tendency, in late nineteenth-century museums, for Aboriginal remains and artefacts to be exhibited as parts of natural history displays (Museum of Australia 1982a: paras 4.27, 4.30). The function of such exhibits was clear. Occupying a

150

twilight zone between nature and culture, Aboriginal materials served both to differentiate the two while also accounting for the transition between them. Placed on the lowest rung of the ladder of human evolution, they represented culture at the stage of its emergence out from nature – a sign whose value was purely negative in demonstrating how far humanity had progressed beyond its 'prehistoric' origins. The above passage clearly intends a decisive breach with such conceptions in the significance it accords Aboriginal culture as well as its inclusion of Aborigines within the national subject ('every Australian') its constructs and addresses. Yet it would be an indulgent reading which remained at this level. Indeed, what is most striking about the passage are the respects in which it retains Aboriginal culture in the same representational space (the relations between nature and culture) albeit transforming the function of that space in using it as a device of nationing. For the role assigned Aboriginal peoples is that of a mediating term connecting the history of European settlement to the deep history of the land (its 'geological antiquity' and 'timeworn landscape') and of its flora and fauna ('ancient life forms'). In thus overcoming the cliff-edge of 1788 to anchor the nation in the structures of a deeper time, this conception fulfils a number of further tasks. First, it overcomes any sense of rupture between the phases of pre- and post-settlement in suggesting that Aborigines be viewed merely as a first wave of settlement (they just came 'early in the colonising surge of modern peoples') who, just as did their successors, adapted the environment to their needs. In this way, an essential unity is constructed for a 40,000 year span of history by enfolding its different phases into a discourse of development which tells the history of the nation as a 'continuing story of the transformation of Australia from a country of hunter-gatherers to an industrial nation', a never-ending story of 'tragedy, triumph, persistence and innovation'. This also enables the discourse of multiculturalism to be back-projected into the mists of time where it finds its support in the regional variation of Aboriginal cultures.

It might be thought that this is making too much of a few paragraphs from a relatively early planning document. Certainly, in many of its details, the Museum of Australia may well turn out differently. Yet, they are key paragraphs – the first definitive statement of the concept of the Museum – and accurately indicative of the nationing rhetoric governing its conception as a co-ordinated arrangement of three galleries: the Gallery of Australia since 1788, the Gallery of Aboriginal Australia and the Gallery of the Australian Environment. There seems little doubt, from more detailed plans, that the Gallery of Aboriginal Australia will be seriously critical in its depiction of the effects of European settlement on Aboriginal peoples. Yet, to some degree, this will be overshadowed by the overall conception of the Museum which, in its very structure, is unavoidably deeply ambiguous in the connecting role it accords Aboriginal history.

At the very least, these remarks should suggest the inappropriateness of displaying Aboriginal materials within the frameworks of nationalized

narratives. There is, however, a further problem with such narrativizations of the national past, one deriving from the discursive pressure to which they are subject from the broader cultural environment. This is particularly true of forms of narrativization which, like that embodied in the plan for the Museum of Australia, are organized in terms of a discourse of development in view of the degree to which this discourse has been annexed to the public imagery of Australia's leading business corporations. Paul James has usefully shown how, in the aftermath of the 'new nationalism', such corporations sought to renovate their public images and, in doing so, to attach the forward impetus of the new nationalism to their corporate interests (James 1983). Yet, in thus claiming to embody the future trajectory of the nation, the advertising strategies of such corporations have also sought to connect pre-existing nationalized images and traditions – the iconography of the Australian landscape, the frontier spirit, the motif of 'the quiet achiever' – to their public images. The meaning potential of such images and traditions is consequently now significantly overdetermined by the corporate imagery which has become attached to them through extended and highly influential advertising campaigns. In BP Australia's 'Quiet Achiever' advertisements, for example, both the Australian land and its surrounding oceans are represented in terms of a discourse of development which presents the corporation's exploratory activities as the outcome of a long story of exploration and development reaching back into the remote history of the continent.[23] Nor have the thematics of multiculturalism proved any less immune to corporate appropriation. The Bond corporation's Bicentennial advertisement, for example, also represents the story of the nation as a continuous story of 'tragedy, triumph, persistence and innovation' in portraying successive waves of settlers and immigrants, all those 'who thought they'd never make it', whose differences are finally annulled as they make their way through to their ultimate historical reward and destiny: a glass of Swan lager.

In his examination of the British national past, Patrick Wright characterizes one of its dominant past–present alignments as 'the complacent bourgeois alignment':

> This alignment makes it possible to think of historical development as complete, a process which finds its accomplishment in the present. Historical development is here conceived as a cumulative process which has delivered the nation into the present as its manifest accomplishment. Both celebratory and complacent, it produces a sense that 'we' are the achievement of history and that while the past is thus present as our right it is also something that our narcissism will encourage us to visit, exhibit, write up and discuss.
>
> (Wright 1984: 52)

The past–present alignment embodied in corporate advertising strategies might appropriately be characterized as an active bourgeois alignment. For

it, too, views the past as a cumulative process which has delivered the nation into the present as its accomplishment. Yet that present, while marking an accomplishment, does not mark a completion; rather, it stands poised as a moment between a past and a future cast in the same mould. The future trajectory for the nation which it marks out is governed by the logic of 'more of the same'; a never-ending story of development in which multinational corporations figure as the primary representatives of a process of uninterrupted development which seems to emerge naturally out of the relations between the very land itself and its inhabitants. The temptation, by no means limited to the Museum of Australia, to work along with such narratives in view of their familiarity and, therefore, ready intelligibility, is understandable. However, given the degree to which those narratives have been hijacked by particular sectional interests, it is a temptation that should be actively resisted.

The penal past

When Millbank Penitentiary opened in 1817, a room festooned with chains, whips and instruments of torture was set aside as a museum (Evans 1982). Thus did a new philosophy of punishment committed to the rehabilitation of the offender through the detailed inspection and regulation of behaviour distance itself from an earlier regime of punishment which had aimed to make power manifest by enacting the scene of punishment in public. The same period witnessed a new addition to London's array of exhibitionary institutions. In 1835, after decades of showing her waxworks the length and breadth of the country, Madame Tussaud set up permanent shop in London. Her new establishment included, as a major attraction, the Chamber of Horrors where, among other things, the barbarous excesses of past practices of punishment were displayed in gory detail (see Altick 1978). As the century developed, the dungeons of old castles were opened to public inspection, as they still are, and, in many places, as the centre-pieces of museums – as at Lancaster Castle, for example, or at York's Castle Museum, located in two eighteenth century prisons. And Madame Tussaud's now has a rival in the London Dungeon, one of the city's most popular tourist attractions, where special-effects technologies reproduce the mutilation of the body in scenes of torture and punishment from yesteryear.

These developments are not merely of an anecdotal significance. Although little remarked upon, there is an important symbolic symbiosis between the development of imprisonment as the major modern form of punishment and the simultaneous tendency of museums and related institutions to include past forms of penality within their repertoire of representational concerns. It is the logic of the penitentiary that punishment should remain hidden from public view. To the degree that this is so, the penitentiary's reforming rhetoric – its claim to embody humane forms of punishment oriented towards the rehabilitation of the offender – is deprived of public validation. The exhibition

of the excesses of past regimes of punishment thus provides the penitentiary with the visible supports which Whiggish views of its history require. The very openness of past scenes and practices of penality to public inspection helps to ensure that the doors of the penitentiary remain well and truly shut in conjuring up visions of such barbarity that the prison, whatever its defects, could not but seem benevolent in comparison.

These considerations are especially pertinent to Australia in view of the unique importance accorded representations of penality within the structure of the national past. Yet this, too, is a relatively new development. Twenty to thirty years ago, most penal institutions from the convict period were either disused or dedicated to other government functions. Since then, the number of such institutions – as well as late nineteenth-century prisons – which have been converted into museums is truly remarkable. Port Arthur, Hyde Park Barracks, Old Melbourne Gaol and Old Dubbo Gaol are among the most obvious examples, but these are complemented in innumerable local prisons which have been converted to house local history displays. Yet it is not simply the marked increase in the quantitative significance accorded representations of penality that most distinguishes their function. This derives from the fact that such representations usually play in two registers simultaneously: as parts of Whiggish views of penal history, and as components of discourses concerning the nation's origins.

Where the former concern predominates, the emphasis falls on depicting the harshness of the convict system or that of the penal institutions developed to deal with indigenous crime in the course of the nineteenth century. It is thus that Jim Allen urges that Port Arthur should be primarily concerned to demonstrate the failure of the convict system. Similarly, although in its day – like Port Arthur – embodying the ideals of nineteenth-century penal reformers in their aspiration to use imprisonment as a mode of rehabilitation, Old Melbourne Gaol now functions as a testimony to the harshness of a penal regime that is represented as past. In its display of the instruments of prison discipline (the cat, truncheons, a whipping post), the scaffold (reconstructed for the film *Ned Kelly*), the condemned cell, the white masks prisoners were obliged to wear outside their cells and the death masks of hanged felons, the Gaol fulfils the same function in relation to Australia's modern penal system as did the museum within the Millbank Penitentiary for the mid-nineteenth century: its locates penal severity in the past.

The more distinctive rhetoric, however, is that which retrieves the convict population as one of the cornerstones of the nation. In this respect, the penal past forms a part of a broader process in which attitudes towards the convict period have been significantly transformed – so much so that the discovery of convict ancestry is now one of the most sought-after prizes of genealogical inquiry (Cordell 1987). A healthy demotic tendency, no doubt. What is more questionable is the accompanying tendency for the convicts to be cast in the role of enlisted immigrants or early pioneers in order to provide an early point

154

of reference to which the subsequent histories of settlers, squatters, miners and so on can be connected in a relationship of uninterrupted continuity. As an official catalogue glosses the lessons of Port Arthur:

> Gradually a tourist traffic developed, until today, visitors from all corners of the globe come in their thousands to Port Arthur to catch a vision of bygone days and relive a history of which we should be very proud, for it is the story of the pioneers, bond and free, who laboured together to build the foundations of the Tasmania we know and enjoy today.
>
> (*Port Arthur Historic Site* 1984).

The same rhetoric is evident at The Rocks where, in being combined with a nationalized version of the Whiggish view of penality, it serves the unlikely purpose of establishing a moment of origin for the nation which, in its developmental tendency, is represented as free of conflict. Cadman's Cottage and the First Impressions sculpture in The Rocks Square thus both suggest that the only forms of conflict to mar early Australian history were those imported from the old world in the form of the antagonistic relations between the colonial administration and the marines on the one hand and the convicts on the other. Yet these antagonisms – alien intrusions imposed by a past and foreign regime of punishment – are retrospectively erased once Australian history proper gets under way as the convicts and marines, when granted land, are portrayed as rubbing shoulders with the settlers in laying the foundations for a free, democratic and multicultural society[24].

While it may seem fairly innocuous, this transformation of the penal past into a device of nationing has the further consequence of pre-empting the uses to which that past can be put. The use of a nationing rhetoric is never an innocent choice; its consequences have to be assessed partly in terms of the alternatives it excludes. Thus, in according the penal past the role of a foundational chapter in the history of the nation, that past is simultaneously detached from other histories to which it might be more intelligibly, and certainly more critically, related – in particular, the broader and subsequent history of Australian penality. This would involve different representational choices at both the synchronic and diachronic levels: synchronically, in relating prisons to other historically contemporary penal institutions – asylums, for example, or institutions for destitute women and their children – and diachronically in relating the penal past to present-day forms of punishment. In their singular failure even to gesture in this direction, all of the institutions mentioned above serve a crucial role in institutionalizing amnesia with regard to contemporary practices of punishment. In aligning the penal past to the present within the framework of a rhetoric of national development, and in representing that past as one whose excesses have been overcome, contemporary forms of punishment are bereft of any public history except that which, axiomatically, declares their benevolence.

The tourist past

Dean MacCannell has argued that 'the best indication of the final victory of modernity over other sociocultural arrangements is not the disappearance of the nonmodern world, but its artificial preservation and reconstruction in modern society'. Museums and heritage sites 'establish in consciousness the definition and boundary of modernity by rendering concrete and immediate that which modernity is not', rendering the present 'as revealed objects, as tourist attractions' (MacCannell 1976: 8–9, 84).

While a useful general comment on the amount of social effort modern societies devote to the social production and preservation of their pasts, MacCannell's observation applies with particular force to living-history or open-air museums. The rapid development of this form – at Sovereign Hill, Timbertown and Old Sydney Town, for example – has constituted the most distinctive addition to Australia's museum complex over the last two decades, and certainly the most popular: Sovereign Hill, a reconstruction of a late-nineteenth-century gold-mining town, attracted five million visitors in the twelve years after its opening in 1970. It is also, seemingly, the most democratic of museum forms in its concern to reproduce the timbre of the everyday lives of ordinary people in past forms of community.

Yet such appearances are often deceptive. The history of open-air folk museums is a deeply ambiguous one. Michael Wallace traces the prehistory of the form to 'such eighteenth-century aristocratic productions as Marie Antoinette's play peasant village (complete with marble-walled dairy), French *folies* such as Parc Monceau, and the great landscape parks of the English gentry which excised all signs of daily peasant activity and eradicated any sense of time other than the artificially constructed "natural"' (Wallace 1985: 40). The late nineteenth-century Scandinavian open-air museum movement – conventionally regarded as the origin of the form – was strongly influenced by romantic conceptions of folk culture as an imaginative antidote to the degradations of capitalism, and accordingly, tended towards an idealized depiction of past social relations cast in the mould of a pre-Edenic organic community. The same was true of the development of the form in the United States in the 1920s and 1930s, except that – as at Henry Ford's Greenfield Village – the lives of the pre-industrial folk to which open-air museums were dedicated were so fashioned as to emblematize 'the "timeless and dateless" pioneer virtues of hard work, discipline, frugality, and self-reliance' – exemplary precursors of capitalism rather than its imaginary antitheses (Wallace 1981: 72).

In brief, the form has tended to be populist rather than democratic in conception, finding a place for the lives of ordinary people only at the price of submitting them to an idealist and conservatively inclined disfiguration. Of course, this is not an intrinsic attribute of the form as such. There is nothing in principle to prevent open-air museums using the resources of the

form – which are, in essence, theatrical – to offer a more critical relation to the pasts they produce.[25] None the less, the form's history does tend, in practice, to exert a pressure on the ways in which its uses are conceived, often with the consequence that serious museum enterprises are side-railed into the heartland of conservative mythologies. An added difficulty is that the form now comes under pressure from another source, one whose development it facilitated: Disneyland, whose evocation of Main Street USA draws substantially on the earlier restoration of colonial Williamsburg.

This is not to suggest a relationship of equivalence between Disneyland (and its imitators) and open-air museums. But they are institutions which overlap, and in several ways. Their thematics are often similar. If Disneyland mimics colonial Williamsburg, the goldmining sector at Dreamworld – a theme park on the Gold Coast – calls Sovereign Hill to mind. They are, moreover, connected by virtue of their closely related positions within the tourist's itinerary. A survey of Disneyland visitors reveals that a high proportion of them regard a trip to Disneyland and visiting historic sites as closely related activities (Real 1977: 72–3). While there is no equivalent information for Australia, it seems likely that associations of meaning are carried over from one type of institution to the other within the tourist's itinerary.

Perhaps most important, however, are the distinct similarities between the ways in which Disneyland and open-air museums organize how their visitors negotiate and experience the relations between their constructed interiors and the outside world. Moreover, these constitute the respects in which Australian open-air museums most strongly resemble one another even though, in other respects, they are quite distinct. Most obviously, they differ with regard to the styles of performance regulating the ways in which costumed museum workers mediate the relations between the visitors and their reconstructed historical milieux. At Timbertown, a museum which reconstructs the life of a logging community in northern New South Wales, the stress falls on the use of such stuff as living history props, costumed complements to the historical setting. The same is true of Sovereign Hill, except that costumed staff will step out of their roles, rupturing their illusionistic function, if asked for information, while there are also non-costumed site interpreters. By contrast, the staff at Old Sydney Town, which recreates Sydney during the period of the Napoleonic Wars, specialize in what can best be characterized as historical hi-di-hi, mixing the routine of vaudeville theatre and holiday camp hosts to produce a jocular relation to the past which, at one level, they are meant to embody. When such differences are acknowledged, however, there remain two overriding common features which – precisely because it embodies them to excess – a comparison with Disneyland usefully illuminates.

Perhaps the most important similarity between the two institutions consists in their miniaturization of past social relations. At Disneyland this is achieved by a reduction in the scale of historical reproductions. The buildings on Main

157

Street USA, for example, are at least an eighth less than their true size. 'This costs more,' Walt Disney explained, 'but made the street a toy, and the imagination can play more freely with a toy. Besides, people like to think that their world is somehow more grown up then Papa's was' (cited in Real 1977: 54). While open-air museums rarely go to the same lengths, their effects are similar. In clustering together, in a compressed space, every conceivable building type – workers' cottages, school, hotel, church, saddlery, smithy, stables, store, sawmill, newspaper office – they offer the visitor the illusion of knowable, self-enclosed little worlds which can be taken in at a glance, revealed to the tourist's gaze in their entirety in the course of a morning's stroll. Or, as at Timbertown, laid open to a controlling vision via the railway ride which – like the one at Dreamworld – circles the site and establishes its perimeters, separating it from the bush with which, however, it also merges imperceptibly. As the brochure prepares the visitor for the experience which beckons:

> Step back into the past . . . and take a stroll through Australia's history. Timbertown is an entire village, re-created to demonstrate the struggles and achievements of our pioneers. It reflects the way they lived, the way they worked, their hardships and their skills.
>
> It is not a lifeless museum . . . it lives! It's an authentic, vital township where the stream train runs, timber is still sawn, the bullock team still trudges with its heavy load, the woodturner transforms natural timber into works of art, and the general store sells home-made wares and lollies in glass jars . . .
>
> Hear, too, the noises of yesteryear . . . the whistle of the steam train, the bellowing of the bullocks, the clanging of the blacksmith's iron. And, as you pass the old hotel, you hear the sounds of the pianola or true Australian folk music, the happy sounds that entice the folk of the village into the tavern for a hearty singalong . . .
>
> And in this atmosphere of rural serenity, its [sic] likely that the township fringes will reveal kangaroos, wallabies, kookaburras, bower birds and other species of Australian fauna.
>
> Timbertown . . . a fascinating reflection of how people lived and worked in the simplicity and ruggedness of 19th Century Australian bush life.

A number of difficulties coalesce here. The first consists in the false naturalization of past social relations which results from their miniaturization and, more particularly, from their self-enclosure. Timbertown is not merely a compressed and knowable little world, it is also an isolated one; the railway does not lead out of the town, connecting it to a wider set of social and economic relations, but rather circles it, closing it in on itself. The consequence is that the tale of pioneer hardship which the museum tells – largely

158

in the form of push-button commentaries which relate the conditions of work in the sawmill or in the forest – seems to be one which flows from the harshness of nature itself. If the millworkers' living conditions were spartan and their working days long and arduous, this is because the bush was a stern taskmaster. It has seemingly little to do with the encompassing system of economic relations which governed the structure of the timber industry – the conditions of ownership prevailing within it, the organization of the world market, the degree to which its profits were retained in Australia or returned to Britain – and thus powerfully influenced the ways and standards of living within timber towns as well as their internal structures of power and authority.

In brief, by excerpting the reconstructed township from any sense of a broader historical context, Timbertown mystifies past social relations, transforming a particular phase in the capitalist exploitation of Australia's natural resources into a rural idyll where the village folk troop off to the tavern every night for a communal singalong. This screening of past economic relations is complemented by the ways in which Timbertown simultaneously masks the economic relations which secure its own existence. As is true of many open-air museums, this venture in living history rests on a dual economy. A part of the function of such museums is to deliver a market for the various retail outlets – selling refreshments, craft products, tourist curios, historical fetishes – which constitute a significant proportion of their interiors. While sometimes run by salaried staff, such enterprises are often run privately by local entrepreneurs who, much like side-stall operators at amusement parks, are leased their premises on a concessionary basis. Although the rent charged such private businesses helps to meet overhead and salary costs – including those associated with the special displays which provide one of the major tourist enticements – these are mostly provided for through admission charges.

Both aspects of this dual economy tend to be shrouded. Transactions with costumed retailers are conducted in an imaginary mode, as if the visitor were buying a genuine historical article from an authentic inhabitant rather than paying for a commodity decked out in the attire of history from an entrepreneur or salaried worker. The masking of the economic relations associated with the demonstration of past crafts and skills has a somewhat more complex structure. At Timbertown, most of the forms of labour displayed are manifestly unproductive on their own terms: a team of bullocks drags the same log round the same circle several times a day, and is yoked and unyoked in a demonstration of traditional skills; an operating sawmill is activated at set times, but it cuts no timber. A significant amount of social labour with no readily discernible end-product, its productivity consists entirely in the revenue which its display generates. It is, in other words, labour as spectacle, labour transformed into a form of tourist consumption whose nature as such, however, is withdrawn from the arena in which it is performed to the degree that the transactions which sustain it take place off-site, outside the boundaries of the fabricated historical milieu in the buffer zone which

regulates the visitors' transition between the site's inside and its outside, between past and present.

The markers of such transition zones are many and various. Those at Old Sydney Town are perhaps the most elaborate, beginning in the car park ('Park your car here and leave the twentieth century behind'), continuing through the entry building – a large, modern complex of tourist kiosks which urge the visitors to make sure they have all they need before they pass through the turnstiles, as there were no cameras, batteries or films in 1788 – and then, once the price of admission has been paid, through a barbecue and tea-house area before entering a tunnel which gives access to the zone of history, to 1788. Although not so complex, the buffer zones of Sovereign Hill and Timbertown are essentially similar in nature. Timbertown is fronted by a hyper-modern building within which the boundary between past and present is marked by a turnstile (staffed by costumed museum workers) which divides the foyer (modern and functional) from a period setting which gives way to a passageway displaying equipment associated with the timber industry – adjustment zones leading to the zone of history proper. The effect of these markers is reinforced by their virtual absence within the reconstructed historical milieux of the museums' interiors. These are rigorous in their exclusion of any signs of modernity. Sovereign Hill is bereft of explanatory notices in case these might detract from the authenticity of the illusion. Old Sydney Town provides historical information in the form of notice-boards which contrive – in their appearance of age, their antiquated spelling and modes of address – to be intended for a citizen of 1788 rather than a modern tourist. Rubbish bins are hidden in barrels. Toilets are coyly signposted as privies and contained within period buildings – as at Timbertown where, as if to deny them official existence, they are not indicated on the plan of the site in the museum's brochure.

Yet nowhere is an inside more effectively separated from its outside than at Disneyland. M.R. Real notes that, apart from the physical boundaries of a huge parking lot, a circulating railway and the ticket booths, the visitors are screened to ensure that prescribed dress codes – no political messages are allowed on patches, buttons or T-shirts – are observed, and that potential unruly elements (drinkers or addicts) are excluded. Perhaps more important, however, is the screening out of money through its replacement by different classes of tickets, special tokens which allow free participation in the entertainments of the interior – but free, of course, only because it has already been paid for. Yet this screening out of money is designed only to secure its more liberal passage when the visitor moves from the entertainments covered by the entry ticket to Disneyland's innumerable retail outlets in encouraging the illusion of a world in which consumption is experienced as play. 'The Main Street facades', as Umberto Eco puts it, 'are presented to us as toy houses and invite us to enter them, but their interior is always a disguised supermarket, where you buy obsessively, believing that you are still playing'

(Eco 1987: 43). The scale, no doubt, is different; none the less, the principle embodied in open-air museums is essentially similar – stimulating commodity circulation by organizing consumption under the sign of history – as are the means by which it is accomplished.

There is, however, a more general problem arising from the relationship between the preserved or reconstructed past and the economics of tourism which open-air museums serve merely to highlight. It is, moreover, a problem which is especially acute in the Australian context and threatens to become more so now that, in contrast with the loftier sentiments of the 1970s, the search for the tourist dollar has become the primary driving force of museum and heritage policy. As Dean MacCannell notes, the logic of historical tourism is to drive a wedge between the modern world and the past by fashioning the latter in the image of modernity's imaginary other; a world which we have supposedly lost and which we retreat to from the present in search of a never-to-be-found set of roots or identity. Even as noted a historian as Manning Clark is not immune to the allure of this conception:

> On a journey round the inhabited parts of Australia today the eye of the traveller is rarely given respite from the monuments of the age of the motor car and the jet engine. The motel, the used car lot, the petrol bowser, the fast food dispenser and the bottle shop have become the main features of the scenery in which we live out our lives. In the cities high-rise buildings dominate the horizon, in the country wheat silos have replaced the temples of an earlier age.
>
> Yet from time to time, in places such as Windsor in New South Wales, Carlton in Victoria, Burra in South Australia, Kalgoorlie in Western Australia, Roma in Queensland, Evandale in Tasmania, Gungahlin in the Australian Capital Territory or Darwin in the Northern Territory, the traveller or the local inhabitant is immediately aware of another Australia, remote from the Australia of the skyscraper and conspicuous waste: there is also an old Australia.
>
> (Australian Council of National Trusts 1978)

It is clear even to casual observation that the structure of the Australian past is the victim of a rural gerrymander which brings with it a marked temporal imbalance owing to its disproportionate concentration on the lives of pioneers, settlers, explorers, gold-mining communities and rural industries in the nineteenth century at the expense of twentieth-century urban history. Nor is this simply a matter of the preponderance of museum and heritage sites devoted to such themes. In tourist literature, with a consistency which belies exception, the past is represented as precisely something to get away to, often in the register of the Dreamworld jingle 'Take a trip away from the everyday'. Michael Bommes and Patrick Wright, noting a similar tendency in the British context, argue that it serves to dehistoricize both past and present to the degree that the former becomes a tourist spectacle precisely because it is

divorced from the present while the latter – or, more accurately, the recent past – seems devoid of history precisely because it does not fall within the zone of the officially demarcated past (Bommes and Wright 1982: 296). There is a clear dilemma here. The more the structure of the past is subject to the exigencies of tourism, the greater the likelihood that it will focus on the country rather than the city, and on the nineteenth rather than the twentieth century. It will, as a consequence tend to offer the great majority of Australians an imaginative diversion from their present conditions of existence rather than affording a familiarity with the more immediate histories from which those conditions effectively flow. Such a policy, in the Australian context, runs the further risk – and the more so as tourism becomes an increasingly export-orientated industry – of fashioning a past which meets the demand of foreign visitors for tourist locations which seem to embody the virtues of the exotic, the eccentric and the authentic – in short, which seem to be the antithesis of the metropolitan centres from which they travel. The more the Australian past is fashioned to meet this demand, the greater will be its tendency to represent Australians to themselves through the cracked looking-glass of the Anglo-American gaze in its tendency to cast the national character in the form of a heroic and primitive simplicity – the Crocodile Dundee factor.

If this is cause for concern, it is because more than history is at stake in how the past is represented. The shape of the thinkable future depends on how the past is portrayed and on how its relations to the present are depicted. Nietzsche recognised this in his comments on those 'historical men' who 'only look backward at the process to understand the present and stimulate their longing for the future' (Nietzsche 1976: 14). Yet he also spoke of an antiquarian attitude to the past which, valuing all that is 'small and limited, mouldy and obsolete', organizes the past as a refuge from the present in which the conservative and reverent soul of the antiquarian builds a secret nest' (ibid.: 24). Both orientations are evident in the structure of the Australian past – a future-orientated trajectory governed by the rhetoric of Australia's unending development and the preservation of the past as an enclave within, and retreat from, the present. Foucault, echoing Nietzsche's critique of these two orientations, recommends instead the virtues of what Nietzsche called 'effective history'. Such a history would not aim to inscribe the nation within an uninterrupted narrative of its self-development. Rather, it would seek to disrupt such pretended continuities, and it would do so, Foucault argues, 'because knowledge is not made for understanding; it is made for cutting' (Foucault 1980a: 154). Perhaps the cause of a critical national consciousness would be best served by the institution of a public past which cut into, and thus questioned, those narratives of nationing which currently enjoy the greatest cultural weight rather than lending them the authority of governmental benediction.

6

ART AND THEORY
The politics of the invisible

In his essay 'The Historical Genesis of a Pure Aesthetic', Pierre Bourdieu
offers a useful thumbnail sketch of the historical processes involved in the
formation of an aesthetic structure of vision – what Bourdieu calls the 'pure
gaze' – in which the work of art is attended to in and for itself. The
organization of the categories governing how works of art are named or
labelled, Bourdieu argues, plays an important role within these processes and
he suggests that the term 'theory' might aptly be used to describe these
categories, the manner of their functioning and their effects. 'Theory', he
writes, 'is a particularly apt word because we are dealing with seeing –
theorein – and of making others see' (Bourdieu 1987: 203).

To analyse the historical processes through which the 'pure gaze' is
constituted is thus, in part, to trace the formation of those spaces and
institutions in which works of art are so assembled, arranged, named and
classified as to be rendered visible as, precisely, '*art*' just as it is also to
examine those forces which produce spectators capable of recognizing and
appreciating those works as such. In truth, these are two sides of the same
coin, the production of '*art*' and the production of aesthetes forming two
aspects of the dialectic through which, as Marx argued in the *Grundrisse*, the
processes of producing an object for consumption and a consuming subject
always organize and beget one another in the forms required for the circuit
of exchange between them to be completed (see Marx 1973: 90–2). As
Bourdieu puts it:

> The experience of the work of art as being immediately endowed with
> meaning and value is a result of the accord between the two mutually
> founded aspects of the same historical institution: the cultured habitus
> and the artistic field. Given that the work of art exists as such, (namely
> as a symbolic object endowed with meaning and value) only if it is
> apprehended by spectators possessing the disposition and the aesthetic
> competence which are tacitly required, one could then say that it is
> the aesthete's eye which constitutes the work of art as a work of art.
> But, one must also remember immediately that this is possible only to

the extent that the aesthete himself is the product of a long exposure to artworks.

<div align="right">(Bourdieu 1987: 202)</div>

It is, however, theory – in this case, a distinctive language of art – which mediates the relations between the aesthete and the work of art offering, through its categories (of art's autonomy, of creativity, of the irreducible individuality of the artist, etc.), a means whereby the works on display can be construed and experienced as the manifestations of a higher order reality (*'art'*) of which they are but the tangible expressions. In this way, theory – present just as much in the principles governing the display of art works as in the aesthete's head – organizes a particular set of relations between the visible (the works of art on show) and the invisible (*'art'*) such that the former is perceived and utilized as a route to communion with the latter. Yet this theoretical ordering of the relations between the visible and an invisible also plays a role in organizing a distinction between those who can and those cannot see; or, more accurately, between those who can only see what is visibly on display and those who are additionally able to see the invisible realities (*'art'*) which the theory posits as being accessible via the objects exhibited.

This helps to account for the different attitudes of different types of visitors to the use of labels, guidebooks or other kinds of contextualizing and explanatory materials in art museums. In their now classic study *The Love of Art*, Bourdieu and Darbel note that working-class visitors typically responded most positively to the provision of guidebooks or directions as to the best route to take through an art museum. It may well be, Bourdieu and Darbel argue, that such clarifications are not always able to 'give "the eye" to those who do not "see"' (Bourdieu and Darbel 1991: 53). None the less, their presence in a gallery is symbolically important just as is the demand for them by working-class visitors in that both testify to the possibility that the gap between the visible and the invisible may be bridged by means of appropriate trainings. If, by contrast, and as their evidence suggested, the cultivated classes are the most hostile to such attempts to make *art* more accessible, Bourdieu and Darbel argue that this is because such pedagogic props detract from that charismatic ideology which, in making 'an encounter with a work of art the occasion of a descent of grace (*charisma*), provides the privileged with the most "indisputable" justification for their cultural privilege, while making them forget that the perception of the work of art is necessarily informed and therefore learnt' (ibid.: 56).

It would, of course, be wrong to eternalize the findings of this study, especially in view of the economistic leanings which characterize Bourdieu's view of the relations between class and culture. As John Frow has shown, there is a tendency in Bourdieu's work to polarize aesthetic dispositions around two options – the popular and the bourgeois – whose coherence

derives from the pre-given class logics on which they depend (Frow 1987). Be this as it may, it is a tendency which runs against the grain of Bourdieu's more general argument that the characteristics of the artistic field, and thus of the specific competences that individuals need to acquire in order to perceive its invisible significances, are a mutable product of the relations between the practices of art galleries, the discursive categories that are made available by art theory, the means by which these are circulated, and the forms of art training and familiarization available in educational institutions. A more recent finding, made some twenty years later and in Australia, that support for the view that art galleries should provide explanatory and contextualizing material was strongest on the part of those with the highest levels of educational attainment, may thus be evidence of an artistic field which is differently structured in these regards (see Bennett and Frow 1991).

Even so, the more general point I am concerned to make here remains valid: that, in art galleries, theory, understood as a particular set of explanatory and evaluative categories and principles of classification, mediates the relations between the visitor and the art on display in such a way that, for some but not for others, seeing the art exhibited serves as a means of *seeing through* those artefacts to see an invisible order of significance that they have been arranged to represent.

The same is true of all collecting institutions. In *Collectors and Curiosities*, Krzysztof Pomian defines a collection as 'a set of natural or artificial objects, kept temporarily or permanently out of the economic circuit, afforded special protection in enclosed places adapted specifically for that purpose and put on display' (Pomian 1990: 9). Pomian defines such objects as semiophores – that is, as objects prized for their capacity to produce meaning rather than for their usefulness – and, in asking what it is that the objects contained in different kinds of collection have in common which accounts for their being selected as semiophores, concludes that their homogeneity consists in their ability to be involved in an exchange process between visible and invisible worlds.

Whatever the differences between them in other respects, then, the objects housed and displayed in collecting institutions – whether museums, temples or cabinets of curiosities – function in an analogous manner. In comprising a domain of the visible, they derive their significance from the different 'invisibles' they construct and from the ways in which they mediate these to the spectators. Or, to put this another way, what can be seen in such institutions is significant only because it offers a glimpse of what cannot be seen. When, in the classical world, offerings intended for the gods were put on public display, the result, Pomian thus argues, was that:

These offerings could continue to function as intermediaries for this world and the next, the sacred and the secular, while at the same time constituting, at the very heart of the secular world, symbols of the distant, the hidden, the absent. In other words, they acted as go-

165

betweens between those who gazed upon them and the invisible from whence they came.

<div style="text-align: right">(Pomian 1990: 22)</div>

In the modern history museum, by contrast, objects are typically displayed with a view to rendering present and visible that which is absent and invisible: the past history of a particular people, nation, region or social group. This organization of a new invisible was the combined result of the choice of a new set of semiophores (period costumes, for example) and of the display of old semiophores in new arrangements (the tombs of notables arranged in chronological succession) through which a national past, say, could be rendered materially present through an assemblage of its artefactual remnants.

However much truth there might be in these generalizations, though, the orders of the visible and the invisible are not connected in an invariant manner. Rather, the ways in which the former mediate the relations between the latter and the spectator depend on the role of specific ideologies of the visible. At times, different ideologies of the visible may even inform the arrangement of the same collection, giving it a multi-levelled structure. Alexandre Lenoir thus arranged his collection at the Musée des monuments français from two points of view. From a political point of view which echoed revolutionary conceptions of the need for transparency in public life, he thus argued that a museum should be established with sufficient splendour and magnificence to 'speak to all eyes' (*parler a tous les yeux*) (cited in Vidler 1986: 141). From this point of view, the invisible which the Musée des monuments français allowed everyone to see was the history of the French state, its glory made manifest in the chronological succession of tombs and relics that had been rescued from revolutionary vandalism in order, precisely, to organize a national past and render it publicly visible and present. As Michelet subsequently described the museum:

> The eternal continuity of the nation was reproduced there. France at last could see herself, her own development; from century to century, from man to man and from tomb to tomb, she could in some way examine her own conscience.

<div style="text-align: right">(Cited in Haskell 1971: 115)</div>

From the point of view of the museum's role as a vehicle for public instruction, however, its artefacts were so arranged, and its architecture so contrived, as to give access to a second-order invisible: the progress of civilization towards the Enlightenment. Conferring a visibility on this developmental conception of time, Anthony Vidler has argued, was the result of an architectural arrangement which, as the visitor's route led chronologically from one period display to another, allowed for a progressive increase in the amount of natural light available to illuminate the exhibits,

<div style="text-align: center">166</div>

thus symbolizing man's journey from darkness towards the light (Vidler 1987). In passing from room to room, as Lenoir put it, the more the visitor *'remonte vers les siècles qui se rapprochent du nôtre, plus la lumière s'aggrandit dans les monuments publics, comme si la vue du soleil ne pouvait convenir qu'à l'homme instruit'* (cited in Vidler 1986: 145).

In the early years of their establishment, public museums were centrally concerned with this latter kind of invisible: that is, with an order of significance which, rather than being thought of as spontaneously available to the inspection of all, was seen as requiring a calculated arrangement to make it visible. In this respect, those critiques which attribute a fetishism of the object to nineteenth-century museum exhibition practices quite often miss their mark. For, by the end of the century, at least in natural history and anthropology museums, the objects on display were far from being regarded as being meaningful and significant in and of themselves. Rather, they were often viewed as merely convenient props for illustrating – making visible – the ordering of forms of life or peoples proposed by scientific principles of classification, a view nicely encapsulated in George Brown Goode's famous maxim that a museum is 'a collection of instructive labels illustrated by well-selected specimens'.

Similar reasoning had been applied to art galleries when their potential to function as instruments for public instruction had been the paramount consideration governing their conception and design. In 1842, a year after a House of Commons Select Committee had recommended that all its pictures should be clearly labelled and that a cheap information booklet be produced for its visitors, Mrs Jameson thus summarized the historicist principles of the chronological hang which had proved so influential in the design of London's National Gallery:

A gallery like this – a national gallery – is not merely for the pleasure and civilisation of our people, but also for their instruction in the significance of art. How far the history of the progress of painting is connected with the history of manners, morals, and government, and above all, with the history of our religion might be exemplified visibly by a collection of specimens in painting, from the earliest times of its revival, tracing pictorial representations of sacred subjects from the ancient Byzantine types . . . through the gradual development of taste in design and sensibility in colour. . . . Let us not despair of possessing at some future period a series of pictures so arranged . . . as to lead the enquiring mind to a study of comparative style in art; to a knowledge of the gradual steps in which it advanced and declined; and hence to a consideration of the causes, lying deep in the history of nations and of our species, which led to both.

(Cited in Martin 1974, no. 187: 279–80)

Of course, the chronological hang was typically not just historicist but also

nationalist in conception. If, as Carol Duncan and Alan Wallach have aptly christened them, 'universal survey museums' display art historically with a view to making the progress of civilization visible through its artistic achievements, the role of the particular 'host' nation in question is always accorded a privileged position such that the state acquires a visibility of its own in and amidst progress's relentless advance. Duncan and Wallach thus argue, taking the post-revolutionary transformation of the Louvre as their example, that art, in being transferred from royal collections into the new space of the public museum, could then be used to make visible 'the transcendent values the state claims to embody' and so lend 'credibility to the belief that the state exists at the summit of mankind's highest attainments' (Duncan and Wallach 1980: 457).

In the case of France, similar principles applied to the development, in the Napoleonic period, of a public museum system in the provinces in view of its dependency on strongly centralized forms of support and direction. Thus, in his study of the *envoi* system whereby works of art were made available on loan from national collections to provincial art museums, Daniel Sherman has shown how the primary purpose of this scheme was to make the state as such visible throughout France. 'It would be only a mild exaggeration', Sherman thus writes, 'to say that the state attached less importance to the pictures themselves than to the labels on them that said "Don de l'Empereur" (gift of the Emperor) or later, more modestly but no less clearly, "Dépôt de l'Etat" (deposit of the State)' (Sherman 1989: 14). It was similarly important that, in the system of inspection set up to supervise the standards of those museums which took part in the *envoi* system, considerable emphasis was placed on the desirability of well-ordered, clearly labelled exhibitions from the point of view of their capacity to instruct. 'If a museum does not, through its methodical arrangement, facilitate general instruction,' the inspector Charvet thus wrote of the art museum in Roanne, 'if it is nothing but a place where objects of artistic or historical interest or curiosities are assembled, it cannot attain precisely that elevated goal that the curator has so well detailed in the preface to his inventory' (cited in ibid.: 76).

However, Sherman also throws useful light on the processes whereby, in its later development, the ethos of public instruction that had initially fuelled the public art museum declined as such institutions – to a greater degree than any other museum type – came to play an increasingly crucial role in the process through which relations of social distinction were organized and reproduced. Three aspects of these developments might usefully be commented on here.

First, in association with the 'Haussmannization' of, initially, Paris and, subsequently, France's major provincial cities, debates regarding suitable locations for art museums took on a new aspect. By the 1860s and 1870s, a premium was no longer placed on the degree to which the general accessibility of an art museum's location could enhance its utility as an instrument

of public instruction. To the contrary, as a part of what would nowadays be called 'city animation' strategies, new art museums – in Bordeaux, Marseilles and Rouen – were typically situated in parts of the city where they might serve as marker institutions targeting hitherto derelict parts of cities for programmes of bourgeoisification. In making such areas fashionable, art museums attracted bourgeois residents to their neighbouring suburbs resulting in a rise in property values which forced working-class residents to seek accommodation elsewhere. In this way art museums furnished a crucial component of the material and symbolic infrastructure around which new forms of class-based residential segregation were developed.

It is, then, small wonder that the bourgeois should wish his or her status to be recognized when visiting art museums. Recognition of such distinction, however, became increasingly difficult to secure – and partly because of the very success of art museums and kindred institutions in reforming the manners, the standards of dress and behaviour, of the museum-visiting public. Although the point cannot be made incontrovertibly, it is likely that the opening of such museums as the Louvre and the British Museum did not spontaneously result in their being regularly used and visited by the urban middle classes. To the degree that such museums could be and were visited by artisans and workers who, if not unwashed, were often rude and boisterous, then so, as Michael Shapiro has argued, the norms of behaviour that were later to facilitate middle-class participation in museums had yet to emerge (Shapiro 1990). Those norms were only gradually fashioned into being through a history of rules and regulations, of prescriptions and proscriptions, by means of which new publics were tutored into codes of civilized and decorous behaviour through which they were to be rendered appropriately receptive to the uplifting influence of culture. As Michael Shapiro puts the point:

> Middle-class audiences learned that the restraint of emotion was the outward expression of the respect for quality, the deference to the best demanded of those who viewed objects in public places. Exhibitions thus became textbooks in public civility, places where the visitors learned to accord their counterparts recognition while avoiding modes of speech and conduct that intruded upon another's experience.
>
> (Shapiro 1990: 236)

But what could be learned by the middle classes could also be learned by the working classes. Indeed, in the conception of those who viewed museums as instruments of social reform, it was intended that they should function as spaces of emulation within which visitors from the lower classes might improve their public manners and appearance by imitating the forms of dress and behaviour of the middle classes. The consequence, viewed in the light of related developments over the same period, was that different classes became less visibly distinct from one another.

169

The development of mass-manufactured clothing, Richard Sennett has argued, resulted, in the second half of the nineteenth century, in a tendency towards increased homogeneity and neutrality of clothing as being fashionable came to mean 'to learn how to tone down one's appearance, to become unremarkable' (Sennett 1978: 164). The more standardized clothing became, however, the greater was the attention paid to those trivial details, the minutiae of costume, through which, to the discerning eye, social status might be symbolized. It is in this light, Daniel Sherman suggests, that we might understand the passion with which, in the 1880s and 1890s, middle-class visitors resisted attempts by French provincial museums to introduce regulations requiring that umbrellas be checked in rather than carried through the galleries. For, Sherman argues, although umbrella-carrying was a habit that had spread to all classes, 'the shape and condition of an umbrella could provide clues about the social status of the person carrying it' (Sherman 1989: 228; see also Sherman 1987). The umbrella was, in short, a visible sign of distinction, and the struggle (largely successful) that was waged to retain the right to carry umbrellas reflected the degree to which the space of the art museum had become increasingly mortgaged to practices of class differentiation.

If, in this way, the bourgeois public rendered itself visibly distinct in a way that was manifest to the gaze of others, it was also able to render itself distinctive in its own eyes by organizing an invisible which it alone could see. By the late nineteenth century, to come to Sherman's third point, the earlier enthusiasm for rationally ordered, clearly labelled displays no longer applied to the new provincial art museums constructed in this period. Instead, under the influence of a revival of Baroque aesthetics, pictures from different schools, types or periods were juxtaposed with one another in densely packed displays which virtually covered entire exhibition areas. Reflecting their concern to please rather than instruct the public, labelling was a low priority for the new museums of this period with the result that they either lacked descriptive labels for several years after their opening or provided such labels in such a minimalist fashion that they tended to institutionalize rather than overcome the cultural divide between their cultivated visitors and (for such is how it was conceived) the residue of the general public.

In recommending that there should be labels indicating the artist and subject for every painting, the director of the Rouen museum thus contended that the result would be 'a kind of abridged catalogue – not enough for real art lovers, it's true, but enough to disseminate some "glimmerings of truth" among the mass of the public, who are only interested in a work when they know the subject or when a famous name halts them en route and forces their admiration' (cited in Sherman 1989: 217–18). As Sherman argues, this recognized a division in the museum's public in a manner which 'emphasised rather than dispelled its less educated members' inferior status' (ibid.: 218).

When endorsing the view that a museum should be regarded as 'a collection

of instructive labels illustrated by well-selected specimens', Henry Flower had not exempted art museums from the requirements this entailed. It is true that he regarded art museums as having further to go to meet these standards than other museum types, complaining of their tendency to display too many works of art, incongruously juxtaposed to one another in unsuitable and poorly contextualized settings. However, Flower could see no reason why art museums should be exempt from the general requirements he believed needed to be met if public collecting institutions were to function effectively as vehicles for instructing the general public. 'Correct classification, good labelling, isolation of each object from its neighbours, the provision of a suitable background, and above all of a position in which it can be readily and distinctly seen,' he argued, 'are absolute requisites in art museums as well as in those of natural history' (Flower 1898: 33).

It is, perhaps, a long way from the decontextualizing Baroque principles of display Sherman describes – and which Flower was reacting to – to the subsequent history of the modernist hang in which the idea of art's autonomy was given a spatial and architectural embodiment. For it is only with the advent of modernism that the art gallery space assumes a value in and of itself as that which, in endowing the work of art with an illusion of separateness and autonomy, also then requires spectators capable of responding to it in its own right. 'The ideal gallery', as Brian O'Doherty puts it, 'subtracts from the artwork all clues that interfere with the fact that it is "art". The work is isolated from everything that would detract from its own evaluation of itself' (O'Doherty 1976: 14). Be this as it may, one can see the respects in which the late nineteenth-century display practices Sherman describes begin to prepare the ground for modernism in their commitment to the organization of a new invisible – 'art' – which only the *cognoscenti* could catch a glimpse of. In the initial phases of their development, public art museums, it was suggested earlier, served, through the arrangement of their exhibits, to make the history of the state or nation, or the progress of civilization, visible. By the late nineteenth century, in a manner which differentiated them sharply from other types of museum, and continues to do so, the relations between the visible and the invisible in art museums became increasingly self-enclosing as the works on display formed part of a coded form of inter-textuality through which an autonomous world of 'art' was made visible to those who were culturally equipped to see it.

If a genealogy for the role of theory in the modern art museum is called for, it is, perhaps, along the lines sketched above that one might be found. If it is true of all collecting institutions that they so arrange the field of the visible as to allow an apprehension of some further order of significance that cannot, strictly speaking, be seen, the art museum is unique in simultaneously organizing a division between those who can and those cannot see the invisible significances of the 'art' to which it constantly beckons but never makes manifest. Far less freely and publicly available than the artefacts on

171

display in the art museum, the aesthetic theories of modernism and post-modernism selectively mediate the relations between the visitor and the museum in providing – for some – a means of reading the invisible grid of intertextual relations through which the works on display can be experienced as '*art*'. Moreover, this affects the production as well as the consumption of artistic objects to the degree that much artistic production is now com-missioned by, or is made with a view to its eventual installation in, art museums. This institutional complicity of art with the art museum has, Ian Burn argues, 'created a need for affirmative (and self- affirming) theory, with art increasingly "spoken for" by the new writing which has evolved its own academic forms of "disinformation" about works of art' (Burn 1989: 5).

Of course, this is not to suggest that there is a simple or single 'politics of the invisible' associated with the modern art museum. To the contrary, it is clear that those critiques of the art museum which have been developed from positions outside it have sought to politicize the museum space precisely by pointing to the respects in which, in making '*art*' visible to some but not to others, it simultaneously occludes a view of the diverse social histories in which the assembled artefacts have been implicated. The feminist critiques of Roszika Parker and Griselda Pollock (1982) and the critical ethnographic perspectives of James Clifford (1988) are cases in point. In both cases, moreover, their implications for the exhibition practices of art museums are the same: that the artefacts assembled in them should be so arranged as to produce, and offer access to, a different invisible – women's exclusion from art, for example, or the role of museum practices in the aestheticization of the primitive.

It is, however, crucial to such interventions that they should take into account the more general 'politics of the invisible' associated with the form of the art museum if they are not to be limited, in their accessibility and therefore in their influence, to those élite social strata who have acquired a competence in the language and theory of '*art*'. This is not to suggest that existing forms of aesthetic training should be made more generally available without, in the process, themselves being modified. Rather, my point is that those interventions into the space of the art museum which seek to take issue with the exclusions and marginalizations which that space constructs, will need, in constructing another invisible in the place of '*art*', to give careful consideration to the discursive forms and pedagogic props and devices that might be used to mediate those invisibles in such a way, to recall Bourdieu and Darbel, as to be able, indeed, to 'give "the eye" to those who cannot "see"'.

The theories which inform such interventions may well be complex. However, the scope and reach of their effectivity will depend on the degree to which such theories are able to be translated into a didactics that is more generally communicable. The question of the role of theory in art museums is thus not one that can be posed abstractly; it is inevitably tied to questions

172

of museum didactics and hence to the different publics which different didactics imply and produce. This means that the place of theory in the art museum has always to be considered in relation to the role of schooling in the production and distribution of artistic trainings and competences. When the schooling system fails to work methodically and systematically to bring all individuals into contact with art and different ways of interpreting it, Bourdieu and Darbel argue, it abdicates the responsibility, which is its alone, 'of *mass-producing* competent individuals endowed with the schemes of perception, thought and expression which are the condition for the appropriation of cultural goods' (Bourdieu and Darbel 1991: 67). To the degree that no schooling system at present accomplishes this, any attempt to renovate the art museum's space theoretically and politically must simultaneously be committed to developing the means of instruction which will help bridge the gap between the invisible orders of significance it constructs and the social distribution of the capacity to see those invisible significances.

Part III

TECHNOLOGIES
OF PROGRESS

7

MUSEUMS AND PROGRESS
Narrative, ideology, performance

In his account of the methods of Voltaire's Zadig, who astounded his listeners by his ability to visualize an animal from the tracks it had left behind, Thomas Huxley likened Zadig's conclusions to 'retrospective prophecies' (Huxley 1882: 132). Anticipating the objection that this might seem a contradiction in terms, Huxley argued that prophetic reasoning rests on the same procedures whether they be applied retrospectively or prospectively. For 'the essence of the prophetic operation', as he put it, 'does not lie in its backward or forward relation to the course of time, but in the fact that it is the apprehension of that which lies out of the sphere of immediate knowledge; the seeing of that which to the natural sense of the seer is invisible' (ibid.: 132). Between the two cases, then, the process remains the same; it is only the relation to time that is altered.

Yet, from the point of view of the various historical sciences in which, over the eighteenth and nineteenth centuries, this method was applied, the relation to time was crucial. In history, geology, archaeology, and palaeontology, Carlo Ginzburg argues, 'Zadig's method' – 'that is, the making of retrospective predictions' – predominated. Where causes cannot be repeated, as Ginzburg puts it, 'there is no alternative but to infer them from their effects' (Ginzburg 1980: 23). However, in translating 'Zadig's method' into the 'conjectural paradigm' which he argues governs the procedures of the historical sciences, Ginzburg loses something of the stress which Huxley had placed on the visualizing capacities of those sciences. 'Any scene from deep time', as Martin Rudwick puts it, 'embodies a fundamental problem: it must make visible what is really invisible. It must give us the illusion that we are witnesses to a scene that we cannot really see; more precisely, it must make us "virtual witnesses" to a scene that vanished long before there were any human beings to see it' (Rudwick 1992: 1).

Rudwick's concern here is with the formation of the modern disciplines of prehistory, perhaps the most crucial of which was palaeontology in view of its role in connecting geology and natural history and so mediating those narratives concerned with the history of the earth and those telling of the history of life on earth. It is, accordingly, to Cuvier's work that he looks for

177

a model of the new procedures which came to characterize these disciplines. In permitting the reconstruction of extinct forms of life on the basis of their anatomical remains, Cuvier had made it possible for a whole new set of objects to be drawn into the sphere of visibility. 'The establishment of the reality of extinction, notably by Cuvier,' Rudwick argues, 'provided for the first time the raw material for composing illustrations that would depict scenes significantly, and interestingly, different from scenes of even the most exotic parts of the present world' (Rudwick 1992: 56).

In describing Zadig's method, Huxley proposes a neologism – 'would that there were such a word as "backteller!"' – as the best way of describing the procedures of 'the retrospective prophet' who 'affirms that so many hours or years ago, such and such things were to be seen' (Huxley 1882: 133). By the time Huxley published his essay in *Science and Culture*, perhaps the most influential 'backteller' of all – Conan Doyle's Sherlock Holmes – was in the process of establishing his reputation in the pages of *The Strand* magazine. As a narrative form constructed around the provision of a trail of clues and their delayed decipherment, the methods of detective fiction are – as Ginzburg has argued – similar to those of the sciences governed by the conjectural paradigm. In a good deal of the discussion of the genre, the emphasis has fallen on the similarities between Holmes's methods and those of the medical sciences (see Sebeok and Umiker-Sebeok 1983). But its relations to the historical sciences are also clear. Like the palaeontologist, the detective must reconstruct a past event – the crime – on the basis of its remnants; and, just as for the palaeontologist, bones may well be 'all that remains' for this purpose. 'A detective policeman', as Huxley put the point, 'discovers a burglar from the marks made by his shoe, by a mental process identical with that by which Cuvier restored the extinct animals of Montmartre from fragments of their bones' (Huxley 1895: 45–6).

Yet if the detective is a 'backteller' and if, as Boris Eichenbaum argued, the detective story is governed by the art of backward construction, the effect of this on the reader is, ideally, to propel him or her through the narrative with as much expedition as possible, driven by an epistemophelia that is unquenchable until the reader knows 'whodunit' (see Eichenbaum 1971). The narrative machinery of detective fiction may be constantly backward-glancing as it infers causes from their effects and makes visible the crime and its perpetrator from the traces he or she has left behind, but it constantly moves the reader forward.

The museum was another 'backteller', a narrative machinery, with similar properties. In the newly fashioned deep-times of geology, archaeology and palaeontology, new objects of knowledge were ushered forth into the sphere of scientific visibility. The museum conferred a public visibility on these objects of knowledge. Of course, it was not alone in doing so: by the 1830s, imaginative pictorial reconstructions of prehistoric forms and scenes of life were widely available. But it was in the museum and its sibling, the

exhibition, that these new pasts were made visible in the form of re-constructions based on their artefactual or osteological remains.[1] It was also in the museum that these new pasts were organized into a narrative machinery through which, by means of the techniques of backward con-struction, they linked together in sequences leading from the beginnings of time to the present.

But what are we to make of this? The answer easiest to hand suggests that, as the influence of evolutionary thought increased, museums came in-creasingly to embody or instantiate ideologies of progress which, in enlisting their visitors as 'progressive subjects' in the sense of assigning them a place and an identity in relation to the processes of progress's ongoing advance-ment, also occluded a true understanding of their relations to the conditions of their social existence. This would be to construe the arrangements of objects within museums as the effect of a mental structure which achieves its influence on the individual through the unconscious effects of recognition and misrecognition to which it gives rise. This view devalues the effects of the museum's own specific materiality and the organization of its practices. It sees the artefactual field the museum constructs as merely one among many possible means or occasions through which a particular mental structure impinges on the field of subjectivity, implying that the effects of that structure are the same whatever the means used to realize it. A better way of looking at the matter, I want to suggest, is to view the narrative machinery of the museum as providing a context for a performance that was simultaneously bodily and mental (and in ways which question the terms of such a duality) inasmuch as the evolutionary narratives it instantiated were realized spatially in the form of routes that the visitor was expected – and often obliged – to complete.

While, empirically, the difference between these two perspectives might seem slight, the theoretical issues at stake are considerable. Does culture work to secure its influence over forms of thought and behaviour through the operation of mental (representational) structures whose constitution is viewed as invariant across the different fields of their application? Or is culture better viewed as an assemblage of technologies which shape forms of thought and behaviour in ways that are dependent on the apparatus-like qualities of their mechanisms? Behind these differences, of course, are different views of the individual: as the invariant substratum of all thought and experience, that is, the individual as subject, or the individual as the artefact of historically differentiated techniques of person formation.

ORGANIZED WALKING AS EVOLUTIONARY PRACTICE

Viewed as a 'backteller', I have argued, the museum bestows a socially coded visibility on the various pasts it organizes. It materially instantiates 'the retrospective prophecies' of the various sciences of history and prehistory,

179

embodying them in linked chains of events – natural and human – which press ever-forward to the present point of civilization which is both their culmination and the point from which these connected sequences are made retrospectively intelligible. The degree to which this narrative machinery was observable in the design and layout of particular museums was variable. This is partly because few nineteenth-century museum collections were constructed *ab novo* and many, accordingly, still bore the traces of earlier systems of classification. Equally important, the specialization of museum types meant that individual museums usually focused on a particular sequence within the museum's overall narrative machinery, albeit that the intelligibility of that sequence depended on its being viewed in the light of the sequences associated with other museum types. The relations between the times represented by these sequences, that is to say, were ones of mutual implication.

This is clear from the manner in which, towards the end of the century, George Brown Goode envisaged the relations between natural history museums, anthropology museums, history museums and museums of art. Here is what he has to say about the natural history museum:

> The Museum of Natural History is the depository for objects which illustrate the forces and phenomena of nature – the named units included within the three kingdoms, animal, vegetable and mineral, – and whatever illustrates their origin in time (or phylogeny), their individual origin, development, growth, function, structure, and geographical distribution, past and present: also their relation to each other, and their influence upon the structure of the earth and the phenomena observed upon it!
>
> (Goode 1896: 156)

The narratives of natural history connect with those of human history in view of the fact that 'Museums of Natural History and Anthropology meet on common ground in Man', the former usually treating 'of man in his relations to other animals, the latter of man in his relations to other men' (Goode 1896: 156). The museum of anthropology, Goode then argues, 'includes such objects as illustrate the natural history of Man, his classification in races and tribes, his geographical distribution, past and present, and the origin, history and methods of his arts, industries, customs and opinions, particularly among primitive and semi-civilised peoples' (ibid.: 155). The narratives of archae-ology are called on to bridge the gap between the fields of anthropology and history with the museum of anthropology extending its concerns to include prehistoric archaeology while the history museum extends its concerns backwards to include those of historic archaeology. As for the museum of history proper, its purpose is to preserve 'those material objects which are associated with events in the history of individuals, nations or races, or which illustrate their condition at different periods in their national life' (ibid.: 155).

The museum of art, finally, is like the history museum but with a specialist orientation. For 'the greater art collections illustrate, in a manner peculiarly their own, not only the successive phases in the intellectual progress of the civilised races of man, their sentiments, passions and morals, but also their habits and customs, their dress, implements and the minor accessories of their culture often not otherwise recorded' (ibid.: 154).

Each museum type, then, is like a chapter within a longer story, pressing towards an end point which is simultaneously the point at which the next chapter commences. Like the reader in a detective novel, it is towards this end point that the visitor's activity is directed. This is not simply a matter of representation. To the contrary, for the visitor, reaching the point at which the museum's narrative culminates is a matter of doing as much as of seeing. The narrative machinery of the museum's 'backtelling' took the form of an itinerary whose completion was experienced as a task requiring urgency and expedition. Alfred Wallace thus complained that casual visitors at natural history museums often learned less than they might because, he observed, they seemed to find it almost impossible 'to avoid the desire of continually going on to see what comes next' (Wallace 1869: 250).

This aspect of the museum's narrative machinery was rarely wholly visible in any particular institution. Just as their collections were frequently assembled from earlier ones, so many of the buildings in which the new public museums were housed were not built specifically for that purpose. Marcin Fabianski's survey of the history of museum architecture suggests that it was not until the late eighteenth century that the museum came to be regarded as a specific cultural institution in need of a distinctive architecture of its own (see Fabianski 1990). Prior to this period, valued collections had typically been housed in buildings which were designed for a variety of learned, scientific or artistic pursuits and derived their main architectural principles from the traditional forms associated with those pursuits. Even where buildings were designed specifically with a museum function in view, this often involved a combination of functional and traditional elements. Schinkel's Altes Museum, Anthony Vidler thus notes, rested on a combination of two principles which simultaneously historicized art and eternalized it: 'the sequence of rooms en suite characteristic of the palace turned museum and responding to the chronological exhibition of the objects; and the temple of memory or Pantheon, emblem of Rome but also of the absolute suprahistorical nature of aesthetic quality, a reminder of the nature of "art" in the historical work of art' (Vidler 1992: 92).

Where museums were custom built, however, the commitment to provide the visitor with a linear route within which an evolutionary itinerary might be accomplished was a strong one. Its continuing influence in the twentieth century is evident in the plan Parr proposed for a natural history museum that would, among other things, offer the 'open progression of a straight line

representative of the historical derivation of the form and properties of the individual objects':

> The visitor would enter the museum at the narrow end of a long hall dedicated to a quasi-historical presentation of the organisation of nature. Some attempt would be made to illustrate the structure of matter and the behaviour of its elementary components. A selected exhibit of naturally pure elements and of the isolated pure compounds of such elements, which we call minerals, would follow, with an exposition of their manner of formation and transformation. From mineralogy, we would proceed to the formation, composition, and metamorphosis of rocks. . . . Having surveyed the materials of the earth, one would turn to a consideration of the geo-physical forces acting with and upon these substances, the mechanisms by which they operate, and the results which they produce. . . . Our next step would carry us to the simplest and most primitive manifestations of life, and, continuing down to the end of the hall, we would finally come to man's place at the end of the sequence.
>
> (Parr 1959: 15)

In her study of Walter Benjamin's *Passagen-Werk*, Susan Buck-Morss quotes a passage from Dolf Sternberger's *Panorama* in which a pictorial popularization of Darwin's theory of evolution comprising a series of sequentially ordered facial types depicting the 'natural progression' from ape to man, was said to function as a 'panorama of evolution', organizing the relations between prehuman and human history and, within the latter, the relations between different races in such a way that 'the eye and the mind's eye can slide unhindered, up and down, back and forth, across the pictures as they themselves "evolve"' (Buck-Morss 1990: 67). In a similar way, the natural history museum envisaged by Parr constructed a path that the visitor can retrace in following the stages through which the exhibits evolve from inanimate matter to simple and, later, higher forms of life.

Similar principles and concerns were evident in the proposal Henry Pitt Rivers put to the British Association in 1888 for an anthropological rotunda as a form particularly suited to evolutionary arrangements of anthropological exhibits. Modelled, in part, on William Flower's proposals for natural history displays and advanced as an alternative to geographic–ethnic display principles,[2] the anthropological rotunda was to give a spatial realization to the relationship between progress and differentiation:

> The concentric circles of a circular building adapt themselves, by their size and position, for the exhibition of the expanding varieties of an evolutionary arrangement. In the innermost circle I would place the implements and other relics of the Palaeolithic period, leaving a spot in the actual centre for the relics of tertiary man, when he is discovered.

The simple forms of the Palaeolithic period would require no larger space than the smallest circle would be capable of affording. Next in order would come the Neolithic Age, the increased varieties of which would fill a larger circle. In the Bronze Age a still larger circle would be required. In the early Iron Age, the increased number of forms would require an increased area; mediaeval antiquities would follow, and so on, until the outer circle of all would contain specimens of such modern arts as could be placed in continuity with those of antiquity.

(Pitt Rivers 1891: 117)

Pitt Rivers was attracted to this arrangement by the prospect it offered of making the visitor more self-reliant by equipping him (or – but only as an afterthought – her) with the means of becoming more auto-didactic. The meaning of every object – which, for Pitt Rivers, meant its place within a sequence – was both readily visible and capable of being learned simply by following its tracks:

By such an arrangement, the most uninstructed student would have no occasion to ask the history of any object he might be studying: he would simply have to observe its distance from the centre of the building, and to trace like forms continuously to their origin.

(Pitt Rivers 1891: 117)[3]

How important it was to these conceptions that a museum's message should be capable of being realized or recapitulated in and through the physical activity of the visitor is evident from F.W. Rudler's proposal for making the gradualism of human evolution more perfectly performable. The minutes of the discussion following the presentation of Pitt Rivers's paper at the British Association record Rudler's perceptions of the performative limitations of the anthropological rotunda and of the means by which they might be overcome:

Looking at the central circle representing the palaeolithic period, it occurred to him that in walking round it, being a closed circle, one would never make any progress. You passed by a jump to the next circle, representing the neolithic, and though no doubt a great gap appeared between the two periods, that only arose from our ignorance. It seemed to him that a continuous spiral would, in some degree, be a better arrangement than a series of circles.

(Pitt Rivers 1891: 122)

Patrick Geddes proposed a similar conception as a part of his proposals for redesigning the urban space of Dunfermline in accordance with evolutionary principles. He suggested that the city should include a series of linked historical sites depicting its history from the medieval to the modern period and, at each stage, connecting that history to broader tendencies of

183

evolutionary development. As the last of these sites, a building devoted to Dunfermline's nineteenth-century history was to culminate in a Stair of Spiral Evolution giving access to a Tower of Outlook 'from which we may look back to the old historic city and forward into its future' (Geddes 1904: 161).

A couple of contrasts will help make the point I'm after here. The first is offered by the way in which the present arrangement of the Musée Carnavalet in Paris organizes the visitor's route in the form of a ruptured narrative which contrasts tellingly with the smooth and continuous evolutionary narratives that Pitt Rivers judged to be essential to the museum's pedagogic mission. Portraying a history of Paris and its people, the Musée Carnavalet consists of a range of different types of artefacts. Most conspicuously, the city's history is evoked through paintings which are contemporaneous with the events they depict. Since they belong to the period to which they refer and are portrayed as active historical forces within that period, these paintings serve both as a part of history and as its representations.[4] The paintings are accompanied by a range of artefacts whose historicality exhibits similar hybrid qualities. In some cases, the objects displayed have been selected because of their association with particular historical events: the keys to the Bastille, for example. In other cases, the function of the objects is to display the marks of history; they bear its impress as a script – in the form of inspirational revolutionary messages on a card-table, for example – through which the past is made decipherable.

Within each room, then, an assembly of paintings and other historical artefacts accompany the elaborate accounts which summarize the main events of the period concerned and explain their relations to one another as well as their connections to those of earlier or later periods. In this way, the museum functions as an ensemble of narrative elements which the visitor – following the arrows which point out how to proceed through the rooms in their proper sequence – is able to rehearse. Since this rehearsal takes place amidst the artefactual trappings of the real, it validates the familiar narratives of French nationhood. These typically contain a moment of interruption – the revolution – which is given a performative dimension. In moving from the pre-revolutionary period to that of the revolution, the visitor must pass from one building (the Hôtel Carnavalet) to another (the Hôtel Le Peletier de Saint-Fargeau) via a gallery which, while connecting these two times, serves also to separate them and so also to introduce an element of discontinuity into the visitor's itinerary.

My second example is derived from Lee Rust Brown's discussion of the ways in which, in the 1830s, the layout of the Jardin des Plantes in Paris provided a pedestrian complement to, and realization of, the system of classification governing the arrangement of exhibits in the Muséum d'histoire naturelle. Within the museum itself, Brown argues, specimens were displayed in a manner calculated to make visible the system of classes which governed their arrangement:

Through the techniques of its various exhibition media, invisible forms of classifications attained democratic visibility. Wall cases, display tables, plant beds, groups of zoo cages, the very books in the library – these devices framed particular collocations of specimens, and so worked like transparent windows through which the visitor could 'see' families, orders, and classes.

(Brown 1992: 64)

This was especially true of the gallery of comparative anatomy which, under Cuvier's direction, had, since its opening in 1806, exploded nature so as to reveal the inner principles of its organization. The arrangement of skeletons in classes was accompanied by preserved specimens, their bodies splayed open to reveal the organs and systems which provided the hidden basis for their external resemblances and so also the key to their taxonomic groupings. 'Cuvier's galleries', as Dorinda Outram usefully puts it 'were full of objects to be looked not at, but *into*', their portrayal of 'the unspoiled beauties and intricate organisation of nature' allowing the museum to function as an 'accessible utopia', a visualization of nature's order and plenitude that could serve as a refuge from the turmoils of revolution (Outram 1984: 176, 184).

Similarly, the layout of the walkways in the botanical gardens were, Brown argues, 'technical devices of particular importance' in prescribing a route through which visitors would, in passing from plant to plant in the orders of their resemblances to one another, both see and perform the principles of classification underlying pre-evolutionary natural history. Strolling through the walkways and passing from one flower-bed to the next, the visitor could both move and read from 'family to family, order to order, class to class' in a form of exercising that was, constitutively, both mental and physical. 'These were media', Brown says of the walkways, 'for both physical and intellectual transit: they themselves were "clear," empty of visible forms; by means of them one walked through the plant kingdom just as one would "think through the steps" of a classificatory arrangement of information' (Brown 1992: 70).

Here, then, is an exhibitionary environment that is simultaneously a performative one; an environment that makes the principles governing it clear by and through the itinerary it organizes. It was an environment, however, which, while not lacking a temporal dimension, did not organize time in the form of irreversible succession. 'The "history" in natural history', as Brown puts it, 'described nature as it presently was – and doing so, measured nature's fall and recovery (or, more precisely, nature's disintegration and reintegration) by reference to the ideal of a total structure, an ideal that found provisional representation in catalogues, cabinets, and gardens' (Brown 1992: 77). Moreover, while this narrative organized and framed the overall visiting experience, it did not inform the visitor's itinerary where the synchronic structures of nature's present organization held sway.

185

In the later decades of the nineteenth century, by contrast, the visitor's pathway through most museums came to be governed by the irreversible succession of evolutionary series. Where this was not so, museums were urged to rearrange themselves so as to achieve this effect.[5] If the essential methodological innovations in nineteenth-century geology, biology and anthropology consisted in their temporalization of spatial differences, the museum's accomplishment was to convert this temporalization into a spatial arrangement. William Whewell appreciated this aspect of the museum's functioning when he remarked, apropos the Great Exhibition, that it had allowed 'the infancy of nations, their youth, their middle age, and their maturity' to be presented simultaneously, adding that, thereby, 'by annihilating the space which separates different nations, we produce a spectacle in which is also annihilated the time which separates one stage of a nation's progress from another' (Whewell, cited in Stocking 1987: 5–6). In fact, the museum, rather than annihilating time, compresses it so as make it both visible and performable. The museum, as 'backteller', was characterized by its capacity to bring together, within the same space, a number of different times and to arrange them in the form of a path whose direction might be traversed in the course of an afternoon. The museum visit thus functioned and was experienced as a form of organized walking through evolutionary time.

PROGRESS AND ITS PERFORMANCES

To summarize, the superimposition of the 'backtelling' structure of evolutionary narratives on to the spatial arrangements of the museum allowed the museum – in its canonical late-nineteenth-century form – to move the visitor forward through an artefactual environment in which the objects displayed and the order of their relations to one another allowed them to serve as props for a performance in which a progressive, civilizing relationship to the self might be formed and worked upon. However, the museum was neither the only cultural space in which evolutionary narratives of progress might be performed, nor was it the only way in which such performances might be conducted.

The relaxed art of urban strolling associated with the figure of the *flâneur*, and the incorporation of spaces in which this practice might flourish in the midway zones of international exhibitions, provides a convenient point of contrast. The new urban spaces in which this art had initially developed and flourished – principally the arcade through its provision of a covered walkway removed from the disturbance of traffic – were developed over roughly the same period as the museum and made use of related architectural principles (see Geist 1983). The arcade, however, encouraged the distracted gaze of a detached stroller proceeding at his or her own pace with a freedom to change direction at will. The museum, by contrast, enjoined the visitor to comply with a programme of organized walking which transformed any tendency to

gaze into a highly directed and sequentialized practice of looking. The differences between these two practices, Meg Armstrong has suggested, were noticeably foregrounded in the contrast between the official exhibition areas of nineteenth-century American exhibitions and the midways which accompanied them (Armstrong 1992–3). For while both areas were governed by rhetorics of progress, these rhetorics often differed significantly, especially so far as their dispositions towards the visitors were concerned.

Focusing particularly on the displays of 'primitive peoples', Armstrong argues that, while these were usually arranged in accordance with evolutionary principles of classification within the official exhibition areas, the effect aimed for on the midways was often much less 'scientific'. Here, rather, the display of 'other peoples' was orientated to achieving the effect of 'a jumble of foreignness' in which such peoples represented a generalized form of backwardness in relation to the metropolitan powers rather than a stage in an evolutionary sequence. This was, no doubt, mainly attributable to the fact that, throughout the nineteenth century and, indeed, into our own, popular forms of showmanship have continued to draw on the principles of the cabinet of curiosities either in preference to or in combination with those of the museum. It is also true that this evocation of an undifferentiated form of backwardness in the form of an exoticized other was a way of making progress visible and performable. Compared with the linear direction of the museum's evolutionary sequences, this was more in tune with the arts of urban strolling which typically predominated in the midways. For the 'eyes of the Midway', as Curtis Hinsley puts it, 'are those of the *flâneur*, the stroller through the street arcade of human differences, whose experience is not the holistic, integrated ideal of the anthropologist but the segmented, seriatim fleetingness of the modern tourist "just passing through"'(Hinsley 1991: 356).

Steven Mullaney also suggests a useful light in which the colonial villages that were often constructed in association with international exhibitions might be viewed. Etymologically, Mullaney argues, the term 'exhibition' once referred 'to the unveiling of a sacrificial offering – to the exposure of a victim, placed on public view for a time preliminary to the final rites that would, after a full and even indulgent display, remove the victim from that view' (Mullaney 1983: 53). Applying this perspective to what he variously calls the 'consummate performance' or 'rehearsal' of other cultures that was frequently associated with public dramaturgies of power in the late Renaissance period, Mullaney views such events as a symbolic complement to the processes through which non-European peoples and territories were colonized. The occasion on which he dwells most is that of Henry II's royal entry into Rouen in 1550. Two Brazilian villages, which had been reconstructed on the outskirts of the town and partially populated with Tabbagerres and Toupinaboux Indians, were ceremoniously destroyed through mock battles which saw both villages burned to ashes. What was most conspicuously expended here, Mullaney argues, was not the financial resources required to

reconstruct and then spectacularly destroy the Brazilian villages – although, clearly this formed part of the politics of ostentatious display through which royal power was symbolized – so much as 'an alien culture itself' (ibid.: 48). The same was true of the colonial villages which, in the later nineteenth and early twentieth centuries, became a more or less staple feature of international exhibitions. Constructed with just as much loving attention to detail and expensive care for verisimilitude as had been the case at Rouen, these temporary structures allowed the visitor to take part in a performance – in this case, street theatre – in which detailed reconstructions and re-enactments of other cultures served as a complement to their being consumed – and so, also used up and annihilated – within and by the culture that staged them. In the colonial village, the peoples on display were sacrificial offerings to the processes of colonization and modernization which, it was envisaged, would eventually remove them entirely from view. Their exhibition was a pre-liminary to the final rites that would see their erasure from the stage of world history.

My concern here, however, is less with the variety of ways in which the rhetorics or narratives of progress provided the scripts for a range of social performances than with the attention that has to be paid to the necessarily embodied nature of the visitor's activity once the performative aspects of exhibitionary institutions are accorded due recognition. This concern has both theoretical and political aspects. Ian Hunter addresses the theoretical issues in his elaboration of the significance of Marcel Mauss's concern with 'techniques of the body' and the ways in which these need to be seen as interacting with 'techniques of the self' in which 'bodily' and 'mental' practices interact as the *recto* and *verso* of specific forms of life (see Hunter 1993). The implication of this argument is that there cannot be any general form of the mind–body relation of the kind that modern Western philosophy posits and then seeks to find. Rather, persons are seen as being formed through particular assemblages of mind and body techniques – particular ways of working on and shaping bodily and mental capacities – which are made available to them via the array of cultural institutions, or technologies, characterizing the societies in which they live.

Viewed in this light, conceptions of the mind and body as separated entities emerge not as a foundational reality for and of all experience but as a historical product of particular ways of dividing up the sphere of the person so as to render it amenable to variable practices of self-formation. The various cultural technologies comprising 'the exhibitionary complex' have, accord-ing to Timothy Mitchell, played a crucial role in the formation and dis-semination of precisely such a conception of the person (see Mitchell 1988). Drawing on Foucault's arguments concerning the role which systems of truth play in the organization and dissemination of relations of power, Mitchell sees in nineteenth-century exhibitionary institutions a particular 'machinery of truth' whose principal characteristic is the division between the world and

its representations which such institutions establish and which is, in turn, a condition of their intelligibility. This introduction of a rift into the relations between the world of socio-material relations and their conceptual plan – that is, their representation in the form of a museum or exhibition – allowed such plans to function as parts of regulative technologies aimed at refashioning the world of socio-material relations in their own image. A part of the surface on which such technologies operated consisted in the parallel 'division of the political subject into an external body and a mental interior' (Mitchell 1988: 176). This conception of the person as 'a thing of two parts' (ibid.: 100) allowed the development of regulative strategies aimed at both body and mind where regulating the environments in which bodies were located was envisioned as a means of promoting inner-directed practices of self-interrogation and self-shaping.

The installation of evolutionary narratives within museums resulted in precisely such a mind–body technology, furnishing an environment in which both body and soul might be constituted as the targets of practices self-improvement aimed at modernizing the individual, bringing (and I use the term advisedly) him more into line with the high point of civilization's advance. But, this demand or possibility was one that only visitors with the right type of bodies could respond to appropriately. Carole Pateman has shown how the assumption, within social contract theory, that the individual should be regarded as a disembodied subject with equal rights served to mask the mandatory requirement that only those with male bodies could be party to those imaginary contracts whereby the social order was founded and perpetuated (see Pateman 1989). An appreciation of the necessarily embodied nature of the visitor's experience is important for much the same sorts of reasons. For the degree to which visitors could comply with or respond positively to the museum's performative regimen depended very much on both the colour and gender of their bodies.

SELECTIVE AFFINITIES

About halfway through the Biological Anthropological Gallery at the Musée de l'homme in Paris, a display depicts the evolution of the crania of *homo sapiens* over the past 100,000 years. As one approaches the end of the series, the crania give way to, first, in the penultimate spot, a photograph of René Descartes and, at the end, in the space where the customary narrative of such displays lead the visitor to expect a cranium representing the most evolved type of the species, a television monitor. As the visitor looks closer he or she finds that the monitor contains a picture of an exhibition plinth on which his or her own image now rests as the crowning glory of the evolutionary sequence that has just been reviewed.

The display nicely plays with and parodies the historicized narcissism to which such evolutionary displays give rise. At the same time it makes an

189

important political statement in organizing the terminal position of human evolution so that it can be occupied by everyone, and on an equal footing, irrespective of their race, gender or nationality. In the nineteenth century, by contrast, the occupancy of such positions was typically reserved for preferred social types – notably, the European male – whilst other types of humans, barred from this position, were assigned to an earlier stage in the evolutionary process. In the cranial displays emerging out of the evolutionary assumptions of late-nineteenth-century craniology, women were assigned a place a few steps behind men, and colonized black peoples a place several leagues behind white Europeans, intermediate stages within evolutionary narratives which they were not yet – and, in some formulations, perhaps never would – be able to complete.

Gillian Beer has suggested that the significance of Darwin's work in the history of scientific thought was that of dethroning man-centred narratives of history. Darwin had shown, she argues, 'that it was possible to have plot without man – both plot previous to man and plot even now regardless of him' (Beer 1983: 21). Georges Canguilhem makes a similar point when he says that Darwin obliged man 'to take his place as a subject in a kingdom, the animal kingdom, of which he had previously posed as monarch by divine right' (Canguilhem, 1988: 104). Yet if this was so, Beer argues, the subjectless plot of natural selection prompted a compensatory narrative of 'growth, ascent, and development towards complexity. . . a new form of quest myth, promising continuing exploration and creating the future as a prize'. In place of man's fall from an originary state of perfection in the Garden of Eden, human perfection was relocated into the future as something to be striven for and achieved in ascending stages where, as Beer puts it, ascent 'was also flight – a flight from the primitive and the barbaric which could never quite be left behind' (Beer 1983: 127–8).

Evolutionary theory prompted a veritable swarming of narratives, and not all of them new ones. Whatever their fate within the scientific community, the teleological and intentional narratives deriving from Lamarckian evolutionary conceptions retained their influence throughout the century. Similarly, especially in Britain, an effective currency allowing for an exchange between evolutionary thought and Christianity was established in which 'savages' were to be both saved and civilized. Many narratives which could not be reconciled with Darwinism continued to be effectively deployed in a wide range of social ideologies. Polygenetic conceptions, in which black and white peoples are held to have developed from separate origins and are destined to continue along separate evolutionary paths, remained influential. This was especially true of the United States where, in the south, the message that 'the Negro' could never expect to jump the gap between the black and white paths of evolution proved a palatable solace in the face of black emancipation. Robert Rydell (1984) has traced the influence of such conceptions on the exhibitions held in the southern states of America in the late nineteenth

century while, in the museum world, they governed the initial arrangement of the collections at the Museum of Comparative Anatomy which Louis Agassiz – the most significant intellectual advocate of polygenetic conceptions – established at Harvard (see Gould 1981; Lurie 1960).

In short, Darwinian thought articulated with contemporary social and political philosophies in complex and varied ways. It was not, and in the nineteenth century never became, the only source of evolutionary narratives. There were other narratives, some of which insisted that the story of human evolution could only be satisfactorily narrated if it were divided into (at least) two stories. The point is worth making if only because the degree of success with which Darwinism was articulated to conservative variants of social evolutionist and proto-eugenicist thought in the late nineteenth century can often eclipse the respects in which it could be and, initially was, connected to progressive currents of social reform. Many of those who were most influential in translating Darwinian thought into an applied social philosophy – Huxley and Spencer, for example – were from a middle-class, dissenting background. In organizational terms, Darwin's work played a crucial role in the affairs of the Ethnological Society. By the 1860s, this Society had recruited the support of most liberal and reforming intellectuals and developed its programme in specific critique of the rabidly racist and virulently sexist conceptions which, under the leadership of James Hunt, characterized the rival Anthropological Society.[6]

Georges Canguilhem gives an inkling as to why this should have been so when he remarks that, before Darwin, 'living things were thought to be confined to their preordained ecological niche on pain of death' (Canguilhem 1988: 104). Clearly, Canguilhem has Cuvier's doctrine of the fixity of species and the impossibility of transformism – that is, of one form of life gradually evolving into another – in mind here. The implications of such conceptions when carried into the social realm, however, were equally clear. Cuvier, arguing that there were 'certain intrinsic causes which seem to arrest the progress of certain races, even in the most favourable circumstances' (cited in Stocking 1968: 35), viewed black races as never having progressed beyond barbarism and – more important to my present concerns – as never likely to do so. If, in Cuvier's system, all living things were confined to their ecological niche, then so also, when it came to divisions within human life, the place that different peoples occupied within racial hierarchies seemed preordained and unchangeable. It is not surprising, therefore, that Cuvier's work remained important in providing a scientific basis for polygenetic conceptions. Such conceptions, when translated into social programmes, proved explicitly anti-reformist. As Stephen Jay Gould notes of Louis Agassiz, who had been a student and disciple of Cuvier's, his polygenetic conceptions, when translated into social policy, aimed to train different races so that they might stay in the separate niches they already occupied: 'train blacks in hand work, whites in mind work' (Gould 1981: 47).

For the liberal and reforming currents in nineteenth-century thought, then, the attraction of Darwin's thought was that, in loosening up the fixity of species by allowing that one form of life might evolve into a higher one, it made the boundaries between them more permeable. Darwinism, in one appropriation, provided a way of thinking of nature which, when applied to the social body, allowed the structure of social relations to be mapped in ways conducive to reforming programmes intended to improve and civilize populations, to lift them through the ranks. At the same time, however, in supplying the process of evolution with a conservative mechanism (natural selection) Darwin's thought allowed evolutionary theory to be detached from the radical associations it had enjoyed in the 1830s and 1840s when the influence of Lamarck's and Geoffroy's evolutionary conceptions – which provided for no such restraining mechanism – had been paramount (see Desmond 1989). This difference was crucial in allowing evolutionary thought to be disconnected from radical programmes aimed at dismantling existing social hierarchies and to be adapted to gradualist schemas of social reform.

Zygmunt Bauman helps clarify the connections I have in mind here. In his *Intimations of Postmodernity* (1992), Bauman discusses the respects in which evolutionary thought allowed a revival of Enlightenment conceptions of human perfectibility. Precisely because of their secular nature – because they reflected an order that was to be made rather than one divinely pre-given – such conceptions allowed social life to be thought of as an object of techniques oriented to the progressive perfectibility of forms of thought, conduct and social interrelation. Viewed in this light, Bauman argues, there is an important connection between the reformist project of culture, in its nineteenth-century sense, and evolutionary narratives of progress. Earlier hierarchical rankings of forms of human life had not given rise to the possibility that populations might be inducted into forms of self-improvement that would help them to move up and through such hierarchies. The only possibility was that individuals might achieve the standards appropriate to their given place in such hierarchies. By contrast, the revised forms of ranking human life made possible by evolutionary theory gave rise to the possibility that, in principle, all populations might be inscribed within a programme of progressive self-improvement. Stocking's comments point in a similar direction when he identifies the similarities between Edward Tylor's view of culture and Arnold's conception of culture as a norm of perfection which, disseminated through the population, might help inculcate practices of self-improvement. For Tylor, the point of arranging human and cultural evolutionary series in parallel with, or emerging out of, natural ones was not to keep populations within the places they occupied within such series but, where possible, to move them through them so that they might draw more closely towards an ever-moving and evolving norm of human development. 'The science of culture', as Tylor put it, 'is essentially a reformer's science' (cited in Stocking 1968: 82). The tenets of evolutionary theory, in their

Darwinian formulation, could lend themselves to liberal and reformist currents of social thought and policy in providing a grid through which the field of social relations could be so laid out so that cultural strategies might be developed which aimed at equipping the whole population with means of self-improvement through which they might ascend through the ranks, thus carrying the whole of society forwards and upwards – but only slowly and gradually, step by step. Any other way of proceeding – and this was the delicate political balancing act that Darwin allowed reforming opinion to perform – by attempting to push progress forward in a radical or revolutionary rush, would be to fly in the face of nature.

Although not the only social philosophy to articulate evolutionary thought to its purposes, this reformist articulation of evolutionary theory influenced the ways in which late-nineteenth-century public museums were viewed as potential instruments for cultural reform. It also shaped the operation of the 'backtelling' structure of the museum's narrative machinery such that its address privileged men over women and white Europeans over black and colonized peoples. The devices which rendered human progress into a performable narrative within the museum entailed that only some humans and not others could recognize themselves as fully addressed by that narrative and thus be able to carry out its performative routines.

The developments within the human sciences which made it possible for colonized peoples to be assigned to earlier stages of evolution, and thus to serve as the means whereby the past from which civilized man had emerged might be rendered visible, are many and complex. The crucial ones concern, first, the establishment of a historical time of human antiquity which, in shattering the constraints of biblical time, showed, as Donald Grayson puts it, that human beings 'had coexisted with extinct mammals at a time that was ancient in terms of absolute years, and at a time when the earth was not yet modern in form' (Grayson 1983; 190). The production of such a time took place over an extended period, initially prompted by developments within ecology but eventually being most successfully organized by the discipline (prehistoric archaeology) that would claim that time as its own. Its definitive establishment, however, took place in 1859 – the same year in which *The Origin of the Species* was published – when Lyell conceded that the excavations at Brixham Cave had demonstrated an extended antiquity for mankind.

This production of an extended past for human life was, in its turn, to play a crucial role in allowing ethnological artefacts to be categorized as 'early' or 'primitive' as distinct from 'exotic' or 'distant'. Again, the developments here were protracted. Within medieval thought, according to Friedman, conceptions of non-European peoples were governed by the classical teratology of Pliny in which such peoples were regarded as exhibiting forms of wildness and incivility which reflected their distance from the world's centre (the Mediterranean). If this system of representation was governed by a

spatial logic, its historical aspects were directly contrary to those which subsequently characterized evolutionary thought. In accordance with the requirements of medieval Christian thought, medieval narratives of the monstrous races were governed by the notion of degeneration: those peoples who lived in conditions of monstrousness or wildness at the world's edges were the degenerate offspring of the wandering tribes of Cain, a fall from the originary perfection of Adam and Eve. As Friedman summarizes the point:

> As for alien forms of social organisation, Western feudal society could not view these as representing earlier stages of development; in Christian history all men had their start at the same time, from the same parents. Cultural evolution from primitive to complex was simply not part of the conceptual vocabulary of the period. To the medieval mind it was more natural to explain social differences as the result of degeneration or decadence.
>
> (Friedman 1981: 90)

The conversion of this spatialized teratology into a historicized system of classification in which 'other peoples' were moved from the world's extremities to the initial stages of human history was closely associated with the history of colonialism. According to Margaret Hodgen, Montaigne was the first, in his reflections on the Americas, to propose the procedure, which Fabian (1983) views as constitutive of modern anthropology, whereby the culture of a presently existing people is interpreted as 'a present and accessible reflection of the past of some very early and otherwise undocumented cultural condition' (Hodgen 1964: 297). However, thinkers associated with the French Enlightenment were to prove most influential in providing a conceptual basis for what was later known as the 'comparative method'. Stocking attributes considerable importance to Baron Turgot's view, developed in a programme of lectures at the Sorbonne during the winter of 1750–1, that 'the present state of the world . . . spreads out at one and the same time all the gradations from barbarism to refinement, thereby revealing to us at a single glance . . . all the steps taken by the human mind, a reflection of all the stages through which it has passed' (Turgot, cited in Stocking 1987: 14). Stocking and Fabian are also agreed in attributing a crucial significance to the text prepared by Citizen Degerando in 1800 for the Société des Observateurs – the most significant institutional base for early French anthropology – to advise on the methods travellers should follow in their observations of 'savage peoples'. By this time the reciprocal spatialization of time and temporalization of space that the comparative method relies on had become explicit. 'The *voyageur-philosophe* who sails toward the extremities of the earth,' Degerando wrote, 'traverses in effect the sequence of the ages; he travels in the past; each step he takes is a century over which he leaps' (Degerando, cited in Stocking 1968: 26–7).

Significant though they were, these developments did not, of themselves,

suggest the means whereby ethnological artefacts might be rearranged as parts of developmental sequences. The crucial developments here were located in the interface between archaeology and evolutionary thought. The extension of time associated with the discovery of human antiquity sketched above proved significant in allowing stone tools and implements – which had been distinguished from minerals and fossils since the sixteenth century but were still regarded as being of relatively recent production – to serve as a means of rendering human antiquity visible. One of the first museological productions of such an extended human time, arranging artefacts in a complex developmental sequence, consisted in the use of the three-age system of classification (stone, iron, bronze) in a mid-century display at the National Museum of Copenhagen. From this, it was a small but decisive step to place the artefacts of still-existing peoples within such series and, usually, as their origins – the ground from which progress sets off. However, it is no accident that one of the first to take this step was Henry Pitt Rivers who, although now most famous for his ethnological collections, was, by training, an archaeologist.

I shall look more closely at Pitt Rivers's translation of these archaeological principles into museum displays in the next section, principally to make clear how he viewed the museum as a machinery that might simultaneously stimulate and regulate progress. My concern thus far, however, has been to identify the respects in which museums might be viewed as having aimed to keep progress on the go by offering their visitors a performative regime organized in the form of a progressive itinerary. But, by the same token, the museum's selective affinities meant that it might address itself in this way to, at best, only a half of a half of the world's population, a limitation that was inscribed in the very heart of its conception as a 'progressive' cultural technology.

EVOLUTIONARY AUTOMATA

The museum has had few more effective or self-conscious advocates of 'Zadig's method' than Henry Pitt Rivers whose typological arrangements of ethnological collections were more or less self-conscious realizations of the principles of 'backtelling'. Nor is this wholly surprising. Huxley and Pitt Rivers were personally acquainted; both were members of the Ethnological Society; and it is likely that Huxley's arrangements at the Museum of Practical Geology, where a concern to educate the public was prominent, influenced Pitt Rivers's own conceptions of the purposes for which museum displays should be arranged and the means by which such ends might best be accomplished (see Chapman 1985: 29).

Most telling of all, however, was the dependency of typological arrangements on the concept of survivals. As Margaret Hodgen argued almost sixty years ago, this was crucial to those temporal manoeuvres through which, by

converting presently existing cultures into the prehistories of European civilization, anthropology has created its object. The doctrine of survivals, as Edward Tyler summarized it in his *Primitive Culture* (1871), referred to those archaic 'processes, customs, opinions, and so forth, which have been carried by force of habit into a new society . . . and . . . thus remain as proofs and examples of an older condition of culture out of which a newer has evolved' (cited in Hodgen 1936: 37). The relationship between this manoeuvre and the organizing principles of typological displays, in which artefacts such as tools and weapons or domestic utensils were severed from any connection with their originating cultural or regional milieu to be placed in a universal developmental sequence leading from the simple to the complex, was made clear by Pitt Rivers in his explication of what he had sought to achieve in the ethnological exhibition he arranged at the Bethnal Green Museum in 1874. 'Following the orthodox scientific principle of reasoning from the known to the unknown,' he argued, 'I have commenced my descriptive catalogue with the specimens of the arts of existing savages, and have employed them, as far as possible, to illustrate the relics of primeval man, none of which, except those constructed of the more imperishable materials, such as flint and stone, have survived to our time' (Lane-Fox 1875: 295).

This is 'backtelling' with a vengeance. The artefacts of presently existing peoples can be read back into the past where they can serve to back-fill the present by being appointed to different stages in an evolutionary sequence because they are construed as traces of earlier stages of human development. The survival, however, is a peculiar kind of trace. On the supposition that the societies in which it is found have stood still, the survival is both the trace of earlier events and their repetition. Survivals are footprints in the sands of time whose imprint is unusually strong and clear to the degree that later generations are supposed to have gone round in circles, treading in the steps of their forebears. 'Each link', as Pitt Rivers puts it a little later in his discussion, 'has left its representatives, which, with certain modifications, have survived to the present time; and it is by means of these *survivals*, and not by the links themselves, that we are able to trace out the sequence that has been spoken of' (Lane-Fox 1875: 302).

Although Pitt Rivers was clearly responsible for codifying the so-called 'typological method', its principles were not unheralded. William Chapman, Pitt Rivers's biographer, points to the influence of a number of earlier collections in which similar elements were in evidence, and it is clear from other contemporaneous proposals that such ideas were very much 'in the air' at the time. The principles Alfred Wallace enunciated for the Ethnological Gallery of his ideal educational museum in 1869 were thus virtually identical to those which Pitt Rivers was subsequently to put into effect in the arrangement of his collections:

The chief well-marked races of man should be illustrated either by life-size models, casts, coloured figures, or by photographs. A corresponding series of their crania should also be shown; and such portions of the skeleton as should exhibit the differences that exist between certain races, as well as those between the lower races and those animals which most nearly approach them. Casts of the best authenticated remains of prehistoric man should also be obtained, and compared with the corresponding parts of existing races. The arts of mankind should be illustrated by a series, commencing with the rudest flint implements, and passing through those of polished stone, bronze, and iron – showing in every case, along with the works of prehistoric man, those corresponding to them formed by existing savage races.

(Wallace 1869: 248)

Pitt Rivers's originality, then, lay elsewhere: in his conception of ethnological exhibitions as devices for teaching the need for progress to advance slowly – step by step – in a manner that was intended to serve the purposes of an automated pedagogy.

While his political views comprised a complex amalgam of different currents of late-nineteenth-century thought, they can perhaps best be summarized as a form of political conservatism which sought to embrace the progressive implications of evolutionary thought while insisting that the rate of progress was more or less naturally ordained. Change for Pitt Rivers was, as David Van Keuren puts it, 'something to be directed and limited, not striven against' (van Keuren 1989: 285). The progressive development of social life was to be welcomed but not hastened. It would come, but – and his target here was clearly socialist thought – in its own time through mechanisms which would depend on the accumulation of a multitude of tiny measures which would gradually become habitual rather than on any sudden or ruptural political action. History, in other words, could not be made to go in a jump: this was the central message Pitt Rivers sought to communicate through his ethnological arrangements. Progress was made visible and performable in the form of a succession of small steps linked to one another in an irreversible and unbridgeable sequence. One had to go through one stage to get to the next. In extolling the virtues of his proposal for an anthropological rotunda as being especially suited to the educational needs of the working classes, Pitt Rivers argued:

Anything which tends to impress the mind with the slow growth and stability of human institutions and industries, and their dependence upon antiquity, must, I think, contribute to check revolutionary ideas, and the tendency which now exists, and which is encouraged by some who should know better, to break directly with the past, and must help to inculcate conservative principles, which are needed at the present

197

time, if the civilisation that we enjoy is to be maintained and to be permitted to develop itself.

(Cited in Chapman 1981: 515)

This helps explain why the doctrine of survivals played such an important political role in Pitt Rivers's museological practice. For it allowed the past to be visualized from the tracks that had allegedly been left behind by our ancestors in the early stages of human evolution. This was common to all ethnological displays. More distinctively, then, the doctrine of survivals provided Pitt Rivers with the means through which the past, in back-filling the present, could also be literally filled up so that, while the gap between the first object in a series (an anthropological throwing stick) and the last (a medieval musket) might be large, the space between them would be densely thicketed with objects repesenting intervening stages in the evolution of weaponry which could be neither by-passed nor jumped over. As Pitt Rivers explained in a letter to Tyler:

If I were going to lecture about my collections, I should draw attention to the value of the arrangement, not so much on account of the interest which attaches to the development of the tools, weapons in themselves, but because they best seem to illustrate the development that has taken place in the branches of human culture which cannot be so arranged in sequence because the links are lost and the successive ideas through which progress has been effected have never been embodied in material forms, on which account the Institutions of Mankind often appear to have developed by greater jumps than has really been the case. But in the material arts, the links are preserved and by due search and arrangement can be placed in their proper sequence.

(Cited in Chapman 1981: 480)

The museological context of the 1870s and 1880s in which Pitt Rivers arranged for his ethnological collections to be exhibited to the public – first, in 1874, in a special exhibition at Bethnal Green and, subsequently, at the South Kensington Museum – was governed by a revival of 'the museum idea' in which a renewed stress was placed on the importance of museums as instruments of public instruction. Two things had changed since this idea had been first promulgated by Henry Cole in the 1840s and 1850s. First, museums were envisaged less as a moral antidote to the tavern than as a political antidote to socialism (see Coombes 1988). Second, there was a growing tendency within museums to dispense with those forms of instruction that were dependent on visitors being accompanied by guides towards a conception of the museum as an environment in which the visitor would become, in a more or less automated fashion, self-teaching. Over the period from the 1840s to the 1860s, the weaponry exhibits in the armoury at the Tower of London were rearranged in a chronological fashion to dispense with the need for attendants.

Edward Forbes made similar adjustments to the Museum of Practical Geology so that it might function as an automated space of self-instruction.

Pitt Rivers had himself displayed a similar commitment during his early days as a collector when his interests centred on weaponry and firearms, a collection which he developed, initially, as a resource for his work as a rifle instructor in the army. In a lecture he delivered in 1858 on the history of the rifle, Pitt Rivers suggested that any instructor would find it useful to complement his practical lessons with lectures, preferably accompanied by exhibits, in the history of small arms using forms of instruction that were designed to be 'proportional to the rank and intelligence of his auditors' (cited in Chapman 1981: 26). Chapman, in glossing Pitt Rivers's concerns in this area, argues that his collections and instruction manuals were meant to produce an interface between two kinds of progress:

> At one level there was the self-evident advance represented by the rifle, each improvement of which in turn represented the successive triumphs of individual thinkers and inventors. At a second level there was the individual triumph of each soldier placed in his charge, the slow development of ideas which his manual was meant to promote.
>
> (Chapman 1981: 26)

The purpose of exhibiting progress was to provide a prop through which the infantryman might be helped to progress through a set of ranked skills in a regulated and gradual manner.

When Pitt Rivers exhibited his ethnological collections at Bethnal Green Museum, his conception of the purpose of exhibitions and of the means by which such a purpose might be accomplished – and especially the commitment to the use of means of instruction 'proportional to the rank and intelligence of his auditors' – was not substantially changed, merely adapted to new circumstances. While this exhibition did not deploy the principles of the 'anthropological rotunda' which Pitt Rivers later advocated, it was directed towards the same end – to make the step-by-step, slow, sequential toil of progress visible and performable. The exhibits were arranged into a number of different series each of which, by means of the 'typological method', depicted a particular developmental sequence. A series of skeletons and crania depicted the evolution from primate to human life and, then, from primitive to civilized races, while a series of weaponry exemplified the functional evolution of human technology with 'painted arrows providing the proper sequence for the visitors' (Chapman 1981: 374).

What was distinctive, however, was the conception of the audience this exhibition was meant to reach and of the means by which it was to achieve its intended effect *with that audience*. The Bethnal Green Museum was the South Kensington Museum's outpost in East London. It was selected as the site for Pitt Rivers's exhibition specifically as a public test-case of the 'educative potential' of evolutionary anthropology in an area that was both

radically pauperized and a centre for working-class radicalism. As Chapman tellingly notes, it was the first such test for anthropology in London. The only previous exhibitions of ethnological collections in East London had been organized by the London Missionary Society and these, reflecting earlier exhibition practices, had been arranged to tell a different story of savagery – a narrative of degeneration and decline, of a fall from grace, rather than one of failed advancement.[7] How, then, did Pitt Rivers think that anthropology's chief political message – 'the law that Nature makes no jumps' (Pitt Rivers 1891: 116) – might be most effectively communicated to working-class visitors? In brief: by employing methods adjusted to their level of mental development.

The assumptions of evolutionary theory informed not just the contents and arrangement of the exhibition: they were central to its pedagogics. When, in 1874, Pitt Rivers addressed the Anthropological Institute on the subject of the Bethnal Green exhibition, he took advantage of the opportunity to outline a distinction between what he called the 'intellectual mind, capable of reasoning on unfamiliar occurrences', and 'an automaton mind capable of acting intuitively in certain matters without effort of the will or consciousness' (Lane-Fox 1875: 296). Having elaborated this distinction, Pitt Rivers posited the existence of a historical dialectic between these two different kinds of mind. Pitt Rivers's views regarding the manner in which this historical dialectic unfolds is crucial to his understanding of the mechanisms of progress and the traces that these have deposited in the distribution of mental attributes between different peoples and cultures. For the automaton mind, he argued, is comprised of actions which, while they may have initially required the use of the intellectual mind, have since become habituated through repetition so that no conscious attention is required for their performance. As such, these capacities of the automaton mind become quasi-physical. They are corporeally ingested so as to become a transmissible mental stock that is passed on – not via social trainings, but by an unspecified hereditary mechanism – from one generation to the next. The ratio of the automaton mind to the intellectual mind can then serve, Pitt Rivers argues, as an index of a population's placement on the ladder of progress. The automaton mind will account for a higher proportion of the total mind the lower the stage of development of a population. Pitt Rivers's reasoning here suggests that such a mental inheritance derives from the situation of backward peoples who, since their societies have remained static, have been able to cope with their circumstances through the simple reflex application of the automaton mind for longer periods than more developed peoples who (to have become more developed) must have had to give more time to exercising the intellectual mind.

The scope of Pitt Rivers's arguments on this matter was clearly a broad one. But they also informed his approach to questions of museum pedagogics. If, he argued, in a later address, 'the law that Nature makes no jumps, can be

taught by the history of mechanical contrivances, in such a way as at least to make men cautious how they listen to scatterbrained revolutionary suggestions', this can only be so if such collections are 'arranged in such a manner that those who run may read'. By 'those who run', Pitt Rivers meant the working classes:

> The working classes have but little time for study; their leisure hours are, and always must be, comparatively brief. Time and clearness are elements of the very first importance in the matter under consideration. The more intelligent portion of the working classes, though they have but little book learning, are extremely quick in appreciating all mechanical matters, more so even than highly educated men, because they are trained up to them; and this is another reason why the importance of the object lessons that museums are capable of teaching should be well considered.
>
> <div align="right">(Pitt Rivers 1891: 116)</div>

If the museum is to teach the working man that progress will come, but only slowly, if he is to advance, but only at a regulated rate, then the museum must address him in forms which he has been 'trained up to'. Since these lessons must be absorbed in the brief snatches which interrupt a life of necessary labour, they must require only the application of the automaton mind.

That the same methods may not work well with educated men is made explicit. But what of women? Pitt Rivers does not address the question directly. However, when discussing the museum he established in Farnham in the 1880s, he does make specific reference to women visitors. Describing a display of crates which women were expected to carry in 'primitive' tribal cultures, he states that he had collected them 'expressly to show the women of my district how little they resemble the beasts of burden they might have been had they been bred elsewhere' (Pitt Rivers 1891: 119). The working man, even though being urged to slow down, was addressed as a potential agent of progress while women were envisaged as only the passive beneficiaries of an evolutionary process whose driving forces were the man made technologies of war and production. Read in the context of the conjunction between evolutionary theory and the prevailing conceptions of sex differentiation, such a display can only have been calculated to reconcile women to their ordained position as always at least one step behind men in the process of evolution's advancement.

ONE SEX AT A TIME

At the Musée de l'homme the visitor's route through the Biological Anthropological Gallery is organized in the form of a journey from the body's surfaces through to its underlying structures. In the process, as layer after layer is stripped away, so the physical substratum of our common humanity

<div align="center">201</div>

is progressively laid bare. While it is shown that there are many respects in which individuals may differ from one another so far as their bodily appearances are concerned – differences of hair-type, height, pigmentation and genitalia – such differences disappear once the anatomical gaze, ceasing to be merely skin-deep, slices into the body's interior. Here, in the body's musculature, in its organs, bones and, finally, the codes of DNA, the world revealed to view is one in which the visitor finds everywhere an identity of form and function, the essential sameness of the bodies of members of the species *homo sapiens*. The only interior differences that are allowed any significance are those affecting the form and function of the reproductive organs of men and women. Even here, the accompanying text makes it clear that these differences relating to the sex of bodies do not have any general consequences. In all respects except for their organs of generation, the bodies of men and women are portrayed as fundamentally the same with regard to their underlying structures. The point is underlined in a display of two human skeletons – one female, the other male – as structurally identical in all significant respects in spite of their obvious differences in height and girth.

No less than their forebears in earlier anatomical displays, these are moralized skeletons. Carrying a message of human sameness, they function as part of a conscious didactic intended to detach the museum's displays of ethnological artefacts and remains from the assumptions of nineteenth-century evolutionary thought. This intention is foregrounded by the inclusion within the Gallery of a historical display outlining the racist principles which governed nineteenth-century exhibitions of the relations between European and 'savage' peoples. The point of this historical exhibit is most graphically made by a brief item relating to Saartje Baartman, the so-called 'Hottentot Venus', who, the visitor is advised, was frequently shown in early-nineteenth-century London as an example of arrested primitivism. Yet curiously, and in what must count as an act of institutional disavowal, no reference is made to the fact that Saartje was frequently shown in Paris. More to the point, after her death her genitalia, whose peculiarities, carefully dissected and interpreted by Cuvier as a sign of backwardness, were displayed at the Musée de l'homme itself. Stephen Jay Gould has recalled how, when he was being shown round the storage areas of the museum some time in the 1970s, he was startled to stumble across Saartje's preserved genitalia side by side with the dissected genitalia of two other Third World women. These were stored, he notes, just above the brain of Paul Broca, the most influential exponent of nineteenth-century craniology who had bequeathed his brain to the museum for the light it might throw on the brain structure of an advanced European. The juxtaposition, Gould argues, provided a 'chilling insight into the nineteenth-century *mentalité* and the history of racism' (Gould 1982: 20). But he is not slow to note the double register in which such exhibitions played. For if it mattered that Broca was white and European whilst Saartje was black and African, it mattered just as much that he was a man and she a

woman. As he goes on to note: 'I found no brains of women, and neither Broca's penis nor any male genitalia grace the collections' (ibid.: 20).

The issue to which Gould alludes here was more fully developed in a later study by Sander Gilman. Noting the extensive interests of nineteenth-century science in comparative anatomy as a means of establishing either the essential difference or the backwardness of black peoples, Gilman observes that this interest rarely extended to the genital organs except in the case of black women whose genitalia 'attracted much greater interest in part because they were seen as evidence of an anomalous sexuality not only in black women but in all women' (Gilman 1985b: 89). This, in turn, reflected the assumption that a woman's generative organs might define her essence in ways that was not true for men.

Nor did the matter rest there. By the mid-nineteenth century, women's bodies – down to their very bones – were regarded as incommensurably different from men's. This resulted in anatomical displays in which, as the radical antithesis of those at the Musée de l'homme today, the purpose was to exhibit and demonstrate unbridgeable sexual differences rooted in the structures of male and female skeletons. This was done in ways which reflected the differential distribution of the anatomical gaze to which both Gould and Broca draw attention. If, where European male skeletons were concerned, the stress fell on the size and shape of the cranium as a sign of the more highly evolved brain of European man, constructions of the skeletons of European woman emphasized her enlarged pelvis. This effected an anatomical reduction of woman to her 'essential function' – no more, in Claudia Honniger's telling phrase, than 'a womb on legs' (cited in Duden 1991: 24). It served also to secure her subordination to the male in the further argument, as Londa Schiebinger summarizes it, 'that the European female pelvis must necessarily be large in order to accommodate in the birth canal the cranium of the European male' (Schiebinger 1989: 209).

The processes through which these incommensurably differentiated sexed bodies were produced was connected to changes in the functions and contexts of anatomical displays. In the Renaissance, deceased human bodies were most typically displayed in the context of public dissections. Since these were usually performed on the corpses of felons, they formed a part of the dramaturgy of royal power, a public demonstration of the king's ability to exercise power over the body even beyond death. They were also associated with the practices of carnival in varying and complex ways.[8] It was, indeed, this latter association which, in Ferrari's estimation, helped prompt the eighteenth-century development of anatomical collections distinct from those of the anatomical theatres at places like Leiden and Bologna in order to provide a means for teaching anatomy in spaces removed from the public sphere and its occasionally turbulent excesses (see Ferrari 1987).

This development had the further consequence that access to anatomical collections tended to become segregated along gender lines. Collections of

the type developed by William and John Hunter over the late eighteenth and early nineteenth centuries and subsequently donated to the Royal College of Surgeons were largely reserved for the exclusively male gaze of trainee or practising doctors and surgeons. The same was true of more popular anatomical exhibitions. Richard Altick notes that men and women were initially admitted together to Benjamin Rackstrow's Museum of Anatomy and Curiosities, a popular London show, first opened in the 1750s. Altick describes this as 'a combination of Don Saltero's knicknackatory and the reproductive-organ department of Dr. John Hunter's museum' in view of its combination of anatomical peculiarities with obsessively detailed wax models and reproductions of the womb plus one specimen of 'the real thing' accompanied by a penis 'injected to the state of erection' (Altick 1978: 55). By the end of the century, however, handbills advised that 'a Gentlewoman attends the Ladies separately' (ibid.: 56) – a practice of sex segregation that was to be continued by Rackstrow's nineteenth-century successors, such as Dr Kahn's Museum of Pathological Anatomy whose main focus was an embryological exhibit showing the growth of the ovum from impregnation to birth, and Reimler's Anatomical and Ethnological Museum.

A further change, finally, consisted in a transformation of the function of anatomical exhibits. Within Renaissance practices of public dissection, a good deal was invested in the singularity of the body: it served an exemplary function because of the specific status (criminal) of the person whose body it was. The body, here, is moralized but not pathologized. While aspects of earlier practices survived in the popular anatomical displays described above, as indeed they did in the medical collections of John Hunter, the nineteenth-century tendency was for anatomical displays to fulfil a normalizing rather than a moralizing function. As parts of a new symbolic economy of the human body, such collections served to construct a set of anatomical norms and then to reinforce those norms through the exhibition of pathologized departures from them. Those norms, moreover, were increasingly conceived in evolutionary terms resulting in a set of hierarchically graded norms appropriate for different populations. When, in 1902, Lombroso established his Museum of Criminal Anthropology at Turin, the mortal remains of criminals had been finally detached from their earlier moralizing function to serve, now, in being pathologized in evolutionary terms as atavistic types, as props for normalizing practices – by this time eugenicist in their conception – directed at the population as a whole (see Pick 1986).

These, then, are the main changes affecting the exhibitionary contexts in which, from the second half of the eighteenth century, anatomical remains or reconstructions – themselves becoming increasingly and implacably differentiated in sexual terms – were typically displayed. Thomas Laqueur's compelling discussion of the formation of the two-sex model of humanity underlines the significance of this production of sexed anatomies. Prior to the early modern period, Laqueur argues, there was 'only one canonical body and

that body was male' (Laqueur 1990: 63). Tracing the more or less continuous influence of the ideas of the Roman physician Galen of Pergamum on European medical thought through to and beyond the Renaissance, Laqueur shows how the female body was typically viewed as an inferior version of the male body. This hierarchized construction of the relations between the male and female bodies was genitally centred in that it depended on the belief that the female organs of generation were an inverted, and for that reason inferior, version of the male organs of generation.[9] While this necessarily entailed that woman was measured as lesser, as imperfect, in relation to norms of anatomical perfection that were unambiguously and explicitly male, it equally entailed that men and women were not viewed as radically distinct from one another, as incommensurably separate. To the contrary, the commonality in the structure of their genital organs and the related fact that these were viewed as functioning in virtually the same fashion in the process of generation, made the notion of two sexes differentiated from one another in terms of characteristics attributed to foundational differences in their genitalia literally unthinkable. Viewed as, genitally, a lesser man, the consequence, as Laqueur puts it, was that 'man is the measure of all things, and woman does not exist as an ontologically distinct category' (ibid.: 62).

In this light, Londa Schiebinger (1989) argues, it is significant that illustrations of the human skeleton designed for teaching purposes were neuter until the early nineteenth century and that, when the female skeleton did make its first appearance, it was in the form of an imperfect realization of the male skeleton rather than as an osteological structure of a radically distinct type. In the mid-to-later decades of the century, however, the female anatomy was subjected to an increasingly reductive gaze. As Ludmilla Jordanova has shown in her discussion of William Hunter's anatomical drawings and anatomical models fashioned in wax, women's genitalia, which had been modestly veiled in earlier medical teaching aids and illustrations, were gazed at and through in unrelenting detail (see Jordanova 1980, 1985). This process, Jordanova argues, in subjecting the bodies of women to the increasingly penetrative vision of a male science, served to 'unclothe' an essentially feminine nature rooted in a now radically differentiated reproductive system. Although disagreeing that women's bodies were any more subjected to such a dissecting gaze than men's, Laqueur's conclusions point in the same direction: the organization of an anatomical field in which male and female bodies no longer confronted one another as 'hierarchically, vertically, ordered versions of one sex' but as 'horizontally ordered opposites, as incommensurable' (Laqueur 1990: 10).

These developments have been attributed to a variety of factors: to the struggle of male medicine to wrest control over women's reproductive functions from midwives; to the assertion of political control over women's bodies in the context of the powerfully anti-feminist strain of the French Revolution which sought to repulse women from the public sphere;[10] and to

the emergence of the domestic sphere as one to which women were 'naturally' suited by their biologically distinct bodies and the different temperaments to which such foundational biological structures were held to give rise. Laqueur is careful to insist, however, that the ascendancy of the view that the two sexes were incommensurable opposites did not entail the complete displacement of the single-sex model which, he suggests, resurfaced in particular regions of sexual representation. Evolutionary theory was a case in point as it could be 'interpreted to support the notion of an infinitely graded scale, reminiscent of the one-sex model, on which women were lower than men' (Laqueur 1990: 293). Schiebinger (1989) is more emphatic: where males and females were now considered each to be perfect in their differences, such differences were arranged hierarchically – man, while no longer more perfect than woman, emerged as simply more evolved.

In short, the move from a one-sex to two-sex anatomical order was simultaneously a shift from an ordering of sexed bodies that was atemporal – woman's place within the hierarchy of being as an imperfect man was destined to be permanent within the one-sex model – to one that was historicized. Over the second half of the nineteenth century, when the view of the incommensurability of men's and women's bodies encountered the developing body of evolutionary social thought, the result was to place woman not below man but behind him. This was thematized in various ways depending on the points of comparison chosen for calibrating the degree of woman's underdevelopment: children, 'savages', the higher primates, criminals – all of these, within one strain or another of evolutionary thought, served as the benchmarks to establish woman's place on the evolutionary ladder.[11] Theoretically, of course, the premises of evolutionary theory allowed that the gap between men and women might be closed through time; indeed, this was precisely the ground taken by many feminists in their early and difficult confrontations with Darwinian theory.[12] In one way or another, this progressive potential of evolutionary thought was closed down within the more influential applications of evolutionary theory to the field of sexual differences.

Developments in craniology were particularly important here. For these discredited the earlier practices of phrenology, which had allowed that the forms of self-knowledge acquired through this technique might lead to forms of self-improvement through which mental capacities, including those of women, might be increased. In their place they substituted a conception in which woman's lower mental capacity was regarded as the inescapable limitation of her inherently inferior skull size (see Russett 1989; Fee 1976, 1979). Worse still, in what was clearly a virulent anti-feminist campaign, the last quarter of the century saw the use of Spencerian arguments to suggest that women could only expect to fall further behind men on the ladder of evolutionary development. Since men's and women's bodies differed more sharply in 'more advanced' civilizations than they did among

206

'savages', and since it seemed that this must be the result of more sharply segregated sex roles in societies where the division of labour was more advanced, the conclusion drawn was that, from the point of view of the species as a whole, it was crucial that women should remain in the domestic sphere for which their anatomies had prepared them even if this meant that the evolutionary gap between the sexes could only increase (see Duffin 1978; Sayers 1982).

Of course, these were not the only ways in which the premises of evolutionary thought got translated into social narratives of sex and gender. And they were opposed. Flavia Alaya notes how Harriet Taylor and John Stuart Mill made a special point of congratulating a feminist conference for sticking out against the tide of debate in choosing *not* to debate questions concerning men's and women's natural aptitudes (Alaya 1977: 263). However, the tendencies I have focused on were the prevailing ones, especially where sexed anatomies were exhibited. How, precisely, these assumptions were reflected in the details of museum displays is sometimes difficult to determine as this is not an especially well-developed area of museum research. We know that, in museums of natural history and ethnological museums, the skeletons and crania of women were arranged in relation to those of men to demonstrate their lower stage of development. They were also arranged in relation to those of 'savages' to suggest a finely calibrated scale of human evolution leading from the evolutionary base of primitive women through primitive men to European women and, finally, European men. We know also that the conventions of taxidermy favoured male-centred displays in their reconstructions of the animal kingdom. At the American Museum of Natural History, where animal life was portrayed in an evolutionary sequence of dioramas depicting habitat groupings, each display was governed by a clear sexual hierarchy with the male being privileged in being accorded the role of representing the most perfect and fully developed form of each species (see Haraway 1992).

It is, then, plausible to assume that, for women, the opportunity the museum offered to conduct a performative realization of evolutionary narratives was of a different kind than that available to men. Within the museum's 'backtelling' structure, European woman encountered herself as both advanced and backward, ahead of her 'savage' brothers and sisters but behind the European male. She was anatomized in such a way that she was unable to participate fully in the progressive performance for which her body served as a prop. The museum's narrative was one that she could never complete. To visit ethnological or natural collections, I have suggested, provided an opportunity for checking out how one measured up in relation to progress's advance. If so, it was an opportunity which, for women, meant that they could never fully measure up to the highest levels of human development.

And sometimes literally so. Francis Galton, whose theory and practice of

anthropometric measurement was to prove one of the most influential techniques for producing the body as a zone of almost infinitely graded and hierarchized sexual and racial differences, set up an anthropometric laboratory at the International Health Exhibition held at South Kensington in 1884. There, for a charge of threepence, men and women were offered the opportunity of having a series of anatomical measurements taken that would enable them to assess where they fitted on the evolutionary scale of things. Initially, the requirements of social tact prevented the measurement of women's skulls as this would have required the removal of their bonnets and the disturbance of their hair styles (see Forrest 1974: 181). However, this precautionary gallantry was dispensed with when, in 1885, the laboratory was transferred to the South Kensington Museum. For eight years, the Museum's visitors, men and women, continued to have their anatomical and cranial measurements taken and recorded as part of Galton's accumulating record of the evolutionary differentiation of the sexes. In so doing, they helped perpetuate the narrative machinery which regulated their performances.

8

THE SHAPING OF THINGS TO COME

EXPO '88

Expositions are among the most distinctive of modernity's symbolic inventions in that, as contrived events looking for a pretext to happen, they have been obliged to seek the occasions for their staging outside themselves. While by no means solely so, the most favoured candidate for this role has been that other symbolic invention of modernity, the national celebration. The Philadelphia Centennial Exposition of 1876, marking a century of American independence, thus counts as the first in a long line of expositions held in conjunction with celebrations marking the passage of national time. The Melbourne International Exhibition held in 1888 in association with the first centenary of Australia's European settlement; the Exposition Universelle held in Paris the following year as a part of the centenary of the French Revolution; and Expo '67, hosted by Montreal in the midst of Canada's first centennial celebrations, are a few examples that might be cited. Even where the connection has not been so direct as in these instances, expositions have usually sought some way of inserting themselves into the symbolic rhythms of national histories. Chicago's 1893 World's Columbian Exhibition was thus staged to celebrate the 400th anniversary of Columbus's discovery of the Americas, while the New York World's Fair of 1939 sought its national legitimation in the sesquicentenary of Washington's presidential inauguration.[1]

Yet it is only rarely that the synchronization of these two kinds of events has resulted in their symbolic fusion. Indeed, and especially in the twentieth century, their simultaneity has more often served to mark the differences between them, throwing into relief the contrivance of their association. For while both events are the progenies of modernity, they are ultimately conceived and organized in relation to different times. If centennial celebrations and the like tick to the clock of the nation, marking its passage through calendrical time in drawing up symbolic inventories of its achievements, expositions tick to the international time of modernity itself. They mark the passage of progress, a time without frontiers, while the inventories they organize are, at least ideally, ones which mark the achievements of the nationally undifferentiated subject of humanity.

209

This is not to suggest a complete dissociation of these two temporal registers. Indeed, expositions have usually aimed to overlap these two times – of nation and of modernity – on to one another by projecting the host nation as among the foremost representatives of the time, and tasks, of modernity. This was the pattern established by the Great Exhibition of 1851 and repeated in most of the major nineteenth-century expositions. Where these were hosted by metropolitan powers, the bringing of these two times together could be accomplished with some conviction. For where national time is also imperial time, its internationalization is but a discursive hop, step and a jump.[2] The situation, however, is different where expositions are hosted by societies on the periphery of the world capitalist order. For, in such cases, the annexation of the time of the nation to the time of modernity requires that the former be shorn of all that is local and limiting, and thus of all that is specific to it. Where this is so, and where expositions and national celebrations coincide, the two are likely to play in different thematic registers, constantly under-scoring their mutual incompatibility.[3]

An added difficulty is that there is often a third time competing with the times of both the nation and modernity: that of the host city. Again, the resulting tensions may scarcely be noticeable where the host city is the capital city of a major metropolitan power. However, they may become acute where expositions are held in provincial centres, and especially so in federal societies in view of the strong inter-state and inter-city rivalries these characteristically generate. In such circumstances, the host city typically seeks to hitch itself directly into the time of modernity, by-passing the nation – indeed, undercutting it – in representing itself as embodying the spirit of progress more adequately than either the national capital or rival provincial cities. Where this is so – and Chicago's 1893 World's Columbian Exhibition is the most frequently cited prototype – expositions are primarily city events.[4] Caught up more in the web of local than of national politics, they are also typically sites for the enunciation of city rather than (and sometimes in opposition to) national rhetorics.

Brisbane's Expo '88 was no exception to these general rules. Indeed, as an expo held in a provincial city in a peripheral country during the midst of its Bicentennial celebrations, it was a paradigm case of the ultimate dissociation of the three times – of the city, the nation and modernity – it installed itself between. Billed as the biggest event of the Bicentenary, and granted quasi-official recognition as such, it was neither sponsored nor funded by the Australian Bicentennial Authority. Governed by a separate authority whose lines of responsibility ran, on the one hand, to the Queensland State Government and, on the other, to the Bureau International des Expositions (BIE), its organizational structures were formally unrelated to those established for the Bicentenary. Moreover, its theme – leisure in the age of technology – which, in accordance with the rules of the BIE, had both to be international in conception and to demonstrate the achievements of progress,

allowed little connection to be made with the lexicon of nationing rhetorics so evident elsewhere in Australia throughout 1988. Visiting the Expo was, in this sense, something of a welcome relief from the discourses of 1988. The most significant concessions made to these were the Captain Cook Pavilion which, in its exhibition of Cook memorabilia, echoed to the tunes of the nation's foundation and settlement, and the Australian Pavilion – of which more later. For the most part, however, the stress fell not on the symbolic time of the nation but on the insertion of the nation into the international time of modernity.

And it fell most especially on the insertion of Brisbane into the time of modernity. The Expo motto – 'Together we'll show the world' – had many resonances, accumulating in their significance as the Expo unfolded. Most obviously, it referred to the representational ambition of the exposition form – that is, to render the whole world metonymically present – as, indeed, to the aspiration that the world, in the form of tourists, would come to see this metonymic assemblage of itself. Its most crucial resonances, however, derived from its conception of the 'we' who were to do the showing. For this was, most assuredly, not the national 'we' of 'all Australians' through which we were so constantly hailed throughout the Bicentenary. On the contrary, this 'we' was intended to recruit a more local subject and organize it in opposition to the national 'we'. It was Queenslanders, and especially Brisbaners, who were hailed as the subjects of this act of showing – an act of showing in which it mattered less what we showed than that we confound all the knockers and showed that we could do it, that we could put on the Expo that the other states had proved too faint-hearted to attempt. What was to be shown, in other words, was Brisbane's capacity to put on the show.

In brief, Expo '88 was, first and foremost, an event in the life of its host city; an instrument that was both to effect and signal its transformation from a provincial backwater into a world city representing the very cutting-edge of modernity – from, as two critics put it, 'Backwoods into The Future' (Fry and Willis 1988). And it mattered little, in this respect, if, as proved to be the case, no one else noticed. For if Expo '88 exceeded its visitor targets, this was less because the world or even the rest of Australia came to see the show than because of the high number of repeat visits made by Queenslanders – and especially by those resident in Brisbane or its immediate environs (Craik 1989). The consequence was an Expo in which the subject of the show and its addressee were curiously intermingled; in which the primary witness to Brisbane's demonstration of its capacity to put on the show was the city itself. Characterized, in one newspaper report, as 'the drug that kept Brisbane in awe of itself for six months' (*Melbourne Sun*, 31 October 1988), Expo '88 did, indeed, construct the city in a peculiarly mesmeric relationship to itself as, in watching it demonstrate to itself its own capacity to show that it could put on the show, Brisbane imaginarily leapfrogged itself over the shoulders of Sydney and Melbourne to bask in a temporary metropolitan status.

Expo '88 was, then, in all these respects, an intensely local affair. So, for the most part, were the political controversies which surrounded it. True, it did occasionally get embroiled in the national political debates which accompanied the Bicentenary. The use of an American company to provide audio-visual technology for the Australian Pavilion provoked a major political scandal, although one which had run its course before the Expo opened.[5] Expo was also a target for Aboriginal protests, although there was some difference of opinion among Aboriginal groups as to whether Expo should or should not be regarded as a part of the Bicentenary and, accordingly, different views as to the appropriate political stances to be adopted in relation to it.[6] For the most part, however, the protests which accompanied Expo's planning and execution had a local, city flavour: protests against the razing of traditional inner-city residential zones to make way for the Expo site; protests against landlords who evicted long-term tenants in order to charge inflated rents during the Expo period; allegations of police harassment of gays as part of a pre-Expo city clean-up; street marches by prostitutes in protest at the loss of business inflicted on Brisbane's night life by the attractions of Expo; and the exertion of 'people power' in protest at the initial plans for the redevelopment of the Expo site as a tourist megapolis.[7]

There was, as a consequence, very little criticism of Expo itself. The politics of what was shown and done there – of the kind of event it was and the nature of the experience it offered – were largely by-passed in a critical climate concerned more with either its impact on the city's economy, residential structure and public utilities or with the more general politics of the Bicentenary which, in part, Expo side-stepped. While I cannot entirely compensate for this deficit here, a consideration of the respects in which the Expo script, in organizing the visitor's experience, served as an instrument for a specifically regional programme of civic modernization might go some way towards doing so.

To engage with matters of this kind, however, requires that Expo '88 be considered in relation to the longer history of the exposition form and the kind of festival of modernity it embodies. For it was this history that wrote many aspects of the Expo script, governing its conception and shaping its main contours in ways which influenced the experience of its visitors as deeply and fundamentally as any of the specifically Australian, Queensland or city resonances that were lent to that script. While an exhaustive account of the origins and development of expositions cannot be attempted here, some brief genealogical excavations of their origins and early history will pay dividends, and particularly if conducted with a view to highlighting the performative rather than the representational aspects of the exposition script. When viewed in this light, I shall suggest, expositions are best regarded as providing their visitors not, as is commonly supposed, with texts for reading, but, rather, with props for exercising.

EVOLUTIONARY EXERCISES

'It was only with the expositions of the nineteenth century', Umberto Eco argues, 'that the marvels of the year 2000 began to be announced.' No matter how much earlier collections, such as the *Wunderkammern* of the sixteenth century, might have resembled modern expositions in their concern to inventorize the past, they were crucially different, in Eco's estimation, in containing 'nothing which pointed to the future' (Eco 1987: 293). Foucault makes a similar point when he contrasts the 'utopias of ultimate development' which predominated in the nineteenth century with the earlier functioning of utopia as 'a fantasy of origins', accounting for the transition from the latter to the former in terms of the influence of a new conception of knowledge in which things are given and known in the form of 'a series, of sequential connection, and of development' (Foucault 1970: 262). If the arrangement of objects within an eighteenth-century cabinet of curiosities derived its cogency from its reference to the ideal taxonomy of the world's beginning, when everything *had been* in its proper place, the nineteenth-century exposition – and museum – points to a future in which everything *will have* arrived at its proper place.

In association with these changes – indeed, as part of them, as both their conditions and effects – the semiotic properties of the objects displayed underwent an equally far-reaching transformation. The principal semiotic value of the object in a cabinet of curiosities was thus, as Carol Breckenridge summarizes it, that of its own *singularity*:

> The object in a wonder cabinet celebrated nothing but itself as rare, sensational, and unusual. Neither beauty nor history appear to have been promoted as a value by which to behold the housed object. Objects were judged according to the amazement they aroused largely because they were rare, uncommon, and even unthought of creations.
>
> (Breckenridge 1989: 200)

By the Great Exhibition of 1851, however, the semiotic value of the object displayed is *representative*. Whether a raw material, instrument of production or finished product; whether a work of art or of manufacture; whether from Britain, India, France or America – most things at the Crystal Palace were displayed as representative of a stage within an evolutionary series leading from the simple to the complex. Subsequent nineteenth-century expositions added little to this aspect of the form except to increase its representational density via the construction of evolutionary series that were evermore extensive and totalizing in their ambit: the organization of national pavilions into an evolutionary hierarchy of racial zones, the construction of 'colonial' or 'native' villages, and so on (Greenhalgh 1988; Rydell 1984).

All this, then, by way of saying that the underlying rhetoric of the exposition form is one of progress. A familiar point, no doubt. But what are

we to make of it? Most accounts, stressing the representational functioning of this rhetoric, view it as an ideological means for the organization of consent to bourgeois hegemony given the respects in which the evolutionary story it tells culminates in the triumphal achievements of contemporary capitalism. While not wishing to gainsay this, Foucault's comments on the relations between 'the discovery of an evolution in terms of "progress"' and the coincident emergence of what he characterizes as the 'evolutive time' constituted by disciplinary methods of training suggest another perspective from which the expositional functioning of this rhetoric might be assessed.

For evolutive time, in Foucault's conception, is not a means of representing power but is rather directly bound up with, and serves as a means for, its exercise. The differentiation of time into a series of stages (classes in a school, say); the administration of examinations to determine whether an individual may progress from one stage to the next; the retardation of the scheduled progress of those who fail to pass such tests: in these ways there is constituted a linear time whose orientation towards some terminal point allows the intervention of disciplinary exercises which prepare the individual for, and mark his or her passage through, evolutive time. 'By bending behaviour towards a terminal state,' Foucault writes, 'exercise makes possible a perpetual characterization of the individual either in relation to this term, in relation to other individuals, or in relation to a type of itinerary' (Foucault 1977: 161). Yet – and this is the key to the relations between disciplinary power and evolutive time – to an itinerary without end in the sense that each terminal state, once it is reached, turns out to be only a step towards a further beckoning task resulting in a 'political technology of the body and of duration' which 'tends towards a subjection that has never reached its limit' (ibid.: 162).

Perhaps, then, the expositionary arrangement of things, peoples and civilizations, all in sequential toil towards a beckoning future, should be viewed less as a field of representations to be assessed for its ideological effects than as an injunction, the laying-out of a task, a performative imperative in which the visitor, exercising in the intersections of the evolutionary time of progress and the evolutive time of discipline, is enlisted for the limitless project of modernity. There are, of course, many versions of this project. At expositions, however, the idea of progress has typically been thematized technologically via the projection of a line between past, present and future technologies – the latter, as in the Democracity of New York's 1939 World's Fair, doubling as progress's means and its destination.[8] In this way, in offering both an inventory and a telos, in summarizing the course of mankind's advance and plotting its future path, expositions allow – invite and incite – us to practise what we must become if progress is to progress, and if we are to keep up with it. They place us on a road which requires that we see ourselves as in need of incessant self-modernization if we're to get to where we're headed.

The theme of Expo '88 – leisure in the age of technology – lent itself well to this modernizing imperative. Modern expositions, Eco has argued, are most clearly distinct from their nineteenth-century predecessors in according less attention to what they show than to the means of its presentation. The international standardization of productive technologies and, consequently, of their products deprives these of any potential competitive display value, with the result that the means of displaying are accorded an increased significance in this regard. 'Each country', as Eco puts it, 'shows itself by the way in which it is able to present the same thing other countries could also present. The prestige game is won by the country that best tells what it does, independently of what it actually does' (Eco 1987: 296). This was written with Montreal's Expo '67 in mind. Robert Anderson and Eleanor Wachtel, writing in the midst of Vancouver's Expo '86, confirmed this tendency in noting, of the tradition of exhibiting new inventions at expositions, that the 'invention shown is now seldom a thing; it is the method of display itself'.[9]

There are, of course, many ways in which a modernist rhetoric informed the expositionary strategies of Expo '88. Although the global nineteenth-century narrative constructions in which things, peoples and civilizations were hierarchically ranked and arranged in evolutionary toil towards the present were not much in evidence, their echoes certainly were. The construction of a Pacific Lagoon, mid-way between the American and Japanese Pavilions (see Figure 8.1), thus provided an imaginary retreat from the Expo sea of modernity, one in which, in however idealized and romanticized a fashion, Pacific Islanders were assigned the role of representing the backwardness from which progress had progressed.[10] Similarly, in many of the national Pavilions, the time of the nation and that of modernity were articulated to one another, albeit by means of a range of presentational strategies. In the United Kingdom Pavilion, for example, their articulation took the form of a disjunction between the outside entertainment areas – stressing, in an 'authentic' English pub and an ongoing performance of cockney musicals, the traditional aspects of English life – and the interior, dominated by a hi-tech, multi-screen presentation of leisure activities in Britain.[11] In the Australian Pavilion, by contrast, the time of the nation and that of modernity were melded together via the use of hi-tech display techniques to offer, in the Rainbowsphere (described, in the official souvenir programme, as 'one of the most sophisticated audio-visual productions ever devised – another world first for Australia'), a kaleidoscopic portrayal of life in modern, multicultural Australia. This was complemented by an illusionistic rendition of the Rainbow Serpent legend in an animated diorama, a hi-tech version of the Dreamtime which served to anchor national time in the deep time of Aboriginal history while simultaneously modernizing that time in technologizing it (see Figure 8.2).

It was, however, and in confirmation of Eco's argument, typically the

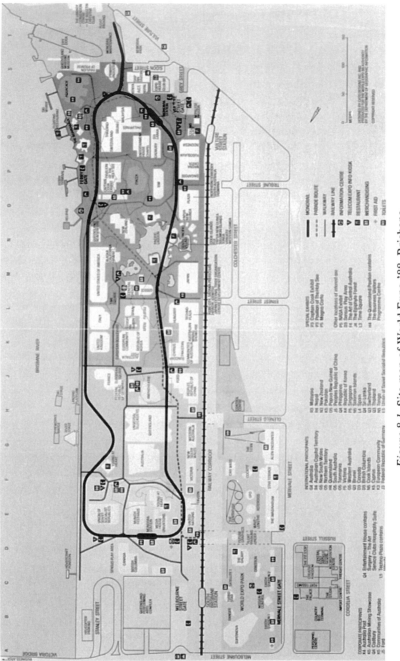

Figure 8.1 Site map of World Expo '88, Brisbane

Source: Reproduced with kind permission of the South Bank Corporation

Figure 8.2 The 'Rainbowsphere'
Source: Used with permission from Selcom.

technologies used in the organization of displays that carried the theme of progress. For it was these which functioned as both the key signs and organizers of modernity. They served as the former in dividing the world up into different blocs: those whose place at the cutting edge of modernity was symbolized by their use of advanced video and computer display technologies (Europe, North America, Japan, Australia); those which, in displaying artefacts as if in a nineteenth-century museum rather than multi-media demonstrations, were not yet modern enough to be postmodern (Russia, China); and those which, in relying solely on live performers to exhibit their culture, symbolized the past of a pre-technological age in relation to which our advance might be measured (Fiji, Tonga). And they served as organizers of modernity in embodying, in their very form, a beckoning future. 'See your past, present and future in a new dimension at the Fujitsu pavilion', the advert for one of the corporate pavilions read, where the past and present referred to a film account of human evolution and the future to the already present means of telling that account: a computer-generated 3D movie.

 In this regard, then, Expo pointed to a future. Yet it also, in instantiating that future – that is, rendering it present, giving it a concrete form – afforded the visitor the means with which to practise for it and thus to engage in an anticipatory futuring of the self. The advanced interactive leisure technologies in the Technoplaza thus, in inviting the visitor to play and learn,

functioned less as representations than as instruments of self-fashioning, a means for engaging in a future orientated practice of the self, a dress rehearsal for what one is to become. The same was true of the use of advanced computer technology in the various on-site visitor information systems which rendered the future present in the form of a demand and a challenge: update yourself or get lost!

While the articulations of this futuring of the self varied from one national pavilion to another, these were all overshadowed by its embodiment in the corporate pavilions where modernity, in the form of advanced technologies of consumption, was free to be its own sign and referent. In this respect, Expo '88 confirmed a cumulative twentieth-century tendency for the corporate pavilion, once a marginal feature of the exposition form, to displace national pavilions as the organizing centres of expositional rhetorics of progress.[12] If, in the national pavilions of Europe and North America, advanced leisure technologies were able to serve as signs of the nation's modernity, this was only because, in the corporate displays – such as that of the IBM pavilion and the Technoplaza (dominated by displays of companies like Hitachi) – the same technologies symbolized the internationally undifferentiated time of the multinational corporation to which national times could then be annexed in a discourse of modernization (see Figure 8.3).

Yet it was also this construction of an undifferentiated time of modernity which allowed the more local time of the city to be connected to it and thus, in a manner typical of 'second city first' rhetorics, to catapult itself ahead of the national time.[13] Tony Fry and Anne-Marie Willis correctly identified many of these aspects of Expo '88 in the prospective critique they offered some months before its commencement. The intention of the Expo, they argued, was 'to signify to the world, the nation, and the local area that the "international", in the form of the appearance of advanced modernity, has arrived' (Fry and Willis 1988: 132). In this respect, they suggested, the event of Expo itself was (or would be) less important than its planned relation to its after-event: its 'co-option in the process of recoding the once "overgrown country town" as a modern, quasi-postmodern, progressive city' (ibid.: 137). Yet, insightful though their criticisms are, Fry and Willis do not altogether escape the pull of the field of discourse they describe. Writing from Sydney, they are thus unable to resist a degree of metropolitan condescension, castigating Brisbane for revealing itself to be provincial in its very attempts to escape provinciality, as still a backwoods in its very claims to be modern – and thereby necessarily showing itself to be behind the times in its failure to register the postmodernist critique of modernity's ambitions.[14]

In this, they merely anticipated the terms in which southern journalists would depict Expo – the unconvincing modern façade of a city which, in failing to disguise its backwardness, merely demonstrated its upstart qualities – thus reproducing the very discursive conditions which gave Brisbane's

'second-city first' rhetoric its strong local edge.[15] Yet, as with the more general aspects of the expositionary discourse of progress, it is not merely as a set of representations that we need to assess the city aspects of Expo '88's modernizing discourse. Rather, and again, we need to understand that the effectivity of such events proceeds not just via the logic of signs but via signs as parts of trainings and exercises which aim at altering less the consciousness than the conduct of individuals. Expo's significance in this regard, that is, has to be assessed less in terms of its suasive qualities than of its capacity for habituating specific norms of conduct and codes of civility orientated to the requirements of a modernized city ethos. To understand how Expo '88 functioned in this regard, however, it will be necessary, first, to expand the scope of this thumbnail genealogy of the exposition form in considering its historical role in providing a training in civics.

CIVIC CALLISTHENICS

The effects of expositions, no less than those of bicentenaries, are not limited to the moments of their occurrence. Preceded by the publicity apparatuses which 'trail' their central discursive preoccupations long before their opening, expositions have proved equally important as the occasions for cultural and symbolic bequests to their host cities. Although somewhat atypical, the Eiffel Tower, a legacy of the 1889 Paris exposition, is the most obvious example. The more usual pattern, however, has been for expositions to stimulate the development of public museums, often supplying these with their buildings and initial collections. The Great Exhibition of 1851, in providing the spur for the development of London's South Kensington Museum complex,[16] thus set an example that was repeated elsewhere – Chicago's great public museums spring from the 1893 Columbian Exhibition – and often, as was the case with the establishment of Victoria's Industrial and Technological Museum in the wake of the 1866 Intercolonial Exhibition, with the South Kensington model directly in mind (see Perry 1972: 2).

In Brisbane's case, however, the museums preceded the exposition with the opening, a couple of years earlier, of the Queensland Cultural Centre with its museum and art gallery, shifted from their earlier premises to new buildings (see Figure 8.4). Developed on the south bank of the Brisbane River, adjacent to the Expo site, this hyper-modern cultural complex symbolized the modernization of civic life for which Expo was to pave the way. Made possible by a forcible clearance of old industrial and working-class residential areas, Expo betokened the beckoning modernization of Brisbane that was promised in plans for the site's redevelopment, a modernization prefigured in the shining face of the new at the Cultural Centre. Although, in this sense, preceded by its own bequest, only one part of Expo itself was envisaged as forming a part of this future – the World Expo Park, described in the official programme as a 'collection of space-orientated rides, exhibits

In 1788, who could have imagined a time in the future where people would drive to their 60-storey office buildings in machines fuelled by the power of a hundred horses?

Or travel halfway around the world in half a day in metal tubes flying 10,000 metres above the ground?

Or use machines that complete many days of work in a few short hours?

Without doubt, the past 200 years more than any other period in history, have seen monumental change.

And it seems certain to be the case for the next 200.

Which is why it's important for IBM to be part of such major public events as World Expo '88.

Figure 8.3 Annexing national time to the multinational corporation
Source: Used with kind permission from IBM Australia Ltd.

"I wonder what things will be like in 200 years time?"

We have provided IBM System/38 equipment to help run the event, but more importantly, we're major exhibitors.

The IBM pavilion, with its two large futuristic theatres and an interactive computer park, will be an attraction where visitors won't simply be entertained.

Certainly those who visit the pavilion will feel they are much more familiar with

computers. Chances are, they'll also be interested in, and stimulated by, the possibilities they offer.

And since computers are bound to play an even greater role in the work and leisure activities of our children than they already do in our lives, the IBM pavilion will provide the next generation with an ideal opportunity to stay ahead.

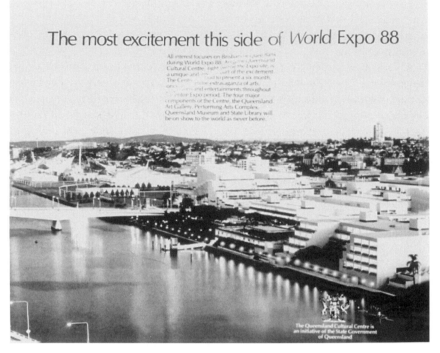

Figure 8.4 Advertisement for the Queensland Cultural Centre

and amusements . . . destined to be Expo's only physical legacy' and sited directly by the Cultural Centre.

That a fun-fair was planned as an integral part of Expo '88 seems to have occasioned neither surprise nor objection. Nor, furthermore, was there any protest at the proposal that the fair should be left behind, nestling cheek by jowl with the museum and art gallery. Yet it is certain that, a century or so ago, such a proposal would have been unthinkable. Museums, art galleries and expositions then stood on one side of a cultural divide and fairs, together with other places of popular assembly, on another, and any proposal to adjoin them would have provoked outrage. Indeed, museums and the like were explicitly conceived and planned as cultural zones distinct from the world of the fair, the tavern, music-hall or popular theatre.[17] David Goodman has thus tellingly argued the respects in which the mid-nineteenth-century foundation and early development of the National Museum of Victoria was shaped by a dual-edged 'fear of circuses': that is, by the desire to construct a cultural space in which a rational ordering of nature would be distinct from the collections of curiosities, of popular zoos, menageries, circuses and commercial pleasure gardens, while also one in which civilized and decorous forms of behaviour could be distinguished from the raucousness associated with places of popular assembly (Goodman 1990).

222

It is, in this light, important to note that, at Expo '88, it was not merely the world of the fair that was brought into a harmonious relation to that of the exposition and museum. Virtually all the other forms of popular entertainment and assembly which, in the mid-nineteenth century, would have stood on the other side of the cultural divide – the circus, remnants of freak shows (the tallest man in the world), parades and carnivals, street theatre, taverns – were enfolded into the Expo, parts of its official programme.

It is not possible, here, to account in detail for the processes through which the terms of this cultural divide have been, if not undone, then certainly loosened.[18] As far as the fair is concerned, however, two developments stand to the fore; and both were incubated in the Midway zones of late nineteenth-century American expositions. The first consists in the modernization of the culture and ethos of the fair effected by the increasing mechanization of its entertainments and the associated tendency for those entertainments to be represented as both the realizations and projections of progress's triumphal advance. In the opening decades of the nineteenth century, popular fairs – still dedicated to the display of human and animal curiosities and still strongly associated with carnivalesque inversions of established cultural values and hierarchies – constituted a moral and cultural universe that was radically distinct from the emerging rationalist and improving culture of the middle classes. The fairs which – unofficially and uninvited – sprang up in association with the early expositions, often occupying adjacent locations, thus gave rise to a dissonant clash of opposing cultures which seriously disconcerted exposition authorities to the degree that they promised to undermine the pedagogic benefits of the expositionary rhetorics of progress.[19]

Even when, following the initiative of Paris in 1867, fairs came to be thought of as planned adjuncts of expositions, this sense of two separate worlds remained strong. Indeed, to some degree, it became institutionalized, the integrity of the exposition's improving rhetorics being protected from contamination by the world of the fair via the construction of the latter as explicitly a frivolous diversion from the instructional and uplifting qualities of the exposition zone proper (see Greenhalgh 1989). Thus, even into the twentieth century, many of the aspects of the early-nineteenth-century fair survived in the Midways of American expositions. At San Francisco's Panama-Pacific Exposition of 1915 we thus find Harry La Brecque, a famous fairground barker, hailing the passing public to visit 'the greatest show on the Midway' containing 'the long and the short, the fat and the lean, the largest, most unbelievable collection of freaks ever assembled on this earth', featuring 'Sombah, the Wild Girl, captured in deepest Africa, and Hoobooh, her savage brother' (cited in McCullough 1966: 76). Similarly, the Midway at New York in 1939 featured an Odditorium and, in Little Miracle Town, a display of midgets while also, in the contrived underwater striptease of Oscar the Amorous Octopus, retaining the association of fairs with the illicit pleasures (burlesque, prostitution) of a phallocentric sexual order.[20]

223

None the less, the mechanization of fair entertainments did enable the ideological thematics of expositions and their accompanying fairs to become more closely harmonized in allowing the latter to be enfolded within the project and discourse of modernity. If, in exposition machinery halls, progress was materially realized in displays of technologies of production, the new mechanical rides which began to be featured in the Midways from the 1890s provided a fitting complement in materially instantiating progress in the form of technologies of pleasure. The consequences of these developments were not, of course, limited to exposition fairs. In functioning as the forcing ground for new ride innovations (the Ferris Wheel at Chicago, 1893; the Aerio Cycle at Buffalo, 1901) – and often ones with futuristic references (the Trip to the Moon, also Buffalo) – which then became permanent attractions at the new fixed-site amusement parks which developed over the same period, American Midways played a significant role in transforming the culture of the fair throughout the English-speaking world. The relations between the Midways and the rush of amusement park development at Coney Island in the 1890s are of particular significance in this regard.[21] In their provision of a series of technological wonders which allowed their visitors to participate vicariously in progress, and in their commitment to a resolute modernization of the ethos of the fair, they provided an example that was rapidly imitated – and often on licence – elsewhere.[22]

Once again, this did not result in a total transformation of the fair. All the Coney Island fun parks, for example, retained the symbolism of carnival, sometimes signifying their separation from the 'real world' via the rites of passage they inflicted on the visitor: visitors to the Steeplechase Park entering from the ocean side, for example, had to pass through a rotating Barrel of Fun. None the less, the fact remains that, rite of passage complete, the fairgoer entered into a world whose ideological horizons had been substantially harmonized with the rhetorics of modernity. In this respect, the World Expo Park merely inherited the legacy which the nineteenth-century expositional adjustment of the popular fair bequeathed to the twentieth-century amusement park. Monolithically futuristic in its resonances (its naming system was uniformly SCIFI – see Figure 8.1) and eschewing entirely any allusions to the world of carnival, the symbolic references of the Park were entirely at one with those of the Expo itself. As merely another realization of the theme of leisure in the age of technology, the fair, here, functioned as directly a part of the Expo's rhetoric. To a degree perhaps unprecedented, Expo and fair thus merged into one another, a world at one with itself, perfectly seamless in its lack of symbolic rifts or tensions.

Yet, as far as its planned adjacency to the Cultural Centre is concerned, it is the second aspect of the fair's nineteenth-century transformation that is perhaps more important. The legacy of the change I have in mind here is most evident in the conception of the World Expo Park as, precisely, a park. According to Ken Lord, its managing director, 'World Expo Park is a park

in the true sense of the word. It's a place for families' (*Australian Post*, 18 April 1988: 17). The field of associations established here (fair, family, park) is, again, one made possible only by that brought into being via the development of turn-of-the-century amusement parks and their conception as places for relaxing and strolling, for taking one's pleasures sedately. Of course, the actual forms of public behaviour exhibited at amusement parks may not always have lived up to this expectation. However, this does not gainsay the point that amusement parks were shaped into being as heirs to the work of such civilizing agencies as public parks and museums – agencies which had, in part, been conceived as cultural instruments for transforming the public manners of the popular classes.

For it was not merely the ideological incompatibility of the fair and the museum which made these seem unlikely bedfellows in the early to mid-nineteenth century. The fair, as the very emblem for the rude, rough and raucous manners of the populace, symbolized precisely those attributes of places of popular assembly to which the museum was conceived as an antidote. If fairs on the one hand, and museums and expositions on the other, were not to be mixed this was partly because they symbolized different forms of public behaviour – and different publics – which, in the view of many, were not to be mixed either. As one visitor to the Great Exhibition commented:

> Vulgar, ignorant, country people: many dirty women with their infants were sitting on the seats giving suck with their breasts uncovered, beneath the lovely female figures of the sculptor. Oh! How I wish I had the power to petrify the living, and animate the marble: perhaps a time will come when this fantasy will be realised and the human breed be succeeded by finer forms and lovelier features, than the world now dreams of.
>
> (Cited in Greenhalgh 1988: 31)

In reforming and progressive opinion, by contrast, museums and parks were regarded as precisely the instruments through which the populace would be weaned from boisterous pursuits and habits and tutored into new forms of civility. Frederick Law Olmstead, the architect of New York's Central Park, thus viewed parks as exerting 'an influence favourable to courtesy, self-control and temperance' and so as 'a gentle but effective school for citizenship' (cited in Kasson 1978: 15). These terms were very similar to those which Sir Henry Cole had used a couple of decades earlier when commenting on the civilizing virtues of museums in view of their capacity to instil respect for property and encourage the adoption of more gentle forms of public behaviour.[23] In providing for the commingling of classes, thus allowing the working classes to adopt new public manners by imitating those of middle-class exemplars, and for the mixing of both sexes and all ages, thus allowing the presence of women and children to exert a civilizing influence on male behaviour, these new kinds of public spaces also provided a context

in which visitors could practise the new forms of public bearing and civility required by new forms of urban life in which encounters with strangers were a daily experience.[24]

Expositions, of course, were regarded in a similar light: as schools for the diffusion of civilized codes of public behaviour. For Olmstead, who designed Chicago's White City, the purpose of the 1893 exposition was to offer an ideal version of an urban order, a space which could function simultaneously as a summons to civic responsibilities and as a means for practising them. Nor was this without consequence for the adjoining Midways or the fixed-site amusement parks those Midways subsequently spawned. For over the same period that these were ideologically renovated via the modernization of their pleasures their architectural organization was transformed. Fairs had previously been temporary structures, accommodating themselves to the existing spaces of street or common, typically erected in an unplanned fashion with the entertainments jostling one another for space, thus cramming the crowd in on itself. By the 1890s, by contrast, amusement parks – whether temporary, like those which accompanied expositions, or permanent, like those at Coney Island – were laid out like cities, with vast promenades, inspection towers, and courts providing for rest and tranquillity; regulated spaces limiting the possibilities, and inclination, for rowdiness. By the turn of the century, the fair, once the very symbol of disorder, could be invoked, regularly and repeatedly, as a scene of regulation, of a crowd rendered orderly, decent and seemly in its conduct.[25] 'It is', as one observer put it of Coney Island's Luna Park, 'the ordinary American crowd, the best natured, best dressed, best behaving and best smelling crowd in the world' (cited in Kasson 1978: 95).

By the time of Expo '88, of course, the crowd had long been tutored into such new forms of public demeanour and civility. Indeed, this became a source and sight of pleasure in itself in the form of the Expo queue whose orderly and good-natured conduct became one of the most talked-about aspects of the Expo. Yet, even though many feigned surprise at this manifestation of public civility, there was nothing new in this. From their beginnings, expositions – often planned in face of the fear of public disorder – have functioned as spaces in which a newly fashioned public (one not formally differentiated by rank) has demonstrated to itself its capacity for orderly and regulated conduct. The pleasures of such a prospect have become a regular trope of exposition commentary while, in their design and layout, expositions have typically afforded their visitors vantage points from which the behaviour of other visitors might be observed and rendered a sight of pleasure – as from the monorail encircling the site at Expo '88. In these respects, expositions have offered not merely technologies whereby the visitor might engage in a modernization of the self; they have also functioned as civilizing technologies precisely to the degree that, in including their publics among their exhibits, they have provided a context in which a citizenry might display to itself, in the form of a pleasurable practice, those

codes of public civility to which it has become habituated.

Indeed, in the case of Expo '88, where only a fraction of the visitor's time was spent in the display pavilions, there are grounds for arguing that this was the central pleasure of the Expo experience. Those who went again and again did so less for the sake of seeing the exhibitions than for that of roaming, rehearsing the codes of urban life in an imaginary city complete with its streets and boulevards, its side-walk cafés and roving entertainers, cabarets and queues – all there solely for the express purpose of relaxed strolling, for seeing and looking, everyone a *flâneur*, but a *flâneur* on the move and, as simultaneously subject and object of vision, constantly open to the casual glance of other strollers.

Yet this was an aspect of Expo that had been prepared for just as it was itself a preparation. 'Brisbane', predicted Sir Lew Edwards, chairman of the Expo Authority, 'will never be the same after Expo – shopping hours, outdoor eating, the greening of the city, our attitudes to hospitality . . . all these things will permanently transform our city' (*Woman's Weekly*, May 1988: 54). For Edwards, Expo was to serve as an instrument in the cosmopolitanization of Brisbane, and of its populace; a cosmopolitanization, however, in which the citizen was addressed as a consumer, and one who needed to be modernized. Alec McHoul, who didn't go to Expo, none the less understood this aspect of its functioning very well in contrasting its address to that of the Brisbane Show:

> It is manifestly trying so hard NOT to be like The Show that, again, the comparisons have to be made. They put each other on the agenda. Expo is where you CAN'T see sheep and cattle, produce and commodities as you move from ride to ride. It's where you CAN'T get a show bag. It's where the food is authentic and international and not cheap and nasty. It's where the beer is imported from Stow-on-the-Wold and sold in authentic pint mugs. Expo is alternative consumption: of commodities and images.
>
> (McHoul 1989: 219)

However, the symbolic geography of Expo consumption is only half understood if viewed exclusively in terms of its self-distantiation from the images and style of consumption associated with the traditional country fair. For if the Expo experience was an alternative to *this* style of consumption, it was also a preparation for another – and, indeed, one which was already present, just across the river, in the new Myer Centre, the face of the new in the form of a shopping development, complete with its own amusement park, where all of the video and computer display techniques and technologies evident at Expo were harnessed to a new style of consumption. Like the Cultural Centre, the Myer Centre had opened before the Expo and stood in need of only one thing: a public sufficiently modernized and tutored in the techniques of hi-tech shopping to use it. In this respect, the leisurely stroll of the would-be

227

Expo *flâneur* was deceptive, concealing the anxious work of one bent to the task of practising new shopping mores, rehearsing new consumption codes in a custom-built environment.

I suggested earlier that Expo '88's major symbolic bequests to its host city had preceded it in the range of cultural – and, we can now add, commercial – facilities which opened their doors before the Expo commenced. Yet this is, perhaps, to distract attention from the more practical, more technological contribution it made – or sought to make – to the modernizing task in the kind of re-tooling of the city's inhabitants it proposed in order to allow them to play their roles within the futures that had been arranged for them. Combining the evolutive time of discipline with the evolutionary time of progress and articulating both to the time of the city, Expo projected the future in the form of a task – a new style and level of consumption – for which, in styling the consumer in the fashion of a new cosmopolitanism, its simulation of civic life provided a training.

9

A THOUSAND AND ONE TROUBLES

Blackpool Pleasure Beach

BLACKPOOL PLEASURE BEACH
Europe's greatest amusement park
Home of the largest collection of
'White Knuckle' Rides in Europe

Everything here is bigger and better: the *Space Tower* not only takes you to the top of its 160 feet, but does the viewing for you as it spirals around its slender column. The *Grand National* is the only double track coaster ride in Europe, whilst the *Steeplechase* is unique in having three tracks for racing. Where else can you hurtle through 360° and view *Blackpool Pleasure Beach* upside down – only here on the *Revolution* – a thrill filled sooperdooperlooper. Or experience the sensations of an astronaut in the upside-downess of the *Starship Enterprise* . . . Or hurtle round the figure of eight track on our *Tokaydo Express* . . . Or experience the unusual sensations of riding the *Tidal Wave* and racing on our own *Grand Prix* . . . all within a few hundred yards?

Such claims, taken from a 1981 publicity leaflet, are typical of the way Blackpool Pleasure Beach represents itself, and has always represented itself – as offering the biggest, the best, the only one of its kind, the unique, the latest, the most up-to-the-minute range of thrills, spills and popular entertainment. It is always one step ahead, always changing – 'The *Pleasure Beach* is never static' – constantly 'in search of new rides which will appeal to the Blackpool public', unrivalled even its claims to be unrivalled (Palmer 1981). Although in its name pleasure struts forth in an unusually brazen way, the Pleasure Beach is neatly decked out in the clothes of modernity. Not only in publicity handouts, but in the names, themes, design and layout of the principal rides and in its architecture, pleasure at the Pleasure Beach is rigorously constructed under the signs of modernity, progress, the future, America. Its face is the bold face of the new. Operating on the threshold between the present and the future, the Pleasure Beach harnesses for our pleasure the technologies developed at the outer limits of progress ('Bright colours and geometric shapes reflect the use of glass fibre and thermoplastics

229

in construction'); it anticipates the future in making advanced technologies a part of the here and now (its operating monorail is 'the first of its kind in Europe'). The past, with qualified exceptions, is as dead as a dodo. In this chapter I want to consider the different types of pleasure that are available at the Pleasure Beach, the ways they are organized and the signs under which they are coded for consumption. Taken together, these constitute a distinct 'regime of pleasure' which occupies a special place in relation to the rest of Blackpool.

MODERNITY AND RESPECTABILITY

Although a *part* of Blackpool in the sense that it is central to the town's commercial well-being and, in turn, dependent on it – an independent source of attraction which brings business to the rest of Blackpool as well as feeding off the business which the rest of Blackpool provides – the Pleasure Beach is also *apart from* Blackpool, a recognizably distinct sub-system in the overall organization of pleasure which the town offers. In the first place, it is geographically separate. Located on the southern edge of the town, it is separated from the town centre leisure pleasure complexes – the Tower, the Golden Mile and the Central Pier – by a 'pleasure-barren' half to three-quarters of a mile of hotels and boarding houses. Just south of the Pleasure Beach, Blackpool – not Blackpool as a municipal entity but Blackpool as 'fun city' – stops abruptly, as an arch over the road bids the visitor goodbye. This geographical isolation is reinforced by a circular wall which encloses the Pleasure Beach, segregating it from the terraced houses at its rear and from the promenade at its front. Nor does this wall just mark a physical separation. It also constitutes a symbolic boundary, operating definite inclusions and exclusions which, to a degree, mark off the forms of pleasure available within it from those available outside it in the rest of Blackpool.

Most obviously, many of the 'excesses' which characterize forms of consumption in the rest of Blackpool – giant foam-rubber stetsons, carnival-like masks, willy-warmers – are not available in the Pleasure Beach. This difference is accentuated by the display of these items in a short row of shops and stalls just outside the Pleasure Beach. More generally, pleasure wears a more uniform face in the Pleasure Beach than it does in the rest of Blackpool. In an impressionistic survey of Blackpool written in the 1930s, Tom Harrison, founder of the Mass Observation movement, commented on the incredibly diverse forms of pleasure competing with each other along the promenade – traditional fortune tellers, quack medicines, appeals to the Orient and to mysticism, freaks and monstrosities, conjuring tricks and unbelievable spec-tacles jostling for space with the joke shops and amusement arcades (Harrison 1938). Something of this diversity remains in the centre of Blackpool, although even here the face of pleasure has been considerably smoothed and streamlined – there are far fewer independent side-shows than there used to

be even in the 1960s. The once messy and variegated sprawl of the Golden Mile, with its mass of rival stalls and side-shows, has been converted into a large, integrated indoor entertainments complex run by EMI.

In the Pleasure Beach, by contrast, pleasure is resolutely modern. Its distinctive 'hail' to pleasure-seekers is constructed around the large mechanical rides, unavailable elsewhere in Blackpool and packaged for consumption as a manifestation of progress harnessed for pleasure. There are amusement arcades, bingo halls, rifle ranges and so on – but no freak shows, no quack medicine, no mysticism and only one fortune teller. Even those forms of entertainment that are widely available at other amusement parks and travelling fairs are here reconstructed under the sign of modernity. The dodgems were billed as 'The first in Europe direct from America' when they were first introduced around 1909. Now, according to *The Pleasure Beach Story*, 'the old Dodgem tubs of pre-war days have been transformed into Auto Skooters, which are built here at Blackpool Pleasure Beach, centre of the British Fun Industry'. They are in fact indistinguishable from dodgems elsewhere but, as a once up-to-the-minute ride which has become traditional, they have been retrieved as super-modern.

Pleasure has not always been so unambiguously coded at the Pleasure Beach. Nor have its relations to the rest of Blackpool always been the same. The Pleasure Beach occupies what used to be, in the mid-nineteenth century, a gypsy encampment (see Figure 9.1) where, in the summer, both the resident families and itinerant entertainers offered a variety of traditional entertainments – astrology, fortune-telling, palmistry, phrenology and so on (see Turner and Palmer 1981). Mechanical rides were first developed on this South Shore site (originally just a vast area of sand stretching back from and continuous with the beach) in the late 1880s – a period which witnessed similar developments in other parts of the town, especially in the town centre at Raikes Hall, an open-air pleasure centre modelled on Manchester's Belle Vue Gardens. The South Shore site, at this time, was merely a jumble of independently owned and operated mechanical rides existing cheek by jowl with the gypsy amusements. The origins of the Pleasure Beach can be traced to 1895 when two local entrepreneurs, John W. Outhwaite, who operated the Switchback Railway on the South Shore, and William George Bean, a one-time amusement park engineer in America who operated the Hotchkiss Bicycle Railway on the South Shore, bought the forty acres of sand on which the mechanical rides and the gypsy encampment were located. Prompted by the closure of Raikes Hall, which reduced the competition for mechanically induced spills and thrills from the town centre, their aim was to develop the South Shore site as an integrated open-air pleasure complex on the model of American amusement parks.

There were two obstacles to be surmounted: the opposition of rival business interests, particularly those which had invested in the new pleasure complexes like the Tower and the Winter Gardens in the town centre, and the

continued presence of gypsy homes and entertainments on the site. Both were overcome by the election of Bean to the town council in 1907. This enabled the interests of the Pleasure Beach to be represented in the local political machinery alongside those of their rivals. Nor was it any coincidence that, in the same year, a set of new Fairground Regulations was announced which forbade gambling, clairvoyance and quack medicine on all fairground sites in Blackpool and declared that no 'gypsy's shed, tent, caravan or encampment shall be permitted on any part of the land set apart as a Fair Ground'. This enabled the eviction of itinerant gypsies from the Pleasure Beach in the following year. (The site had been christened The Pleasure Beach in 1906, the company of The Blackpool Pleasure Beach Ltd being formed in 1909.) By 1910, the last of the permanent gypsy families had left.

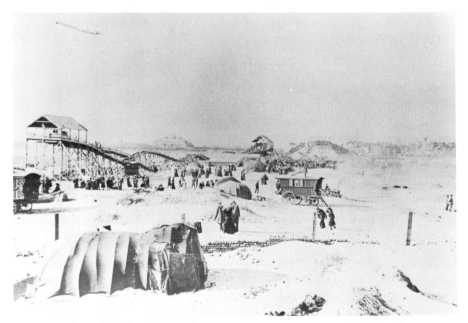

Figure 9.1 The nineteenth-century gypsy encampment, Blackpool

This campaign against the gypsies was consistent with the general drive, manifest throughout Blackpool's history, to give pleasure an air of bourgeois respectability – a drive that has always been, to a degree, thwarted as a result of the town's peculiar structure of land tenure. As John Walton and Harold Perkin have both noted, land ownership in Blackpool was extremely fragmented by the beginning of the nineteenth century, largely because the sale of the Layton estate, owned by the Clifton family, allowed the centre of the town to be split into small parcels (Perkin 1975/6; Walton 1975). This contrasted sharply with resorts like Southport, where the dominance of large landholders allowed an integrated and planned development to cater for the

respectable and well-to-do day-trippers and holidaymakers. The morsell-ization of land tenure in Blackpool inhibited attempts to develop Blackpool along similar lines as it enabled the more commercially oriented entre-preneurs, with an eye to the working-class trade of the industrial towns of Lancashire and Yorkshire, to cater for the tastes of the 'non-respectable' in spite of the opposition of local magnates.

This is not to suggest that the history of Blackpool can be construed as one of unbridled commercialism riding rough-shod over opposing principles. To the contrary, it was not really until the 1880s that the working-class market became significant enough – both in size and in spending power – to prevail over the requirements of the middle-class visitors who had previously provided the town's mainstay. Elegance, respectability and cultivation – these were the watchwords of Blackpool's early history, and the town quite deliberately sought to maintain a lofty air which would exclude *hoi polloi*. However, such attempts were consistently undercut by the ease with which entrepreneurs could buy town-centre sites and evade corporation regulations. The first pier, today's North Pier, opened in May 1863, aiming above all at dignity. It was an elegant walkway over the sea, utterly lacking in commercial embellishment – but in 1868 it was forced to provide various forms of diversion as its revenues declined after the rival South Jetty opened. Today's Central Pier, this was known at the time as 'The People's Pier'; it offered dancing from dawn to dusk, seven days a week. Similarly, in the theatre, it took a succession of financial failures before the town's impresarios accom-modated themselves to popular taste – a shift nicely encapsulated in the contrast between the founding ambition of the Winter Gardens' shareholders to provide 'high class entertainment which no lady or gentleman would object to see' to the maxim of Billy Holland, appointed manager of the Winter Gardens in 1881: 'Give 'em what they want.' The origins of The Golden Mile perhaps indicate most clearly the contradictory forces at play in Blackpool's development. As an unregulated zone, the beach had always been a trading area for itinerant hawkers, phrenologists, showmen and the like – much to the consternation of the local tradesmen who regarded these 'sandrats' as unfair competition driving away the town's 'respectable' business. Respond-ing to this pressure, the Corporation prohibited trading on the beach in 1897, but this in turn provoked such a public outcry that the Corporation relented. 'Ventriloquists, Niggers, Punch and Judy, Camels, Ice Cream, Ginger Beer, Blackpool Rock, Sweets in Baskets and Oyster Sellers' could remain on the beach, but not 'phrenologists, "Quack" Doctors, Palmists, Mock Auctions and Cheap Jacks'. The result was that the prohibited traders merely set up shop in the forecourts of the houses fronting onto the promenade – the origins of the Golden Mile, an ideological scandal, an affront to the town's carefully constructed image of modernity and respectability.

At the Pleasure Beach, a single site under single ownership, it was possible to construct a more closely integrated regime of pleasure. Early photographs

(see Figure 9.2) convey the impression of a quite different organization of pleasure from that which obtains today. The Pleasure Beach and the beach were virtually indistinguishable, with no physical boundaries separating the two. The rides and side-stalls were simply placed on the sand and some rival entertainments were installed on the beach itself. Pleasure-seekers moved uninterruptedly from the one to the other. They formed overlapping and merging (rather than separate and distinct) pleasure zones. The layout of rides was fairly haphazard, as gypsy stalls and side-shows jostled for space with the big rides. The signs of pleasure were multiple and contradictory: the pleasure-seeker could move from the futuristic vertigo of the Scenic Railway to the pseudo-past of a mock-Tudor village street in a few paces. During the pre- and immediately post-war years, the Pleasure Beach was not so much transformed as added to, mainly in the form of rides imported 'direct from America': the House of Nonsense, containing 'over 60 of the latest American Amusement Devices'; the Gee Whiz, 'The latest Invention and Most Intriguing Ride in Blackpool'. Even the past was constructed under the sign of science. According to a contemporary report on a reproduction of the Battle of Monitor and Merrimac: 'With the aid of fine scientific appliances, history has been made to live.' This appeal to America, to the future and to a super-modernity was not the only sign-ensemble under which pleasure was reconstructed during this period. There was also and still is a latent democracy of pleasure. The Social Mixer aimed to make 'Everybody Happy, Happy, Happy.' 'Everybody's Doing It' proclaimed the House of Nonsense, and the local

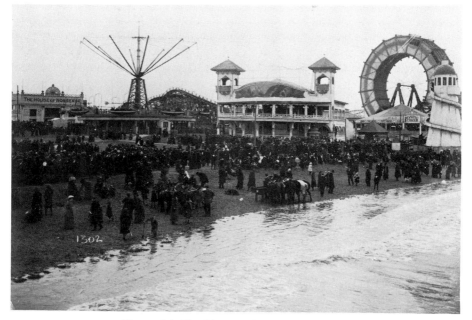

Figure 9.2 The Pleasure Beach, Easter 1913

paper recommended the Joy Wheel as a great social leveller: 'Nobody can be pompous on the Joy Wheel: we prescribe it as a cure for the swelled-head.' But the appeal to modernity was becoming the dominant form of 'barking'.

This was even more apparent in the 1920s and 1930s, when the Pleasure Beach began to acquire the collective form and identity that is still recognizable today. The extension of the promenade, which had hitherto stopped at the northern entrance to the Pleasure Beach, finally separated Pleasure Beach and beach into distinct zones. It was also at this time that the Pleasure Beach was walled off. More important perhaps, especially in the late 1930s, the Pleasure Beach hauled its architecture unequivocally into the age of the new. In the period around the Great War, many of the main architectural features had been imperial in their references. The Casino, the main entrance to the Beach and its architectural show-piece, was constructed in 1913 in the style of an Indian palace and many of the individual rides echoed this in their imitation of various other outposts of Empire. But now these recurring motifs of the oriental, the ornate and the exotic were swept away. Leonard Thompson, Bean's son-in-law and managing director of the Pleasure Beach at the time, commissioned Joseph Emberton, a leading modernist architect, to redesign the whole Pleasure Beach in a single style. The Casino became a clean white building with smooth lines and no frills, totally functional in appearance. The Fun House, heir to the timber House of Nonsense, was rebuilt in reinforced concrete to harmonize with the new Casino. The Grand National, in the same style, replaced the Scenic Railway. Even the architectural minutiae were modernized. The interior of the River Caves was restyled in cubist designs: so were the animals on the Noah's Ark, giving them an angular, futuristic appearance – a bizarre modernization of the past! By the end of the 1930s, the Pleasure Beach looked resolutely modern. Its architecture of pleasure had taken on a streamlined, functional appearance. And the sand had been covered by asphalt. 'If you can see a foot of asphalt in August', Leonard Thompson said, 'we aren't doing well.' The situationists of 1968 might have responded that, by the end of the 1930s, the Pleasure Beach had managed to bury 'la plage sous les pavés'.

Since the 1930s, the architectural modernity of the Pleasure Beach has been updated from time to time. In the 1950s Jack Radcliffe, designer of the Festival of Britain in 1951, was commissioned to give it a new look – largely by superimposing an American jazz and glitter on Emberton's clean white façades. In the 1960s most of the new rides were stylistically indebted to innovations pioneered in world fairs and exhibitions. This was merely following a time-honoured pattern of development for Blackpool as a whole – the Tower was modelled on the Eiffel Tower constructed for the Paris Exhibition of 1889; the giant Ferris Wheel which dominated the Winter Garden skyline from 1896 to 1928 was based on the one designed for the Oriental Exhibition at Earls Court in 1895, in turn modelled on the first Ferris Wheel exhibited at the Chicago World's Fair in 1893. In like vein,

the chair-lift (1961) was inspired by one used at the World Fair in 1958, the dome of the Astro-Swirl (1969) was based on the design of the American Pavilion at 'Expo '67' in Montreal, and the Space Tower (1975) was a smaller replica of an exhibit in Lausanne in the early 1970s. Since then, the Pleasure Beach has acquired a series of rides derived from American amusement parks, many of them still with futuristic references – the Revolution in 1979, and, in 1980, the Tokaydo Express and the Starship Enterprise.

THE PLEASURE BEACH AND BLACKPOOL

I have already noted that the Pleasure Beach is to some degree separate from Blackpool. Unlike the town-centre pleasure complexes – the Tower, the Golden Mile, the piers – which hail the passer-by and rely on impulse consumption, the Pleasure Beach is a place to be visited, perhaps just once or twice in a holiday, for a special occasion. It offers something different. Yet that 'something different' is not in reality distinct from Blackpool. Rather, it is a heightening of Blackpool, a synecdoche of the town's constructed image.

From its earliest days as a seaside resort the by-word of Blackpool, recurring again and again in its publicity brochures, has been *Progress*. This has always had a particular local, Lancashire articulation, a kind of capping of Lancashire pride in the period when Lancashire claimed to be the workshop of the world. If Manchester used to claim that what it thought today, London did the next day and the world heard about the day after, then Blackpool's claim was to be even one step ahead of Manchester. Nor was the claim an idle one. Blackpool has an impressive number of 'firsts' to its credit – the first town in Britain with electric street lighting (1879) and the first town in the world to have a permanent electric street tramway (1885), for example. Furthermore, its achievements were all the product of northern capital and of northern capitalists. Virtually all the investment which fuelled Blackpool's development came from local entrepreneurs, from the town Corporation or from the business communities in Halifax and Manchester. London capital did not get a look in – at least not until the 1960s when most of the town's leisure-pleasure complexes passed into the hands of what is now Trust House Forte (the three piers) and EMI (the Tower, the Winter Gardens, the Grand Theatre and a part of the Golden Mile). A shining testimony to the power and verve of northern capital, Blackpool offered the working people of the industrial north a place in the vanguard of human development in their leisure analogous to that which the ideology of progress constructed for them in their work-places. The Pleasure Beach's claim, quite simply, has been to have capped the lot, to have done yesterday what the rest of Blackpool is only thinking of getting round to today – all this, and the product of local capital too!

There is little doubt that this has been the explicit aim of the Pleasure Beach management. They seem always to have regarded it as the spearhead of

Blackpool, with distinctive interests not necessarily in line with those of the town as a whole. In its early days, the Pleasure Beach company extracted some very shrewd concessions from the town council. In agreeing to the extension of the promenade beyond its northern entrance, for example, it was able to stipulate that no entertainment sites should be constructed beyond its southern boundary for a period of fifteen years. But if it is to a degree in competition with the rest of the town the Pleasure Beach has differentiated itself only by being Blackpool to the n^{th} degree, more Blackpool than Blackpool itself. Just as the town has its Tower, so there is a tower at the Pleasure Beach too – not a rusty old iron thing that you go up and down in an old-fashioned lift and have to walk round when you reach the top, but an aggressively up-to-date tower which, using the very latest technology, 'does the viewing for you as it spirals around its slender column'. Provocatively placed at the very front of the Pleasure Beach, the Space Tower makes Blackpool Tower look quaint, the relic of an outmoded technology. To travel from the town centre to the Pleasure Beach is to travel through time – but only to reach an exaggerated, updated version of your point of departure. Blackpool's ideological centre is located not in the town centre but at the South Shore, in the Pleasure Beach where there are no scandals to embarrass its aspirations to progress and modernity. As an executive of the Pleasure Beach told me, 'The Pleasure Beach *is* Blackpool.'

A SITE OF PLEASURES

'The Pleasure Beach', according to Leonard Thompson, 'provides a conglomeration of thrills, spectacles and a myriad of activity, so arranged together for providing that operation known as separating the public from their money as painlessly and pleasantly as possible.' In this, it is spectacularly successful, attracting over eight million visitors annually. It has remained so consistently profitable that the original company remains in private hands and is still run as a family concern by the grandson of one of its co-founders. Given the size of the Pleasure Beach and the considerable capital costs incurred in its development – plus the fact that the company also owns an amusement park at neighbouring Morecambe – it would seem that the provision of pleasure at Blackpool has paid handsome dividends. Whereas most amusement parks have only one or two roller-coaster-type rides, the Pleasure Beach boasts four – along with something like seventy major rides or features. In addition, there are the usual side-stalls by the dozen, several large amusement arcades, an ice-drome and a huge indoor entertainments complex incorporating several bars, a nightly floor show and restaurants.

What most impresses, however, is the sheer diversity of the thrills, spills and entertainments. Theoretically speaking, this is something of a problem as it would not be difficult, with a little imagination, to find confirmation for virtually any theory of pleasure you cared to mention. Is the never-endingly

laughing clown in front of the Fun House a testimony to the bubbling-up of Kristeva's semiotic chora? And the hall of mirrors – or '1001 Troubles' as it is called at the Pleasure Beach – brazenly advertises a multiple troubling and cracking of self-identity that might tempt the unwary Lacanian into an excess of instant theorization. For the most part, however, the Pleasure Beach addresses – indeed assaults – the body, suspending the physical laws that normally restrict its movement, breaking the social codes that normally regulate its conduct, inverting the usual relations between the body and machinery and generally inscribing the body in relations different from those in which it is caught and held in everyday life. However, it is equally important to stress the self-referring structure of the Pleasure Beach. A strong sense of 'intertextuality' prevails in the way that different rides allude to the pleasures available on other rides – either by mimicry, inversion or by a recombination of their elements. As the pleasure-seeker moves from ride to ride, he or she is always caught in a web of references to other rides and, ultimately, to the Pleasure Beach as a whole.

The major rides and features at the Pleasure Beach can be divided into five somewhat crude categories, although particular rides may overlap these. The largest category consists of the big open-air 'thrill rides' – the Roller Coaster, the Grand National, the Revolution, the Steeplechase, the Log Flumes, the Big Dipper and so on (see Figure 9.3). These are not only the main attractions of the Pleasure Beach. They also serve as the centre of its system of pleasure – constantly alluded to by other rides, but not themselves referring outward to these in a reciprocal fashion. The pleasures offered by these rides are complex and diverse. In some cases, the dominant appeal is that of liberating the body from normal constraints to expose it to otherwise unattainable sensations. The Revolution, the Starship Enterprise (rather like the Ferris Wheel, except that the rider is placed on the inside of the wheel and travels upside down) and the Astro Swirl (based on the centrifugal training equipment used by American astronauts) all defy the laws of gravity. In releasing the body for pleasure rather than harnessing it for work, part of their appeal may be that they invert the normal relations between people and machinery prevailing in an industrial context. More generally, the thrill rides give rise to a pleasurable excitation by producing and playing on a tension between danger and safety. The psychic energies invested in deliberately placing the body at risk – only partly offset by assurances of safety (faith in technology put to the test) – are pleasurably released at the end of the ride. The public nature of these rides adds to this pleasure of tension and its release. Thresholds are important here. To pay the price of an entrance ticket is to commit oneself – there's no going back, except through taunts of 'chicken'. The psychic thrill of physical danger is therefore intensified by the pleasures of bravado, by the public display of conquering fear.

The pleasures afforded by the thrill-rides differ according to whether they are addressed to small groups or larger collectives. Most of the rides are for

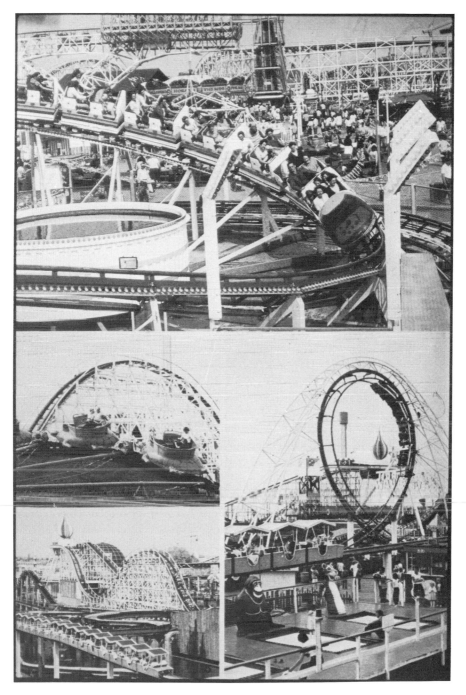

Figure 9.3 The 'white knuckle' rides, Blackpool

couples – two in a car. Others address groups of four to five – The Reel, for example. Rides like the Roller Coaster are for couples within larger groups. Two rides incorporate an element of competition – the Grand National ('the only double track coaster ride in Europe') and the Steeplechase. In the case of the Grand National, it is groups that are in competition with one another as distinct from the individual competitions available in the amusement arcades. Like these, however, the competitive rides effect an equalization of the competitors with respect to the machinery. The outcome of the race is entirely fortuitous – it cannot be influenced by the participants – and, except momentarily, is inconsequential. Finally the Tidal Wave, a huge mechanical swing, seating dozens at a time, is for an undifferentiated mass – the 'body of the people', the romantic might say, swinging in unison. This appeal to groups is a characteristic trait of the Pleasure Beach as a whole, again distinguishing it from the piers and promenades. No place for the solitary, and least of all for the leisurely *flâneur*, its pleasures are pleasures only if shared by a group or, as its minimal 'pleasure unit', a couple. To go there alone is to do something odd, a tactless reminder of singularity in a world which, except for its amusement arcades, respects and addresses only plural identities.

Enclosed rides offer two main types of pleasure. There are the pleasures of looking afforded by imaginary transport to other worlds – the exotic, the remote, the fantastic, the quaint. The Goldmine, Alice in Wonderland (*à la* Walt Disney) and the River Caves, 'a boat journey through exotic scenes from every culture in the world' are the clearest examples, especially the last in its claim to offer the public sights otherwise unseeable. Geoffrey Thompson, currently managing director of the Pleasure Beach, capped these claims when he told the local paper, on the completion of the construction of a replica of the temples of Angkor Wat in Cambodia: 'The temples are no longer on view to the Western World since the Khmer Rouge took over Cambodia so you could say that we are offering people the only chance they will get to see them' (*Blackpool Evening Gazette*, 21 March 1977). Other rides function as abbreviated narratives, mimicking the tensions produced by popular fictional forms. The Ghost Train is the clearest example: a journey through an enclosed universe where you encounter all the imaginary terrors of the Gothic novel and horror film before coming into the light of day again. Here, as with the thrill-rides, thresholds are important – once in, there's no going back – but, as in the hall of mirrors, it is the psyche that is (flirtatiously) exposed to assault.

A number of enclosed walk-through features like Noah's Ark and the Haunted Hotel use mechanical contrivances to expose the body to unexpected perils (moving floors) and ritual insults (wind up the skirts). The Fun House is especially worthy of mention as it inverts the usual relations between the body and machinery at the Pleasure Beach. On most thrill-rides, the body is surrendered to the machinery which liberates it from normal limitations. In

the Fun House, the body competes with the machinery, tries to conquer it and is forcibly reminded of its limitations. Most of its activities involve trying to get the better of various mechanical devices – walking through a revolving drum, attempting to stay at the centre of a spinning wheel, crawling to the centre of a centrifugal bowl or climbing impossibly slippery slopes. The sense of crossing a threshold in the Fun House is quite strong. Before getting into the main entertainment area, the body is subjected to a number of ritual assaults – you are buffeted by skittles, the floor shifts beneath your feet and you have to cross a series of revolving discs. These obstacles also mark a boundary between the Fun House and the rest of the Pleasure Beach – a sign of a reversal of the relations between the body and machinery, a warning that in the Fun House the body will be opposed by machinery rather than assisted or transported by it, and that the body must resist machinery and struggle against it rather than surrender itself to it.

A degree of intertextuality also characterizes the new 180° indoor cinema shows like Journey into Space and Cinema USA. These allude to the thrill-rides in two rather contradictory ways. Whereas thrill-rides take the normally stationary body and hurtle it through space, they hurtle the vision through space whilst fixing the body as stationary. Yet the cinema shows also compete with the thrill-rides by claiming to outdate them, to reproduce all the thrills and excitement of the big rides by means of a more advanced, simpler and safer technology. Nestling beneath the Revolver, the Cinema USA – which includes a film of the largest rollercoaster ride in America – seems to declare the 'sooperdooperlooper' redundant, a mass of unnecessary machinery. Rule breaking is also evident in the placing of familiar activities in new contexts. This is especially true of various self-drive rides – the Auto-Skooters, Go-Karts, Swamp Buggies and Speedboats. Clearly, the Auto-Skooters, where the aim is to hit other cars rather than to avoid them, invert the usual rules of driving. More generally, our normal expectations of transportation are suspended as travel is presented as a self-sufficient, functionless pleasure, rather than a means of getting from A to B. You can also travel by all possible means of transportation. 'You can travel by land, sea or air when you come to Blackpool Pleasure Beach: by land on the Pleasure Beach Express, on water by Tom Sawyer's Rafts, and in the air along the one-mile Monorail or the Cableway.' This, however, is to speak of the various through-site transportation systems – a markedly distinctive feature of the Pleasure Beach. You can travel through and around the Pleasure Beach by a small-gauge railway, through it and over it by the monorail, over it by cable-cars; you can survey it as a whole from the top of the Space Tower. In these ways the Pleasure Beach offers itself as a site of pleasures to the gaze of the passing spectator.

Finally, the self-referential structure of the system of pleasure in operation at the Pleasure Beach is clearly evident in miniaturized duplications of many of the major rides. The Wild Mouse is a miniature of rides like the roller-coaster and, more generally, there are miniaturizations of the Auto-Skooters,

Go-Karts and Speedboats – small, electronically controlled vehicles which confer on the user total control over the machinery as distinct from surrendering yourself to it, as on the thrill rides, or being opposed by it, as in the Fun House.

A WORLD TURNED UPSIDE DOWN?

In view of the degree to which the rules and constraints which normally hem in the body are either inverted or suspended at the Pleasure Beach, it might be tempting to draw parallels between the Pleasure Beach and the world of carnival, to view it as 'a world turned upside down'. Tom Harrison commented on a general and pervasive confusion of categories in Blackpool, directly reminiscent of the world of carnival:

> The motif of sea and land, east and west are inextricably confused. On the sand a great teapot serves refreshments, while the name Central Beach refers only to the tangle of pleasure shows on the prom, and Pleasure Beach refers to Emberton's shining white permanent Wembley The rams are ships of land. Over the inland pleasure zone of Olympia towers a pseudo lighthouse.
>
> <div align="right">(Harrison 1938: 393)</div>

At the Pleasure Beach, direct allusions to the world of carnival are not hard to find. The revolving figures at the front of the Fun House – various heads which rotate so that a different face appears according to whether they are upside up or upside down, although it's impossible to determine which of these is which – make clear reference to the 'world turned upside down' aspect of carnival. Similarly, a frequent mixing and confusing of categories effects a carnival-like dissolution of opposites – the most obvious juxtaposition is that between the laughing clown, a King of Mirth, in front of the Fun House and the laughing death's head (itself merging and dissolving opposites: life laughs at death, death mocks life) which presides over the Ghost Train roughly at the centre of the park. There are numerous allusions to the world of the fantastic (the Alice Ride, the giant figure of Gulliver that supports the monorail), to the tradition of what the Soviet literary critic Mikhail Bakhtin called 'carnivalised literature', an incorporation of the transgressive potentialities of carnival into a subversive literary tradition (Bakhtin 1973).

But although such connections are undeniable, it would be misleading to draw them too tightly or to take them at their face value in construing the Pleasure Beach as an anticipation of a people's utopia of pleasure, as Bakhtin conceived of carnival. Indeed, as Terry Eagleton has noted, Bakhtin's populist utopianism has its limitations even in regard to carnival:

> Carnival, after all, is a *licensed* affair in every sense, a permissible

rupture of hegemony, a contained popular blow-off as disturbing and relatively ineffectual as a revolutionary work of art Carnival laughter is incorporative as well as liberating, the lifting of inhibitions politically enervating as well as disruptive. Indeed from one viewpoint carnival may figure as a prime example of that mutual complicity of law and liberation, power and desire, that has become the dominant theme of contemporary post-Marxist pessimism.

(Eagleton 1981: 148)

Even accepting these limitations, a populist construction of the Pleasure Beach would reflect a serious misunderstanding of Bakhtin's position. For Bakhtin, the carnival of the late medieval period was not just a festival of transgression. It was characterized by the inversion not just of everyday rules and behaviour, but of the dominant symbolic order. As his study of Rabelais makes clear, carnival was a festival of *discrowning* in which the axial signifiers of medieval ideology were scandalously and often scatalogically debased, tumbled down from heaven to earth, trampled over and sullied by the heavily material feet of the people's practice – as well as being opposed and overwhelmed by the 'popular belly' of carnival in its anticipatory celebration of a world of material surfeit (see Bakhtin 1968). The Pleasure Beach is simply not like that, not even remotely. The body may be whirled upside down, hurled this way and that, but, in the coding of these pleasures for consumption, the dominant symbolic order remains solidly intact and unwaveringly the right way up. It has not always been so. Tom Harrison records that imitation bosses once figured prominently at the Pleasure Beach, and there used to be a dummy policeman in a stationary car on the dodgems, but this was abandoned as the figure was smashed up in no time at all – which suggests many possibilities as to what a 'people's fair' might look like! And outside the Pleasure Beach, debasements of the dominant symbolic order are relatively easily purchased – in 1981, street-sellers were offering dartboards printed over with a full-face picture of Margaret Thatcher.

Inside the Pleasure Beach, however, the brash themes of modernity and progress dominate all. This does not mean they are the only themes in operation. Subsidiary themes are in evidence on individual rides and at-tractions – particularly the reference to other universes, to imaginary pasts (the Gaslight Bar, done out in Edwardian decor), to popular narrative universes (the Goldmine, Diamond Lil's Saloon, the Starship Enterprise) and to the exotic (the River Caves). In all such cases, however, it is an assimilated otherness that is on offer, an already recuperated and tamed fantastic – *Walt Disney*'s Alice, a *functional* Gulliver, and so on. (Although he may not have been much fun to take to the Pleasure Beach, Adorno would definitely have been an instructive companion!) What most needs to be stressed is the ultimate subordination of such divergent themes to the theme of modernity articulated at the level of the Pleasure Beach's collective hail to its visitors.

243

This is due not solely to the quantitative preponderance of this theme over others but also to the structure of 'barking' in operation on the site. In its economic relations, the Pleasure Beach has two levels. The whole of the site is owned by Blackpool Pleasure Beach Ltd, which also runs all of the major rides and features as well as the indoor entertainment complexes. Most of the smaller rides, side-shows and small stalls, by contrast, are run by independent operators, or 'concessionaires', who make over a portion of their take to the company in return for the right to operate. This dual economy has definite consequences for the structure of 'barking'. Traditional forms of aggressive salesmanship survive only in the independently operated side-shows and stalls where relations of competition persist. The large rides and features are run as an integrated business rather than as separate enterprises. They are staffed by uniformed employees and, following the practice at Disneyland, the visitor is increasingly encouraged to buy books of tickets giving access to all rides rather than to pay for rides individually. Given these economic relations, it is the collective 'hail', getting people into the Pleasure Beach, that is important. Once there, it is immaterial how they spend their money so long as they spend it. As a consequence, few of the individual rides aggressively solicit custom – there's no address made to the public and, mostly, they contain merely the name of the ride, its price and a notice saying which class of ticket applies. It is by the collective hail of the Pleasure Beach as a whole – by its architecture, its public address systems, and its claims to be the biggest, the best, the latest – that the individual is placed as a pleasure-seeker under the sign of modernity.

Yet such interpellations can be refused or, at least, negotiated. It is easy to get a one-sided impression of the Pleasure Beach by concentrating solely on the system of pleasure constituted by the nature of its rides, their disposition in relation to one another and the signs under which they are coded for consumption. The Pleasure Beach is not just a site of pleasures, not just a set of buildings and rides conceived as uninhabited structures; there are usually people there too, mostly in groups of different sizes, shapes and complexions and with different histories, traditions and purposes. Usually to go to the Pleasure Beach is a cultural event, a distinct moment in the history of a group, be it a couple, a family, a youth-club or neighbourhood outing or a works trip. Far from imposing its 'regime of pleasure' on a series of individuals, construed as puppets of its organization, the Pleasure Beach is used and negotiated in different ways by different groups in accordance with the cultural relations and processes characterizing the group concerned. The group context in which you go to the Pleasure Beach, as well as the timing of the visit, makes a difference to the way it is experienced. To go in the daytime, as a parent, is one thing: you are a custodian in a complex initiation ceremony as terror quickly gives way to the no-hands sang-froid of a six year old pestering to go on the Revolution. But go there in the night with a group of friends and it's quite different. Pleasures are less surreptitiously taken than

in the daylight. Space is compressed – by other people and by the darkness pressing in – and there's the added edge of an assertive pleasure that refuses and conquers the life-denying darkness, friends to egg or be egged on by, to dare and double dare. It's one thing to go in 'Glasgow week' – not my scene, personally – and, as an Oldhamer, quite another to go in 'Oldham week'.

For Bakhtin, carnival was, above all, a practice of the people. It possessed not a sedimented form in fixed and permanent structures, but a vibrant and changing form, living only in the street-theatre of the people. If carnival enters the Pleasure Beach – and sometimes it does – it is through the people who tumble in from the promenade with their stetson hats, group swagger and bravado, appropriating the Pleasure Beach for a different practice as they break the rules of its laid-out and provided pleasures – by marching arm-in-arm down the walkways, dipping one another in the pools by the River Caves and splashing passers-by, whooping it up in the Ghost Train, trying to sink the logs on the Log Flume, taking the piss out of the laughing clown, rocking the Roller Coaster. The Pleasure Beach is not a site of transgressions. It is a site to be transgressed but one which, to a degree, invites – incites even – its own transgression. In its constructed separateness from the outside world, materially bracketed by the enclosing walls, the Pleasure Beach engenders expectations of untramelled pleasures which the ideological coding operative within it can only partly contain.

NOTES

INTRODUCTION

1 Apart from a brief period in revolutionary France, the impetus for the nineteenth-century development of public museums has usually derived from statist or governmental strategies rather than from any commitment to democratic principles as unqualified ends in themselves. However, this has not prevented retrospective accounts in which the development of public museums and the development of political democracy are presented as essentially related phenomena. Perhaps the most passionately stated of such accounts was presented by T.R. Adams in 1939. For Adams, the ideals of museums and those of political democracy were so closely intertwined that it was impossible to imagine the one developing and prospering without the other: 'a flourishing museum in a city of moderate size', as Adams puts it, 'can be taken as a symptom of rounded democracy' (Adams 1939: 16).

2 For details of such assessments, see Kasson (1978).

3 For the most influential account of this kind, see Wittlin (1949).

4 Edwards's position, however, was quite complex in that his objection to asking library users to reveal their occupation was partly that the formality of the request might deter some from joining libraries. See Edwards (1869).

5 This conclusion is based on the bibliography of visitor studies in Hudson (1975) and the annotated bibliography of museum behaviour papers by Erp and Loomis (1973).

1 THE FORMATION OF THE MUSEUM

1 I have discussed these matters in greater detail elsewhere. See Bennett (1992).

2 For a discussion of the role of Ruskin – and Morris – in the development of museums as instruments for the reformation of popular taste, see MacDonald (1986).

3 Edwin Chadwick was especially taken with the last of these possibilities, dwelling at length on an incident in Manchester when the Chief Commissioner of Police prevented a Chartist meeting from becoming an occasion 'for getting up what was called a demonstration of the working classes' by persuading the mayor 'to get the Botanical Gardens, Zoological Gardens, and Museum of that town, and other institutions, thrown open to the working classes at the hour they were urgently invited to attend the Chartist meeting'. This stratagem, Chadwick notes, succeeded in so reducing attendance at the Chartist meeting that it 'entirely failed'. See Richardson (1887, vol. 2: 128).

4 See, for the classic discussions of the juridico-discursive conception of power, Foucault (1980b), especially the essays 'Two Lectures' and 'Truth and Power'.

5 See Gordon (1991) for a discussion of the relations between the concepts of disciplinary and governmental power in Foucault's work.

6 While Habermas's account of the formation of the bourgeois public sphere is concerned primarily with common tendencies in seventeenth- and eighteenth-century European societies, he also notes national differences. In the case of France and England, these had a crucial bearing on the gendered composition of the institutions comprising the bourgeois public sphere with the role accorded the salons in France allowing women more influence in this respect than was true of Britain where the critical institution of the coffee-house excluded women. Women's opposition to coffee-houses was thus strong from the earliest days of their establishment; see Ellis (1956) for details.

7 See Crow (1985) for a discussion of the role played by criticism of the annual exhibitions of the Academy in the formation of a political culture critical of the state.

8 For a discussion of related issues in relation to scientific societies, see Forgan (1986).

9 It is worth noting that Habermas has subsequently indicated his acceptance of criticisms of this type in outlining how Bakhtin's work led him to revalue the position of plebeian culture in relation to the bourgeois public sphere. See Habermas (1992: 427).

10 Geoff Eley usefully stresses the respects in which this active exclusion of women from the political sphere should be regarded as a new set of gender relations rather than as a survival of archaic patriarchal structures. See Eley (1992).

11 For the most illuminating discussion of these similarities see Harris (1978), although there is also much useful incidental information in Ferry (1960).

12 Susan Porter Benson thus notes the respects in which American department stores would reserve exclusive zones for special categories of customers while also using marketing techniques to differentiate 'the carriage trade' from 'the shawl trade' and, where possible, to segregate these in different sections of the store. See Benson (1988: 83–9). For a discussion of similar tensions in the case of the nineteenth-century art museum and of the ways in which these were managed, see Sherman (1989).

13 See also Haug (1986) for a discussion of the ways in which the body of the sales assistant was tailored to the requirements of the sales process in being streamlined to fit in with the world commodities. McBride (1978) offers a related discussion in the French context.

14 This invisible order of significance is both an effect of the arrangement of objects within the sphere of the visible while also supplying the grid of intelligibility governing the field of the visible. In this respect, in spite of their contrasting terminologies, there is a good deal in common between Pomian's concept of the invisible and Foucault's notion of *visibilities*: that is, systems of visualization governing the distribution of things within the sphere of the visible but which themselves remain unseen, not because they are hidden but because they provide the distribution of light and shade through which things are given to be seen in the context of specific relations of knowledge and power. For a more detailed discussion of this aspect of Foucault's work, see Rajchman (1988).

15 I have relied mainly on Pommier (1989) for this discussion of the Louvre. However, see also Poulot (1983) and Quoniam and Guinamard (1988). Canteral-Besson (1981) has also proved useful: it comprises the minutes of the proceedings of both the *Conservatoire* and the earlier *Commission du Museum* and a useful

introduction which explains why – out of political prudence – these bodies fought shy of controversial museological issues.

16 For the most telling discussion of the temporalizing strategies through which modern anthropology made its object, see Fabian (1983).

17 For a parallel discussion of the inter-epistemic character of the anatomical theatre at Leiden, see Cavaillé (1990).

18 Owen was engagingly precise in his formulations on this matter when submitting his estimates to parliament regarding the space requirements of a national museum of natural history. Allowing for the number of specimens already collected, for the recent rate of discovery of new species and projecting this forward to provide for an increase in the rate of discovery, and allowing for display principles that would allow the visitor to see variations within a class as well as the historical succession of different forms of life, he calculated that a two-storey building spread over five acres would allow for an adequately representative collection.

19 Johann Geist, in tracing the network of relations between the architectural principles of arcades, exhibitions, museums and social utopias, suggests that it would be meaningless to assert a historical priority for any one of these architectural forms over the others. Rather, he argues, they have to be understood as an ensemble whose different elements interacted from the outset. See Geist (1983). Be this as it may, museum architecture often followed on, rather than leading, developments in other fields. This was partly because the influence of earlier building types intended to house valued objects (temples for the arts, royal palaces, etc.) inhibited the construction of buildings that were specifically designed for the museum's new purpose of mass instruction. This led to frequent complaints on the part of reformers anxious that culture should perform its reforming labours in a custom-built environment. 'We have thirsted for knowledge,' James Fergusson complained in 1849, 'and our architects have given us nothing but stones' (Fergusson 1849: 8). See, for similar complaints two decades later, Wallace (1869).

2 THE EXHIBITIONARY COMPLEX

1 This point is well made by MacArthur who sees this aspect of Foucault's argument as inimical to the overall spirit of his work in suggesting a 'historical division which places theatre and spectacle as past' (MacArthur 1983: 192).

2 For discussion of the role of the American state in relation to museums and expositions, see, respectively, Meyer (1979) and Reid (1979).

3 For details of the use of rotunda and galleries to this effect in department stores, see Ferry (1960).

4 For further details, see Miller (1974).

5 A comprehensive introduction to these earlier forms is offered by Impey and MacGregor (1985) and Bazin (1967).

6 I have touched on these matters elsewhere. See Bennett (1983) and (1986).

7 For details of these interactions, see Rudwick (1985).

8 I draw here on Foucault (1970).

9 For the most thorough account, see Mulvaney (1958: 30–1).

3 THE POLITICAL RATIONALITY OF THE MUSEUM

1 I have, however, touched on this matter with particular reference to Australian museums. See Bennett (1988b) and Chapter 5 of this volume.

2 For details of the changing fortunes of Cuvierism and Darwinism at the Natural History Museum, see Stearn (1981).
3 See on the first point, Cooper (1974) and, on the second, Stallybrass and White (1986).
4 This aspect of the rational recreations movement is vividly highlighted by Bailey (1987).
5 I intend the phrase 'supervised conformity' as a means of foregrounding the contrast between the museums and what Ian Hunter has characterized as the space of 'supervised freedom' of the school playground. See Hunter (1988). Whereas the latter encouraged the free expression of the child's culture under the supervision of the teacher in order that the values of the street might be monitored and corrected, the museums encouraged, instead, exterior compliance with the codes of behaviour.
6 For further details, see Altick (1978).
7 For fuller information on the sources of nineteenth-century museum architecture, see Giedion (1967).
8 Foucault, in reminding us of this aspect of Bentham's vision of panopticism, notes the respects in which it echoes the Rousseauist dream, so influential in the French Revolution, of a society rendered transparent to itself. See Foucault (1980b). In this respect, a further architectural lineage for the museum could be suggested in tracing its descent from various architectural arrangements proposed in revolutionary France in order to build a principle of public inspection into the design of political assemblies. For details of these, see Hunt (1984).
9 See, for example, Mann (1986), Heinich (1988) and Dixon et al. (1974).

4 MUSEUMS AND 'THE PEOPLE'

1 For useful surveys of these developments, see Minihan (1977) and Pearson (1982).
2 The most thorough survey of these matters is Hosmer (1965).
3 It has been estimated that, in Britain, a new museum was opened on average every two weeks throughout the 1970s when the number of visitors per annum also averaged out at 25 million. See Bassett (1986).
4 One of the best discussions of these questions is the penultimate chapter of Inglis (1974).
5 For the best account of the War Memorial, see Inglis (1985).
6 For a brief history of the Barracks and its conversion, see Betteridge (1982).

5 OUT OF WHICH PAST?

1 The reference is to the campaigns of John Ruskin and William Morris against the often somewhat violent practices of nineteenth-century restorers. For details, see Prince (1981).
2 By way of emphasizing this point, my position differs from that of Hodge and D'Souza who argue that, in museums 'An artefact communicates by being what it is. It therefore communicates or signifies that perfectly' (Hodge and D'Souza 1979: 257). This ignores the fact that, once placed in a historical frame, an artefact never is what it was and so, simply by virtue of this difference, cannot claim a meaning which is identical with itself – for that identity is split. The historical frame, in opening up a distance between the present and past existence of an object, enables the artefact to function as a sign. But it can function as a sign only within this gap which can therefore never be entirely closed down through a circuit of perfect communication such as Hodge and D'Souza suggest. It is solely

by virtue of its present conditions of existence (its placement in a museum and its arrangement in relation to other artefacts) that the museum artefact is transformed into a sign-vehicle for the communication of meanings about its past conditions of existence (its uses, its role in economic activities or communal ways of life). Unless the non-identity between these two different aspects of the museum artefact is maintained, it is impossible to appreciate the nature of its functioning as a sign and especially the potential for the same artefact to signify the past differently if the broader representational context provided by the historical frame in which it is located is modified.

3 See, for a telling discussion of such considerations, Bickford (1985).

4 Pevsner traces the origins of historicized principles of museum display to the Dusseldorf Gallery in 1775. However, he agrees with Bann and Bazin in contending that nationalized conceptions of history first achieved a museological embodiment in post-revolutionary France – in, first, Alexandre Lenoir's Musée des monuments français (1795) and, subsequently, in Alexandre du Sommerard's collection at the Hôtel de Cluny. See, respectively, Pevsner (1976), Bann (1984) and Bazin (1967).

5 For a brief review of European (and Japanese) heritage legislation, see Tay (1985). For details of American heritage legislation, see Hosmer (1965 and 1981).

6 See Inglis (1983) for a discussion of the role of local committees and local subscriptions in the erection of war memorials.

7 The Order of the AIF, encouraging troops to donate war mementoes, recognized the strength of anti-Commonwealth feeling in fostering the impression that donated materials would be housed in national collections, with the stress on the plural. It was thought that more materials would be donated if it was believed they were destined for state collections. It was similarly important that the materials were shown for extended periods in both Sydney and Melbourne prior to their permanent location in Canberra, as this enabled state-based emotional investments in the collections to be subsequently transfered to the capital. For details, see Millar (1986).

8 For a detailed summary of these debates, see Kavanagh (1984).

9 For details of the processes through which the ideological associations of the figure of the digger were transformed, see Ross (1985) and White (1981).

10 The protracted debates regarding the appropriate imagery for the central statue in the Hall of Memory are of special interest in this respect. While several allegorical female figures were considered for this purpose, the final decision, as Inglis puts it, was for 'a huge and upright male figure: the serviceman himself' (Inglis 1985: 120). Inglis elaborates the dominant effect of this figure as follows: 'To the uninstructed observer the only clear message it emits is that this Memorial belongs to men at war. The sculpture finally chosen for the scared space affirmed no continuity between the soldiers and the rest of the nation' (ibid.: 122).

11 The text describing the symbols accompanying the naval gunner representing Ancestry reads as follows: 'The wreath indicates reverence for the renowned; the book, traditional knowledge; cricket stumps and ball, traditional recreation; church spire, the European tradition of Christianity' (*Guide to the Australian War Memorial*, revised edition, 1953: 3).

12 These paintings, now housed in one room, were originally contained in two separate rooms, and were thus accorded a greater symbolic importance than is presently the case.

13 The bitter struggle was with the Imperial War Memorial which also wished to claim the Mosaic. The point at issue in the dispute was whether the AIF could lay claim to war spoils in its own right or whether, as an imperial force, its claims in this regard should be ceded automatically to Britain.

14 As with all starting points, however, this one is to some degree arbitrary. The

initiatives of the Whitlam government in the spheres of museum and heritage policy need also to be viewed in the context of the tendency towards the nationing of cultural property evident throughout the 1960s – the Menzies-initiated committee of inquiry leading to the eventual establishment of the Australian National Gallery; the 1960 legislation enabling the establishment of the National Library of Australia, and so on. For details of these developments, see Lloyd and Sekuless (1980).

15 This is contrary to the view of the Planning Committee of the Gallery of Aboriginal Australia, which recommended that the Gallery be established as an autonomous institution on its own site. This outcome was to some degree anticipated by the context governing the terms of the Planning Committee's inquiry. Set up at the same time as the Pigot Committee, its position was ambiguous from the outset, in that it was required to report to parliament in its own right while also reporting to the Pigott Committee which then incorporated that report within its own.

16 This commitment was reviewed in 1987 when it was uncertain whether the projected Museum of Australia would go ahead or not.

17 By 1981, the National Trust had a total of 70,000 members while the Australian Federation of Historical Societies had 45,000 members. The National Trust of New South Wales increased its membership from 22,865 in 1978 to an estimated 30,080 in 1981. See *Australia's National Estate: The Role of the Commonwealth* (1985) – first published as *The National Estate* in 1981.

18 Ministerial statement on the National Estate, *Parliamentary Debates*, House of Representatives, vol. 90, 23 August–30 October, 1974, p. 1536.

19 While still a relatively subordinate curatorial grouping within the Australian museum world, historians (and especially social historians) have, since the 1970s, become increasingly involved in the development of curatorial and display policies – at the Power House Museum, the West Australian and the Victorian Museum for example. Their role in planning the Museum of Australia has also been appreciable. The Interim Council of the Museum of Australia thus undertook 'to establish the basis for continuing involvement by professional historians in the planning and development of the Museum' (Museum of Australia 1982a: 3). One consequence of this commitment was a conference of historians convened by the Interim Council to canvass a range of possible themes for the Museum. For the collected proceedings of this conference, see Museum of Australia 1982b.

20 For a critical assessment of the basis on which tourist industry calculations are made, see Craik (1988).

21 This discussion of verisimilitude is drawn from Barthes (1987: 34–6).

22 A good example of this is provided by Lord Chartis of Amisfield (1984) who, in listing a number of items 'saved' by the British National Memorial Fund, manages to place trade-union barriers cheek-by-jowl with an avenue of elms, Coalbrookdale Old Furnace and the *Mary Rose* without any sense of incongruity.

23 The specificity of this rhetoric of the land is highlighted by Bommes and Wright's (1982) discussion of the sharply contrasting rhetoric of preservation which has characterized Shell's advertising in Britain.

24 I have discussed the Rocks in more detail elsewhere. See Bennett (1988d).

25 For a discussion of a critical experiment with this form, see Fortier (1981).

7 MUSEUMS AND PROGRESS: NARRATIVE, IDEOLOGY, PERFORMANCE

1 The first life-size reconstructions of dinosaurs placed on public display were those designed for the gardens accompanying the Crystal Palace when, after 1851, it was removed to Sydenham. Their design and installation was superintended by

Richard Owen whose depiction of the dinosaurs (a term he coined in 1841) was designed to refute the existence of the mechanism of transformism on which Lamarckian evolutionary theory depended. For details, see Desmond (1982), Rudwick (1992) and Stocking (1987).

2 I have already discussed Flower's proposals for natural history displays in Chapter 1. For details of the relations between Pitt Rivers and Flower and their respective proposals for the arrangement of museum exhibits, see Chapman (1981).

3 This is not to say that Pitt Rivers's expectations proved to be validated by experience. In a spirited defence of the principles of geo-ethnic displays, W.H. Holmes, the head curator in the Department of Anthropology at the United States National Museum, took issue with the kind of concentric arrangement proposed by Pitt Rivers as likely to 'be highly perplexing to any but the trained student, and wholly beyond the grasp of the ordinary visitor' (Holmes 1902: 360).

4 In other rooms, however, paintings are accorded quite different functions. There are thus a number of connecting galleries in which the paintings are displayed because of their place in the history of art rather than as parts of more general social or political histories. This inconsistency, however, is a productive one in the tension it establishes with more conventional forms of art exhibition. The Musée Carnavalet has been similarly innovative in its special exhibitions: see Mitchell (1978).

5 Henry Balfour, President of the Museums Association, founded in 1888, was thus active in urging museums to adopt the evolutionary principles of display exemplified by the Pitt Rivers Museum. See Skinner (1986: 392–3).

6 There is not space here for a detailed discussion of the relations between these two Societies. For informative, if also somewhat contrasting accounts, see Stocking (1987: 245–63), Rainger (1978) and Burrow (1963).

7 For an example of this degenerationist discourse in an early nineteenth-century religious tract written to guide parents in ways of using museum visiting as an aid to biblical instruction for their children, see Elizabeth (1837).

8 This is obviously an oversimplified version of a complex history. For further details, see Ferrari (1987), Richardson (1988) and Wilson (1987).

9 The reasons for viewing the female genitalia as inferior to the male derive from Galen's views regarding the flow and distribution of heat within the body. The male organs were viewed as more perfect in view of their capacity to generate their own heat and so be able to function outside the body. The uterus, viewed as an inverted penis, lacked this capacity for self reliance and so was tucked up within the body as a source of warmth.

10 For an especially interesting discussion of the politics of the representation of women's bodies in the French Revolution, see Hunt (1991).

11 The literature on this subject is vast. Apart from the relevant sources I have cited for other purposes, I have drawn on the following discussions in elaborating my arguments: Haller and Haller (1974), Easlea (1981), Mosedale (1978), Fee (1979) and Richards (1983).

12 Sayers (1982) and Love (1983) discuss the difficulties that Darwinism created for feminist thought, while Gamble (1894) exemplifies an early feminist rebuttal of the view that woman was merely a less-evolved man.

8 THE SHAPING OF THINGS TO COME: EXPO '88

1 For a fuller discussion and exemplification of this connection, see Greenhalgh (1988) and Anderson and Wachtel (1986).

NOTES

2 For as good an example as any of the synchronization of these different times, see Silverman (1977).

3 Although not dealing specifically with an official international exposition, Colin McArthur's discussion of the Glasgow Empire Exhibition offers a telling illustration of this point. See McArthur (1986).

4 See, for a detailed discussion of the city politics associated with Chicago's World's Columbian Exhibition, Reid (1979).

5 The scandal was occasioned by the decision of the Minister for Tourism, John Brown, to use a new technology in telling the story of the Dreamtime. The technology concerned – holavision – basically comprises a diorama animated by both living actors and holographic projections, thus providing an expositionary equivalent of the techniques for combining animation and live acting used in films like *Mary Poppins*. Unfortunately, it was an American invention and had already been used for a similar purpose at Vancouver's Expo '86. The debates this occasioned nicely illustrated the potential contradiction between the time of the nation and the international time of modernity. For how could the Australian Pavilion portray Australia as modernity's leading edge when it had to rely on imported technology to tell the story of its oldest inhabitants in the most modern manner possible? For fuller discussions of the episode and its role in occasioning Brown's resignation, see the reviews of Amanda Buckley and Margo Kingston in *Times on Sunday*, 10 January 1988.

6 For Bob Weatherall of FAIRA, the Brisbane-based Foundation for Aboriginal and Islander Research Action, Expo was unequivocally a part of the Bicentenary and, apart from offering a suitable public vehicle for Aboriginal protest against the Bicentenary, was itself to be opposed as being tarred with the same brush. (See the feature 'Aboriginals to push rights "inside Expo"', *Brisbane Telegraph*, 15 January 1988, and 'Assessing the Bicentennial: Interview with Bob Weatherall', *Social Alternatives*, vol. 8, no. 1, April 1989). Oodgeroo of the tribe Noonuccal was somewhat more equivocal when commenting on her part in writing the text for the Rainbow Serpent in the Australian Pavilion: 'This is not a Bicentennial thing. The Bicentenary is the celebration of white settlement. What we have written is for the world's market-place' (*Melbourne Age*, 28 March 1988). This view does not, however, seem to have been widely supported. Nigel Hopkins reports that, when asked about the Rainbow Serpent, a FAIRA representative replied: 'We do feel concerned about it. It's an important part of spiritual culture. But we can't comment on it; that's a matter for us to deal with. Just say we won't be going to see it, that's all' (Nigel Hopkins, 'Exposé: the story behind Brisbane's megashow', *Adelaide Advertiser*, 30 April 1988). No matter how its relations to the Bicentenary were assessed, however, Expo's impact on the local Aboriginal culture – and especially the threat it posed to Musgrave Park, a meeting place for the Turabul people – provided widely shared grounds for opposition to Expo and a stimulus for the organization of the Indigenous Cultural Survival Festival timed to coincide with Expo's opening. The community feeling over this was so strong as to result in the banishment of Don Davidson, president of the Brisbane Aboriginal Legal Service, when, later in the year, he criticized Aboriginal protests against Expo and assisted Sir Llew Edwards, the Expo Chairman, in raising an Aboriginal flag on the Expo site. (See 'Elder banished in Expo row', *The Australian*, 24 May 1988). As for official responses to Aboriginal protests, these were all vintage Queensland in style. Long before Expo opened Edwards was stern in warning that protest would not be tolerated, advising of State Government plans for 150 riot police to prevent racial violence. When, in May, a land-rights march developed into an unauthorized sit-in protest at a refusal to serve an elderly Aboriginal at the Melbourne Hotel, thirty arrests were made. The following

morning saw Mike Ahern, State Premier, announce a 'get tough' campaign against Aboriginal demonstrators, stating: 'If they want to continue some reasonable demonstrations over in a corner somewhere, that's fine' (*The Australian*, 4 May 1988).

7 See, on the first of these issues, 'Expo's tragic exiles', *Melbourne Sun*, 9 April 1988; 'Gays allege Expo clean-up', *National Times*, 23 February 1988; and 'City gets bare facts on Expo', *Melbourne Sun*, 24 June 1988.

8 For other instances of the technology/progress connection, see Greenhalgh (1988: 23–4).

9 It might be argued that, in this respect, modern expositions rest on a different signifying economy from their nineteenth-century predecessors. These, Timothy Mitchell has suggested, formed part of a new machinery of representation in which everything 'seemed to be set up as though it were the model or the picture of something, arranged before an observing subject into a system of signification, declaring itself to be a mere object, a mere "signifier of" something further' (Mitchell 1989: 222). The tendency for expositionary technologies to become self-referring, however, confirms Eco's contention that modern expositions are increasingly expositions of themselves.

10 For the fullest discussion of the display of people as living props for evolutionary rhetorics of progress, see Rydell (1984).

11 The stress on modernity is a relatively recent innovation in Britain's exposition pavilions. While imperialist themes had governed the terms of Britain's self-display at the Great Exhibition and most of its immediate successors, the late nineteenth-century threat to Britain's imperial supremacy prompted the invention of Olde England as the main component in Britain's exposition pavilions. This was complemented, at the New York 1939 World's Fair, by the projection of England as the mother of democracy via a display in the Magna Carta Hall which suggested the American revolution had sprung from the love of democracy implanted by English settlers. (Further details, see Greenhalgh 1988: 112–28, 137–8). A similar claim was made at Expo '88 where the Lincoln Cathedral copy of the Magna Carta was displayed as a foundational document in the establishment of modern civil and democratic rights. In these and other respects – the display of Cook memorabilia in the Captain Cook Pavilion, a hi-tech animated mannikin of Joseph Banks in the entry to the British Pavilion, the Domesday Project computer allowing Australians to trace their roots back to their English forebears – the British displays sought to assert some rights of progeny over the Australian nation.

12 For an account of the emergence and increasing significance of corporate pavilions, see Benedict (1983).

13 For a discussion of a similar rhetoric in another context, see Bennett (1986).

14 It's relevant, in this context, to note the contrast between Expo '88 which, as Fry and Willis rightly note, remained modernist in its governing conceptions, and the Australian Bicentennial Exhibition (ABE) whose design principles, emerging largely from Sydney, were governed by postmodernist assumptions. For a discussion of this aspect of the ABE, see Cochrane and Goodman (1988).

15 Melbourne correspondents were especially prone to describe their experiences of Expo in the terms of these discursive co-ordinates, typically driving a wedge between the time of Expo and that of the city in suggesting that the hyper-modernity of the former served to underscore the backwardness of the latter. In some cases, this was merely a matter of keeping Brisbane in the discursive register of the quaint and thus confirming its continuing suitability as an imaginative retreat from the more advanced and harassed rhythms of urban life in Sydney and Melbourne. Thus, for Beverley Johanson, while Brisbane may have 'come of age'

in terms of development, the 'pace is still slower than its southern counterparts, and the street fashion a little less fashionable, but it is an interesting, relaxing and friendly place' (*Melbourne Age*, 16 March 1988). In other cases, however, the concern was to put the country cousins back in their place. For Robert Haupt, going outside Expo and into the city was a trip into the past – back to 1962 – just as talking to its inhabitants was to encounter a backward species, friendly types, but 'all "Hi!" and no tech' (*Melbourne Age*, 26 April 1988).

16 For detailed discussion of the role of the Great Exhibition in this regard, see Altick (1978).

17 These distinctions were, however, less sharp in the United States where museum ventures like P.T. Barnum's straddled the worlds of circus, zoo, freak show, cabinet of curiosities, theatre, and museum. For further details, see Harris (1973) and Betts (1959).

18 I have, however, offered a fuller account elsewhere. See Bennett (1988a).

19 The record regarding the exclusion of fairground culture from official exposition exhibits is clear. Greenhalgh (1988) thus records the refusal to allow the exhibition of the 'preserved remains of Julia Pastrana, half woman, half baboon, the oldest loaf in the world and a man-powered flying machine' at the South Kensington Exhibition of 1862 because of their fairground associations. For one of the best general discussions of this tension, see Benedict (1983).

20 See, for a literary portrayal of the 1939 Midway, Doctorow (1985). According to McCullough, the voyeurism of the Oscar the Amorous Octopus show was paralleled in the official exposition itself with various pretexts being exploited for the exhibition of naked women.

21 Three amusement parks were established at Coney Island in the course of a decade: Sea Lion Park in 1895 (changed to Luna Park in 1903); Steeplechase Park in 1897; and Dreamland in 1904. For full accounts of these, see Kasson (1978). For a discussion focusing specifically on the role of mechanical rides in modernizing the culture of the fair, see Snow and Wright (1976).

22 See, for example, my discussion of the formation of Blackpool's Pleasure Beach in Chapter 9.

23 See the section 'National Culture and Recreation: Antidotes to Vice' in Cole (1884).

24 See, on this aspect of nineteenth-century public life, Sennett (1978).

25 This transformation in the symbolism of the fair is fully detailed in Cunningham (1980).

BIBLIOGRAPHY

Aarsleff, Hans (1982) *From Locke to Saussure: Essays on the Study of Language and Intellectual History*, London: Athlone.

Adams, T.R. (1939) *The Museum and Popular Culture*, New York: American Association for Adult Education.

Adorno, Theodor W. (1967) *Prisms*, London: Neville Spearman.

Agassiz, L. (1862) 'On the arrangement of natural history collections', *The Annmals and Magazine of Natural History*, 3rd series, vol. 9.

Alaya, Flavia (1977) 'Victorian science and the "genius" of woman', *Journal of the History of Ideas*, no. 38.

Allen, J. (1976) 'Port-Arthur Site Museum, Australia: its preservation and historical perspectives', *Museum*, vol. 28, no. 2.

Altick, Richard (1978) *The Shows of London*, Cambridge, Mass. and London: The Belknap Press of Harvard University Press.

Anderson, Benedict (1983) *Imagined Communities: Reflections on the Origin and Spread of Nationalism*, London: Verso Editions.

Anderson, Robert and Wachtel, Eleanor (1986) *The Expo Story*, Madeira Park, British Columbia: Harbour Publishing.

Anon. (1828) 'Suggestions for the establishment of an Australian Museum' in *The Australian Quarterly Journal of Theology, Literature and Science*, vol. 1.

Armstrong, Meg (1992–3) '"A jumble of foreignness": the sublime musayums of nineteenth-century fairs and expositions', *Cultural Critique*, Winter.

Arscott, Caroline (1988) 'Without distinction of party: the Polytechnic Exhibition in Leeds, 1839–45' in Janet Wolff and John Seed (eds) *The Culture of Capital: Art, Power and the Nineteenth-Century Middle Class*, Manchester: Manchester University Press.

Australian Council of National Trusts (1978) *Historic Places of Australia*, vol. 1, Sydney and Melbourne: Cassell Australia.

Australia's National Estate: The Role of the Commonwealth (1985) Canberra: Australian Government Publishing Service. (First published in 1982 as *The National Estate in 1981*.)

Bailey, Peter (1987) *Leisure and Class in Victorian England: Rational Recreation and the Contest for Control, 1830–1885* (revised edition), London and New York: Methuen.

Bakhtin, M. (1968) *Rabelais and his World*, Cambridge, Mass.: MIT Press.

—— (1973) *Problems of Dostoevsky's Poetics*, Ann Arbor, Mich.: Ardis.

—— (1981) *The Dialogic Imagination*, Austin and London: University of Texas Press.

Bann, Stephen (1984) *The Clothing of Clio: A Study of the Representation of History in Nineteenth-Century Britain and France*, Cambridge: Cambridge University Press.

Barthes, Roland (1979) *The Eiffel Tower and Other Mythologies*, New York: Hill & Wang.
—— (1987) *Criticism and Truth*, Minneapolis: University of Minnesota Press.
Bassett, D.A. (1986) 'Museums and museum publications in Britain, 1975–85, part I: the range and nature of museums and their publications', *British Book News*, May.
Bauman, Zygmunt (1992) *Intimations of Postmodernity*, London: Routledge.
Bazin, G. (1967) *The Museum Age*, New York: Universal Press.
Beamish: The Great Northern Experience, a souvenir guidebook (n.d.).
Beamish One: First Report of the North of England Open Air Museum Joint Committee (1978) Stanley, County Durham: Beamish Hall.
Beer, Gillian (1983) *Darwin's Plots. Evolutionary Narrative in Darwin, George Eliot and Nineteenth-Century Fiction*, London: Ark Paperbacks.
Benedict, Burton (1983) 'The anthropology of world's fairs', in Burton Benedict (ed.) *The Anthropology of World's Fairs: San Francisco's Panama Pacific Exposition of 1915*, New York: Scolar Press.
Benjamin, Walter (1936) 'The work of art in the age of mechanical reproduction', in Walter Benjamin (1970) *Illuminations*, London: Jonathan Cape.
—— (1973) *Charles Baudelaire: A Lyric Poet in the Era of High Capitalism*, Harvard University Press.
Bennett, Tony (1979) *Formalism and Marxism*, London: Methuen.
—— (1983) 'A thousand and one troubles: Blackpool Pleasure Beach', *Formations of Pleasure*, London: Routledge & Kegan Paul.
—— (1986) 'Hegemony, ideology, pleasure: Blackpool', in Tony Bennett, Colin Mercer and Janet Woollacott (eds) *Popular Culture and Social Relations*, Milton Keynes: Open University Press.
—— (1988a) 'The museum, the fair, and the exposition', *Eyeline* (7), December.
—— (1988b) 'Convict chic', *Australian Left Review*, no. 106.
—— (1988c) 'The exhibitionary complex', *New Formations*, no. 4, Spring.
—— (1988d) 'History on the Rocks', in Don Barry and Stephen Muecke (eds) *The Apprehension of Time*, Sydney: Local Consumption Press.
—— (1988f) 'Museums and "the people"', in B. Lumley (ed.) *The Museum Time Machine*, London: Methuen. (Also see Ch. 4 of this volume.)
—— (1988g) *Out of Which Past? Critical Reflections on Australian Museum and Heritage Policy*, Brisbane: Institute for Cultural Policy Studies, Griffith University, Occasional Paper no. 3.
—— (1992) 'Useful culture', *Cultural Studies*, vol. 6, no. 3
—— and Frow, John (1991) *Art Galleries Who Goes? A Study of Visitors to Three Australian Art Galleries with International Comparisons*, Sydney: Australia Council.
Benson, Susan Porter (1979) 'The palace of consumption and machine for selling: the American department store, 1880–1940' *Radical History Review*, Fall.
—— (1988) *Counter Cultures: Saleswomen, Managers and Customers in American Department Stores, 1890–1940*, Urbana and Chicago: University of Illinois Press.
Betteridge, M. (1982) 'The Mint and Hyde Park Barracks', *Kalori*, nos 59/60.
Betts, John R. (1959) 'Barnum and natural history', *Journal of the History of Ideas*, no. 20.
Bickford, Anne (1982) 'The nature and purpose of historical displays in museums', *Proceedings of the Museum of Australia Conference on Australian History*, Canberra: Commonwealth of Australia.
—— (1985) 'Disquiet in the warm parlour of the past: material history and historical studies', Paper presented to the History and Culture Resources Seminar, Canberra.
Blackbourn, David and Eley, Geoff (1984) *The Peculiarities of German History:*

Bourgeois Society and Politics in Nineteenth Century Germany, Oxford: Oxford University Press.

Blackpool Evening Gazette (1977) 21 March.

Bommes, Michael and Wright, Patrick (1982) '"Charms of residence": the public and the past', in Centre for Contemporary Cultural Studies, *Making Histories: Studies in History Writing and Politics*, London: Hutchinson.

Borges, Jorge Luis (1970) *Labyrinths: Selected Stories and Other Writings*, Harmondsworth: Penguin.

Bourdieu, Pierre (1987) 'The historical genesis of a pure aesthetic', *Journal of Aesthetics and Art Criticism*, no. 46.

—— and Darbel, Alain (1991) *The Love of Art: European Art Museums and their Public*, Cambridge: Polity Press. (First published in French in 1969.)

Boyer, Christine M. (1986) *Dreaming the Rational City: The Myth of American City Planning*, Cambridge, Mass.: MIT Press.

Brand, Dana (1986) *The Spectator and the City: Fantasies of Urban Legibility in Nineteenth-Century England and America*, Ann Arbor, Mich.: University Microfilms International.

Breckenridge, Carol A. (1989) 'The aesthetics and politics of colonial collecting: India at world fairs', in *Comparative Studies in Society and History*, vol. 31, no. 2.

Brown, Lee Rust (1992) 'The Emerson Museum', *Representations*, no. 40.

Buckingham, James Silk (1849) *National Evils and Practical Remedies, with the Plan of a Model Town*, London. (Facsimile edition by Augustus M. Kelley, Clifton, 1973.)

Buck-Morss, Susan (1990) *The Dialectics of Seeing: Walter Benjamin and the Arcades Project*, Cambridge, Mass. and London: MIT Press.

Burchell, Graham, Gordon, Colin and Miller, Peter (eds) (1991) *The Foucault Effect: Studies in Governmentality*, London: Harvester/Wheatsheaf.

Burke, P. (1977) 'Popular culture in Norway and Sweden', *History Workshop*, no. 3.

Burn, Ian (1989) 'The art museum more or less', *Art Monthly*, November.

Burrow, J.W. (1963) 'Evolution and anthropology in the 1860s: The Anthropological Society of London, 1863–71', *Victorian Studies*, vol. 7, no.2.

Bushman, Richard L (1992) *The Refinement of America: Persons, Houses, Cities*, New York: Knopf.

Canguilhem, Georges (1988) *Ideology and Rationality in the History of the Life Sciences*, Cambridge, Mass.: MIT Press.

Canteral-Besson, Yveline (ed.) (1981) *La Naissance du Musée du Louvre. La Politique Muséologique sous la Révolution d'apres des Musées Nationaux* (2 vols), Paris: Ministère de la Culture, editions de la réunion des musée nationaux.

Cavaillé, Jean-Pierre (1990) 'Un théâtre de la science et de la mort à l'époque baroque: l'amphithéâtre d'anatomie de Leiden', *Working Papers HEC*, no. 90/2, Florence: European University Institute.

Chambers, Iain (1985) 'The obscured metropolis', *Australian Journal of Cultural Studies*, vol. 3, no. 2.

Chapman, William Ryan (1981) 'Ethnology in the Museum: AHLF Pitt Rivers (1827–1900) and the Institutional Foundations of British Anthopology', D.Phil thesis, Oxford University.

—— (1985) 'Arranging ethnology: A.H.L.F. Pitt Rivers and the typological tradition', in George W. Stocking Jr (1985).

Chartis, Lord of Amisfield (1984) 'The work of the National Heritage Memorial Fund', in *Journal of the Royal Society of Arts*, vol. 132.

Clifford, James (1988) 'On collecting art and culture', in *The Predicament of Culture: Twentieth-Century Ethnography, Literature, and Art*, Cambridge, Mass.: Harvard University Press.

258

Cochrane, Peter and Goodman, David (1988) 'The great Australian journey: cultural logic and nationalism in the postmodern era', in Susan Janson and Stuart MacIntyre (eds) *Making the Bicentenary*, Australian Historical Studies 23 (91), October.

Cole, Sir Henry (1884) *Fifty Years of Public Work of Sir Henry Cole, K.C.B., Accounted for in his Deeds, Speeches and Writings* (2 vols), London: George Bell & Sons.

Colquhoun, Patrick (1796) *A Treatise on the Police of the Metropolis; containing detail of the various crimes and misdemeanours by which public and private property and security are, at present, injured and endangered: and suggesting remedies for their prevention*, London.

—— (1806) *A Treatise on the Police of the Metropolis*, London: Bye & Law.

Coombes, Anne E. (1988) 'Museums and the formation of national and cultural identities', *Oxford Art Journal*, vol. 11, no. 2.

Cooper, David D. (1974) *The Lesson of the Scaffold*, London: Allen Lane.

Cordell, M. (1987) 'Discovering the chic in a convict past', *Sydney Morning Herald*, 31 January.

Craik, Jennifer (1988) *Tourism Down Under: Tourism Policies in the Tropics*, Brisbane: Institute for Cultural Policy Studies, Griffith University, Occasional Paper no. 2.

—— (1989) 'The Expo experience: the politics of expositions', *Australian–Canadian Studies*, vol. 7, nos. 1–2.

Crimp, Douglas (1985) 'On the museum's ruins', in Hal Foster (ed.) *The Anti-Aesthetic; Essays on Postmodern Culture*, Washington: Bay Press.

—— (1987) 'The postmodern museum', *Parachute*, March–May.

Crosby, Christina (1991) *The Ends of History: Victorians and 'the Woman Question'*, London: Routledge.

Crow, Thomas E. (1985) *Painters and Public Life in Eighteenth-Century Paris*, New Haven and London: Yale University Press.

Cunningham, Hugh (1977) 'The metropolitan fairs: a case-study in the social control of leisure', in A.P. Donajgrodzki (ed.) *Social Control in Nineteenth Century Britain*, London: Croom Helm.

—— (1980) *Leisure in the Industrial Revolution*, London: Croom Helm.

—— (1982) 'Class and leisure in mid-Victorian England', in B. Waites, T. Bennett and G. Martin (eds) *Popular Culture: Past and Present*, London: Croom Helm.

Davies, Colin (1984) 'Architecture and remembrance', *Architectural Review*, February.

Davison, Graeme (1982/83) 'Exhibitions', *Australian Cultural History*, no. 2, Canberra: Australian Academy of the Humanities and the History of Ideas Unit, ANU.

Desmond, Adrian (1982) *Archetypes and Ancestors: Palaeontology in Victorian London*, Chicago: University of Chicago Press.

—— (1989) *The Politics of Evolution: Morphology, Medicine and Reform in Radical London*, Chicago and London: University of Chicago Press.

Dixon, B., Courtney, A.E. and Bailey, R.H. (1974) *The Museum and the Canadian Public*, Toronto: Arts and Culture Branch, Department of the Secretary of State.

Doctorow, E.L. (1985) *World's Fair*, London: Picador.

Donato, E. (1979) 'The museum's furnace: notes toward a contextual reading of *Bouvard* and *Pécuchet*', in J. Harrari (ed.) *Textual Strategies: Perspectives in Post-Structuralist Criticism*, Ithaca and London: Cornell University Press.

Doyle, Brian (1989) *English and Englishness*, London: Methuen.

Duden, Barbara (1991) *The Woman Beneath the Skin: A Doctor's Patients in Eighteenth Century Germany*, Cambridge, Mass.: Harvard University Press.

Duffin, Lorna (1978) 'Prisoners of progress: women and evolution', in S.D. Delamont and L. Duffin (eds) *The Nineteenth-Century Woman*, London: Croom Helm.

259

Duncan, Carol and Wallach, Alan (1980) 'The universal survey museum', *Art History*, vol. 3, no. 4.

Eagleton, Terry (1981) *Walter Benjamin, or Towards a Revolutionary Criticism*, London: New Left Books.

Easlea, Brian (1981) *Science and Sexual Oppression: Patriarchy's Confrontation with Woman and Nature*, London: Weidenfeld & Nicolson.

Eco, Umberto (1987) *Travels in Hyper-Reality*, London: Picador.

Edwards, Edward (1869) *Free Town Libraries: Their Formation, Management, and History in Britain, France, Germany and America*, London: Trubner & Co.

Eichenbaum, Boris (1971) 'O. Henry and the theory of the short story', in L. Matejka and K. Pomorska (eds) *Readings in Russian Poetics*, Cambridge, Mass.: MIT Press.

Eley, Geoff (1992) 'Nations, publics, and political cultures: placing Habermas in the nineteenth century', in Graig Calhoun (ed.) *Habermas and the Public Sphere*, Cambridge: Polity.

Elias, Norbert (1983) *The Court Society*, Oxford: Blackwell.

Elizabeth, Charlotte (1837) *The Museum*, Dublin: Religious Tract and Book Society for Ireland.

Ellis, A. (1956) *The Penny Universities: A History of the Coffee Houses*, London: Secker & Warburg.

Erp, Pamela Elliot-Van and Loomis, Ross J. (1973) *Annotated Bibliography of Museum Behaviour Papers*, Washington: Office of Museum Programs, Smithsonian Institute.

Evans, Robin (1982) *The Fabrication of Virtue: English Prison Architecture 1750–1840*, Cambridge: Cambridge University Press.

Fabian, Johannes (1983) *Time and the Other: How Anthropology Makes its Object*, New York: Columbia University Press.

Fabianski, Marcin (1990) 'Iconography of the architecture of ideal musaea in the fifteenth to eighteenth centuries', *Journal of the History of Collections*, vol. 2, no. 2.

Fee, Elizabeth (1976) 'The sexual politics of Victorian social anthropology', in Mary S. Hartman and Lois Banner (eds) *Clio's Consciousness Raised. New Perspectives on the History of Women*, New York: Octagon Books.

—— (1979) 'Nineteenth-century craniology: the study of the female skull', *Bulletin of the History of Medicine*, vol. 53.

Fergusson, James (1849) *Observations on the British Museum, National Gallery and National Records Office, with Suggestions for Their Improvement*, London: John Weale.

Ferrari, Giovanna (1987) 'Public anatomy lessons and the carnival: the Anatomy Theatre of Bologna', *Past and Present*, no. 117.

Ferry, John William (1960) *A History of the Department Store*, New York: Macmillan.

Fisher, Phillip (1991) *Making and Effacing Art: Modern American Art in a Culture of Museums*, New York: Oxford University Press

Flower, Sir William Henry (1898) *Essays on Museums and Other Subjects connected with Natural History*, London: Macmillan & Co.

Forgan, Sophie (1986) 'Context, image and function: a preliminary inquiry into the architecture of scientific societies', *British Journal for the History of Science*, vol. 19, part 1.

Forrest, D.W. (1974) *Francis Galton: The Life and Work of a Victorian Genius*, London: Paul Elek.

Fortier, John (1981) 'Louisbourg: managing a moment in time', in R.E. Rider (ed.) *The History of Atlantic Canada: Museum Interpretations*, Ottawa: National Museum of Canada.

Foucault, Michel (1970) *The Order of Things: An Archaeology of the Human Sciences*, London: Tavistock.
—— (1972) *The Archaeology of Knowledge*, London: Tavistock.
—— (1977) *Discipline and Punish: The Birth of the Prison*, London: Allen Lane.
—— (1978) 'Governmentality', in Graham Burchell, Colin Gordon and Peter Miller (1991).
—— (1980a) 'Nietzsche, genealogy, history', in *Language, Counter-Memory, Practice*, Ithaca: Cornell University Press.
—— (1980b) 'The eye of power', in *Power/Knowledge: Selected Interviews and Other Writings, 1972–1977*, New York: Pantheon Books.
—— (1986) 'Of other spaces', *Diacritics*, Spring.
Friedman, John Block (1981) *The Monstrous Races in Medieval Art and Thought*, Cambridge, Mass.: Harvard University Press.
Frow, John (1987) 'Accounting for tastes: some problems in Bourdieu's sociology of culture', *Cultural Studies*, vol. 1, no. 1.
Fry, Tony and Willis, Anne-Marie (1988) 'Expo 88: backwoods into the future', *Cultural Studies*, vol. 2, no. 1.
Gamble, Eliza Burt (1894) *The Evolution of Woman: An Inquiry into the Dogma of her Inferiority to Man*, London and New York: The Knickerbocker Press, J.P. Putnam's Sons.
Garrison, Dee (1976) 'The tender technicians: the feminisation of public librarianship, 1876–1905', in Mary S. Hartman and Lois Banner (eds) *Clio's Consciousness Raised: New Perspectives on the History of Women*, New York: Octagon Books.
Geddes, Patrick (1904) *City Development: A Study of Parks, Gardens, and Culture-Institutes*. A Report to the Dunfermline Trust, Bournville, Birmingham: Saint George Press.
Geist, Johann Friedrich (1983) *Arcades: The History of a Building Type*, New York: MIT Press.
Gibbs-Smith, C.H. (1981) *The Great Exhibition of 1851*, London: HMSO.
Giedion, Sigfried (1967) *Space, Time and Architecture: the Growth of a New Tradition*, Cambridge, Mass.: Harvard University Press.
Gilman, Sander L. (1985a) 'Black bodies, white bodies: toward an iconography of female sexuality in late nineteenth-century art, medicine and literature', *Critical Inquiry*, vol. 21, no. 1.
—— (1985b) *Difference and Pathology: Stereotypes of Sexuality, Race, and Madness*, Ithaca and London: Cornell University Press.
Ginzburg, Carlo (1980) 'Morelli, Freud and Sherlock Holmes: clues and scientific method', *History Workshop*, no. 9.
Goode, G. Brown (1895) *The Principles of Museum Administration*, York: Coultas & Volans.
—— (1896) 'On the classification of museums', *Science*, vol. 3, no. 59.
Goodman, David (1990) 'Fear of circuses: founding the National Museum of Victoria', *Continuum*, vol. 3, no. 1.
Gordon, Colin (1991) 'Governmental rationality: an introduction', in Graham Burchell, Colin Gordon and Peter Miller (1991).
Gould, Stephen Jay (1981) *The Mismeasure of Man*, Harmondsworth: Penguin.
—— (1982) 'The Hottentot Venus', *Natural History*, vol. 91, no. 10.
Gramsci, Antonio (1971) *Selections from the Prison Notebooks*, London: Lawrence & Wishart.
—— (1985) *Selections from Cultural Writings*, London: Lawrence & Wishart.
Grayson, Donald (1983) *The Establishment of Human Antiquity*, New York, London, Sydney: Academic Press.

Greenblatt, Stephen (1987) 'Towards a poetics of culture', *Southern Review*, vol. 20, no. 1.

—— (1991) 'Resonance and wonder', in Ivan Karp and Steven Lavine (1991).

Greenhalgh, Paul (1988) *Ephemeral Vistas: The Expositions Universelles, Great Exhibitions and World's Fairs, 1851–1939*, Manchester: Manchester University Press.

—— (1989) 'Education, entertainment and politics: lessons from the great international exhibitions', in Peter Vergo (ed.) *The New Museology*, London: Reaktion Books.

Greenwood, Thomas (1888) *Museums and Art Galleries*, London: Simpkin, Marshall & Co.

Guide to Australian War Memorial (1953). Revised edition.

Habermas, Jurgen (1989) *The Structural Transformation of the Public Sphere: An Inquiry into a Category of Bourgeois Society*, Cambridge, Mass.: MIT Press.

—— (1992) 'Further reflections on the public sphere', in Craig Calhoun (ed.) *Habermas and the Public Sphere*, Cambridge, Mass.: MIT Press.

Hall, Catherine (1992) *White, Male and Middle Class: Explorations in Feminism and History*, Cambridge: Polity.

Haller, J.S. Jr and Haller, Robin, M. (1974) *The Physician and Sexuality in Victorian America*, Urbana: University of Illinois Press.

Haraway, Donna (1992) 'Teddy bear patriarchy: taxidermy in the Garden of Eden, New York City, 1908–1936', in *Primate Visions: Gender, Race and Nature in the World of Modern Science*, London: Verso.

Hareven, Tamara and Langenbach, Randolph (1981) 'Living places, work places and historical identity', in David Lowenthal and Marcus Binney (eds) *Our Past Before Us. Why Do We Save It?*, London: Temple Smith.

Harris, Neil (1973) *Humbug: The Art of P.T. Barnum*, Boston: Little Brown & Co.

—— (1975) 'All the world a melting pot? Japan at American fairs, 1876–1904', in Akira, Iriye (ed.) *Mutual Images: Essays in American–Japanese Relations*, Cambridge, Mass.: Harvard University Press.

—— (1978) 'Museums, merchandising and popular taste: the struggle for influence', in I.M.G. Quimby (ed.) *Material Culture and the Study of American Life*, New York: W.W. Norton.

Harrison, Tom (1938) 'The fifty-second week: impressions of Blackpool', *The Geographical Magazine*, April.

Haskell, Francis (1971) 'The manufacture of the past in nineteenth-century painting', *Past and Present*, no. 53.

Haug, W.F. (1986) *Critique of Commodity Aesthetics*, Cambridge: Polity Press.

Hayden, Dolores (1976) *Seven American Utopias: The Architecture of Communitarian Socialism, 1790–1975*, Cambridge, Mass.: MIT Press.

—— (1981) *The Grand Domestic Revolution: A History of Feminist Designs for American Homes, Neighborhoods and Cities*, Cambridge, Mass.: MIT Press.

Heinich, N. (1988) 'The Pompidou Centre and its public: the limits of a utopian site', in Robert Lumley (ed.) *The Museum Time-Machine: Putting Cultures on Display*, London: Routledge.

Hinsley, Curtis M. (1991) 'The world as marketplace: commodification of the exotic at the World's Columbian Exposition, Chicago, 1893', in Ivan Karp and Steven Lavine (1991).

Hobsbawm, Eric (1983) 'Mass-producing traditions, Europe, 1870–1914', in E. Hobsbawm and T. Ranger (eds), *The Invention of Tradition*, Cambridge: Cambridge University Press.

Hodge, Robert and D'Souza, Wilfred (1979) 'The museum as a communicator: a

semiotic analysis of the Western Australia Museum Aboriginal Gallery, Perth' *Museum*, vol. 31, no. 4.

Hodgen, Margaret T. (1936) *The Doctrine of Survivals: A Chapter in the History of Scientific Method in the Study of Man*, London: Allenson & Co.

—— (1964) *Early Anthropology in the Sixteenth and Seventeenth Centuries*, Philadelphia: University of Pennsylvania Press.

Holmes, William H. (1902) 'Classification and arrangement of the exhibits of an anthropological museum', *Journal of the Anthropological Institute of Great Britain and Ireland*, vol. 23.

Hooper-Greenhill, E. (1988) 'The Museum: The Social-Historical Articulations of Knowledge and Things', Ph.D. thesis, University of London.

—— (1989) 'The museum in the disciplinary society', in J. Pearce, *Museum Studies in Material Culture*, Leicester: Leicester University Press.

—— (1992) *Museums and the Shaping of Knowledge*, London: Routledge.

Hosmer, C.B. Jr. (1965) *Presence of the Past: a History of the Preservation Movement in the United States before Williamsburg*, New York: G.P. Putnam's Sons.

—— (1981) *Preservation Comes of Age: From Williamsburg to the National Trust 1926–1949* (2 vols), Charlottesville: University Press of Virginia.

Hudson, Kenneth (1975) *A Social History of Museums*, New Jersey: Humanities Press.

Humes, Walter (1983) 'Evolution and educational theory in the nineteenth century', in D. Oldroyd and I. Langham (1983).

Hunt, Lynn (1984) *Politics, Culture and Class in the French Revolution*, London: Methuen.

—— (1991) 'The many bodies of Marie Antionette: political pornography and the problem of the feminine in the French Revolution', in L. Hunt (ed.) *Eroticism and the Body Politic*, Baltimore and London: Johns Hopkins University Press.

Hunter, Ian (1988) *Culture and Government: The Emergence of Modern Literary Education*, London: Macmillan.

—— (1993) 'Mind games and body techniques', *Southern Review*, vol. 26, no. 7.

Huxley, Thomas Henry (1882) 'On the method of Zadig: retrospective prophecy as a function of science', in *Science and Culture and Other Essays*, London: Macmillan & Co.

—— (1895) *Science and Education*, London: Macmillan & Co.

Impey, Olive and MacGregor, Arthur (eds) (1985) *The Origins of Museums: The Cabinet of Curiosities in Sixteenth and Seventeenth Century Europe*, Oxford: Clarendon Press.

Inglis, K.S. (1974) *The Australian Colonists: An Exploration of Social History 1788–1870*, Carlton: Melbourne University Press.

—— (1983) 'War memorials in our landscape', *Heritage Australia*, Summer.

—— (1985) 'A sacred place: the making of the Australian War Memorial', *War and Society*, vol. 3, no. 2.

Jacknis, Ira (1985) 'Franz Boas and exhibits: on the limitations of the museum method of anthropology', in George W. Stocking Jr (ed.) (1985) *Objects and Others: Essays on Museums and Material Culture*, Madison: University of Wisconsin Press.

James, Paul (1983) 'Australia in the corporate image: a new nationalism', *Arena*, no. 61.

Jordanova, Ludmilla (1980) 'Natural facts: a historical perspective on science and sexuality', in P. MacCormack and M. Strathern (eds) *Nature, Culture and Gender*, Cambridge: Cambridge University Press.

—— (1985) 'Gender, generation and science: William Hunter's obstetrical atlas', in W.F. Bynum and R. Porter (eds) *William Hunter and the Eighteenth Century Medical World*, Cambridge: Cambridge University Press.

Karp, Ivan and Lavine, Steven (eds) (1991) *Exhibiting Cultures: The Poetics and Politics of Museum Display*, Washington and London: Smithsonian Institute Press/ Cambridge University Press.

Kasson, John F. (1978) *Amusing the Millions. Coney Island at the Turn of the Century*, New York: Hill & Wang.

Kavanagh, Gaynor (1984) 'Museums, Memorials and Minenwerfers,' *Museums Journal*, September.

van Keuren, David K. (1984) 'Museums and ideology: Augustus Pitt Rivers, anthropological museums, and social change in later Victorian Britain', *Victorian Studies*, vol. 28, no. 1

—— (1989) 'Museums and ideology: Augustus Pitt-Rivers, anthropology museums, and social change in later Victorian Britain', in Patrick Brantlinger (ed.) *Energy and Entropy: Science and Culture in Victorian Britain*, Bloomington and Indianapolis: Indiana University Press.

Key, Archie F. (1973) *Beyond Four Walls: The Origins and Development of Canadian Museums*, Toronto: McClelland & Stewart Ltd.

King, E. (1985) *The People's Palace and Glasgow Green*, Galsgow: Richard Drew.

Kirshenblatt-Gimblett, Barbara (1991) 'Objects of ethnography', in Ivan Karp and Steven Lavine (1991).

Kohlstedt, S.G. (1983) 'Australian museums of natural history: public practices and scientific initiatives in the 19th century', *Historical Records of Australian Science*, vol. 5.

Kusamitsu, Toshio (1980) 'Great exhibitions before 1851', *History Workshop*, no. 9.

Lancaster, J. (1838) *Improvements in Education as it Respects the Industrious Classes of the Community*, London.

Landes, Joan B. (1988) *Women and the Public Sphere in the Age of the French Revolution*, Ithaca and London: Cornell University Press.

—— (1992) 'Re-thinking Habermas's public sphere', *Political Theory Newsletter*, no. 4.

Lane-Fox, Col. A. (1875) 'On the principles of classification adopted in the arrangement of his anthropological collections, now exhibited in the Bethnal Green Museum', *Journal of the Anthropological Institute*, no. 4.

Laqueur, Thomas (1990) *Making Sex: Body and Gender from the Greeks to Freud*, Cambridge, Mass.: Harvard University Press.

Leach, William R. (1984) 'Transformation in a culture of consumption: women and department stores, 1890–1925', *Journal of American History*, vol. 71, no. 2.

Lloyd, Clem (1983) *The National Estate: Australia's Heritage*, Adelaide: Savaas Publications.

—— and Sekuless, Peter (1980) *Australia's National Collections*, Sydney and Melbourne: Cassell.

Love, Rosaleen (1983) 'Darwinism and feminism: the "woman question" in the life and work of Olive Schreiner and Charlotte Perkins Gilman', in D. Oldroyd and I. Langham (1983).

Lowenthal, D. (1978) 'Australian images: the unique present, the mythic past', in Peter Quartermaine (ed.) *Readings in Australian Arts*, Colchester: University of Essex Press.

—— (1985) *The Past is a Foreign Country*, Victorian: Cambridge University Press.

Lurie, Edward (1960) *Louis Agassiz: A Life in Science*, Chicago and London: University of Chicago Press

MacArthur, John (1983) 'Foucault, Tafuri, Utopia: Essays in the History and Theory of Architecture', M.Phil thesis, University of Queensland.

McArthur, Colin (1986) 'The dialectic of national identity: the Glasgow Empire

Exhibition of 1938', in T. Bennett *et al.* (eds) *Popular Culture and Social Relations*, Milton Keynes: Open University Press.

McBride, Theresa M. (1978) 'A woman's world: department stores and the evolution of women's employment, 1870–1920', *French Historical Studies*, vol. 10, no. 4.

McBryde, Isabel (ed.) (1985) *Who Owns the Past?*, Melbourne: Oxford University Press.

MacCannell, Dean (1976) *The Tourist: A New Theory of the Leisure Class*, New York: Schocken Press.

McCullough, Edo (1966) *World's Fair Midways: An Affectionate Account of American Amusement Areas*, New York: Exposition Press.

MacDonald, Sally (1986) 'For "swine of discretion": design for living: 1884', *Museums Journal*, vol. 86, no. 3.

Mace, Rodney (1976) *Trafalgar Square: Emblem of Empire*, London: Lawrence & Wishart.

MacGregor, Arthur (ed.) (1983) *Tradescant's Rarities: Essays on the Foundation of the Ashmolean Museum 1683, with a catalogue of the surviving early collections*, Oxford: Clarendon Press.

Macherey, Pierre (1978) *A Theory of Literary Production*, London: Routledge & Kegan Paul.

McHoul, Alec (1989) 'Not going to Expo: a theory of impositions', *Meanjin*, vol. 48, no. 2.

MacKenzie, John M. (1984) *Propaganda and Empire: The Manipulation of British Public Opinion, 1880–1960*, Manchester: Manchester University Press.

Mahood, Linda (1990) *The Magdalenes: Prostitutes in the Nineteenth Century*, London: Routledge.

Malraux, André (1967) *Museum without Walls*, London: Secker & Warburg.

Mann, P. (1986) *A Survey of Visitors to the British Museum*, British Museum Occasional Paper no. 64.

Marcuse, H. (1968) *One Dimensional Man: The Ideology of Industrial Society*, London: Sphere Books.

Marin, Louis (1988) *Portrait of the King*, London: Macmillan.

Markham, S.F. and Richards, H.C. (1933) *A Report on the Museums and Art Galleries of Australia*, London: The Museums Association.

Martin, Gregory (1974) 'The founding of the National Gallery in London', *The Connoisseur*, nos. 185–7.

Marx, Karl (1973) *Grundrisse: Foundations of the Critique of Political Economy*, Harmondsworth: Penguin.

Meyer, K.L. (1979) *The Art Museum. Power, Money, Ethics*, New York: William Morrow & Co.

Millar, Ann (1986) 'The origin and establishment of the Australian War Memorial, 1915–41', Paper delivered at Australian War Memorial Conference.

Miller, Edward (1974) *That Noble Cabinet: A History of the British Museum*, Athens, O.: Ohio University Press.

Miller, Michael B. (1981) *The Bon Marché: Bourgeois Culture and the Department Store, 1869–1920*, London: George Allen & Unwin.

Minihan, J. (1977) *The Nationalisation of Culture: The Development of State Subsidies to the Arts in Great Britain*, London: Hamish Hamilton.

Minson, Jeffrey (1985) *Genealogies of Morals: Nietzsche, Foucault, Donzelot and the Eccentricity of Ethics*, London: Macmillan.

The Mint and the Hyde Park Barracks (1985) Sydney: Trustees of the Museum of Applied Arts and Sciences.

Mitchell, Hannah (1978) 'Art and the French Revolution: an exhibition at the Musée Carnavalet', *History Workshop Journal*, no. 5, Spring.

Mitchell, Timothy (1988) *Colonising Egypt*, Cambridge: Cambridge University Press.
—— (1989) 'The world as exhibition', *Comparative Studies in Society and History*, vol. 31, no. 2, April.
Mosedale, Susan Sleeth (1978) 'Science corrupted: Victorian biologists consider "the woman question"', *Journal of the History of Biology*, vol. 11, no. 1, pp. 1–55.
Mullaney, Steven (1983) 'Strange things, gross terms, curious customs: the rehearsal of cultures in the late Renaissance', *Representations*, no. 3.
Mulvaney, D.J. (1958) 'The Australian Aborigines 1606–1929: opinion and field-work', *Historical Studies*, 8.
Murray, David (1904) *Museums: Their History and Their Use*, Glasgow: James MacLehose & Sons.
Museum of Australia (1982a) Report of the Interim Council, *Plan for the Development of the Museum of Australia*, Canberra: Commonwealth of Australia.
—— (1982b) *Proceedings on Conference of Australian History*, Canberra: Common-wealth of Australia.
Museums in Australia (1975) Report of the Committee of Enquiry on Museums and National Collections, Canberra: Australian Government Publishing Service.
Nietzsche, Friedrich (1974) *The Use and Abuse of History*, New York: Gordon Press.
Nittim, Z. (1980) 'The coalition of resident action groups', in J. Roe (ed.) *Twentieth Century Sydney: Studies in Urban and Social History*, Sydney: Hale Iremonger in association with The Sydney History Group. (Also in Jack Mundey (1981) *Green Bans and Beyond*, Sydney: Angus & Robertson).
O'Doherty, Brian (1976) *Inside the White Cube: The Ideology of the Gallery Space*, San Francisco, The Lapis Press.
Oldroyd, D. and Langham, I. (eds) *The Wider Domain of Evolutionary Thought* London: D. Reidel Publishing Co.
Olmi, Giuseppe (1985) 'Science-honour-metaphor: Italian cabinets of the sixteenth and seventeenth centuries', in Olive Impey and Arthur MacGregor (1985).
Outram, Dorinda (1984) *Georges Cuvier: Vocation, Science and Authority in Post-Revolutionary France*, Manchester: Manchester University Press.
Owen, Richard (1862) *On the Extent and Aims of a National Museum of Natural History*, London: Saunders, Otley & Co.
Ozouf, Mona (1988) *Festivals and the French Revolution*, Cambridge, Mass.: Harvard University Press.
Palmer, Steve (1981) *The Pleasure Beach Story*, Blackpool: Blackpool Pleasure Beach Ltd.
Parker, Roszika and Pollock, Griselda (1982) *Old Mistresses: Women, Art and Ideology*, New York: Pantheon.
Parliamentary Debates (1974) Ministerial Statement on the National Estate, House of Representatives, vol. 90, 23 August–30 October.
Parr, A.E. (1959) *Mostly about Museums*, Washington: American Museum of Natural History.
—— (1962) 'Patterns of progress in exhibition', *Curator*, vol. V, no. 4.
Pateman, Carole (1989) *The Disorder of Women*, Cambridge: Polity Press.
Pearson, Nicholas (1982) *The State and the Visual Arts: A Discussion of State Intervention in the Visual Arts in Britain, 1780–1981*, Milton Keynes: Open University Press.
Perkin, H.J. (1975/6) 'The "social tone" of Victorian seaside resorts in the North West', *Northern History*, no. 11.
Perry, Warren (1972) *The Science Museum of Victoria. A History of its First Hundred Years*, Melbourne: Science Museum of Victoria.
Pevsner, Nikolaus (1976) *A History of Building Types*, New Jersey: Princeton University Press.

266

Physik, John (1982) *The Victoria and Albert Museum: The History of its Building*, London: Victoria and Albert Museum.

Pick, Daniel (1986) 'The faces of anarchy: Lombrosa and the politics of criminal science in post-unification Italy', *History Workshop*, no. 21.

Pitt Rivers, A.H.L.F. (1891) 'Typological museums, as exemplified by the Pitt Rivers Museum at Oxford, and his Provincial Museum at Farnham', *Journal of the Society of Arts*, 40.

—— (1906) *The Evolution of Culture and Other Essays*, Oxford: Clarendon Press.

Pomian, Krzysztof (1990) *Collectors and Curiosities. Paris and Venice, 1500–1800*, Cambridge: Polity Press.

Pommier, Edouard (1989) *Le Problème du Musée à la Veille de la Révolution*, Montargis: Musée Girodet.

Port Arthur Historic Site: Museum Catalogue (1984) Trial version. National Parks and Wildlife Service and the Education Department.

Poulantzas, Nicos (1980) *State, Power, Socialism*, London: Verso.

Poulot, Dominique (1983) 'Les finalités des musées du XVII siècle au XIX siècle', in D. Poulot (ed.) *Quels Musées, Pour Quelles Fins Aujourdhui*, Paris: Documentation Français.

Prakash, Gyan (1992) 'Science "gone native" in colonial India', *Representations*, no. 40.

Prince, Hugh (1981) 'Revival, restoration, preservation: changing views about antique landscape features', in David Lowenthal and Marcus Binney (eds) *Our Past Before Us. Why Do We Save It?*, London: Temple Smith.

Quoniam, Pierre and Guinamard, Laurent (1988) *Le Palais Louvre*, Paris: Éditions Nathan.

Rainger, Robert (1978) 'Race, politics, and science: the Anthropological Society of London in the 1860s', *Victorian Studies*, vol. 22, no. 1.

Rajchman, John (1988) 'Foucault's art of seeing', *October*, no. 44.

Real, M.R. (1977) 'The Disney universe: morality play', in *Mass Mediated Culture*, Englewood Cliffs, N.J.: Prentice-Hall.

Reid, Badger R. (1979) *The Great American Fair: The World's Columbian Exposition and American Culture*, Chicago: Nelson Hall.

Report from Select Committee on National Monuments and Works of Art (1841) *British Parliamentary Papers*, Shannon: Irish University Papers, 1971.

Richards, Evelleen (1983) 'Darwin and the descent of woman', in D. Oldroyd and I. Langham (1983).

Richardson, Benjamin Ward (1876) *Hygeia, a City of Health*, London: Spottiswoode. (Facsimile edition published by Garland Publishing, New York, 1985).

—— (1887) *The Health of Nations: A Review of the Work of Edwin Chadwick, with a Biographical Dissertation*. (2 vols). (Facsimile edition by Dawsons of Pall Mall, London, 1965).

Richardson, Ruth (1988) *Death, Dissection and the Destitute*, Harmondsworth: Penguin.

Riley, Denise (1988) *Am I That Name? Feminism and the Category of "Women" in History*, London: Macmillan.

Ripley, Dillon (1978) *The Sacred Grove: Essays on Museums*, Washington: Smithsonian Institute Press.

Ross, J. (1985) *The Myth of the Digger: The Australian Soldier in Two World Wars*, Sydney: Hale & Iremonger.

Rudwick, Martin J.S. (1985) *The Meaning of Fossils: Episodes in the History of Palaeontology*, Chicago: University of Chicago Press.

—— (1992) *Scenes from Deep Time: Early Pictorial Representations of the Prehistoric World*, Chicago and London: University of Chicago Press.

Russett, Cynthia Eagle (1989) *Sexual Science: The Victorian Construction of Womanhood*, Cambridge, Mass.: Harvard University Press.

Ryan, Mary P. (1990) *Women in Public: Between Banners and Ballots, 1825–1880*, Baltimore and London: Johns Hopkins University Press.

Rydell, Robert W. (1984) *All the World's a Fair: Visions of Empire at American International Expositions, 1876–1916*, Chicago: University of Chicago Press.

Sayers, Janet (1982) *Biological Perspectives. Feminist and Anti Feminist Perspectives*, London: Tavistock Publications

Schiebinger, Londa (1989) *The Mind Has No Sex? Women in the Origins of Modern Science*, Cambridge, Mass.: Harvard University Press.

Sebeok, Thomas and Umiker-Sebeok, J. (1983) '"You know my method": a juxtaposition of Charles S. Peirce and Sherlock Holmes', in Umberto Eco and Thomas Sebeok (eds) *Signs of Three: Dupin, Holmes, Peirce*, Bloomington: Indiana University Press.

Seelig, Loren (1985) 'The Munich Kunstkammer, 1565–1807', in Olive Impey and Arthur MacGregor (1985).

Seling, H. (1967) 'The genesis of the museum', *Architectural Review*, no. 131.

Sennett, Richard (1978) *The Fall of Public Man*, New York: Vintage Books.

Shapiro, Michael S. (1990) 'The public and the museum', in M.S. Shapiro (ed.) *The Museum: A Reference Guide*, New York: Greenwood Press.

Sherman, Daniel J. (1987) 'The bourgeoisie, cultural appropriation, and the art museum in nineteenth-century France', *Radical History Review*, no. 38.

—— (1989) *Worthy Monuments: Art Museums and the Politics of Culture in Nineteenth-Century France*, Cambridge, Mass.: Harvard University Press.

Shorter, Audrey (1966) 'Workers under glass in 1851', *Victorian Studies*, vol. 10, no. 2.

Silverman, Debora (1977) 'The 1889 exhibition: the crisis of bourgeois individualism', *Oppositions: A Journal of Ideas and Criticism in Architecture*, no. 45.

Skinner, Ghislaine M. (1986) 'Sir Henry Wellcome's museum for the science of history', *Medical History*, no. 30.

Smart, Barry (1986) 'The politics of truth and the problem of hegemony', in David Couzens Hoy (ed.) *Foucault: A Critical Reader*, Oxford: Blackwell.

Snow, Robert E. and Wright, David E. (1976) 'Coney Island: a case study in popular culture and technical change', *Journal of Popular Culture*, vol. 9, no. 4.

Stallybrass, Peter and White, A. (1986) *The Politics and Poetics of Transgression*, London: Methuen.

Stearn, W.T. (1981) *The Natural History Museum at South Kensington: A History of the British Museum (Natural History) 1753–1980*, London: Heinemann.

Stocking, George W. Jr. (1968) *Race, Culture and Evolution: Essays in the History of Anthropology*, New York: Free Press.

—— (ed.) (1985) *Objects and Others: Essays on Museums and Material Culture*, Madison: University of Wisconsin Press.

—— (1987) *Victorian Anthropology*, New York: Free Press.

Strong, Roy (1984) *Art and Power: Renaissance Festivals, 1450–1650*, Berkeley/Los Angeles: University of California Press.

Tafuri, Manfredo (1976) *Architecture and Utopia: Design and Capitalist Development*, Cambridge, Mass.: MIT Press.

Tay, A.E.S. (1985) 'Law and the cultural heritage', in Isabel McBryde (ed.) (1985).

Turner, Brian and Palmer, Steve (1981) *The Blackpool Story*, Cleveleys: Palmer & Turner.

Turner, Gerard (1985) 'The cabinet of experimental philosophy', in Olive Impey and Arthur MacGregor (1985).

Turner, Ralph E. (1934) *James Silk Buckingham, 1786–1855: A Social Biography*, London: Williams & Norgate.

Vidler, Anthony (1978) 'The scenes of the street: transformations in ideal and reality, 1750–1871', in Stanford Anderson (ed.) *On Streets*, Cambridge, Mass.: MIT Press.

—— (1986) 'Gregoir, Lenoir et les "monuments parlants"', in Jean-Claude Bornet (ed.) *La Carmagole des Muses*, Paris: Armand Colin.

—— (1987) *The Writing of the Walls: Architectural Theory in the Late Enlightenment*, Princeton, N.J.: Princeton Architectural Press.

—— (1990) *Claude-Nicolas Ledoux: Architecture and Social Reform at the End of the Ancien Régime*, Cambridge, Mass.: MIT Press.

—— (1992) 'Losing face', in *The Architectural Uncanny: Essays in the Modern Unhomely*, Cambridge, Mass.: MIT Press.

Waites, Bernard, Bennett, Tony and Martin, Graham (eds) (1982) *Popular Culture: Past and Present*, London: Croom Helm.

Walkowitz, Judith R. (1992) *City of Dreadful Delights: Narrations of Sexual Danger in Late-Victorian London*, Chicago and London: University of Chicago Press.

Wallace, Alfred R. (1869) 'Museums for the people', *Macmillans Magazine*, no. 19.

Wallace, M. (1981) 'Visiting the past: history museums in the United States', *Radical History Review*, no. 25.

—— (1985) 'Mickey Mouse history: portraying the past at Disneyland', *Radical History Review*, no. 32.

Walton, J.K. (1975) 'Residential amenity, respectable morality and the rise of the entertainment industry, the case of Blackpool, 1860–1914', *Literature and History*, vol. 1.

Webber, Kimberley (1987) 'Constructing Australia's past: the development of historical collections, 1888–1938', *Proceedings of the Council of Australian Museums Association Conference (1986)*, Perth.

West, B. (1985) 'Danger! history at work: a critical consumer's guide to the Ironbridge Gorge Museum', Birmingham: Centre for Contemporary Cultural Studies, History Series Occasional Paper no. 83.

White, David (1983) 'Is Britain becoming one big museum?', *New Society*, 20 October.

White, Richard (1981) *Inventing Australia: Images and Identity, 1788–1980*, Sydney: George Allen & Unwin.

Wiener, M. (1985) *English Culture and the Decline of the Industrial Spirit, 1850–1980*, Harmondsworth: Penguin.

Williams, Elizabeth A. (1985) *The Science of Man, Anthropological Thought and Institutions in Nineteenth Century France*, Ann Arbor, Mich.: University Microfilms International.

Wilson, Luke (1987) 'William Harvey's *Prelectiones*: the performance of the body in the Renaissance theatre of anatomy', *Representations*, no. 17.

Winson, Mary P. (1991) *Reading the Shape of Nature: Comparative Zoology at the Agassiz Museum*, Chicago and London: University of Chicago Press.

Wittlin, A.S. (1949) *The Museum: Its History and Its Tasks in Education*, London: Routledge & Kegan Paul.

Wright, Patrick (1984) 'A blue plaque for the labour movement? Some political meanings of the "national past"', *Formations of Nation and People*, London: Routledge & Kegan Paul.

—— (1985) *On Living in an Old Country: The National Past in Contemporary Britain*, London: Verso.

INDEX

typological method 196, 199

Uffizi Gallery 27
United States National Museum
 Smithsonian Institution 96, 252n
universal survey museum 38
Uren, Tom 143

Vaccine Institute 124
van Keuren, David 197
Vauclause House 131, 135
verisimilitude 251n
Victoria and Albert Museum 109, 118
Victoria's Industrial and Technological
 Museum 219
Vidler, Anthony 28, 48, 166, 181
Viennese Royal Collection 34
visibilities 34–6, 48, 56, 63–4, 69–75,
 83–4, 163–73, 179, 184, 198; and
 social regulation 48–55; and space
 48, 52, 63, 101

Wachtel, Eleanor 215, 252n
walking; as evolutionary practice
 179–86; as supervised conformity 100
Walkowitz, Judith 30
Wallace, Alfred 181, 196, 248n
Wallace, Michael 115–17, 156
Wallach, Alan 36, 38, 168
Walton, John 232
Ward, Dr 70

Weatherall, Bob 253n
Webber, Kimberley 146
Welsh Folk Museum 115
Wembley Empire Exhibition 83
West, Bob 114
Western Australian Museum 251n
Westminster Abbey 101
When the Boat Comes In 118
Whewell, William 186
Whig history 95, 154–5
White, A. 27, 79, 86, 249n
White City 56
White, Richard 250n
Whitlam government 142–3, 146, 251n
Wiener, Martin 114
Williamsburg 157
Willis, Anne-Marie 218, 254n
Wilson, Luke 252n
Wittlin, A.S. 246n
Wordsworth, William 86
world fairs 82–3, 103, 214; and
 feminism 103
Wright, David 255n
Wright, Patrick 132, 134, 147, 152,
 161, 251n
Wunderkammer 40, 73, 93, 213
Wylde's Great Globe 84

Yosemite National Park 129

Zadig's method 177–8, 195